FRANKLIN PARK PUBLIC LIBRARY
FRANKLIN PARK, ILL.

Each borrower is held responsible for all library
material drawn on his card and for fines
accruing on the same. No material will be
issued until such fine has been paid.

All injuries to library material beyond
reasonable wear and all losses shall be made
good to the satisfaction of the librarian.

**Replacement costs will be
billed after 42 days overdue.**

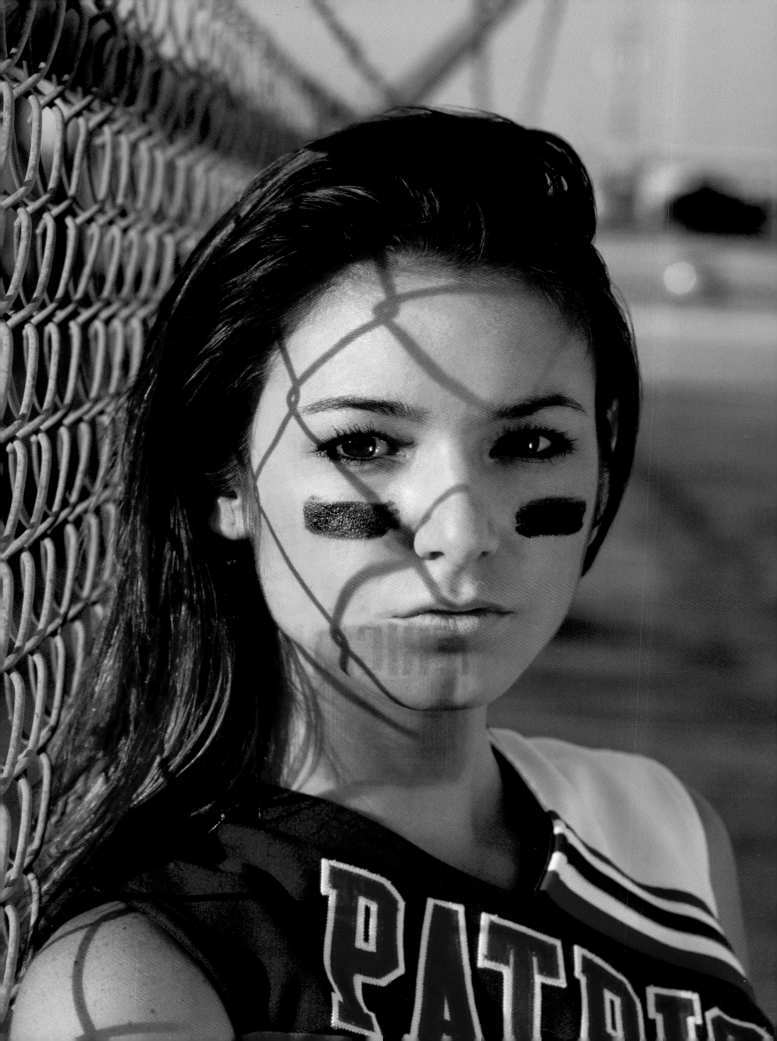

MICHAEL FRANZINI
ONE HUNDRED YOUNG AMERICANS

COLLINS | DESIGN

An Imprint of HarperCollinsPublishers

ONE HUNDRED YOUNG AMERICANS

Copyright © 2007 by COLLINS DESIGN
and Michael Franzini

All rights reserved. No part of this book
may be used or reproduced in any
manner whatsoever without written
permission except in the case of brief
quotations embodied in critical articles
and reviews. For information, address
Collins Design, 10 East 53rd Street,
New York, NY 10022.

HarperCollins books may be purchased
for educational, business, or sales
promotional use. For information,
please write: Special Markets
Department, HarperCollins*Publishers*
Inc., 10 East 53rd Street, New York,
NY 10022.

First Edition

First published in 2007 by:
Collins Design
An Imprint of HarperCollins*Publishers*
10 East 53rd Street
New York, NY 10022
Tel: (212) 207-7000
Fax: (212) 207-7654
collinsdesign@harpercollins.com
www.harpercollins.com

Distributed throughout the world by:
HarperCollins*Publishers*
10 East 53rd Street
New York, NY 10022
Fax: (212) 207-7654

Designed By:
Shaun Forouzandeh

Art Direction:
Robert Ruehlman

Library of Congress Control Number:
2007928223

ISBN: 978-0-06-119200-5
ISBN-10: 0-06-119200-7

Printed in China
First Printing, 2007

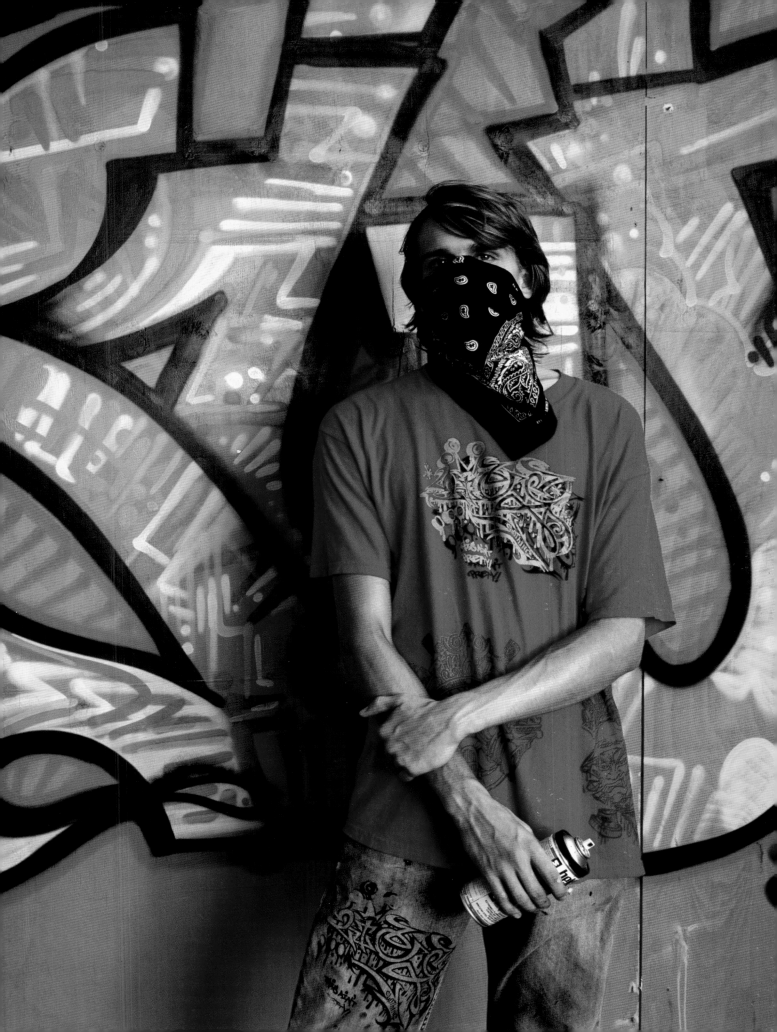

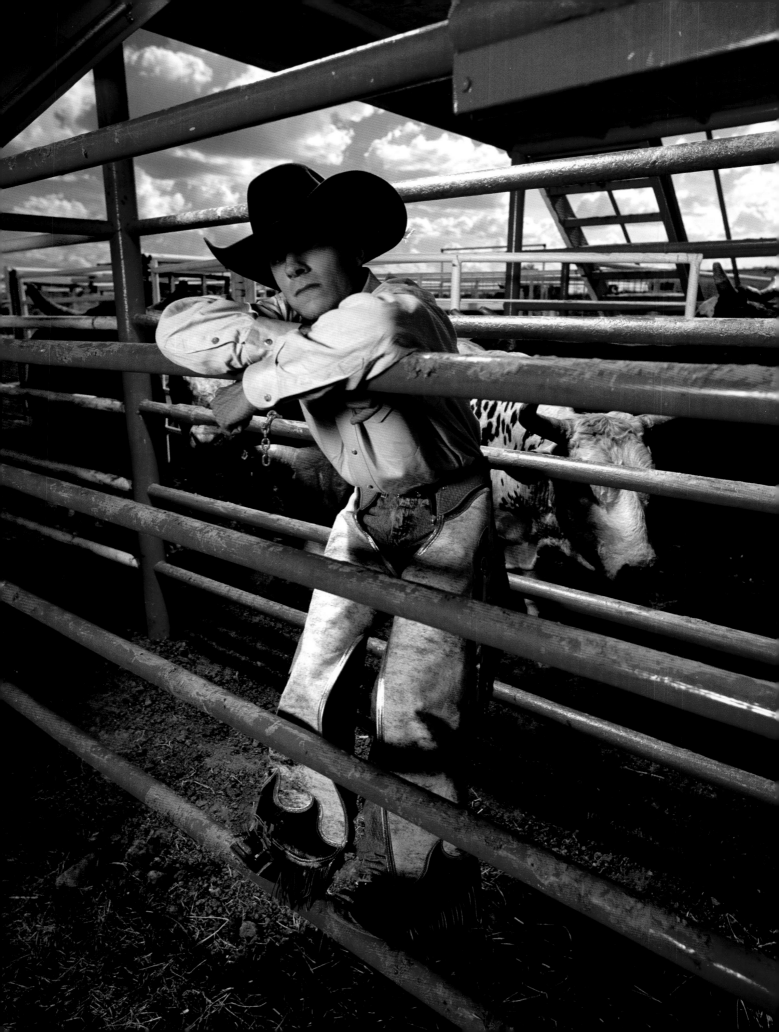

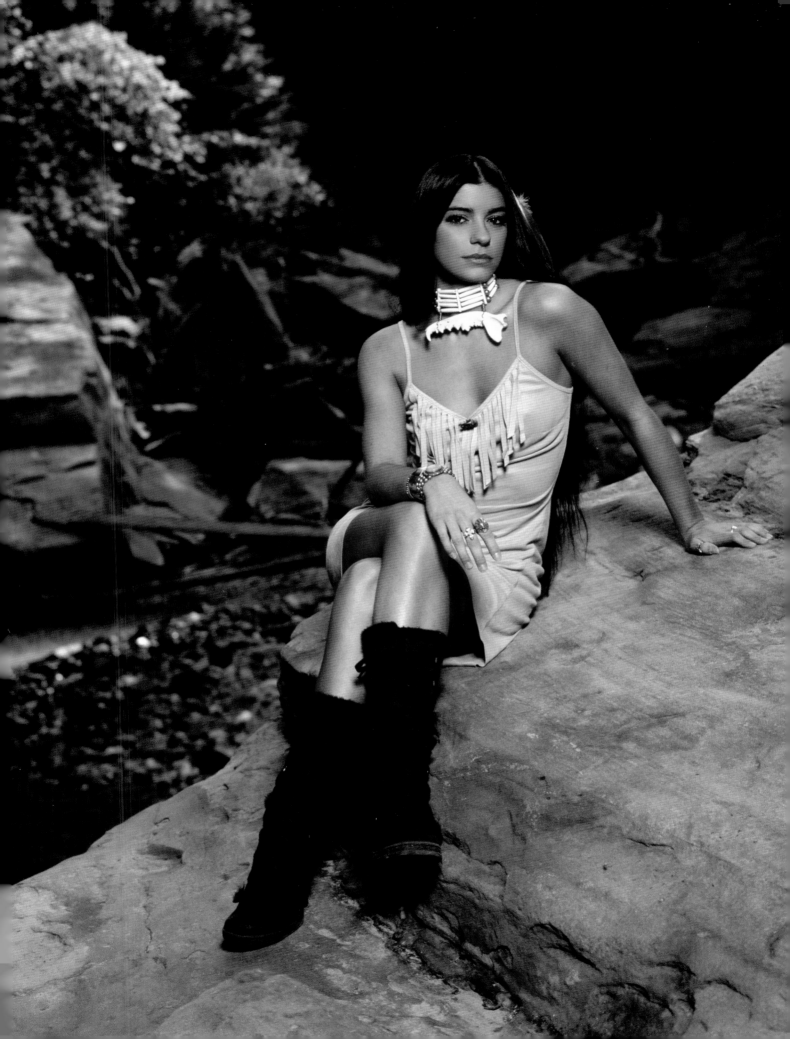

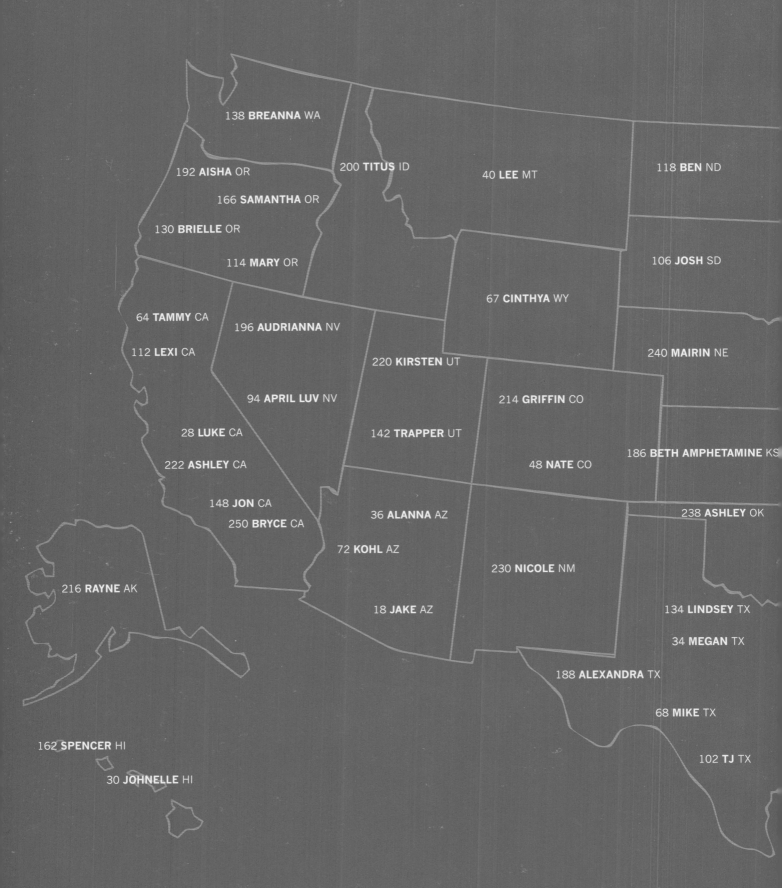

138 **BREANNA** WA

192 **AISHA** OR

166 **SAMANTHA** OR

130 **BRIELLE** OR

114 **MARY** OR

200 **TITUS** ID

40 **LEE** MT

118 **BEN** ND

106 **JOSH** SD

67 **CINTHYA** WY

64 **TAMMY** CA

196 **AUDRIANNA** NV

112 **LEXI** CA

220 **KIRSTEN** UT

240 **MAIRIN** NE

94 **APRIL LUV** NV

214 **GRIFFIN** CO

28 **LUKE** CA

142 **TRAPPER** UT

222 **ASHLEY** CA

48 **NATE** CO

186 **BETH AMPHETAMINE** KS

148 **JON** CA

250 **BRYCE** CA

36 **ALANNA** AZ

238 **ASHLEY** OK

72 **KOHL** AZ

230 **NICOLE** NM

216 **RAYNE** AK

18 **JAKE** AZ

134 **LINDSEY** TX

34 **MEGAN** TX

188 **ALEXANDRA** TX

68 **MIKE** TX

162 **SPENCER** HI

102 **TJ** TX

30 **JOHNELLE** HI

158 **ALISON** MN

76 **BETHANY** NH

110 **SARAH** ME

126 **ANASTASIA** VT

246 **RESKEW** NY
144 **ELLENORE** NY
212 **ANDY** NY
24 **ANGEL** NY
46 **JOEL** NY
236 **BLACKMAN** NY
244 **BENTZY** NY

98 **MISTY** MA
62 **BLESSING** MA

206 **LIANE** RI

38 **MIKAYLA** WI

170 **JOSH** MI

22 **JANAI** MI

43 **SIMONE** CT
242 **CHRISTINE** CT

88 **BART** IA

90 **MOHAMMED** MI

58 **STEPHEN** PA

44 **MONIQUE** NJ
32 **NATE** NJ
128 **KRYSTAL** NJ

146 **CALVIN** IA

140 **MIKE** IA

84 **JUSTIN** OH

160 **JOSH** PA

80 **ADRIAN** IN

208 **JACQUELINE** OH

234 **MEGAN** DE
154 **PARSON** DE

184 **BILLY** IL

218 **KIMAMA** OH

232 **BRADY** IN

54 **CARY** WV

82 **DREW** VA

50 **DAVID** MD
178 **JANINE** MD

168 **CHRIS** MO

226 **KATY** VA

120 **BROOKS** KY

194 **WILL** DC

228 **CHAD** NC

131 **KELSEY** TN

167 **KAYLEIGH** NC

52 **ALISSA** TN

225 **TRAVIS** AR

100 **JESS** SC

132 **ROSS** AL

152 **DELINO** GA

66 **ANGELINA** MS

224 **CHUCKEE** GA

156 **BROCK** LA

42 **MICHAEL** MS

190 **ERIC** LA

210 **ALESSANDRA** FL

198 **KAMMIE** LA

180 **BORIS** FL

60 **CHRISTINA** FL

164 **KATRINE** FL

174 **KYLE** FL

CONTENTS

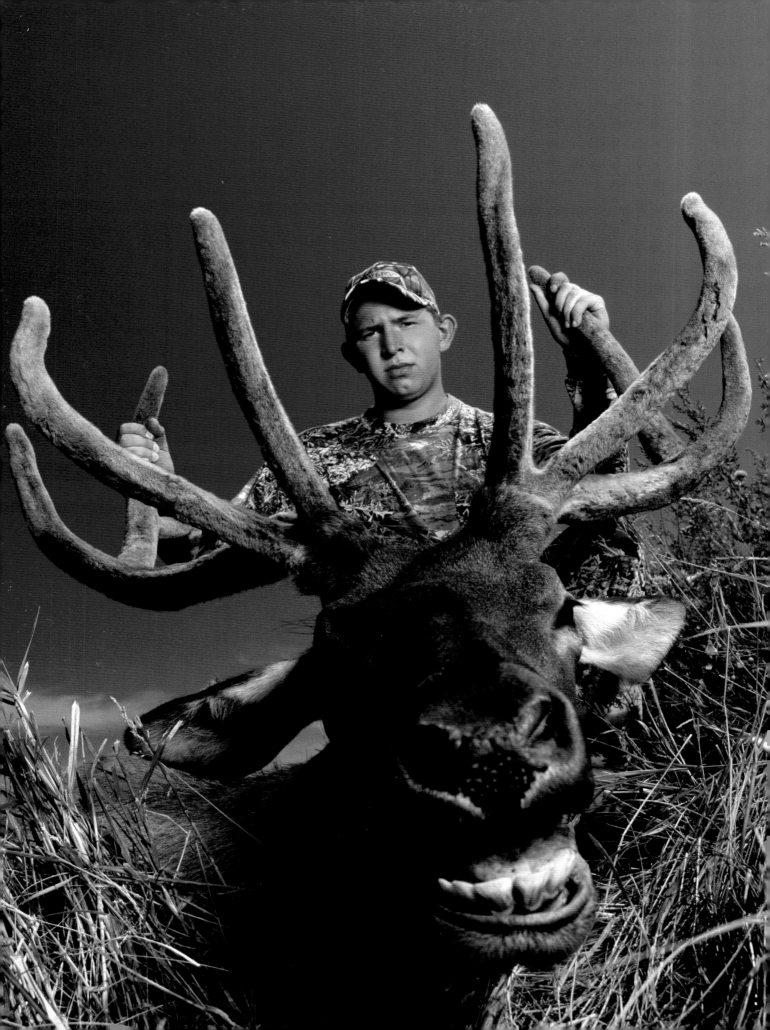

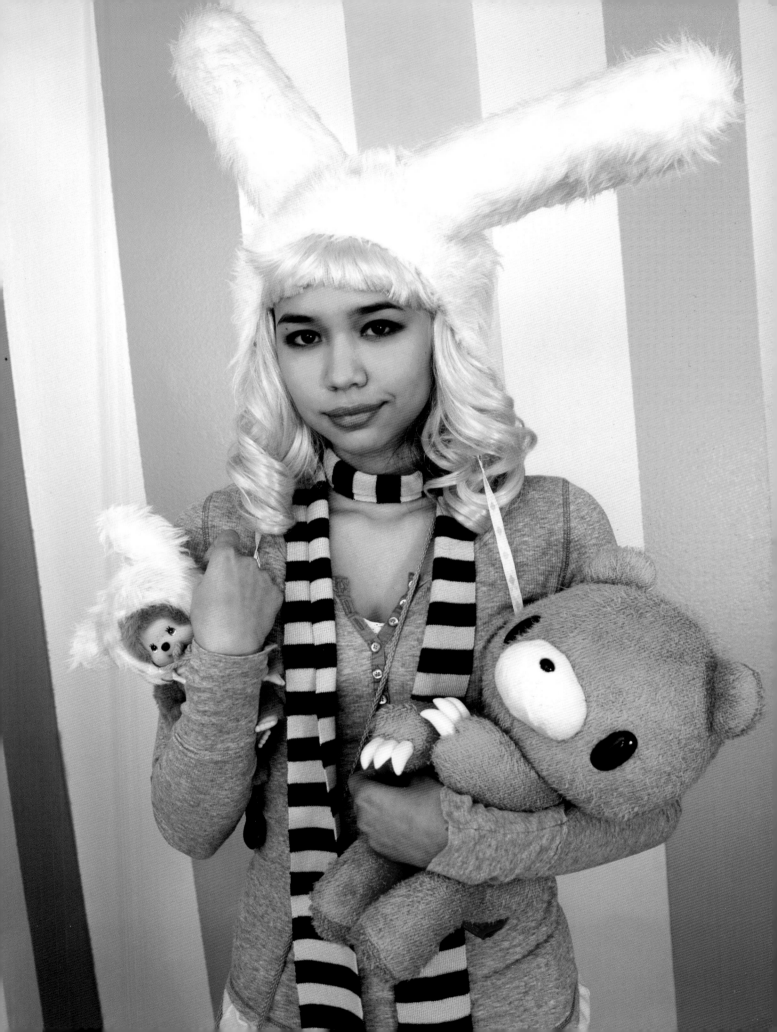

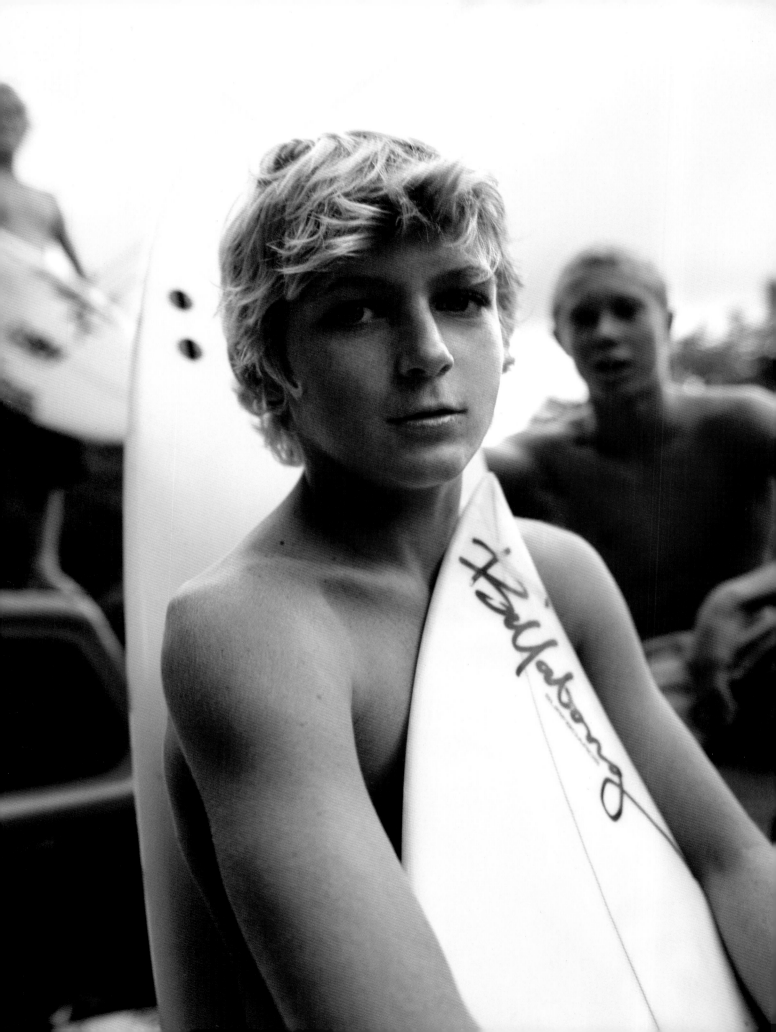

GROWING UP IN AMERICA

It is the most intense time in the life of a human being. A time of explosive energy and terrifying uncertainty.

Every teenager has heard adults say, "I was your age once." When they hear this, they shake their heads and think, "Yes, but it was different back then."

They're right.

Teenagers today have instant access to people, information, and entertainment on a scale that their parents could not have imagined..

It's not unusual for teenagers to have hundreds—or thousands—of online friends. They regularly chat with 20 friends simultaneously, while listening to music, watching TV, and talking on a cell phone.

Fashion trends last months—or weeks—instead of years. Tiny obscure cliques take root and flourish in cities and small towns across America.

This book is the first close look at the *instant access generation*.

My crew and I traveled to every state in the union—a total of 30,000 miles in 5 months— sometimes covering 3 states in a single day, to find a group of 100 individuals who best capture the full spectrum of teen life in America.

I met every kind of teenager: cheerleaders, jocks, student body presidents, prom queens, nerds, band geeks, gamers, skaters, stoners, goths, punks, druggies, and kids who defy all labels. The kids that are a part of this book closely match the demographics of the most recent census data, as follows:

What I found during this journey is both intuitive and surprising.

Independence is still the central theme in the lives of teenagers. But technology has changed the meaning of independence.

Cell phones, the Internet, and instant messaging give these teenagers a brand-new level of freedom. Their social networks literally span the globe.

Many use this freedom to pull away from parents at an early age, and they find excitement, stimulation, and communities of like-minded people in the outside world.

Others hide under the protective wing of their parents, afraid to venture too far into a world that feels overwhelming and frightening.

This is the context for the photographs and stories in this book.

No one individual can represent a generation. But this group of 100 is a startling window into the lives of American teenagers today.

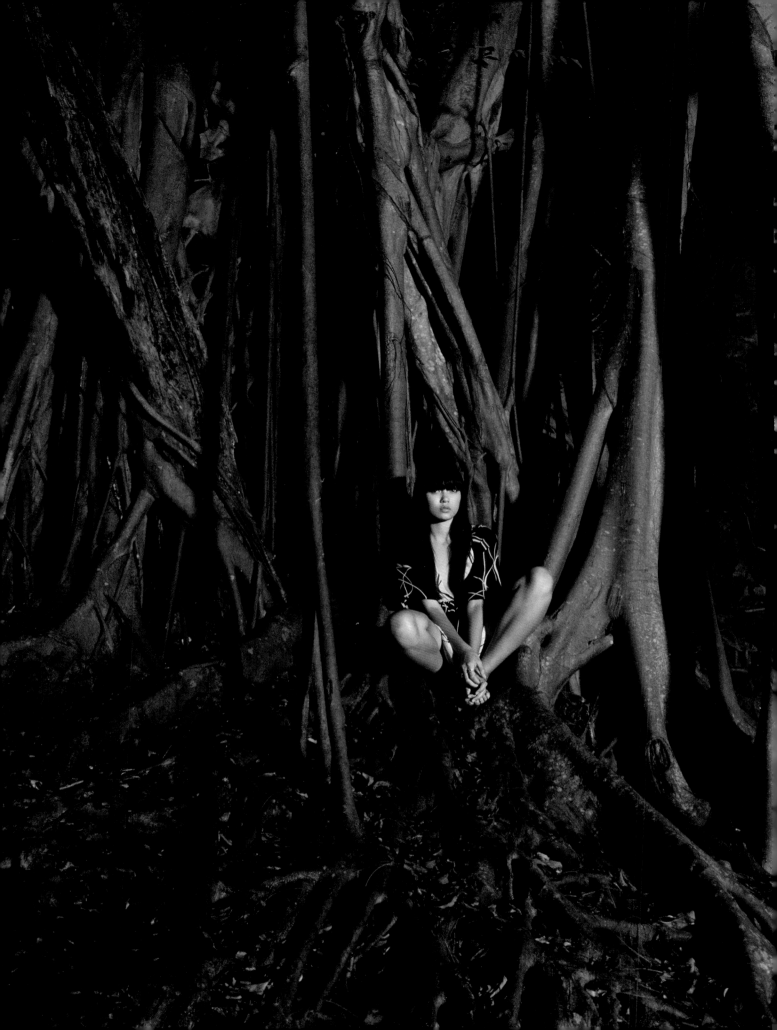

ABOUT THIS BOOK

The images in this book are portraits of teenagers presenting themselves as they want to be seen.

These are not candid fly-on-the-wall documentary photographs. These are images in which there is a connection between the subject and the camera.

I'm sometimes asked why I always take pictures of people staring into the lens.

The short answer is that I like eye contact.

The long answer is that I believe you can learn more about people by looking into their eyes and interacting with them than you can by watching without being noticed.

I have no interest in being invisible.

When I sit in an airport, I look around and wonder about the lives of the people I see. I want to know who they are, where they come from, and what they're about.

And when I meet someone I find interesting (like these 100 young people), I want to look in their eyes and understand who they are.

I think a lot of people have the same curiosity that I do.

This book is an answer to that desire.

Choosing the right group of 100 teenagers to represent American youth culture was a mammoth undertaking.

We had a team of people (at its peak about 12) using every conceivable means to identify the group that best captured a representative cross section of American teens.

We started out with census data for gender, race, religion, and sexual orientation, and we made it our mission to match those percentages.

Then we conducted extensive research to identify the current top 50 niches in youth culture, and we charted out the ones we wanted to make sure to cover.

In many cities and towns, we hired locals to go out and find candidates for the book. They approached teens in malls, on the street, and in schools (with principals' permission). They handed out brochures about the book and asked kids to get in touch if they were interested.

Thousands across the country sent in forms (with answers about their beliefs, activities, opinions, etc.) and snapshots.

Every week—for almost half a year—we had a meeting in which we reviewed hundreds of submissions and identified ones that potentially filled our needs.

One person was dedicated full-time to tracking how well we were achieving the diversity we wanted. Our goal was to have a balance of city/suburban/rural as well as rich/poor/middle-class and mainstream/fringe.

Once we made our selections, the real work began: getting past the parents' fears. More than 90% of parents assumed that we were either predators or scammers.

In almost every single case, we had several long conversations with parents, sent them to my web site, mailed them materials—and, often, they still were not sufficiently reassured to let their kids participate.

In one case, the parents were so afraid that the father held a claw hammer in his hands for the first 15 minutes we were in their house.

In rare cases, the parents had absolutely no fear. (We met one girl in the mall at 10:00 PM and showed up at her house at midnight. Her parents made us coffee.)

The teenagers had their own fears, but they were different from their parents'. Mainly, they wanted to make sure that they weren't going to be embarrassed in front of their friends.

They needed to feel comfortable and know that they were not being judged.

Teenagers place adults in two categories: those who are authority figures, like parents and teachers, and those they relate to as peers. (The parents and teachers who relate to their kids/students as peers are notable exceptions; we encountered a number of these.)

My crew and I quickly established ourselves in the "peer" category.

It's hard to say how we did this. We made it clear that we understood something about their world and that we were not there to judge them.

Most important, I think, was that we made it clear that they were the center of attention, and they were in charge of how they wanted to present themselves, what they wanted to say, where they wanted to go.

The locations for these photographs were all chosen by the young people themselves. Typically, we'd meet at their houses and ask them where they thought would be a cool place to take pictures.

Sometimes they'd shrug and say, "I dunno, my backyard?" And sometimes they'd take us to amazing, breathtaking spots.

The incredible thing was how casual we were about choosing where to shoot and how well it always worked out.

Their clothes were always their own; they made their own choices. Occasionally, they'd ask us if we liked one outfit or another (especially some of the girls), but it was always what they pulled from their own closets.

Their poses were also purely their own.

While some of these images look like pictures of models in magazines, each of these young people made their own choices about how to pose.

For most of the girls and a few of the guys, we had a local makeup artist with us, mainly to keep skin from getting too shiny and to fix hair that got messed up by the wind.

The makeup artist always, without exception, stayed true to the person's look. If a girl wore lots of makeup, we stuck with that look. If her look was raw and natural, we went with that.

The whole time I was with these young people, I recorded our conversations (with permission) on a small digital voice recorder. I later called each of them on the phone to conduct much longer interviews—asking about their family, school, religion, relationships, hobbies, and everything else in their lives.

Recently, we asked everyone to ship us a box of personal artifacts—anything that they considered important or meaningful in their lives. Some sent diary pages and notebooks filled with artwork. Others sent trophies and awards. A motocross racer from the Midwest even sent us the muddy boots he wore when he won a big race.

I photographed each of these items, and we shipped them back. A few made it into this book, and the rest are on the book's web site, along with a wealth of other materials from these young Americans.

When you want to know more about anyone in this book, you can visit **www.100youngamericans.com** for the rest of the story.

But first look closely at the images on these pages. Each one was painstakingly selected (sometimes from as many as 1,000 images of the same person) because of what it says about the individual—and the generation.

I believe each of these images tells an important part of the story of youth culture in America.

To begin the story, turn the page and meet the first of our 100 young Americans.

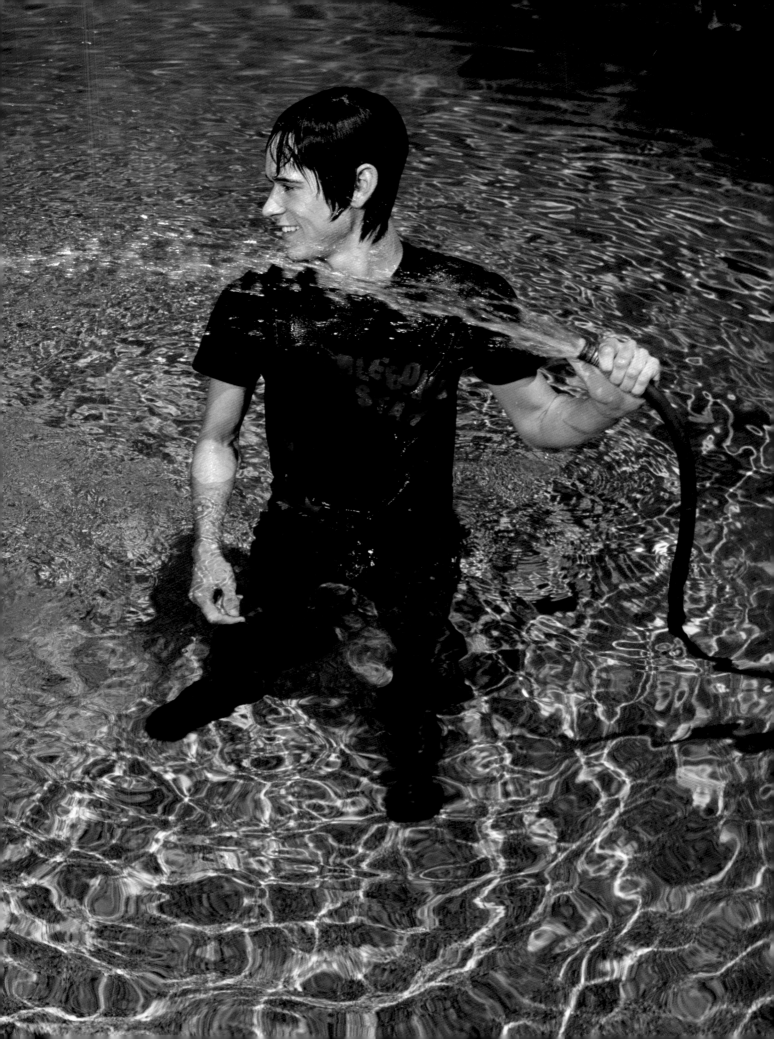

JAKE
19 ★ ARIZONA

Jake has 15,000 friends around the world, and most of them don't know his real name. They know him as Eye Candy, which is his handle on MySpace. He says some people think he's vain for calling himself that, but the truth is it's just a joke.

When Jake was a freshman, a girl who had a crush on him went around saying, "Jake is my eye candy." Jake thought that was funny and decided to use it. He had no idea how many people would eventually know him by that name.

When Jake goes out in public, strangers yell out "Eye Candy" as they drive by. Groups of girls from MySpace follow him around the mall. They recognize him from the pictures on his MySpace page.

"You're Eye Candy! You are sooo hot," they say to him.

Jake says he was one of the first 200 people on MySpace. For years, he put in five or six hours a day on the site, and his "friend space" grew exponentially.

66 IT TAKES TIME TO MAKE 15,000 FRIENDS. 99

You need to check out each "friend's" page individually, then click to accept or reject their "friend invitation." Jake says he pretty much accepts all invitations, except ones from creepy older guys.

Until recently, the scary world of online predators was all Jake's parents knew of the Internet. They'd watch *To Catch a Predator* on TV and warn Jake not to talk to anyone on the computer.

"All you hear is the bad stuff," Jake says. "You hear about some 10-year-old kid who went over to someone's house and got molested and killed."

"That kid didn't get killed because of MySpace. He got killed cuz he's dumb and went over to some dude's house he didn't know. You just gotta be smart. I was always raised not to trust people you don't know."

Now that Jake's mom has discovered that he's an online celebrity, she's proud that her son's sex appeal has taken him so far. She laughs and tells him he gets his looks from his mother.

Looks are important to Jake. His plan, at least for the next few years, is to dedicate his life to helping people look their best. He's in cosmetology school, studying to be a hair stylist.

Jake says the school is pretty much all girls and gay guys. At first, it bothered him that everyone assumed he was gay, but now he doesn't care. He dealt with the same thing in high school. "Size 28 jeans have always been, like, gangsta huge on me," he says. "So I've worn girl jeans my whole life."

Jocks would make fun of him for his look and his music. A lot of them called him emo because of the long hair and tight pants, but he was more into screamo. (More screaming, less depression, he says.)

The only other place Jake likes to go on the web is PB-Nation, which is "the largest online paintball community." Jake plays paintball every weekend and wants to be a pro paintball player.

As soon as paintball gets into the X Games—the Olympics of extreme sports—then, Jake says, it will explode. That's when he plans to turn pro and get famous.

Jake says fame is definitely in his future. He loves the idea that people all over will know him and he won't know them.

"The whole MySpace thing is a good warm-up for when I'm really famous."

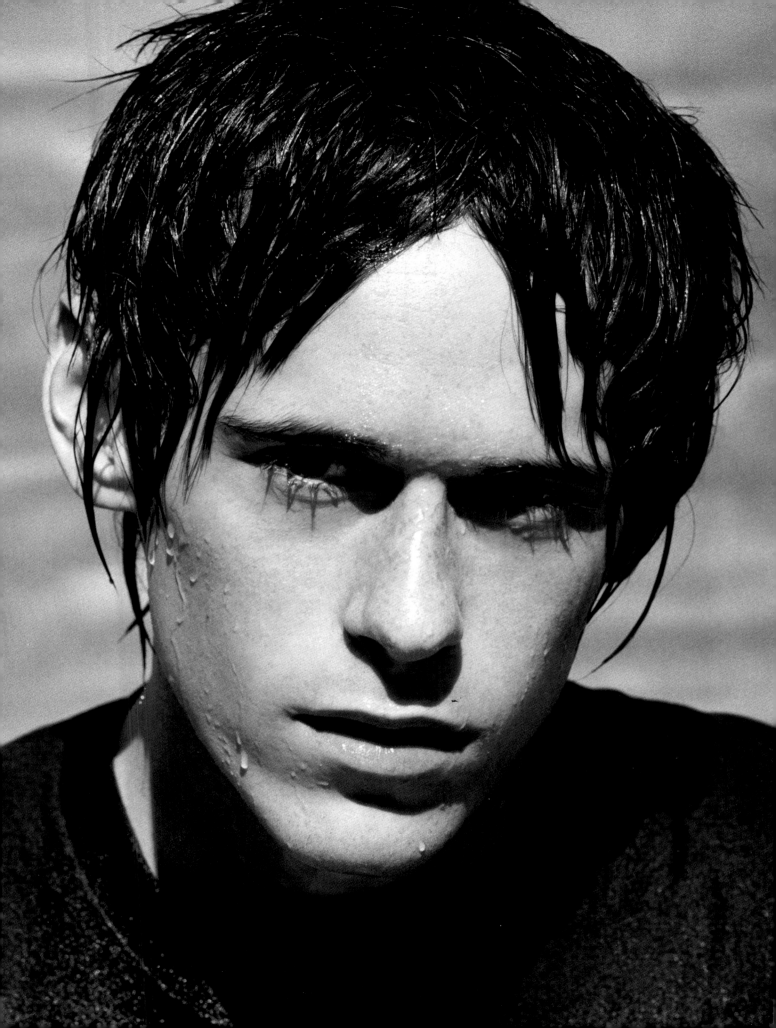

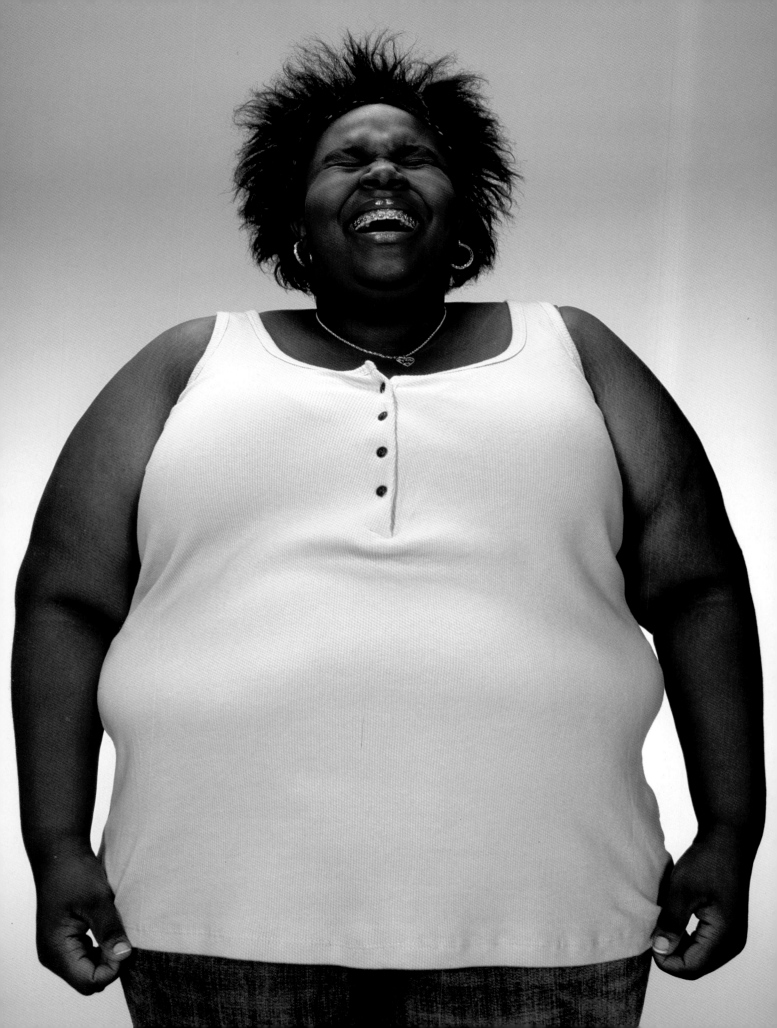

JANAI
16★ MICHIGAN

Janai's dream is to play softball as well as Jennie Finch, the pitcher who helped win the U.S. a gold medal in the 2004 Olympics.

She says the main thing standing in the way of making the U.S. World Softball team is her weight, and she's working on it.

66 ALL THE POPULAR GIRLS AT SCHOOL ARE THIN, BUT I DON'T REALLY PAY ATTENTION TO THAT STUFF. 99

Janai smiles nonstop, and everything she says is positive.

Despite a lifetime of moving in and out of shelters, Janai says life is good. Kids make fun of her for being poor, but she keeps her positive outlook.

"I just want to be successful so my mom doesn't need to worry about money any more," she says.

Janai wants to earn enough so that her mom never needs to work again. And she wants her 3-year-old brother to have a full-time mom.

Two years ago, her brother's dad came to the house and got in a big argument with her mom. Janai was frying catfish in hot oil at the time, and the man threw the pot of oil at her mom.

He missed and it ended up scalding both the kids. They still have scars on their backs.

Everyone in school heard about the drama, and Janai's mom decided it would be best for her to switch schools. Now she attends a 3,000-student school known for its strong academics.

Janai misses playing softball and swimming at her old school, but she likes the people at her new school. She also likes the classes, especially math and science, and she's working to get her grades up so she can make it to medical school.

"I want to be a doctor," she says, "so I can find a way to help with breast cancer." Breast cancer runs in the family, and Janai says she'd want to help save her mom if she ever got it.

Janai's pediatrician says that type 2 diabetes is the real threat. "I have to lose weight, or I could get that," Janai says. In health class, the teacher says that 40% of African-American teenagers will get diabetes, and everyone needs to drink less sugary sodas.

Janai says if she could change one thing about herself, it would be her weight. Not only for softball and health reasons, but also because the guys always go for the girls who are "pencil thin."

She doesn't want to be skinny. Her goal is to be a size 12, the same as Marilyn Monroe at her heaviest.

To get there, she eats in moderation and avoids fatty foods—although there are days when she gives in and has the bacon cheeseburger and large fries at Wendy's.

In the meantime, she's happy that she gets to take care of her little brother, and she's happy that her mom is going to help paint her room pink—to match all her pink clothes, her pink computer, pink Care Bear, and pink iPod.

I ask Janai what she thinks about having kids, and she says she definitely wants to, but not for a long time.

"I want to make sure that they don't struggle," she says. "I want them to be able to ask for what they want and get it."

23

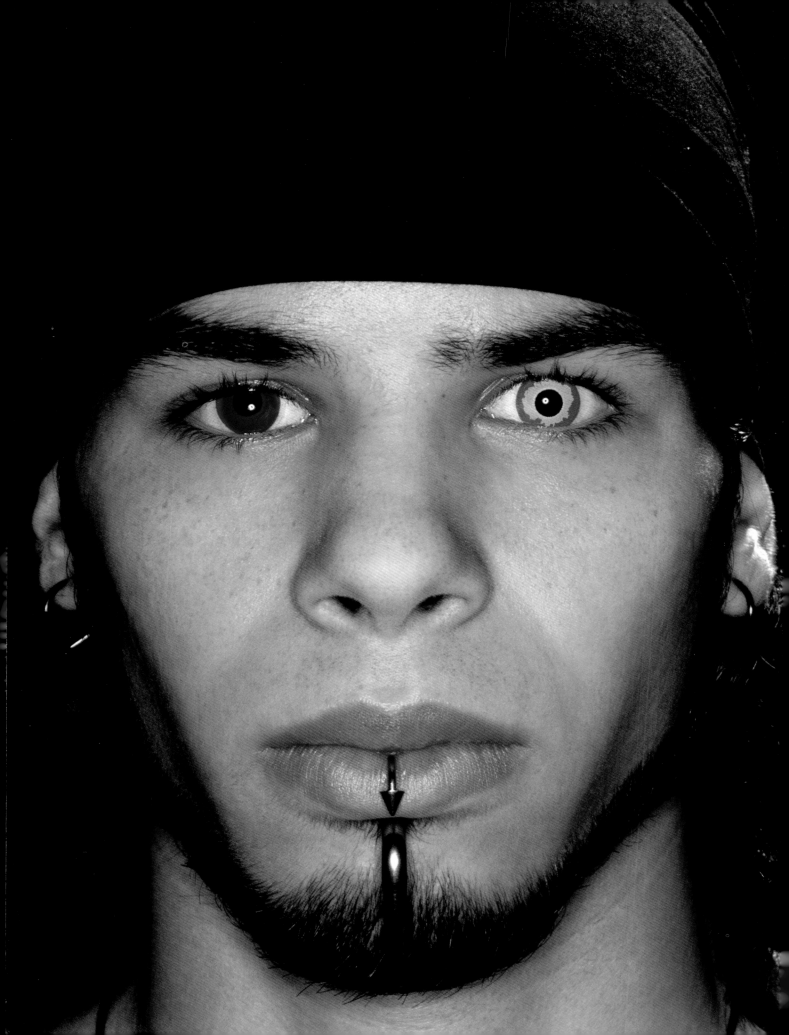

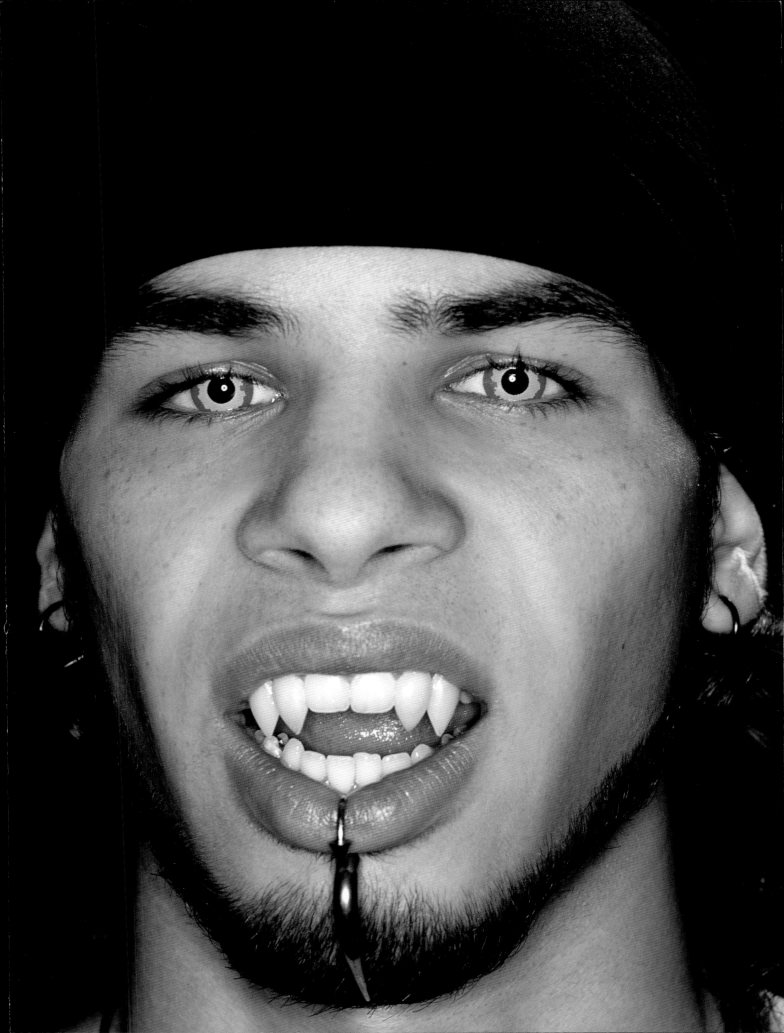

ANGEL
18★ NEW YORK

Angel has friends who are blood feeders, but he isn't that kind of vampire. Angel says he's a sexual vampire. He feeds on sexual energy instead of blood.

Until a couple of years ago, Angel was just a regular metalhead, meaning that he was into heavy metal, death metal, and black metal. "Heavy metal is what most people listen to," he explains, "and death metal is more deep screaming. Black metal is more satanic—heavier and more demonic."

His first taste of the New York vampire scene was at a death metal show in Manhattan. He noticed a guy with fangs and was intrigued. Angel asked if he was a vampire, and the guy said yes. Angel thought that was cool and started hanging out with the guy and his wife all the time.

Angel lives with his parents, six brothers, and a sister in Brooklyn, but he spends a lot of time with his vampiric family. It's like a second home.

"My vampiric name is Dark Genocide Arcadius. It was given to me by my vampiric father. Genocide means 'the master source of many races,' and I still need to find out what Arcadius means."

When Angel first got into the scene, one of the elders in the family told him to go online and take a test to find out which of the 13 vampire clans he belongs to. He found out that he's one of the Bruhas, who are the warriors of the vampire world. Angel wears the Bruha symbol—an upside-down anarchy sign—everywhere he goes.

This was a big year for Angel because he turned 18. "Just like in all the vampire movies," he explains, "when you turn 18, you become a vampire, and you're immortal. Forever young." Angel knows he won't stay young forever, but he believes this is his first year as a real vampire.

On his eighteenth birthday, Dark Genocide was allowed to get his first fangs. "I have a fang-smith who makes them for me. They're acrylic, and they mold right into your teeth."

He keeps the fangs in all the time, except when he's sleeping and eating. He says they're really sharp, so you've got to be careful with them. The ones he has are called Lost Boys because they're like the ones from the 1980s cult film. He's saving up to get a set of six fangs that look like the ones from *Interview with the Vampire*.

The necklace Angel wears is a pentacle, which he says is a symbol of the devil, although he's not into devil worship. Angel says pentacles are way more popular in the Lycan community—which are people who consider themselves werewolves and have bigger fangs than vampires.

ANGEL SAYS BLOOD TASTES PRETTY WEIRD AND HE'S NOT REALLY INTERESTED IN SUCKING ANY.

Angel is still in school, but he's doing a full-time internship as an electrician's apprentice, and he's planning to go to technical college to study electrical engineering. Sometimes, he has to go to work in a bad neighborhood, but he says no one ever messes with him, although people do stop and stare.

"I don't care what people think of me," he says. "This is what I am."

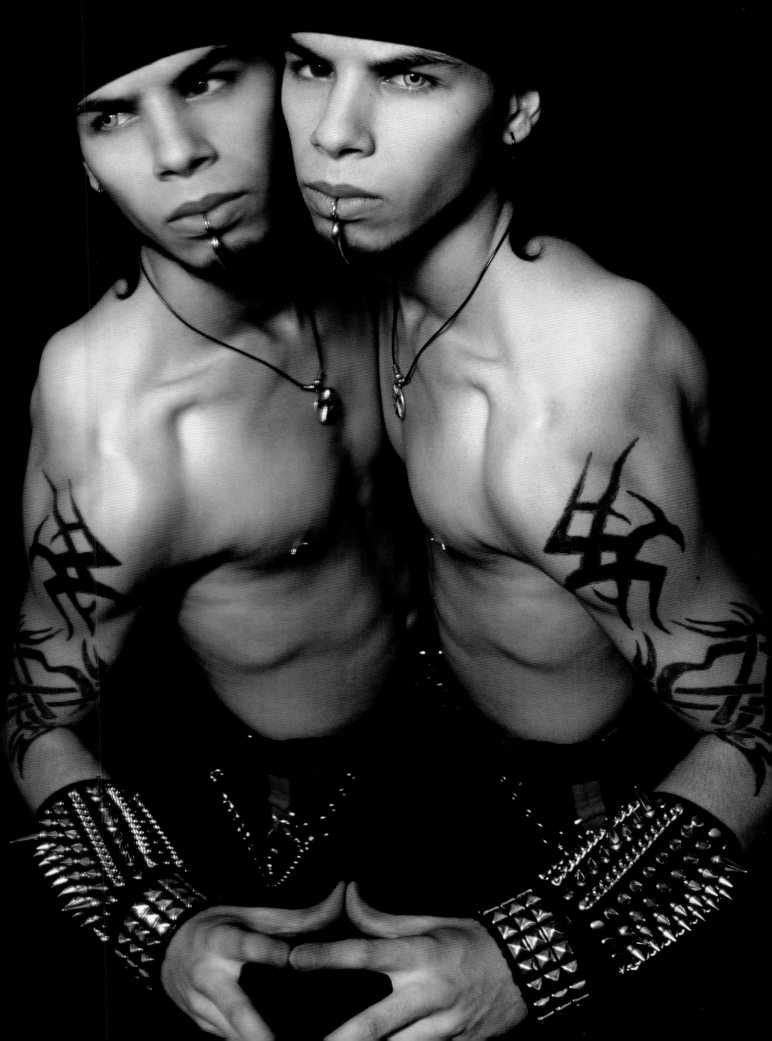

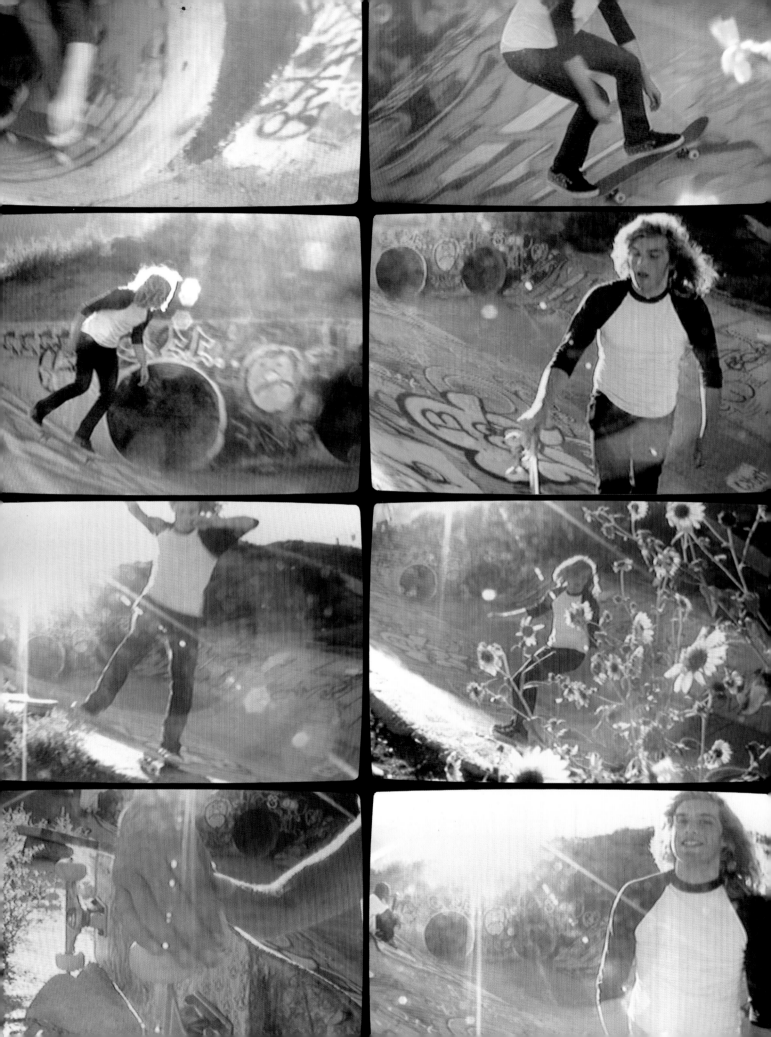

LUKE
16 ★ CALIFORNIA

LUKE IS A "SKATEBOARDER SLASH PUNK ROCK SUPERSTAR."

He rejects the "hesh" versus "fresh" distinction that divides his local skate community but then admits he's hesh and not fresh. (You're hesh if you've got shaggy hair and tight pants; fresh if you've got short hair and baggy pants.)

He makes a big deal about not caring about his appearance, but then he shouts "I'm a sexy guy" loud enough for the neighbors to hear. And he gets a new pair of white Converse All-Stars every month and wears a leather jacket "to keep it legit."

Luke wants to be an actor, he says, because it's all about the attention. Two weeks before our shoot he did a TV commercial for a new skate shoe brand launched by Steve-O of *Jackass* fame. Luke's video camera is his second favorite possession (after his board), and he spends a lot of time shooting his friends skating and BMXing, then cutting together his own skate films to post on YouTube.

Skateboarding is his life, but he talks about sex pretty much all the time. I ask him what a typical conversation with his friends is like:

"We're gonna talk about the tits. And we're gonna talk about the ass."

He has an 18-year-old girlfriend but says he's not really into chicks that much. In the next breath, he says he can

get a BJ whenever he wants one ("maybe it's because of my long blond beautiful hair"). But he won't take one from the "skate-park sluts" who are just there to get some penis.

Luke gets quiet when he tells me about the time they put his dog to sleep for almost ripping off the mailman's hand. This girl he went to school with, whose dad was the postmaster, told him how they sent the dog's head to the mailman.

He used to be in a gifted and talented program at school, but now he's homeschooled and has stopped caring. Not caring seems to be at the core of the "heshen" philosophy.

He's proud of the fact that his buddy Eric, a 6-foot, 7-inch, 16-year-old flatland BMXer, had a sore throat one day and cut his own tonsils out at the skate park using a pocket knife. (He took us to meet Eric, who confirmed the story and said the doctor told him he probably saved his own life.)

"Like, nothin' really scares me," Luke says. "I'm not tryin' to sound, like, tough or anything but... I'm not scared of dying. I'm not scared of... really anything."

JOHNELLE
17 ★ HAWAII

"Fuck this, I'm going to public school."

That's what Johnelle said after 2 years at an elite all-girls Anglican school that was founded by the queen of Hawaii, long before Hawaii became a state.

"I'm a free spirit," she says.

We're climbing through the jungle, looking for a giant banyan tree, when something catches Johnelle's attention and she wanders off. After a few minutes, we start to worry. Then she reappears with a cool tropical flower she found.

Johnelle smiles and runs barefoot across the damp ground.

Like everyone else in Johnelle's orbit, we learn that her presence is fleeting, and we'll take what we can get. (We almost gave up on meeting after six unreturned calls, but then she appeared and made us feel like we'd always been best friends.)

Her mother wants her to be more like her sister, who studies hard, takes religion seriously, and doesn't go out to nightclubs.

In private school, Johnelle didn't want to tuck her shirt into the black-and-white plaid skirt they made her wear. And she didn't see why it was such a big deal to chew gum or fall asleep in chapel.

The reason she was tired is that she would sneak out late at night to go see her skater boyfriend. He was hapa (half Hawaiian, half white) and briefly attended community college until he quit to skate professionally for Nike and Volcom.

Freedom is the theme of Johnelle's life, and she says it's what her whole generation is about.

> **"WHEN ME AND MY FRIENDS DRINK, STUFF HAPPENS. GUYS AND GIRLS, IT DOESN'T MATTER; ANYTHING GOES. WE'RE ALL SUPER OPEN-MINDED."**

Johnelle has almost 4 years to wait before her first legal drink, but she has no trouble getting what she wants now.

She hangs out with her best friend, Courtney, who's a model, and the two of them can get in to all the 21-and-over clubs for free, without showing ID.

Johnelle's parents get upset when she's not home by her midnight curfew. She wants them to be more reasonable. All her friends have curfews of 2:00, 3:00, or 4:00 AM.

Her mom is a 45-year-old bubbly, outgoing radio DJ for a Phillipine station in Honolulu, and her dad is a "conservative white boy."

She says she's not supposed to say how old he is, but she does mention that he's been working at the same big insurance company for the past 50 years, and it's not his first job.

"Things were different when he was my age," she says. "He just doesn't understand what life is like for us."

When her dad was a boy, the Japanese navy killed a thousand sailors on the USS *Arizona* in Pearl Harbor.

Johnelle can see the USS *Arizona* memorial from her window, and sometimes she notices fighter jets flying over. But she doesn't worry too much about history or current events.

"As long as I can be my own person and have good people around me," she says, "then I'll be happy."

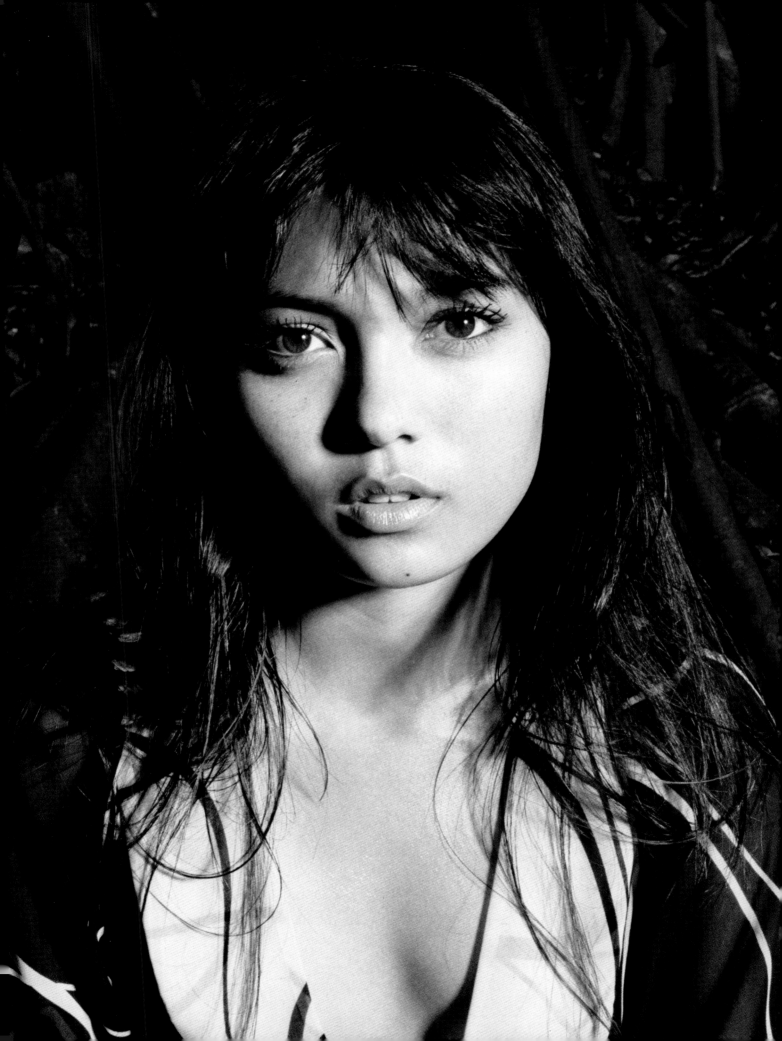

NATE
17★ NEW JERSEY

Nate lives in one of the most dangerous cities in America, but he says it's not that bad. He's not afraid to walk through the worst part of town in the middle of the night.

Nate is the star player on his school's basketball team and that makes him a local celebrity.

The fact that Nate is 6 feet 8 inches and towers over the rest of us may be another reason no one messes with him. He loves being tall. "People look up to me," he says.

Nate started playing basketball in eighth grade, when he was only 6 foot 3 inches—by far the tallest kid in the class. His brother Mike, now 19, got him started playing. Now both of them have full-ride basketball scholarships to good colleges.

Nate gives his dad a lot of the credit. The Cleveland Cavaliers drafted Nate's father right out of high school, but he hurt his knee before the season even began. All he wanted was to play pro basketball, but he never got the chance.

His dad now owns a barber shop in downtown Camden, and Nate hangs out there all the time, talking basketball with his dad's friends and customers.

Both of his parents are always there for him, Nate says. They raised him to be a good Christian and to steer clear of anything that will keep him from succeeding—including alcohol and weed.

66 NOTHING'S GONNA GET IN MY WAY. 99

When he finds something that works, he sticks with it. A couple of years ago during a street game, he ate a packet of Skittles and dunked a minute later. Now he eats three packets of Skittles before every game.

Nate has other rituals. "Every time I dunk on a guy, I write their name and number on my shoe," he says. "I've got 9 or 10 of them on my right shoe and a few on my left."

When he fills up a pair of shoes, he gets new ones using his employee discount at Foot Locker. He stocks shelves there, because he's the only one who can reach the top shelf.

Nate is pretty sure he's going to make it as a pro. Ten years from now, he'd like to be NBA Rookie of the Year, with a college degree, a beautiful wife, and a son who can follow in his footsteps.

Nate says it's all about his dad. He wants to make his dad's dream come true.

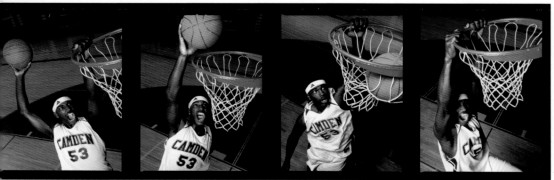

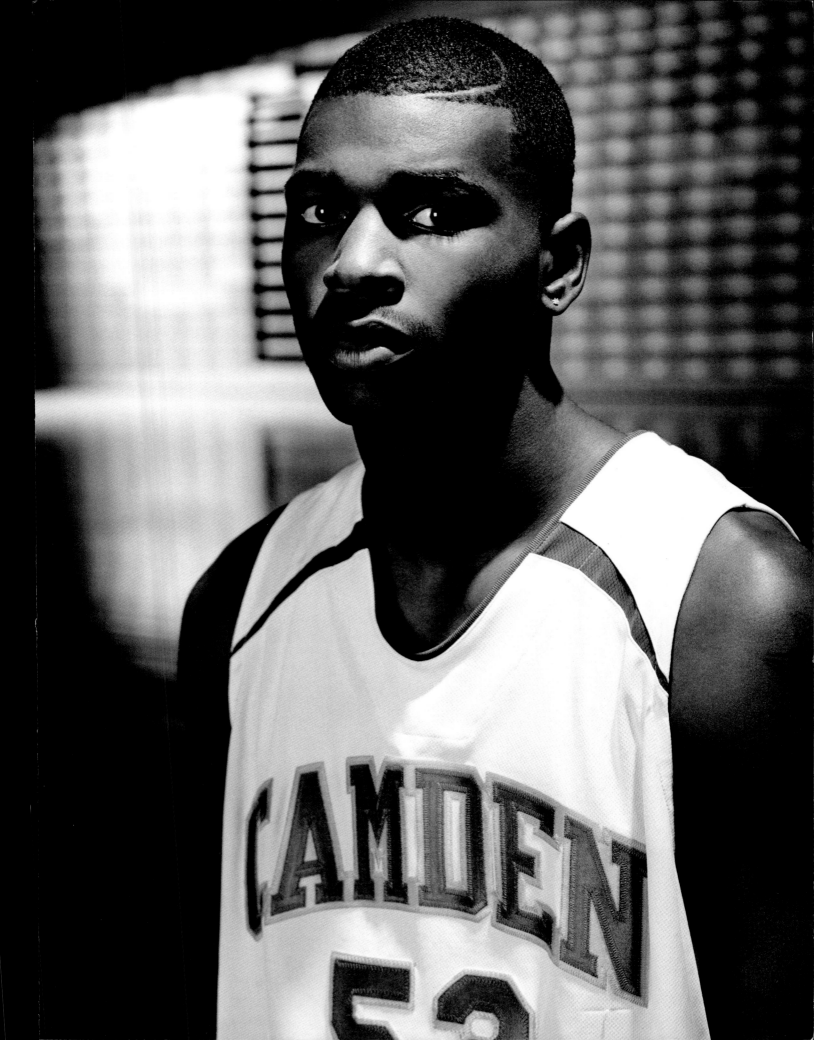

MEGAN
18 ★ TEXAS

Megan is afraid.

"I don't feel comfortable talking to strangers," she tells me. "People will stab you in the back in a heartbeat."

Megan stopped going to high school after ninth grade because she felt claustrophobic in the crowded classrooms. Her last 3 years of high school were online, at home. She did her coursework every day from 8:00 AM to noon and then went to the gym or the pool for the afternoon.

She says high school had too much drama for her, anyway. The only thing she really missed was the dance team. She loved doing the pom-pom routines during half-time.

Most of the cheerleaders in ninth grade were outgoing and popular. Megan was shy.

"People would get the wrong impression," she says. "They'd think I was snobby, because I kept to myself."

"I NEVER GO ON ONE-ON-ONE DATES."

"You don't want to go on a date and have something bad happen. Like if he's driving, maybe he won't take me home." Megan tells her friends to be careful on dates, but they think she's overprotective.

On her eighteenth birthday, Megan wanted to go on a cruise by herself, like her mom did when she turned 18. Her parents wouldn't let her. "My mom said I could get stolen. The world is different now."

Megan plans to go to dental school and move to New York—but she'll live in a house in the suburbs. "I don't trust apartments," she says. "You live so close to people. They can see you come and go. They can go through your stuff. You never know what will happen."

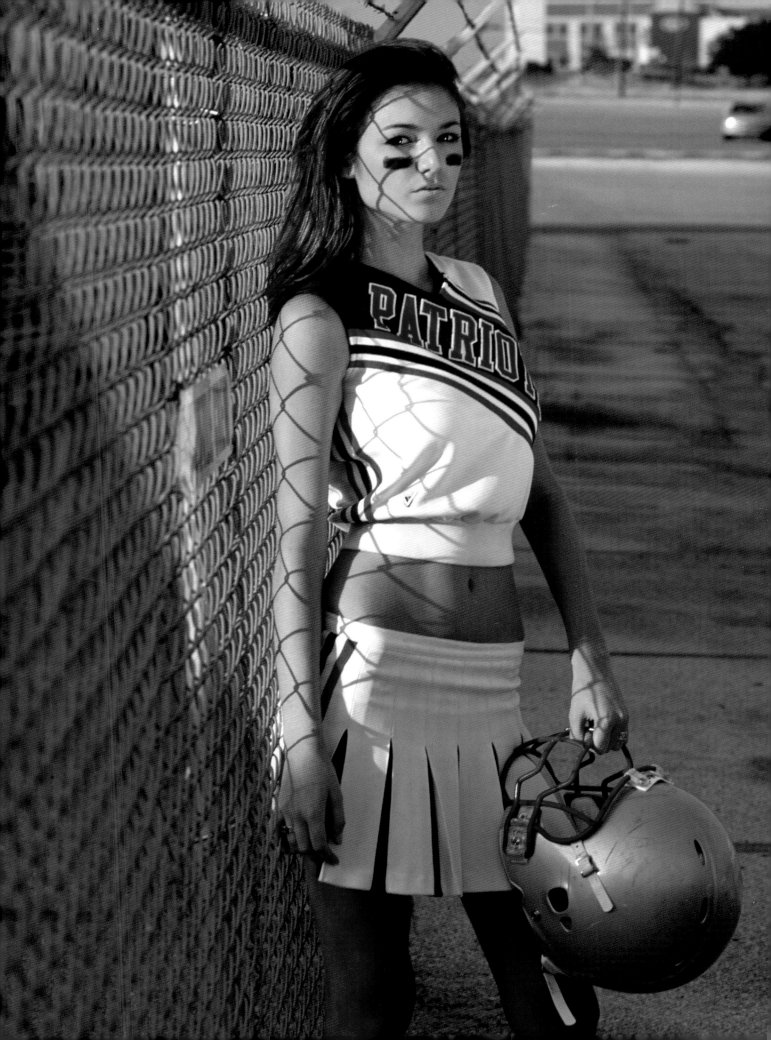

ALANNA
19 ★ ARIZONA

When Alanna was 8 years old, her mom showed up at school and pulled her out of class. "I have some bad news about your dad," she said. Alanna thought he was dead.

Back at her house, the door was smashed open and her dad's blood was everywhere. The cops had come for him again, and when they were taking him away, they accidentally cut his face on some glass or something. The blood stains didn't get cleaned up for months.

That was just over 10 years ago. Now I'm on the phone with Alanna, a few months after these pictures were taken, and she's talking superfast. It's hard for me to keep up.

So far today, Alanna's eaten a dozen Hostess donuts—six chocolate, six crumb—and she's eating a Suzie Q while she talks to me. Alanna says meth gives her the munchies.

For people who aren't used to meth, it takes away your appetite and makes it hard to sleep, she explains. For Alanna and her friends, it's the opposite.

When we photographed Alanna, she was still living with her mom—and still playing the violin once in a while, after years of lessons.

Alanna says her mom "went crazy" and had her put in jail for a while. She's talking so fast it's hard to get a clear sense of what happened. "My mom is evil," she says. "I don't talk to her. Ever."

Now she lives on the outskirts of Phoenix with five friends in a place she describes as a "singlewide trailer with a house built around it." She sleeps in a windowless room with cardboard walls. "It's kind of a freaky place," she says.

She says she's been on something for as long as she can remember: "When I was little, they'd give me Ritalin, because I had ADHD real bad, and I'd just sit there and drool. It made me into a zombie." When she got older, they switched her to Adderall, an amphetamine.

"Now I'm not on health insurance and I can't get the Adderall. So I'm doing this." Tweak, she explains, is just like Adderall, but way stronger. She and her boyfriend smoke an 8-ball of meth a day. That's a 3.5-gram baggie, which costs about $100.

When she was like 6 or 7, her dad would smoke meth out of a glass pipe, right in front of her. She didn't know what it was, but it seemed normal to her.

HE CALLED IT "VITAMIN M."

After her dad got sent away, she waited by the phone every night at 6:30. "That was the time he always called. Except sometimes they'd be on lockdown, and he wouldn't call. Those were sad days."

She also had an uncle who was around a lot before he had an "alcoholic seizure" and died of an aneurysm. She remembers him sitting at the kitchen table drinking vodka straight out of a green bottle. They called him Vodka Man.

Alanna hates drinking, and she hates "slammers," people who inject meth. "Slammers are dirty and nasty," she says. "They can't stop moving and twitching. They get obsessed with it and get all 'twacked' out."

"We're all tweakers, not twackers. Twackers go around and steal from people, and they don't share. We're not like that."

I ask about happy memories and she gets quiet for about five seconds.

She tells me about being 4 years old and living in southern California. "My mom and dad were together then, and they'd take me to Disneyland every weekend. They'd let me ride Dumbo the Flying Elephant, over and over. That's the only happy memory I have."

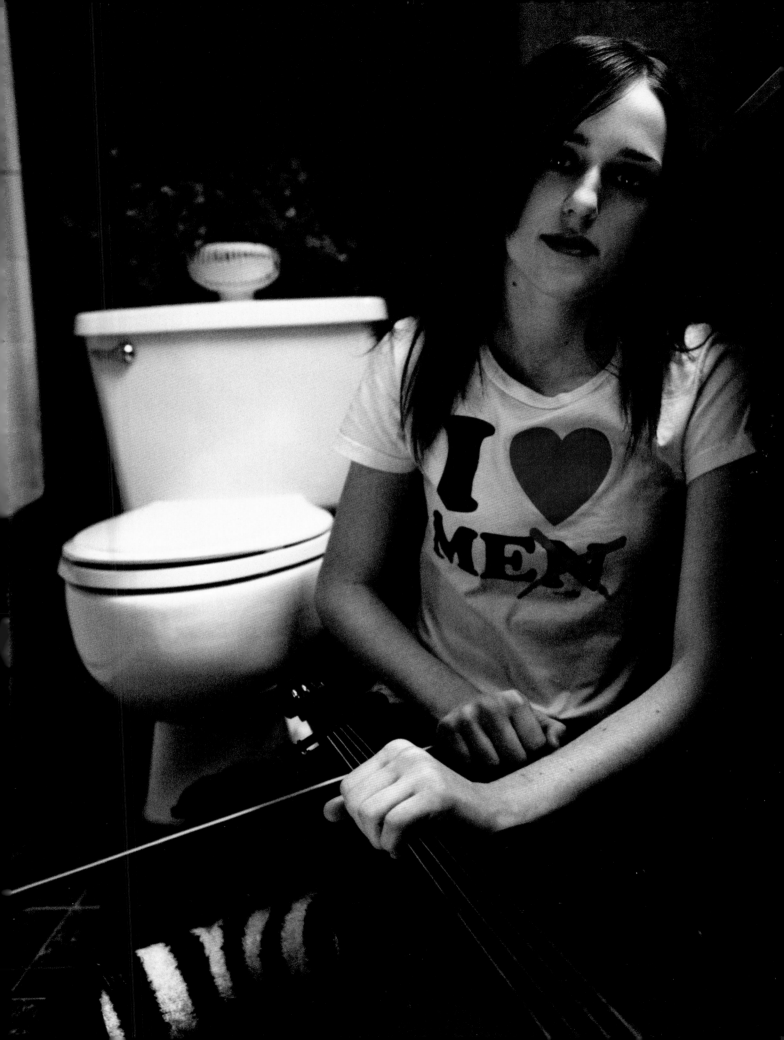

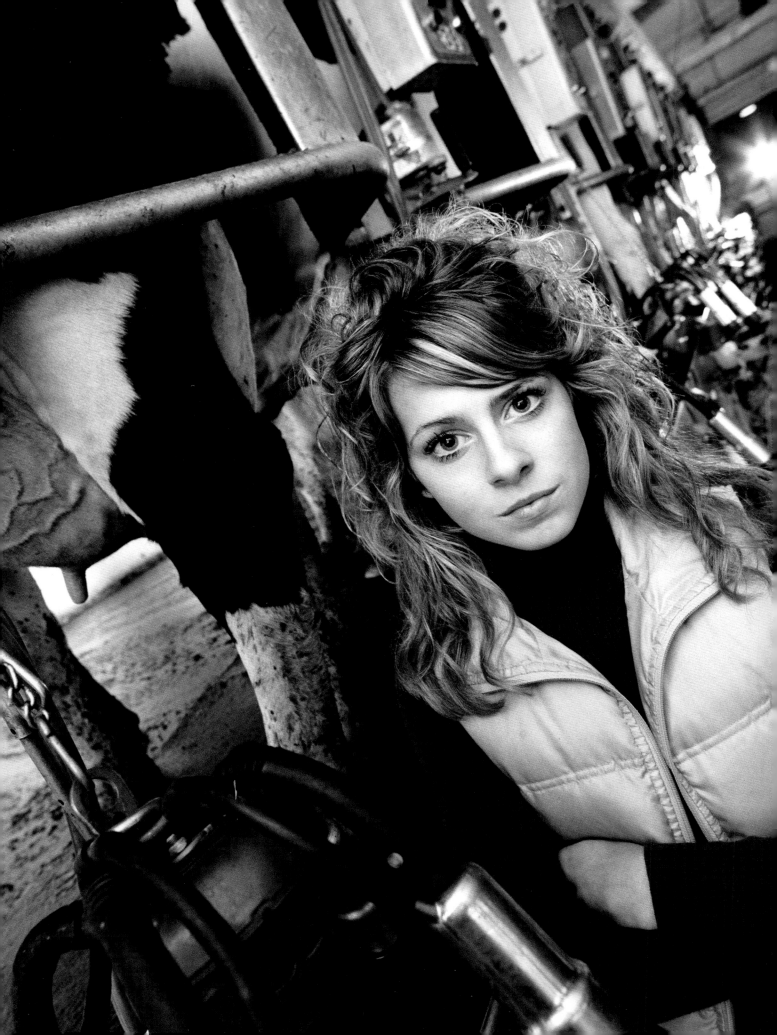

MIKAYLA
15★ WISCONSIN

The first time Mikayla saw a homeless person was 3 years ago. "I was shocked," she says. "I mean, you always see them on TV, but not in person."

She was on a trip to New York City with her grandparents, and she couldn't believe how crowded and noisy it was. She's a farm girl and could never imagine living in a place like that.

"I grew up going to cow shows and going to church, like every other kid."

For almost a century, Mikayla's family has run this 2,000-acre farm. She and her sisters are the fourth generation of kids to grow up here. We pull up at sunset as her dad's giving 1,700 cows their evening meal.

When the calves are little, Mikayla feeds them formula out of a giant baby bottle. After a few weeks, she trains them to drink from a bucket, and within a couple of months they're ready to move on to a diet of hay grown here on the farm.

Her dad does the hardest jobs on the farm, like impregnating the heifers (adolescent female cows). Mikayla says they use AI—artificial insemination. Other farms let bulls do the work, but then you don't know exactly who the daddy is.

Mikayla says they get a tank of bull semen delivered, and her dad puts on long rubber gloves and reaches inside the heifer. For now she just watches, but she's going to take a class so she can do it herself.

Once the sun goes down, the family drives us to the dairy—the other side of the farm where they do the milking. They take us into a giant room where 32 cows simultaneously get the milk sucked out of them. Ten gallons per cow, every day.

Mikayla's mom warns us not to make any sudden moves, because there may be projectile pooping. (We spend our final hour here wiping cow shit off of our equipment.)

Every member of her family drinks a full glass of milk with every meal. Strangely, they get their milk the same place as the rest of us: at the store. She says it's not safe to drink raw milk, and all of theirs gets made into Swiss Miss hot cocoa and Reddi-Wip.

"IT WOULDN'T BE A MEAL WITHOUT MILK."

I ask if she could possibly live a life without cows, and she says no way. "This is my world, and I could never leave it. It's what I love doing."

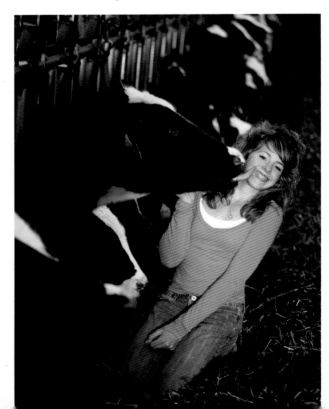

LEE
19 ★ MONTANA

"I WANT TO MOVE SOMEWHERE SMALLER."

Lee says she really doesn't like being around people, and she wants to move out to the middle of nowhere. She wants to be able to drive for five minutes and see nothing.

Lee says this while sitting on her 2-year-old horse, Patriot, here in the middle of nowhere. To get here, we drove eight hours through wide open prairies, with occasional glimpses of mountains—and almost no sign of human life.

Horses keep Lee grounded, and she'd be lost without them. She and her dad own five horses, and she says they're all like puppy dogs. Especially Patriot.

"Patriot is all mine," she tells me. "He's branded under my name."

Lee says there are a lot of horse thieves in Montana. I ask if Lee did the branding herself, and she laughs. "No, the brand inspector does that."

He works for the state's Department of Livestock, and he comes out to the ranch when you call. Lee says they still use hot branding for cattle, but now they use freeze branding for horses. She used a brand passed down from her great-grandpa, who ran the VK ranch not far from here.

She stroked Patriot's nose while the inspector soaked the branding iron (the letters *VK*) in liquid nitrogen. He pressed it into a shaved patch of skin for six seconds, and Patriot bucked a little but he was okay.

Lee doesn't like the way people in Montana treat the Indians. (No one here says "Native Americans," she tells me.) She says there are a lot of reservations around here, and people stereotype the Indians as lazy and hard drinking.

About 50 of the 200 kids in her senior class were Indians.

None of them were invited to the senior keg, which is a huge annual beer-drinking event on someone's ranch. Only the preppy kids go to that, and they're all white. Lee seems to enjoy the fact that this year's senior keg got busted because their bonfire got too big and attracted the cops. Lee doesn't like the preps too much.

"I'm attracted to cowboys," she tells me, "and cowboys usually drink a lot and get themselves into trouble." She says rodeo cowboys are the worst, because all they want to do is rodeo and party.

Ranch cowboys are okay, Lee says. She'll probably marry one of them someday.

Lee does her fair share of drinking. Her favorite is the "cowboy cocksucker," which is Baileys and butterscotch. Lee says everyone drinks a lot here.

"When it gets dark out, what else are you gonna do?"

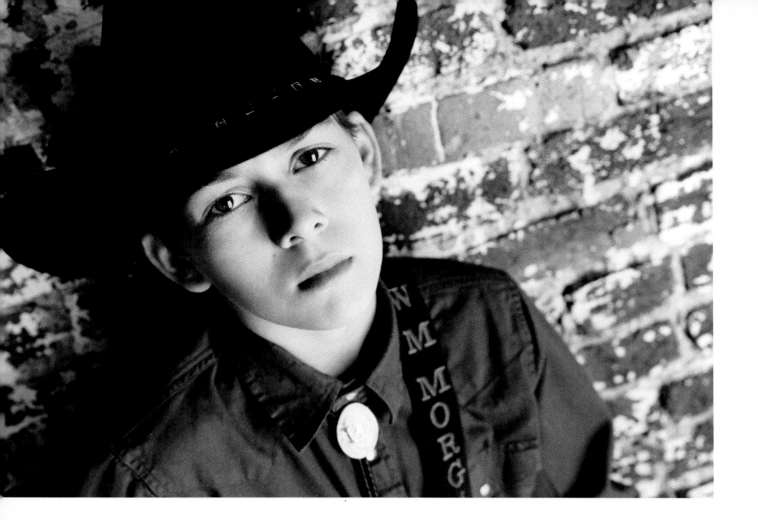

MICHAEL
13 ★ MISSISSIPPI

❝IF IT WASN'T FOR GOD, THEN I WOULDN'T HAVE THIS TALENT. I THANK HIM A LOT.❞

According to his MySpace page, Michael is "country music's next big superstar." Those are his dad's words, but a lot of people agree. Whenever he can, especially when he's on TV, he proudly tells people he's the North American Music Association's Male Vocalist of the Year.

Michael's dad, Mike, is so proud of his son that he quit his jobs as a taxidermist and police officer to manage Michael's career. "He's been singing since he could open his mouth," his dad says.

At one time, his dad had ambitions to be a country music star himself, but then he got a job and a wife. "You get married and have a family, and music takes second place. Then it comes back when you get someone like Michael."

Michael's parents say they're doing their best to keep him a child. They know what happens to a lot of child stars, and they don't want Michael to go that route.

Michael says if he told people at school about his career, he'd be "bombarded." He says they treat him like a "normal person" and that's the way he wants it. "I don't want to get bigheaded," he tells me. "I just want to sing."

SIMONE
18 ★ CONNECTICUT

Early one morning, a gross old van was rocking back and forth outside the classroom window. Simone says the whole class ran out and started pushing on the van. They were all chanting "Tip the van," and they did. A student was in there with a girl from some other school, and they pulled their clothes on and ran off down the street.

That was 4 years ago. Now Simone says her life is all about Tip the Van, a "rockin' female-fronted power-ska band" she started with her sister.

"IN MY LIFE, MUSIC, FRIENDS, AND FAMILY ARE ALL COMBINED."

Despite the "unwritten rule not to fuck around with band members," Simone has a secret romance with her guitar player, and one member of the band doesn't know about it. It started one night last summer when they locked eyes after a concert and kissed. That changed everything.

Now Simone and Brian are inseparable. They even go off on secret snowboarding trips. They just don't want Steph the trombone player to find out, because she might get jealous. And that can't happen, because the band always comes first.

"I want to be out there in a stadium, with my sister next to me, opening up for Chicago. And I want Sheryl Crow to get up on stage and sing with us. That's my dream."

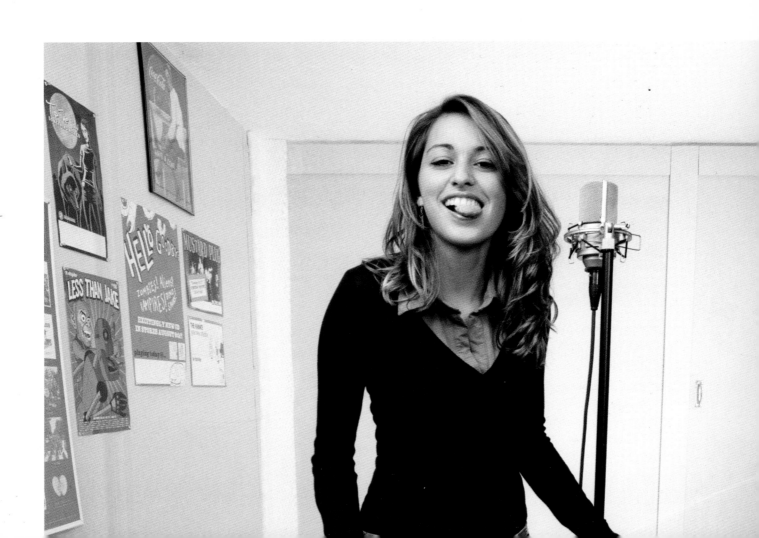

MONIQUE
19 ★ NEW JERSEY

Monique's favorite color is white, and she prefers vanilla over chocolate.

Monique is a rapper, an Ivy League college sophomore, and a Korean-American, in that order.

Monique's friends are shocked when they see her on-stage persona for the first time. They think of her as shy, quiet, and reserved, but then she blows them away with her anger-filled rhymes about ex-boyfriends and discrimination.

Her friends ask, "Why can't you be like this when we're out at the club?" She says it's an alter ego, like Slim Shady is for Marshall Mathers.

"I'm playing a character on stage," she explains. "That's why I like it. I get to be wild."

Her life as a student of economics at Columbia is a different story. She's afraid she might be slipping into sophomore slump, because her GPA has plunged to 3.4. Her friends hear this and think she's crazy; they'd do anything for her grades. But she considers anything below 3.6 "unacceptable."

Surprisingly, Monique says the pressure to achieve has nothing to do with her parents. "The last report card of mine they've ever seen was in second grade. They have absolutely no idea how I did in high school. I'm considered the jock of the family."

Columbia recruited Monique to join the golf team, but she quit playing soon after school began, partly because her obsession with golf gave way to an obsession with hip-hop.

Not that Monique likes hip-hop. She likes rapping, but she doesn't really like everything hip-hop culture represents these days. It was alright back in the '90s, before gangsta rap ever happened. But now it's all about hating and degrading women. Her iPod is full of soft rock.

Monique interns at a major record label in New York, where all the A&R people spend their days on MySpace searching for new talent. She asks her boss, a music executive, about the "ethnic oppression" of Asians by the entertainment establishment.

He says, "America's not ready for an Asian hip-hop artist." Monique explains, with some disdain, that the country listens to country music. "The average person in the South hasn't ever seen an Asian person," she says.

Monique grew up in a small town in north Jersey that is 90% white and less than 2% Korean. Against her will, her parents forced her to attend a Korean school every Saturday for eight hours, from kindergarten through sixth grade.

"WHEN I WAS YOUNGER, I SHUNNED MY KOREAN ROOTS. I'D TELL PEOPLE, 'I'M STRAIGHT-UP AMERICAN. I DON'T WANT TO BE CALLED KOREAN.'"

Now she's determined to be the first Asian rapper to break through.

Her mom, who went to Juilliard (and is now a travel agent) fully supports Monique's ambition. Her dad, a dentist, wants Monique to be an investment banker and has told her he doesn't think she'll make it in hip-hop. He lives for golf, and he's heartbroken that Monique gave it up to pursue a music career. I ask her how she feels about that and she smiles.

"I can still kick his butt on the golf course—by a good 10 strokes," she says. "That makes him happy."

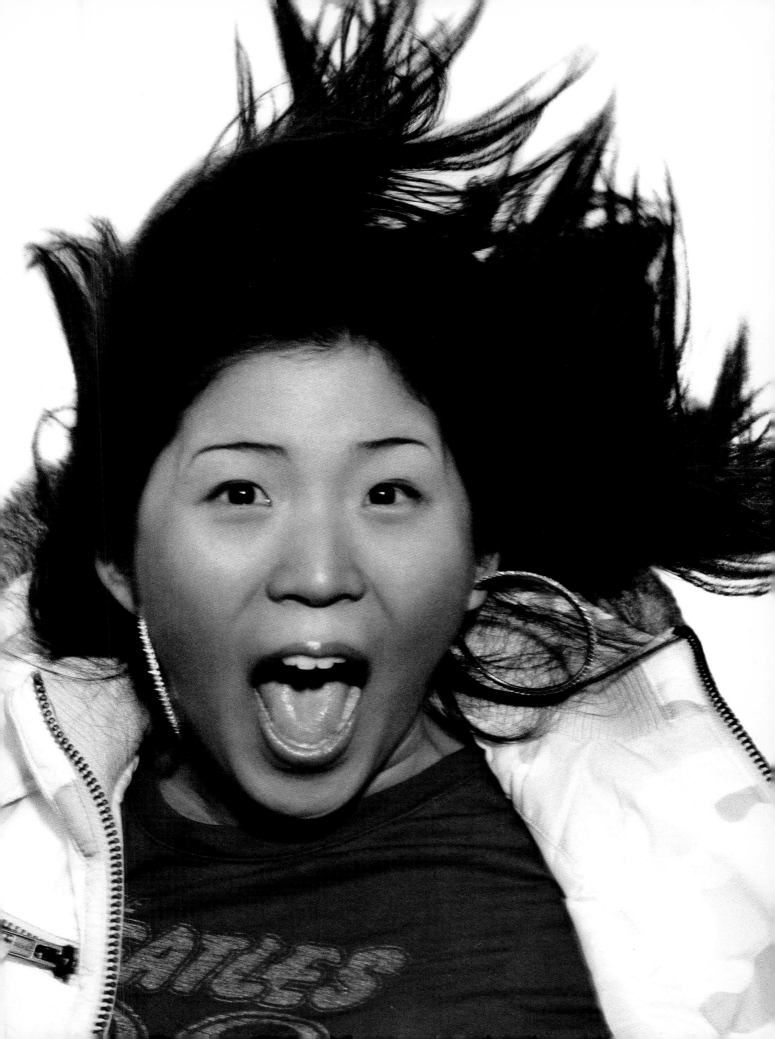

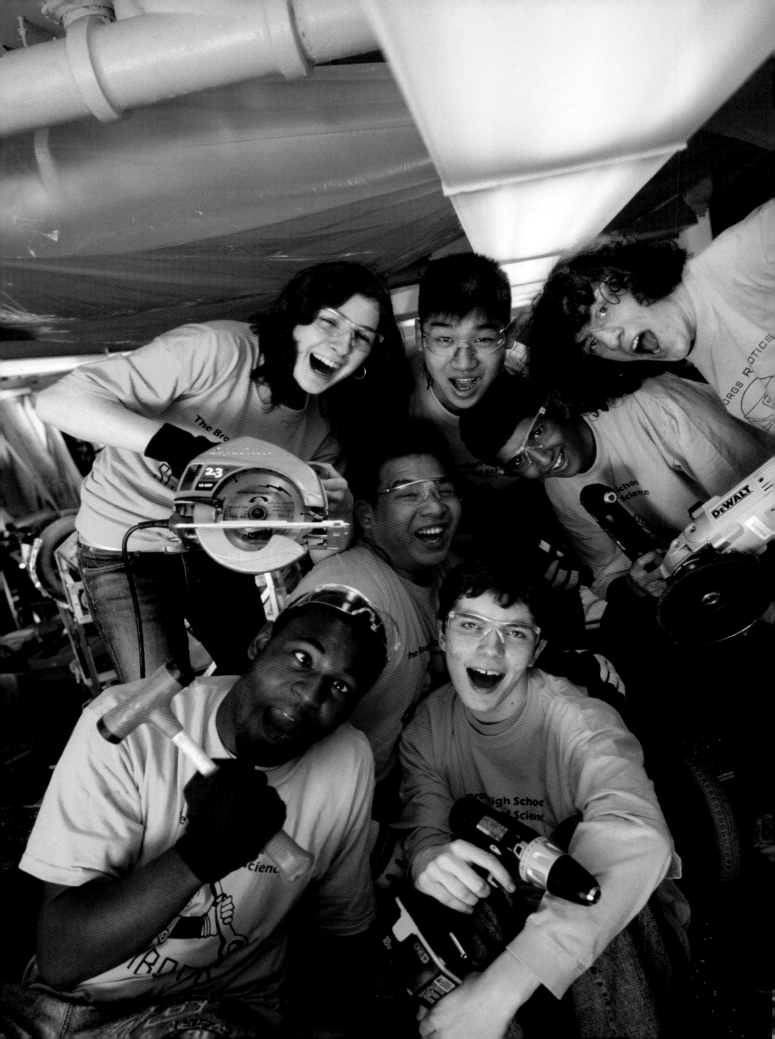

JOEL
16 ★ NEW YORK

JOEL SAYS HIS MOTHER WANTS HIM TO SPEND MORE TIME WITH GIRLS AND LESS TIME WITH ROBOTS.

Joel is co-captain of the Bronx Sciborgs, one of the top high-school robotics teams in the nation. Every year, they go up against 50 other teams in a competition founded by Dean Kamen, creator of the Segway electric scooter.

Other kids in school tell Joel he should just go out and have fun like a regular teenager. He says they're talking about partying and drinking, and he's not interested.

"I actually find this enjoyable. I have fun doing robotics."

Every morning at 6:30 AM, Joel boards a school bus in Queens for the 90-minute ride to the Bronx High School of Science, which he says is the second best public school in the city.

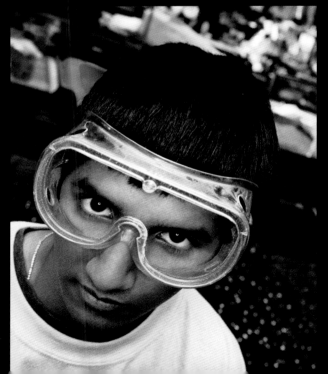

We're with Joel and his teammates in the basement robotics lab, and last year's team's robot is sitting quietly in the corner. Everyone talks at the same time. They're telling us how the robot learned to throw big Nerf balls through a basketball hoop.

I ask everyone to grab a power tool and goggles for a group picture, and one of them objects.

"Excuse me," he says, "but these are not the proper goggles to use with this type of tool."

Not everyone at Bronx Sci is like this. A lot of them—especially the rich kids with Park Avenue addresses—are more into partying and fashion. But Joel says everyone gets along.

"I see life through a different lens from a lot of kids."

His parents came here from India when Joel was 3. "In India, education, family, and religion are most important," he says. "My parents would do anything to support my education."

Joel spends his evenings at home online researching robotics, and he doesn't believe in MySpace.

"It's just a crappy social networking thing," he says. "If you want to meet people, do it yourself, in person. All those kids with hundreds of friends—I doubt they even know 20 of them. What's the point?"

Joel stays busy managing the various divisions of the robotics team, including the programming division, which is his main responsibility. (His co-captains handle the construction, design, web, and public relations divisions.)

When I tell Joel this sounds a lot like the life he'll have 20 years from now, he vigorously disagrees. "No, I hope not," he says. "This is middle management. I expect to have my own technology company by then."

"My real dream," he says, "is to start the next Google."

NATE
16 ★ COLORADO

66 IN THEIR NATURAL STATE, HUMANS ARE BRUTAL AND VIOLENT. 99

"As long as there are other human beings on earth," Nate says, "there's going to be constant conflict and war."

We're outside Denver, next to the train yard, and Nate and his friends are talking punk politics. He says that punk is more than a style. It's a way of getting people to pay attention. They want people to think about what society says is right and question it.

Nate says people look at them and assume they're violent druggies. "Drugs are just a way of throwing your brain

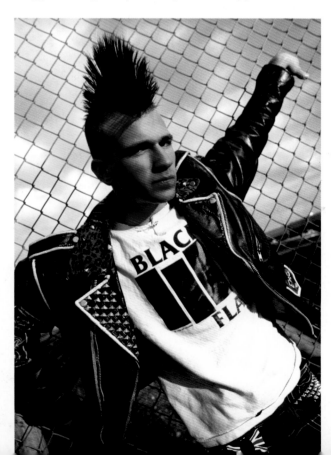

into the garbage," he says. "All these kids are putting white shit up their nose, fucking curled up in a ball puking on themselves." Nate says drugs are sickening and he'd never touch them.

For all the talk about violence, Nate and his friends don't see much of it. Nate says his school is pretty rough, but no one messes with him in the halls. "No one seems to want to fight me."

The first time Nate got a mohawk was in seventh grade. He walked in the door and his dad yelled, "What the hell is that on your head?" He went into the bathroom and shaved it off.

Two years later, his friend Trenton helped him do it again. His dad didn't talk to him for 3 weeks.

"I thought it was really immature," Nate says. "It was just cuz he's a redneck. He grew up in a family that all wear cowboy hats."

The most annoying thing his dad says is, "You'll grow out of it." The more he says that, the more Nate thinks he won't.

Nate does plan to shave his mohawk when he graduates, so he can go to technical school and learn to be a diesel mechanic. But he's only in tenth grade now, and he won't be giving up punk rock anytime soon.

The music and politics of punk rock are the center of Nate's life. There's nowhere he'd rather be than at a punk show, in the mosh pit with his friends.

I ask him what it's all about, and he says, "Separation from society." Nate and his friends don't want to listen to anyone. They just want to do what they think is right.

"You only get to live once. Do whatever the fuck you want with your body and your life."

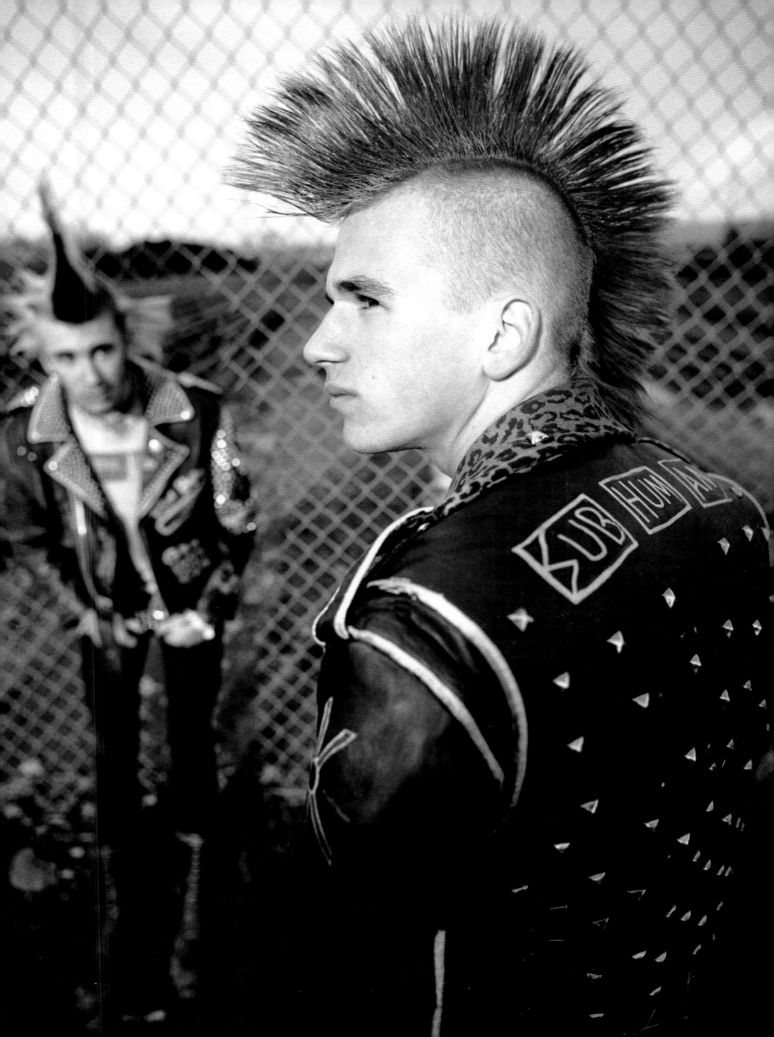

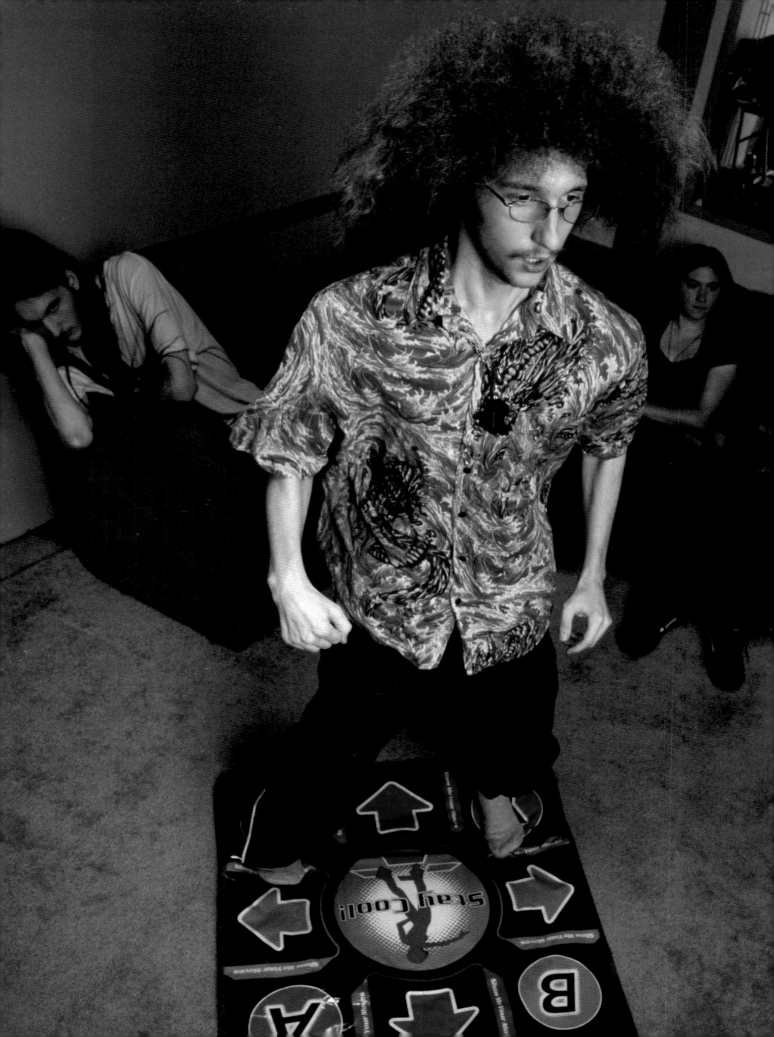

DAVID
17 ★ MARYLAND

It's late Friday night, and we're driving down a dirt road through a soybean field in Maryland. We get to a trailer in the middle of the field. This is David's house.

We walk in the door and find the whole family sitting and watching David play Dance Dance Revolution on the PlayStation 2. Arrows scroll up the TV screen indicating a sequence of dance moves to perform on the sensor mat.

David is good. His feet are a blur of motion. His hair bounces wildly while he dances. He says some people call it a "white boy 'fro." He likes it because it's the one unique thing about him.

66 GET A HAIRCUT. 99

These words—or sometimes things far worse—echo in the school hallways as David walks to class, pretending not to hear. He says he doesn't care what they say.

"If people try to talk to me, then I answer with as few words as possible." With the exception of the other video gamers, he says the kids at his school probably wouldn't even know he goes there—except for the hair. They all know the hair.

David's not sure what the future holds. He'd like to do something with video games, but when I ask if he wants to be a game designer, he says, "Uh, I don't know if I could do that, but it would be nice."

David has never gone on a date and gets embarrassed when I ask if virtual girls (female characters in video games) are hot. "I really don't think of them that way. I mean, they're not real."

I ask if there's a real girl he wants to ask out. He answers reluctantly, "Well, yeah, but that will never happen."

ALISSA
17 ★ TENNESSEE

Back in eighth grade, Alissa was into punk rock and hung out with kids who did drugs. She spent a lot of time on MySpace and would even drink alcohol sometimes.

A year later she started dating a guy named Chris who was really into Jesus. He brought her to their town's Methodist church, and she was hooked right away.

She loved the local bands the music ministry brought in. The bands aren't all Christian; pretty much anyone can come as long as they don't have cuss words in their lyrics.

"The Bible says 'not a hint of a cuss word' or something like that," she tells me.

"WHEN MY FRIENDS CUSS, I HOLD THEM ACCOUNTABLE."

Now Alissa mainly hangs out with other Christian teens, and they do the same things most teenagers do. Like watching funny videos on YouTube. There's this one gay guy she likes watching named Chris Crocker. "He just sits there and acts like a faggot. It's disgusting and hilarious at the same time."

Alissa says it's a sin to be gay, but she's cool with the gay kids at school; it's not her place to judge.

In her health class, they talk about sex. They say, "Just wait until you're ready." Alissa says everyone her age thinks they're ready, but they're not.

I ask her if she ever feels temptation. "Heck yeah! I don't understand how I control it, but I do." She meets a lot of guys at her job—working as a carhop at a drive-in burger place—but she never hooks up with any of them.

"I don't want my life to revolve around a guy and what he can do for me, you know?"

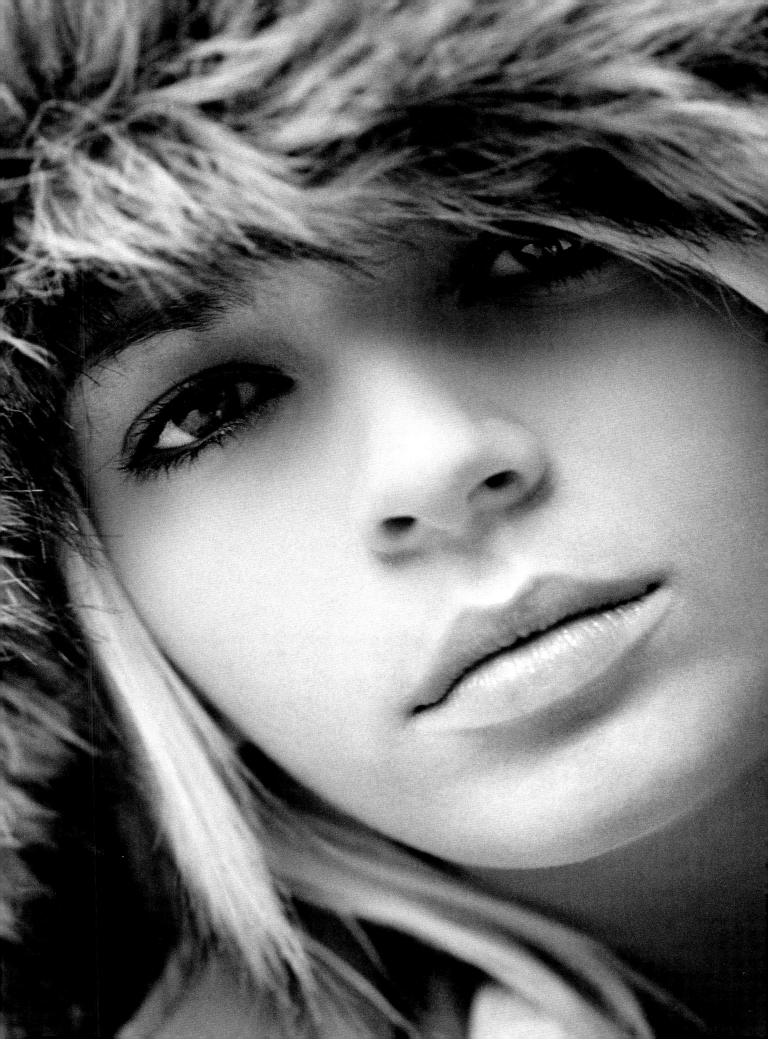

CARY
17★ WEST VIRGINIA

One night around Thanksgiving, Cary drank a bottle of Jack Daniels and broke two of his stepdad's ribs.

His stepdad weighs 280 pounds, and Cary's not sure how he did it. He blacked out and has no idea what happened. His brother Eddie (turn the page to see him), says Cary just got drunk and then got angry for no reason.

Cary weighs a little over 150 now, but 2 years ago he was 5 feet 10 inches and 95 pounds. He's glad those days are over.

Back then, Cary lived with his real dad and stepmom. He'd always see them smoking a glass pipe, and one day he asked his stepmom what they were doing.

"She was like, 'Here you can try it.'" Cary was 13. Starting that day, he smoked meth pretty much nonstop till he was 16.

About a year into Cary's meth addiction, a battalion of county narcotics officers surrounded his dad in the parking lot of Advanced Auto Parts. They found a half-pound of meth in his truck.

Cary's been clean for a year and says meth is the worst drug in the world.

He still has problems with his head—he can't think right—and he has problems with the law. He's done "a little bit of juvie" for some assault and battery charges, but that was mostly when he was using. He smashed a guy's skull with a baseball bat. The guy was a dealer wanting a blow job in exchange for meth.

"I try not to get in fights," Cary says. But he can't seem to stay clear of trouble. Like the bathroom brawl he had last week at a nightclub over some spilled beer. "That guy got the best of me," he says, meaning that the guy used Cary's skull to break open a full bottle of Budweiser.

When Cary was still in school, he hung out with all the black kids, and he didn't care that all the preps and rednecks called him a "wigger." He dressed black and talked black, so they could call him what they wanted.

Back then, Cary was in a crew called the B-Town-Gang.

❝IT WAS JUST YOUR USUAL GANGBANGING THING— SMOKING WEED AND STEALING SHIT OUT OF YOUR YARD.❞

Now Cary's getting ready to move into an apartment, because his stepdad is afraid of him and wants him out.

He says his stepdad isn't all bad; he's giving him some money for the apartment, as long as Cary keeps his job. He works doing telemarketing to raise money for a police charity in California.

His real dad gets out in 2 years. Cary hopes to be living in Florida by then, working as a hip-hop producer. But he's not counting on it.

"Not everything works out," he says.

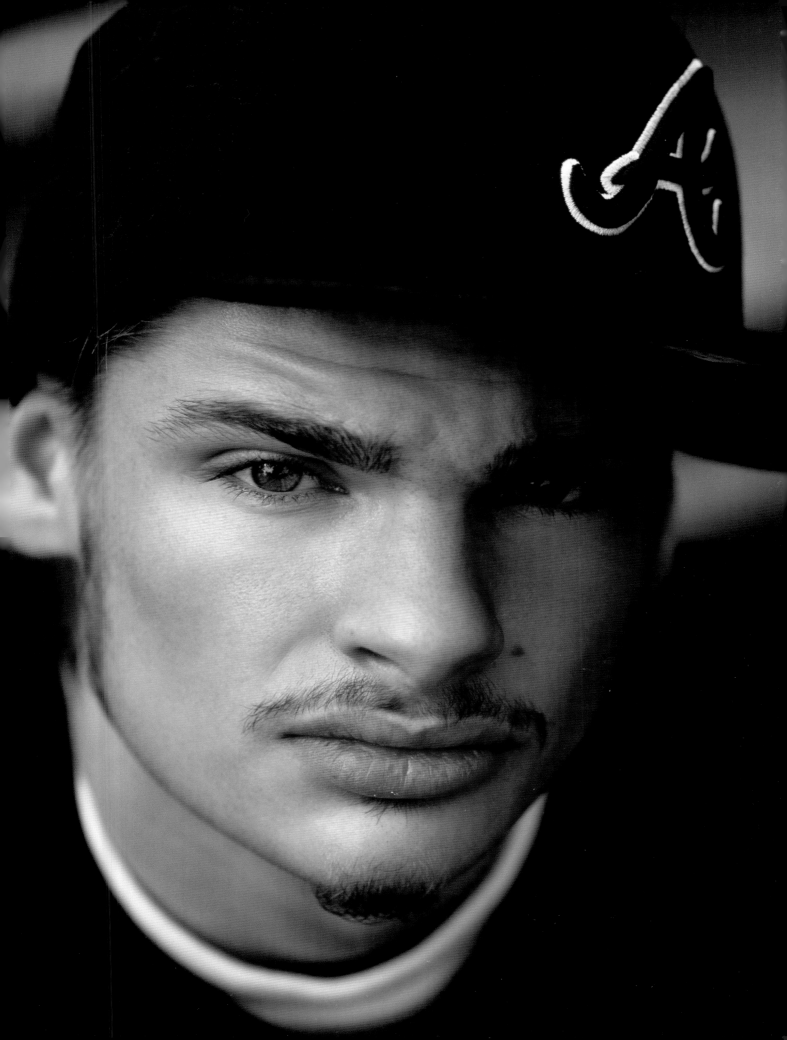

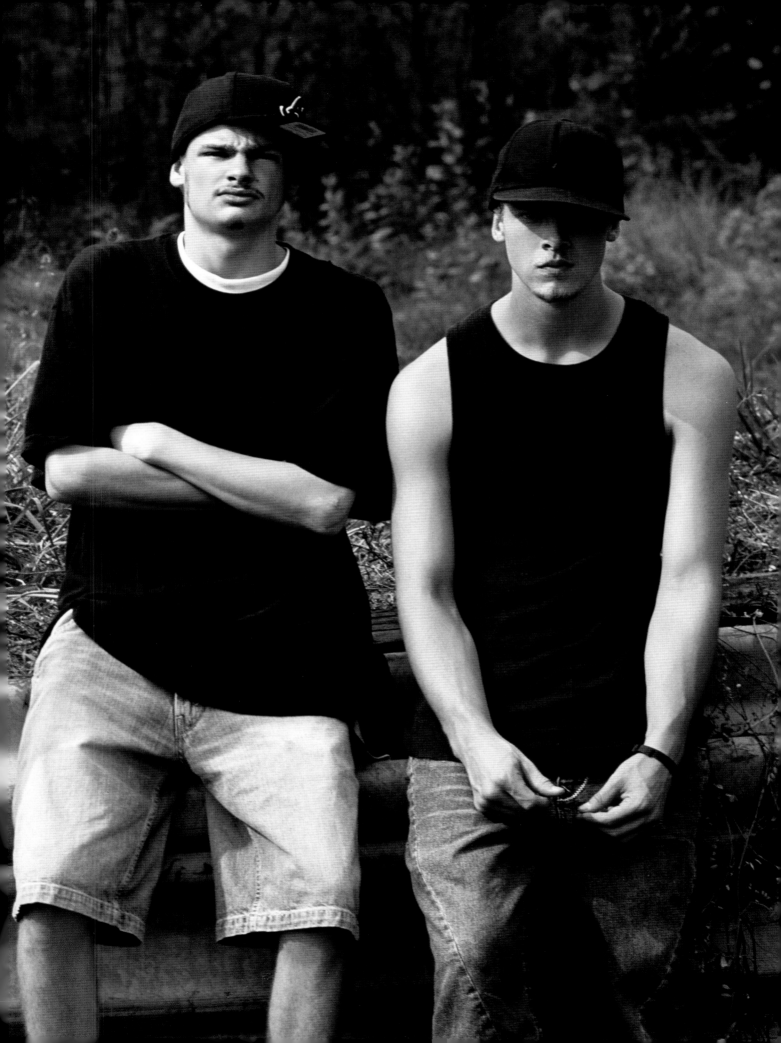

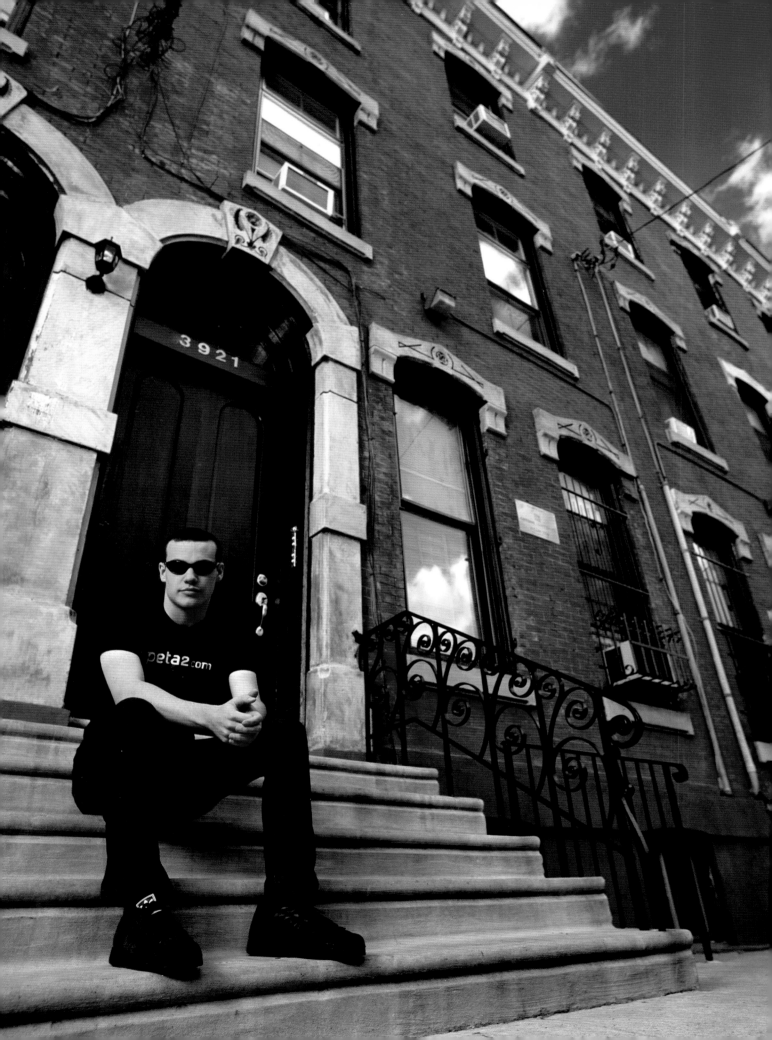

STEPHEN
18★ PENNSYLVANIA

When Stephen was 8, his dad made a $10,000 bet with him.

If Stephen made it to his twenty-first birthday without smoking a cigarette, his dad—a senior executive at Coca Cola—would give him the cash. Stephen says he's going to make it.

Smoking is not the only vice he avoids. He calls himself a "straight-edge," which means he lives a life free of alcohol, cigarettes, and drugs.

Stephen used to drink. When he was 9, his family moved to Europe, where it was easy to get served at bars. He started drinking with friends at 13, and, by the time he was 15, everyone considered him an alcoholic. He would drink in his room every night and go to school with a hangover.

Stephen says he finally accepted he had a drinking problem and started seeing a shrink. He quit drinking cold turkey. A week later, he broke up with the first girl he ever loved when he discovered she had cheated on him. The breakup hit him hard; he went to the biggest bridge in Budapest and decided to jump off.

While he was standing there looking down at the water, he couldn't stop thinking about lyrics from a song by his favorite metal-core band, Bleeding Through:

I WON'T BE YOUR CARCASS.
YOU CAN'T ADD ME TO
 YOUR PILE OF DEAD BODIES.
I'M DRIVING THE NAILS
 THROUGH YOUR HANDS.
YOU CAN'T FUCK THE LIFE
 OUT OF ME.
I NEVER LOVED YOU.

Stephen says music saved his life. Now it's what he lives for. He and a high-school friend started their own metal-core band and came to Philadelphia to make it big.

He has no idea why they came here, but he says it was the wrong choice for metal-core, which is a mix of heavy metal and hard-core punk.

"Philly has this tough-guy hardcore scene going on. They have these gangs, which they call crews, who go around beating people up. There are fights at every single show. I think it's stupid and unnecessary."

Stephen has a different perspective on life than most American teenagers. Not only did he grow up overseas, but his parents have taken him around the world to more than 40 different countries. He says you can see what a country is like more clearly from the outside.

"People think that America is the greatest country—the only country that matters—and that's dangerous," he says. "That's the view the German people had when Hitler came to power."

Stephen is passionate about a lot of things. He's a vegan and an active PETA member. Last summer, he was the top neighborhood fundraiser for the Democratic National Committee, raising $17,000 just by knocking on doors. And he is proud to call himself an atheist.

"Just treat other people the way you want to be treated," Stephen says, "and you don't need religion."

Stephen changes the subject and tells me he has a mouse problem in his apartment.

"What's the point of a rodent? They eat all our food, they shit all over, they reproduce, and they die. Think about it. Are we any different?"

CHRISTINA

17 ★ FLORIDA

> **"THE FACT THAT I'M BLONDE AND THIN MEANS THAT PEOPLE LOOK AT ME AND THINK I'M DITSY, STUCK-UP, AND SNOBBY."**

"Then they talk to me and find out the truth."

Every day at lunch, Christina sits with the special-ed kids in the cafeteria. Sometimes she'll bring a friend, but everyone else at the table is mentally challenged.

"Some of them are shy," Christina says, "because they've been bullied so much. As long as you're nice to them, they'll open up."

Christina has always hated bullies and protected their victims. "If you don't stand up for someone who's being bullied," she says, "you're just as bad as the person bullying them."

She says there are a lot of mean kids at school, and it's incredible how cruel they can be. She gets choked up as she talks about it. "There's this one little boy who got shoved in a locker every day at lunch time. That's really sad."

"I don't like seeing anyone in pain," she says. "Children. Animals. Anyone who can't defend themselves." Christina hasn't eaten meat since she was 13, and she won't wear leather, fur, or any cosmetics tested on animals.

Her mom backs her up and even tried being a vegetarian for a while. Her dad supports her but says, "You can't save the world." He says all you can do is just live life as a good Christian.

Christina grew up Catholic but doesn't agree with a lot of the old-fashioned beliefs of the church.

She says sex before marriage doesn't make you a bad person. "Just don't go sleeping around with everyone."

And she gets a lot of people mad when she talks about gay marriage. "The United States is supposed to be a free country. If they want to get married, let them get married. They're not hurting anyone."

She's determined to make a difference in the world, but she says you need money to make things happen. Recently, she started modeling, because it seems like an easy, fun way to make good money. She'd love to make it big, so she can have the money to travel around the world helping people.

But she's not counting on modeling to pay off. She's headed to college, where she'll study psychology or maybe environmental engineering—something that will give her the tools to help people.

In the Best Buddies program at school, Christina is paired with a girl with Down syndrome. The girl got superexcited when Christina invited her over to hang out with her family last Friday.

When the girl's mom came to pick her up, she apologized for "wasting" a Friday night. "Are you kidding?" Christina told the mom. "There's no one I'd rather hang out with on a Friday night."

"Everyone deserves to have a friend," Christina says.

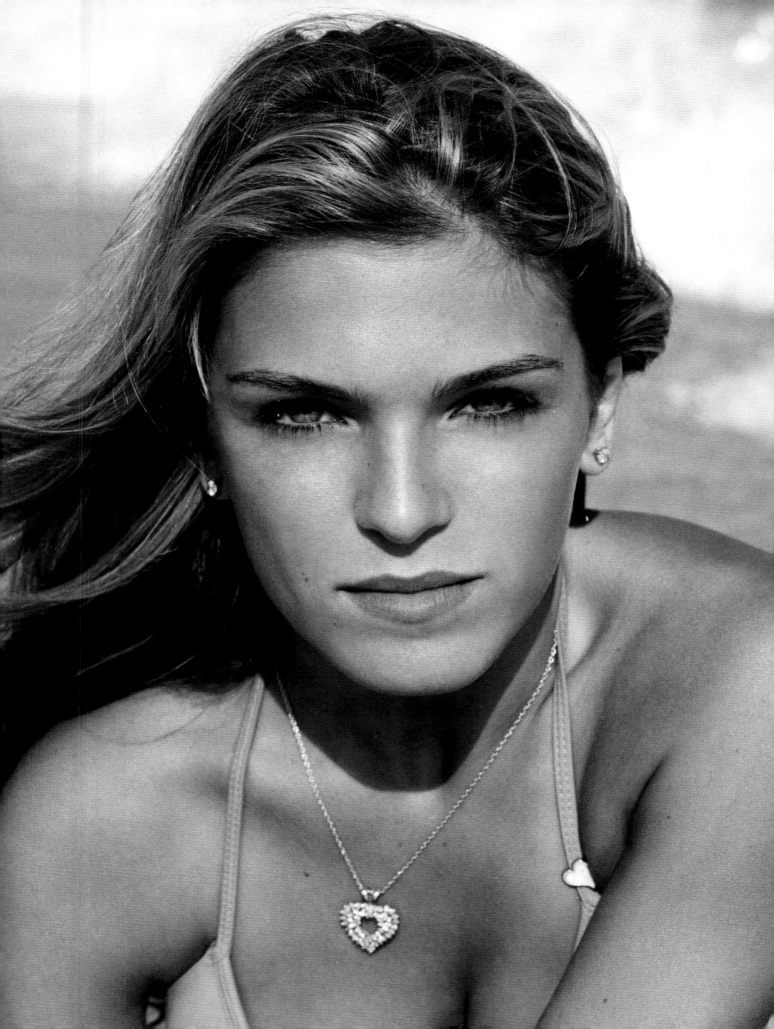

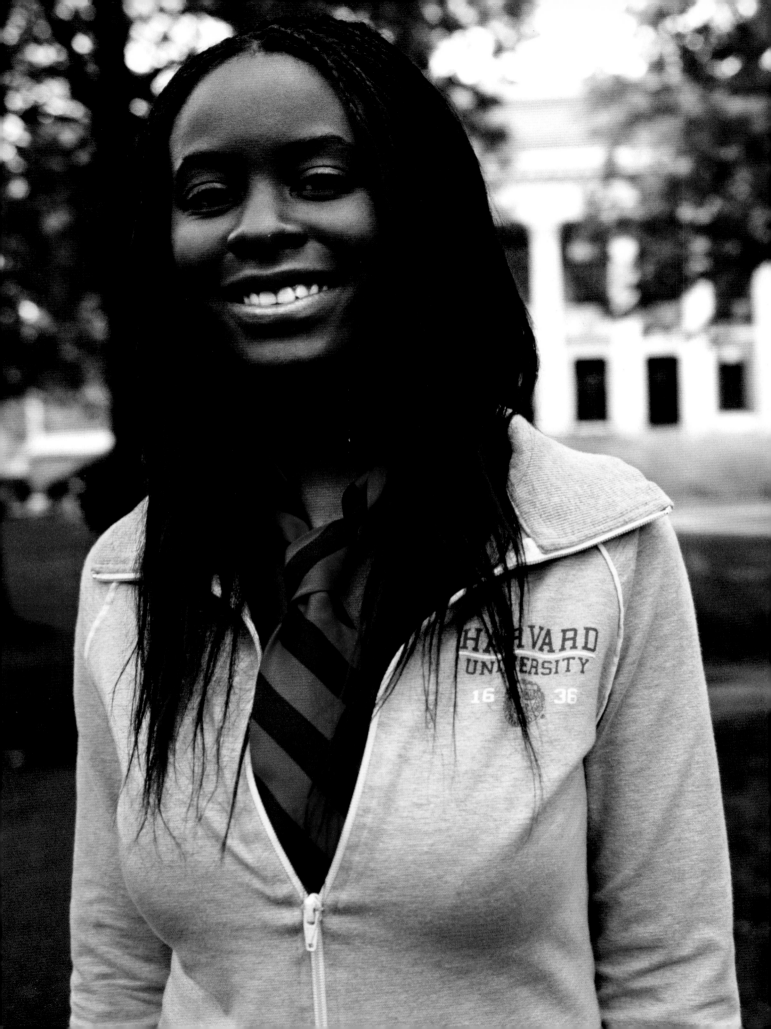

BLESSING
18★ MASSACHUSETTS

Rain is pouring down on Harvard Yard, and Blessing isn't sure she wants to leave her dorm room to take pictures, even if the sun comes out. Getting into Harvard is the biggest opportunity she's gotten in her life, and she doesn't want to risk it by breaking Harvard's strict rule against unauthorized photo shoots.

"I WAS THIS POOR LITTLE KID FROM NIGERIA—I NEVER THOUGHT I'D BE GOING TO FUCKING HARVARD UNIVERSITY. AND HERE I AM TODAY."

Blessing is the only person in this book to use the term "off the record" when she answers questions. She doesn't want her parents—who are devout Baptists—or the Harvard administration to get the wrong idea about her.

Blessing grew up in Nigeria, until her parents won the U.S. immigration lottery when she was 7. They moved to a suburb of Dallas and started a new life. Back home, her dad was a pilot and her mom was a bank manager. In Texas, they had to take menial jobs and go back to college.

Blessing is grateful to her parents for giving up so much to bring her to America, which she says really is the land of opportunity—although most teenagers here don't recognize that.

"Coming from the third world, I can see all the opportunity surrounding me," she says. "I can make something of myself here."

In Africa, Blessing says that women are expected to be good wives and take care of their husbands. Here, Blessing can focus on herself and her career before even thinking about marriage.

Blessing is a pre-med freshman, majoring in molecular and cellular biology. Her favorite TV show is *Trauma: Life in the ER*, and she plans to become a surgeon.

She says she is not afraid of blood and guts. In fact, when she was in twelfth grade, she had to dissect the fattest cat she ever saw, and she thought that was pretty cool.

"The million dollar question," Blessing says, "is why I got in here." She was a straight-A student with a perfect SAT score, but she says a lot of kids like that apply to Harvard. "I mean, I wasn't even the valedictorian—I was number five in my class."

In high school, Blessing was kind of gothic and punkish, she says. She wore black all the time and spent countless hours playing Final Fantasy on her PlayStation 2.

Here at Harvard, she says, people aren't into standing out and being different as much as in high school. But there are still traces of teenage rebellion, like the traditions of peeing on the statue of John Harvard and running naked through the Yard just before finals.

Blessing won't say whether she participates in any of that. She just wants to do well here and make the most of her life. "Harvard med school would be nice, but they take like 165 people a year, so that might not happen."

But then again, it might.

TAMMY
17 ★ CALIFORNIA

Tammy knows all the dark alleys in San Francisco's Chinatown. She shows us where the opium dens were and where Frank Sinatra once got his hair cut. She shows us former brothels, gambling parlors, and the secret headquarters of Dr. Sun Yat-sen, father of the 1911 Chinese revolution.

Tammy says that Chinatown gives her comfort, because it's like Hong Kong, where she lived until her mom brought her here at age 5 so she could get a better education.

In class, Tammy is quiet and reserved. Here, she's bubbly and energetic, walking too fast for us to keep up.

She puts in four to five hours a night on homework, and she gets pretty much all As. But she's in chat rooms and sending instant messages while she studies, which she says is "really bad."

After I leave Tammy, I check out her MySpace page and am shocked to see her headline:

"F.I.N.A.L.S. (FUCK I NEVER ACTUALLY LEARNED THIS SHIT.)"

I can't imagine the girl I met using the word *fuck*.

Suddenly, I realize that I was getting treated as an elder. "From the day we are born," she told me, "we know that, whatever we do, we must always respect our elders."

"If I'm arguing with my mom, even if I know I'm right, I'll just step back," she said. "In an argument, someone needs to sacrifice their stand and step back."

I asked her why the adult always wins, and she seemed puzzled by my question. She told me the basic fact of Chinese culture:

"Our parents are older and wiser."

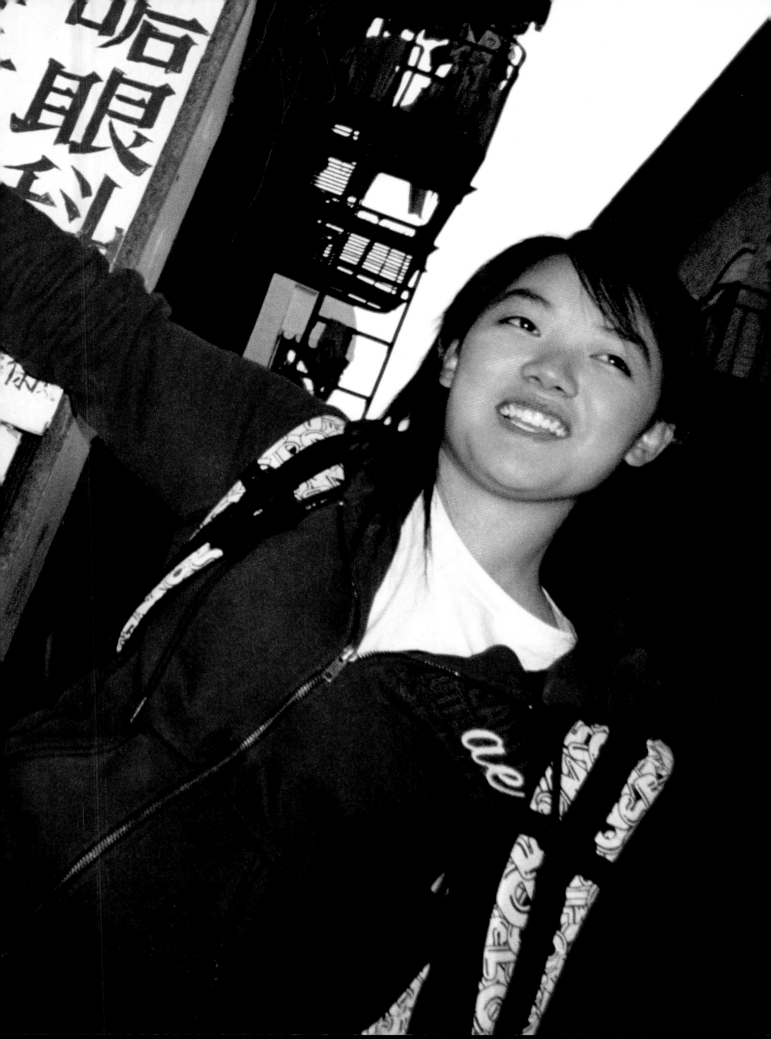

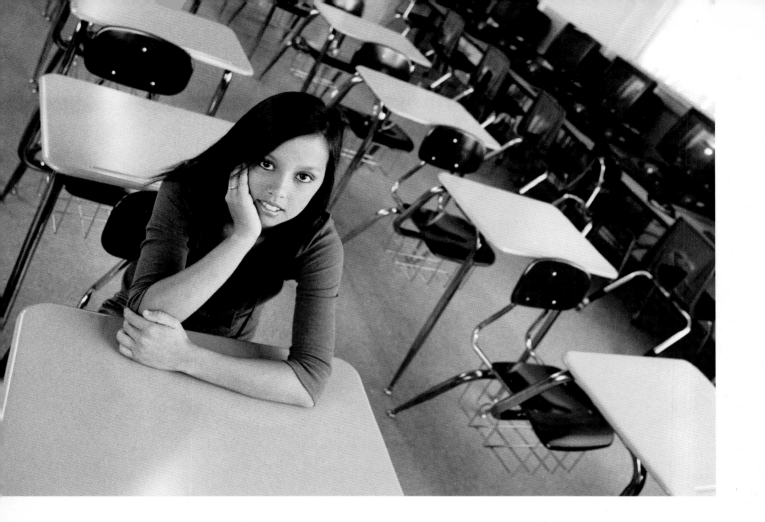

ANGELINA
17 ★ MISSISSIPPI

When we arrive at Angelina's school to photograph her, we're sent directly to the principal, who wants us to know that Angelina is a good kid whom everyone likes.

For the third year in a row, she's class president.

66 SHE'S SO POPULAR THAT NONE OF THE OTHER 500 SENIORS DARED RUN AGAINST HER. 99

Angelina is a member of one organization for every day in the school week—including the Color Guard and the National Honor Society—and she works 4 days a week at Old Navy.

Eventually, she'd like to be a store manager or maybe work her way into corporate marketing.

Next year, she's going to junior college, because she doesn't feel ready to go to a big university, even though she could get in anywhere she wants.

She's quiet and modest and doesn't like being called popular. But she admits that she is. And she makes a point of being nice to everyone. "People say I smile a lot."

Although we can see the cliques in the hallway—the country boys in their camo and boots and the city kids in their Hollister—Angelina tells us that everyone gets along.

"We mind each other here," she says. "Everyone is nice to everyone."

CINTHYA
16★ WYOMING

Cinthya was born in a car on the way to the hospital in Mexico City.

Two years later, her uncle smuggled Cinthya and her mother across the border and drove them to Idaho. They lived for 4 years in an unheated trailer next to a potato farm.

Her dad drove a tractor, and her mom stood in a cold tin building all day pulling out bad potatoes.

When Cinthya was 6, they moved to Jackson Hole, Wyoming, because they had an uncle here who could get them work. Now her mom works as a personal assistant to a rich woman who owns 16 acres in the expensive part of town. And her dad works in a body shop.

"A LOT OF THE IMMIGRANTS HERE DON'T GET JUSTICE."

Cinthya wants to dedicate her life to helping people.

Cinthya is proud to be Mexican, but her little brother just wants to be American. He dresses like a skater and refuses to speak Spanish.

I ask her what she wants for her future, and Cinthya smiles:

"Someday, I'd like to be mayor of this town, so I can bring justice to everyone who lives here."

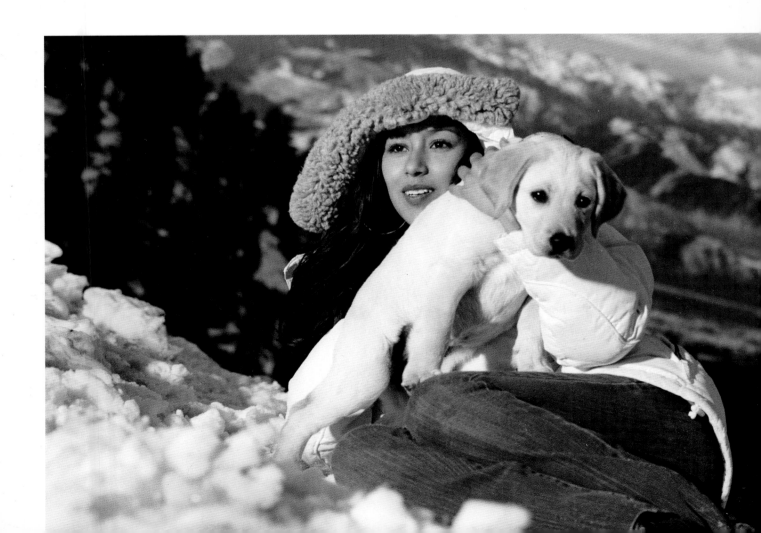

MIKE
18 ★ TEXAS

After spending a day with Mike, we all wished we had grown up in Texas.

Mike lives life at a million miles an hour. He's always on his way somewhere to do something. Football practice, partying, mudding, or just hanging out in the back of a pickup truck. And never, ever by himself.

Ask Mike about mudding—or pretty much anything—and he gets excited. Before we finish telling him we've never been mudding, he's already leading us out to his truck and rounding up friends on his cell phone.

Mudding is a major pastime for Texas country boys like Mike. Well, he's not exactly country, because he loves going into "the city"—by which he means San Antonio—to drink and meet girls.

Two minutes on the cell phone is all it takes for Mike to get a dozen friends to show up at the mud hole with their trucks and some cases of beer.

For Mike, there's no better way to spend an afternoon than spinning out in the mud and drinking beer with a bunch of good friends.

He says he wasn't popular in high school, but he knew everyone in the school.

"MY ONE GOAL IN LIFE IS FOR EVERYONE TO KNOW WHO I AM."

When he goes to a party, he walks up to every single girl in the room and introduces himself. He won't leave till every girl knows his name.

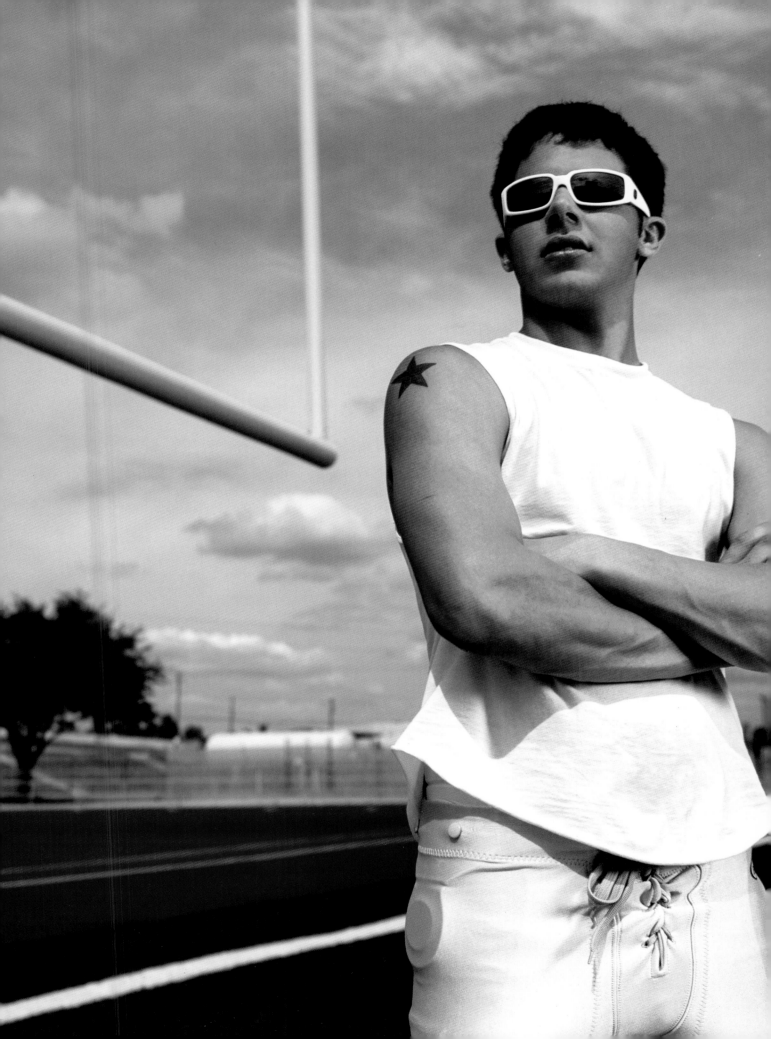

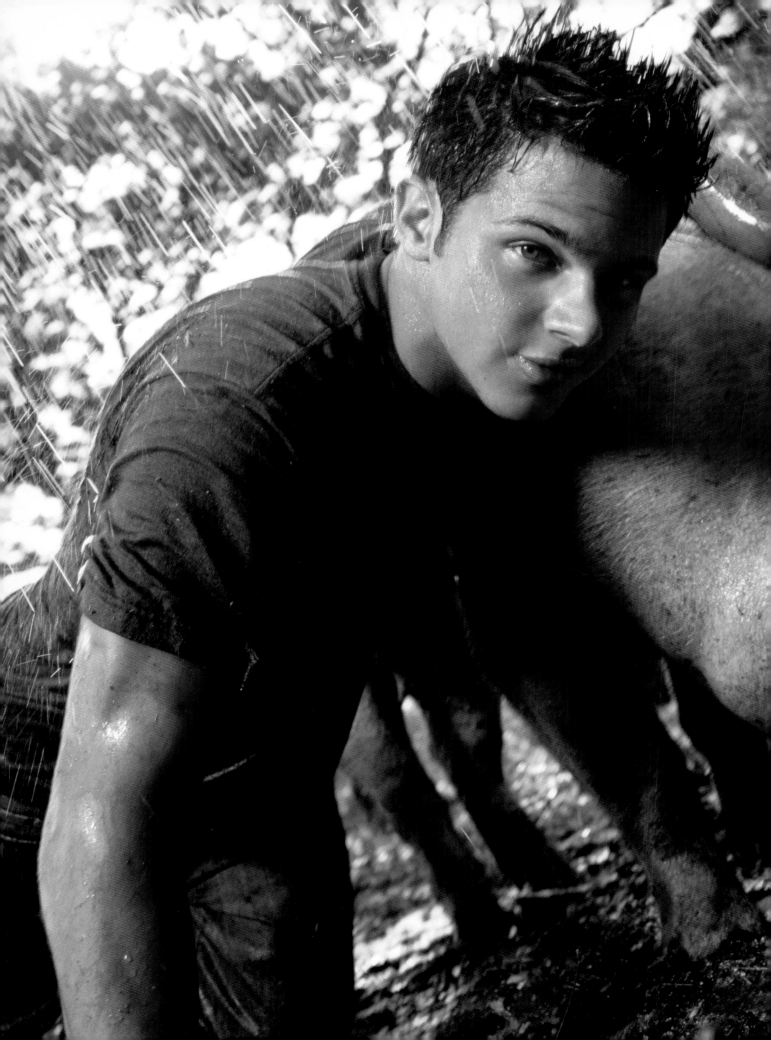

Mike probably has a thousand friends in south Texas, but that's not enough.

He wants to be the guy in the giant photograph at the front of Abercrombie and Fitch. He wants to be the one in the glossy magazine ads. He wants to go to L.A. and make it big.

I ask if he's scared to leave a place where he's the big fish in a small pond. "Hell no!" Mike says; if he could, he'd put his face up on a giant billboard in Los Angeles so people could see the next big thing coming.

Here in suburban San Antonio, Natty Light is the beer of choice, because it's the cheapest you can get. It's wet in Mike's backyard and we have no beer, so he's not sure about getting muddy with his pig, Hercules. But Mike doesn't like saying no, so he gets inside the pig pen and slides around in the mud.

WHEN MIKE ISN'T DRINKING BEER IN THE MUD, HE'S PICKING UP CHICKS.

He says he can drive his truck into the city and pull up at a stoplight next to a hot girl in another car, and all it takes is a smile and a wink. He'll pull away in seconds with her number in his cell phone, and they'll be partying the next day.

"I mean, I'm not a big man-whore or anything," he says, "but I have fun."

KOHL
18 ★ ARIZONA

"Just wait. In like 20 years, you're going to be fat, old, bald men who thought they were going to make it big in high school and then ended up working like at a Blockbuster."

That's what Kohl says to the popular, rich kids when they call him queer or faggot. And when they want to fight him, he tells them to think about how humiliating it would be if they lost to a fag. Kohl is proud of the fact that he can talk his way out of any fight.

Kohl wants to make it perfectly clear that he's gay and not bi. He doesn't understand the trend among teenagers to say they're bi just because it's cool. "It's a stupid fad."

Against all odds, Kohl's boyfriend is also named Kohl. Well, actually they haven't met in person yet. But they talk online every day, and on the phone a few times a week.

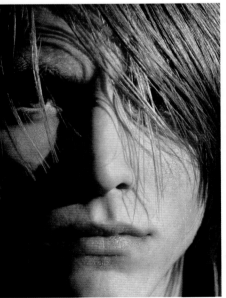

Kohl (our Kohl) was bored one day and decided to search MySpace for another guy with the same name. He found one in Colorado whom he thought might be his clone. Not only the same name but also the same height, weight, and shoe size. And the same color eyes. Plus, he's gay. It was fate.

Kohl's afraid of starting new relationships because of how much it hurts when they end. His parents split up when he was 3 and he seems to have a lot of rough landings. One ex went on MySpace and posted a picture of himself holding hands with another guy. That was his way of letting Kohl know it was over. Kohl's previous boyfriend also dumped him on Myspace.

" I LOOKED AT HIS PAGE ONE DAY AND THERE WAS THIS OTHER GUY AS HIS TOP FRIEND. I GOT SO ANGRY AT HIM. "

The breakup hit him kind of hard, because they had talked about proposing to each other and moving in together when they turned 18. Kohl thinks the new boyfriend is different, but he's taking it slow.

Both Kohls are emo kids. Emo is short for emotional and refers to a genre of emotionally charged punk rock. Emo kids, Kohl explains, have long straight hair falling into their face, tight pants, and lip rings. (He considered getting "snake bites"—a pair of rings in the lower lip— but he decided his lips weren't made for that.)

According to Kohl, about 75% of what adults think about teenagers is wrong. "The way we feel, the way we dress, the way we act. It's all different from how it was in their age."

"My dad told me that if I ever did my hair a certain way or dressed in black or had chains on my pants, he'd beat the shit out of me and take me to get a haircut." Now Kohl doesn't talk to his dad much.

These days, his biggest fear is that a friend will dump him. "Till I was 10, I didn't have a single friend. Now if I lost a friend, I'd probably fall into a deep depression and never come out of it."

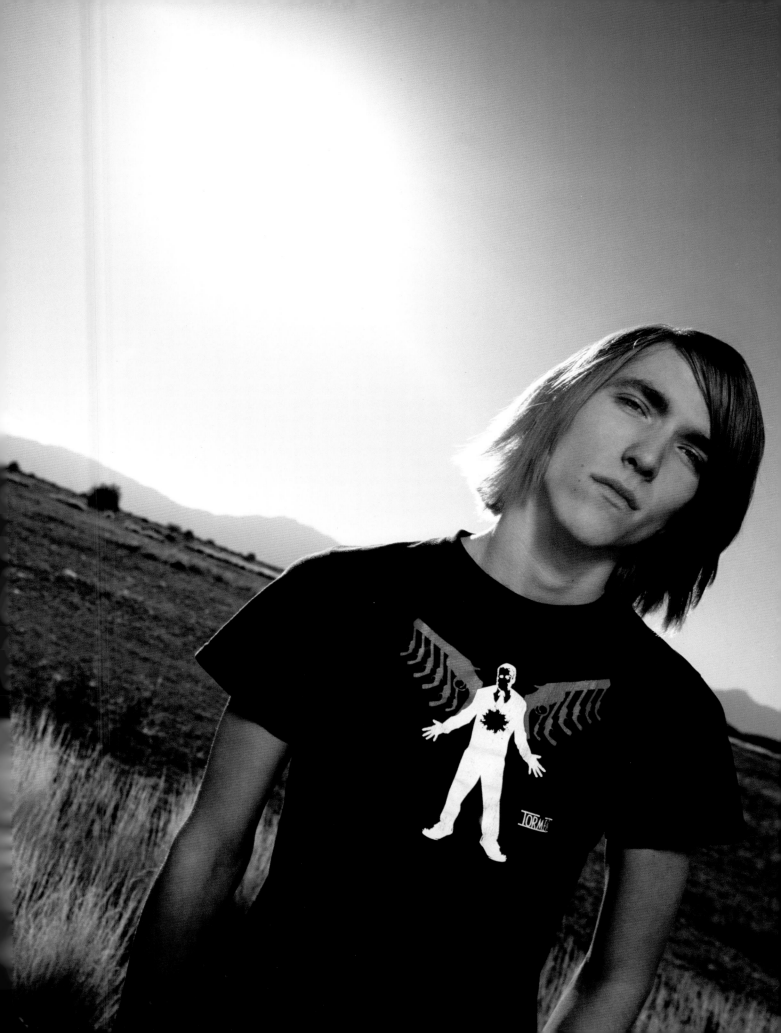

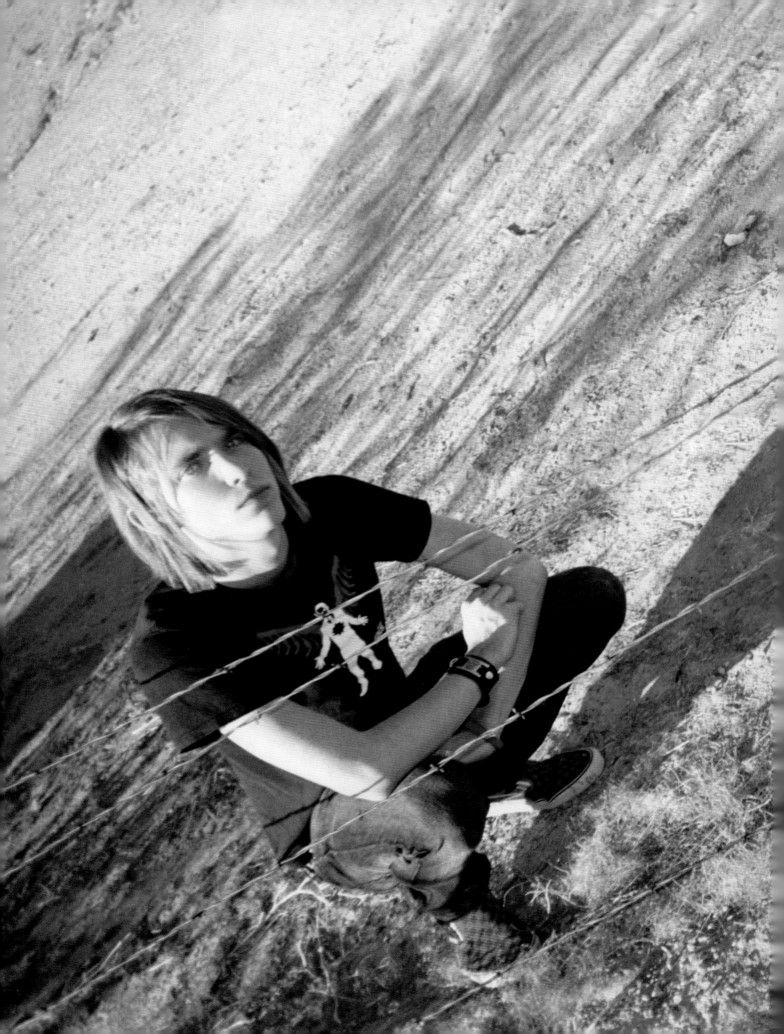

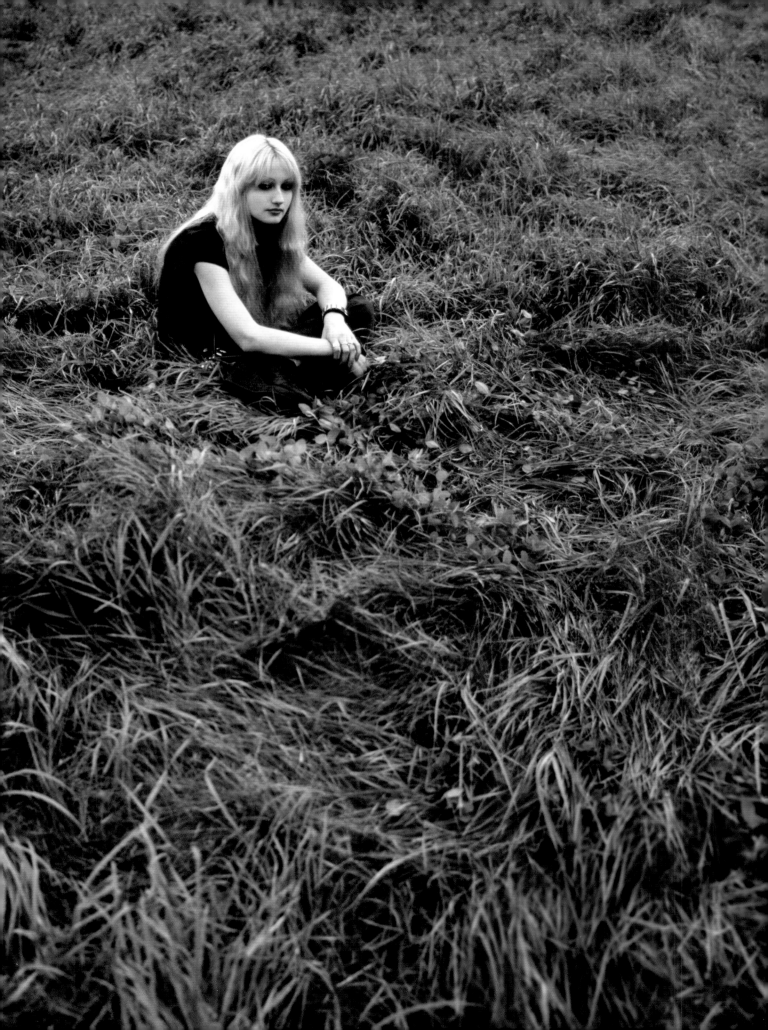

BETHANY

16 ★ NEW HAMPSHIRE

As the sun begins to set, Bethany leads us down a path into the woods.

SHE SAYS SHE'S TAKING US TO A SPECIAL PLACE. IT'S CALLED TENTOPIA.

Less than five minutes from the main road, we get to a circle of tents set up around a camp fire. A 16-year-old boy wearing lipstick runs up and tells Bethany he's having a panic attack. This is Adam, her boyfriend.

Panic attacks are nothing new for Adam, and Bethany doesn't think it's her place to tell the story of why he has them. She sends him to get firewood and introduces us to the others. The three founders of Tentopia are Colby, Loki, and Merlin, all twentysomethings who work in fast food and needed a place to escape.

A few of them live here, but a lot of kids who sleep in big colonial houses also come here to sit around the fire, drink Keystone Light, and smoke weed. Here in Tentopia, there is a strict no-parents rule.

Bethany calls this her sanctuary.

She goes to a massive "academy" that has a big wooden sign out front that says "Founded 1814." It's a semiprivate school—meaning that it's private but the town pays for kids to attend—and Bethany guesses that it's one of the best in New England. But she hates it.

She's a student at the academy's special education department. She says this is where they send students with disabilities whom they're not allowed to expel. She's in classes with all the problem kids, and the teachers just don't give a shit. Kids will scream and yell and talk to themselves.

Sometimes Bethany yells "Shut up" really loud in the middle of class. But she's not yelling at the other kids when she does this; most of the time, she's yelling at the voices in her head.

When Bethany hit puberty, she started to hallucinate.

The hallucinations got more intense each year, and now she hears voices and sees bugs all over the floor. People's faces sometimes get distorted and look demon-ish, like an acid trip.

She takes a mild antipsychotic called Seroquel, but it doesn't work. It just makes her tired and hungry.

When Bethany started middle school, she wrote at a college level, and she had all As and Bs. When the voices started, her grades plunged. At first, it was just an occasional D or F. Now she's failing every class. She says she has no choice but to drop out.

Bethany says her mom is trying to get the school to help, but there's only so much she can do.

Her mom doesn't know that one night earlier this year, the stress of school drove her to swallow a whole bottle of Seroquel with a chaser of nail-polish remover. She still has a big scar where she slashed her wrist that night.

Bethany's dad hasn't been around since he threatened to throw a computer at her mom, 11 years ago. These days, he and Bethany trade e-mails all the time, but she lives with her mom. In fact, they share a bedroom, and Bethany resents the fact that her 19-year-old brother—"a nerdy, fat, messy slob"—gets his own room.

When I ask Bethany what the future holds, she is for the first time in a long, animated conversation at a loss for words. She finally answers:

"I don't know."

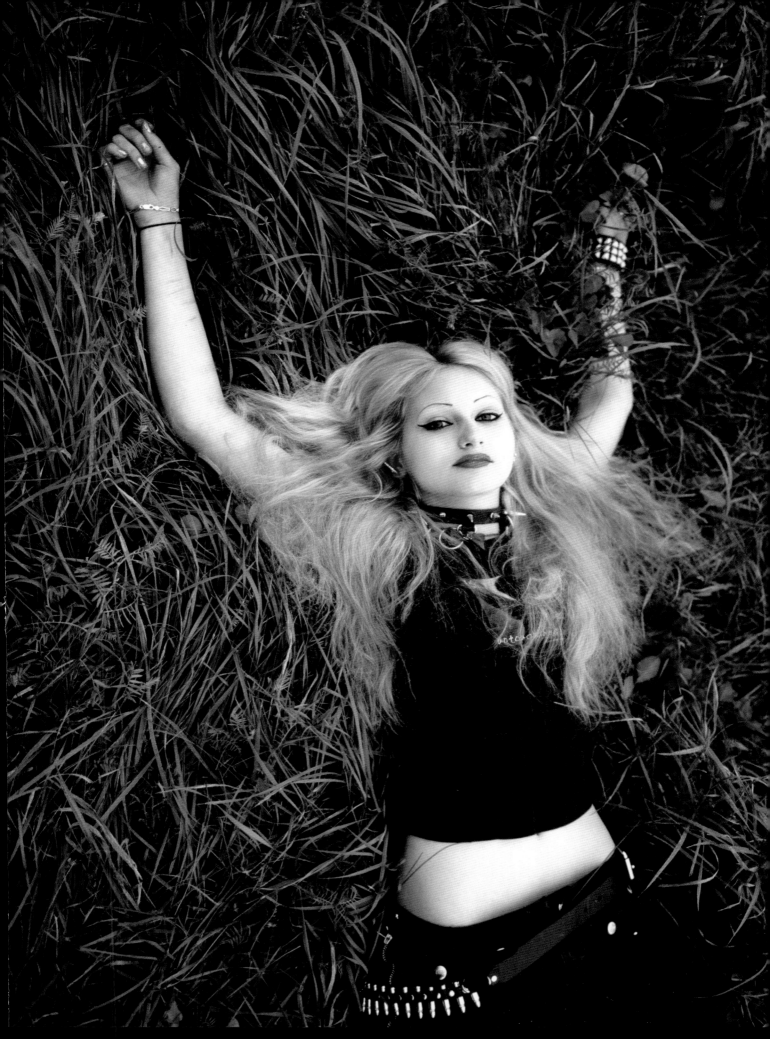

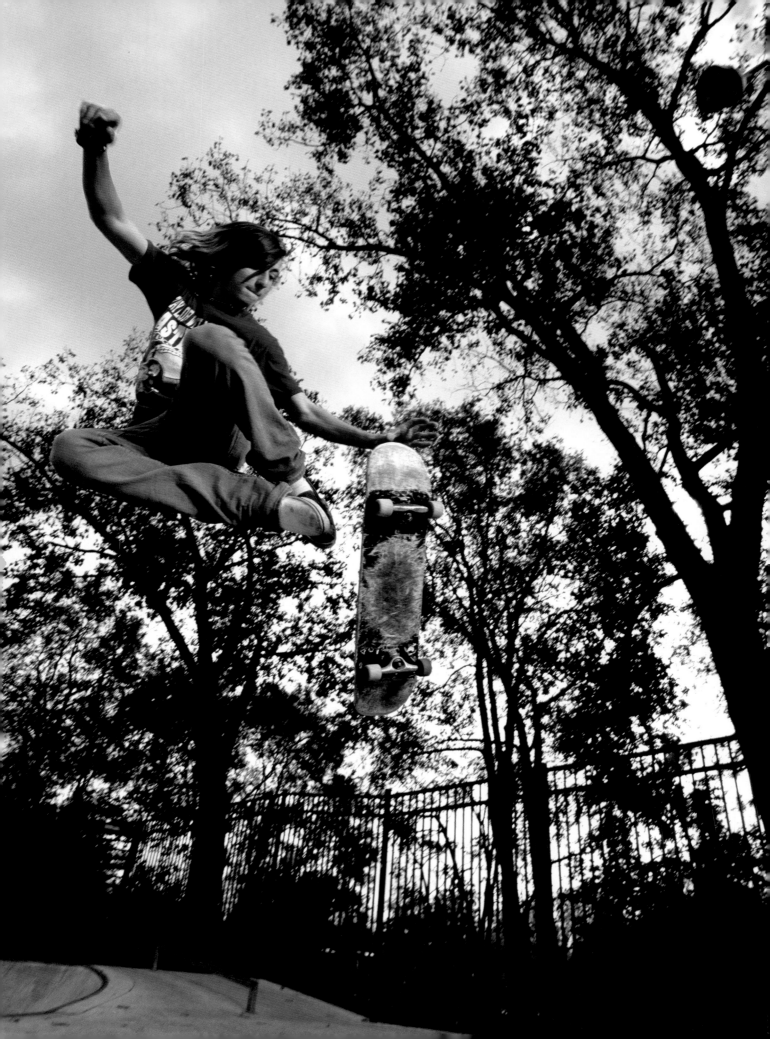

ADRIAN
15 ★ INDIANA

Adrian's mom was born on Independence Day, 1964. She died on October 18, 2006, 2 days before his dad takes us to a downtown skate park for our photo shoot.

He is willing to answer questions about his mom—who had been fighting heart disease for years—but he really just wants to skate.

It's a bitter cold morning in Indiana and Adrian is working up a sweat. He's only been skating for a year, but he's good.

"SOME SKATERS ARE COOL; OTHERS ARE COCKY AS HELL."

Usually, the cocky ones are "wiggers": White kids who wear baggy shorts, an XXL·T·shirt, and a baseball cap to the side with the shiny size-label still stuck to the visor. "They just suck," he says. "They do tricks that aren't really tricks—like kicking your board over and trying to jump on it again." He shakes his head. "That's not a trick."

He describes himself as a regular skater who wears tight jeans and skate shoes made by DC, which he says is the coolest skate brand.

Adrian says his dad told him the reason his mom died is that "she made a mistake in her life." Because of that, they wouldn't give her a new heart. He can't explain what this means—or what exactly her mistake was.

There is no sign of emotion anywhere in the conversation. Partly, he says, it's that she'd been dying for a long time. And partly it's that his parents had been separated for a while. He's been with his dad since his mom got really sick last year.

He and his little brother have anger problems. His brother always starts the fight, Adrian says.

His dad may even send his little brother to boarding school "to get some Jesus in him."

Adrian says his stepdad doesn't really like him or his little brother, not since they smashed up the stepdad's car with baseball bats. "We didn't think he needed it," he explains.

When his mom got sick, he moved in with his dad and started at a new school. He's proud of the fact that he plays first cello in the school orchestra; he's even thinking about becoming a professional musician. He doesn't want to count on making it as a pro skater.

Adrian tells me that July 4 has always been a special holiday for him, because it was also his mom's birthday. He thinks it will be different now. But he doesn't want to talk about that.

He just wants to skate.

DREW
17 ★ VIRGINIA

DREW IS JUST STARTING TO FIGURE OUT HE'S DIFFERENT FROM EVERYONE ELSE.

I ask if he knows he has Williams syndrome, and he smiles and nods his head. "Yeah, I did know that."

But he doesn't seem to know what it is.

Drew's genetic condition is sometimes called a "cocktail party syndrome." He loves meeting new people and making friends. He has trouble with names, but he remembers everyone's face, and he always says something that makes people smile.

However, what makes him appealing is also what makes him vulnerable. He likes and trusts everyone. His parents are afraid that a stranger could take advantage of him.

Drew is the oldest of eight kids in a Catholic family, and he's unaware that he gets more of his parents' attention than his siblings.

He excels at some things, like music, but he struggles with basic daily tasks like brushing his teeth and showering.

"It was like pulling teeth to get him to take a shower every day," his dad says. "He thought it was cruel and unusual punishment."

In a lot of ways, he's just like any other teenager. He loves playing drums. His favorite meal is McChicken and fries. And his favorite song is "In The End" by Linkin Park.

He recently wrote a love letter to a girl at school, "just to say how nice and sweet she is." The girl kissed him on the cheek when she read it.

"Then my face turned red," he says, "and I was, like, 'Oh my gosh!'"

Every day, after school, he makes what he calls his "rounds" to all the neighbors who need their lawns mowed. He always shows up at the right house on the right day, and if he finds that a neighbor's mower isn't working, he'll fix it.

On his birthday, he gets leaf blowers and weed eaters. Usually, after about 6 months he'll decide that something doesn't sound right, and then the weed eater will be in a hundred pieces on the garage floor.

Drew says he's definitely going to college. "I want to go to James Madison University," he says.

"The truth," his dad says, "is that Drew won't go to college."

I ask Drew how he'd feel if he found out that his Williams syndrome kept him from going to college.

He shrugs and says, "I'd say okay, that's fine with me."

Drew says he knows about sex. "It's not very good. You have to wait until you are married before you are allowed to do that. I've seen a lot of girls get pregnant by doing that, and I don't want to be blamed."

He says he won't be getting married for at least another 5 or 6 years.

"After I finish school," he says, "I'll stay around here to help out my family."

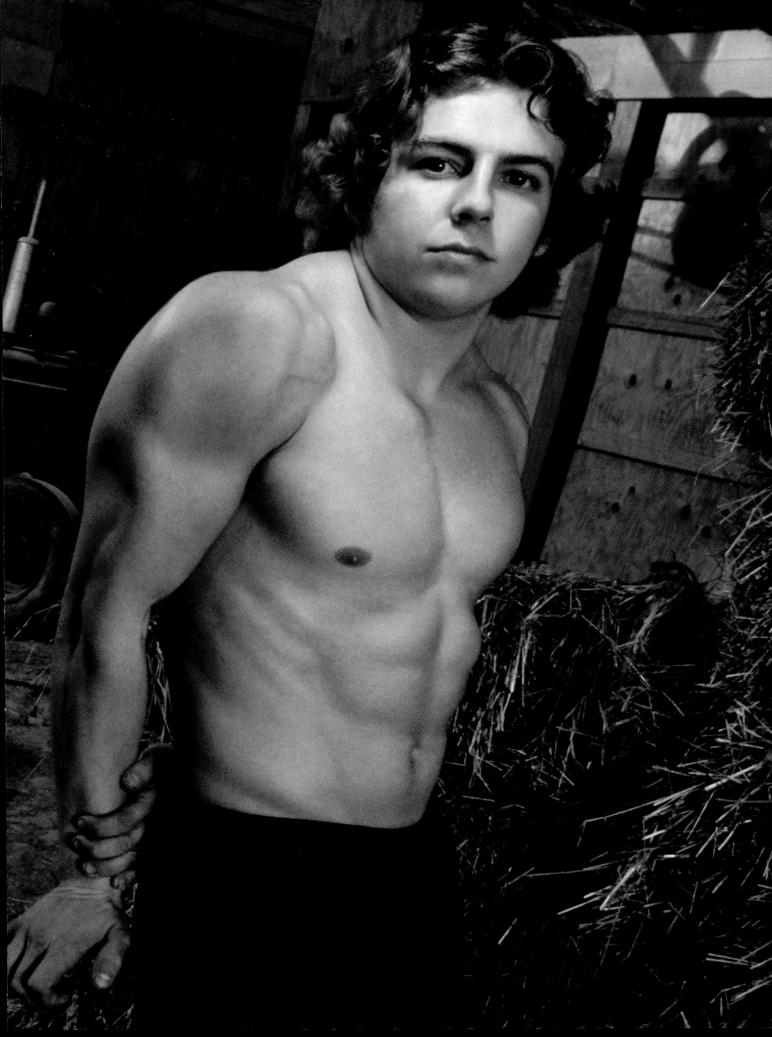

JUSTIN
19 ★ OHIO

"I WON'T BE THE SKINNY KID WITH GLASSES. I'D RATHER SHOOT MYSELF WITH A STAPLE GUN."

Justin does need glasses, and he did recently shoot himself with a staple gun (his dad had to pull the staple out of his hand), but he's definitely not the skinny kid anymore.

When Justin was in seventh grade, he weighed 100 pounds, and "dickhead kids" bigger than him used to kick his ass. In 6 years, he's doubled his weight, and he says he's still not big enough.

We're in a dusty old barn where Justin works out every day. He likes being hidden away where no one can see him train. "It's like, one day you're gonna step out, and everyone is gonna be like 'Holy shit, where did this kid come from?'"

That day has already come for Justin. He stepped out of the barn earlier this year and won the Mr. Natural Teen Ohio bodybuilding title. The word natural means he got there without steroids (*juicing* is the word Justin uses).

Will Justin ever juice? Well, he does plan to be a pro bodybuilder, and he says there isn't a single pro that doesn't juice. "All the big guys out there had to trick their bodies into doing that. Obviously, if you've got 3% body fat at 275 pounds, that's not natural."

To compete, Justin needs to lose 30 pounds. Getting there means a brutal period of "carb depletion." He'll have a can of tuna every two hours, all day, and nothing else. Maybe he'll cheat and have a pickle, but he says that's not a big deal, because there's only about one gram of carbs in a pickle.

Then after the competition, he goes back into a bulking-up phase—eating anything and everything. He's always in one phase or the other.

Although Justin's body is his temple, he does like to party. "At the very least, I can breathe some freedom," he says with a giant smile. He used to drink but had to stop because of gastric reflux. This is tough for Justin. "It's the Midwest; drinking is really all there is to do around here."

One night last month, he had a couple of beers and crashed his '88 Cougar. But he only blew a 0.05, so he wasn't legally drunk. He was heading down a road at about 60, when an S-curve came out of nowhere. The Cougar flew through a small gap between a giant oak tree and a pine tree and slammed into a drainage ditch.

Justin says the hand of God pulled him out of there. He describes being outside his body, climbing out of the big-ass ditch and jumping over live electric fences. He ran through a cow field and rang a stranger's doorbell. He was stunned that Justin had gotten through the high-voltage wires that keep their cows in.

He still calls himself a "hillbilly kid" but he's a lot more confident than he used to be.

"When someone tells me they don't like something about me, I go 'Oh, that's wonderful; good for you,' and I turn around and walk away."

I ask when he'll be happy with his size. He laughs:

"When I can't wipe my ass."

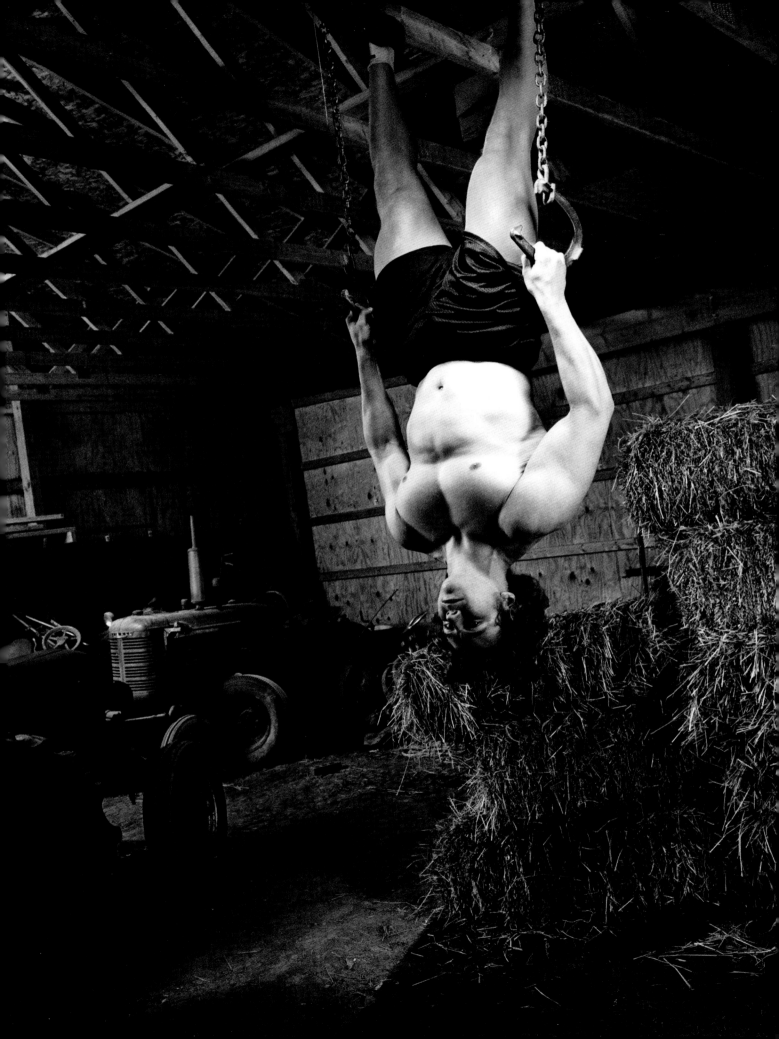

BART

20 ★ IOWA

t happened last year on June 23, when Bart was still 19. He was at the wheel of a Humvee, just outside Baghdad, returning from the Syrian border, when he swerved to miss an improvised explosive device (IED) in the roadway. He breathed a sigh of relief.

A moment later his vehicle exploded. It was a second IED, and the blast took both his arms.

Bart isn't sure he wants to be in this book. He doesn't want people to see him as a freak, and he doesn't want people to question what he was doing over there. He just wants to live a quiet life now with his wife, Heather, and their little girl, Sabrina.

When he comes to the door of his suburban house I reach out to shake hands. I hesitate, but then grasp the metal hook. He makes it clear that this is the right thing to do.

He leads us into the backyard, and a barking puppy comes tumbling toward us. Sabrina follows closely, yelling, "Sponge Bob!"

We ask Bart if he would pose for a picture with Sabrina and Sponge Bob and he shrugs.

Sabrina runs, screaming, into the house. Then Sponge Bob runs off.

After a while, my producer returns with Sabrina, who's holding a crown.

She has reluctantly agreed to sit on her daddy's shoulders—provided that she can wear her crown and hold Sponge Bob.

She gets in place and takes the puppy, but then starts crying again.

After one roll of film, Bart's had enough.

I ask him if he'd put on his uniform for a picture, and I quickly regret asking. He hasn't worn it since returning.

Heather helps him squeeze into it and tells him how handsome he looks.

He stands solemnly and salutes for the camera.

"You would never believe what I've seen," Bart says.

❝I'M ACTUALLY PRETTY LUCKY.❞

MOHAMMED
16★ MICHIGAN

When Mohammed was little, he was afraid of people coming to the door to kill his family. At age 10, he watched some people from the government come and drag his neighbors away, never to return.

Mohammed lived in Iraq till he was 11. This year, he read George Orwell's *1984*; "I was like, wow, that's just what it was like over there." He says you could never tell who worked for the government; they were everywhere.

In the heavily Arabic town in Michigan where Mohammed lives, there was a huge party in the street when Saddam was hanged. The local paper ran a picture of Mohammed playing a drum in the celebration.

He says Saddam was a very bad man, and he is grateful to President Bush for removing him. But then he says he's not so sure how he feels about the war, because there are still people dying where he lived as a child.

Two years ago, Mohammed's father left Michigan to work as a translator for the U.S. Army in Iraq. Soon after he got there, he uncovered a theft ring: Iraqi gangs were stealing national treasures and fencing them through the British army.

Shortly after his dad shared this information with the family, they got a phone call. His mom got up from the dinner table and was paralyzed by the news. She held the phone and couldn't speak. "We took the phone from her, and we found out."

Some people shot up the Humvee Mohammed's father was riding in, killing everyone inside.

Mohammed was close with his father, who served in the Iraqi air force for most of his life. As a small child, Mohammed and his mother used to stand in the backyard and watch for his dad's plane, which had distinctive flags on its tail; his dad would fly over their house every day.

Mohammed's father was murdered right before finals week. The principal let him skip the exams and get passing grades in all his courses.

He likes his school, which is mostly Arabic, but some of the white kids call them "camel jockies" or "sand people," which really gets to him.

He regularly travels to visit uncles in Florida and Nevada, and he says he almost always gets taken in to the back room at the airport and searched—often strip-searched. They usually take his suitcases, and he doesn't get them back for days.

Once he got pulled over in a minivan with two guys named Ali and a white guy named Mike. The cops sent Mike back into the car but interrogated the three Middle-Eastern teens about whether they had a bomb in the trunk.

HE HATES THE FACT THAT PEOPLE SEEM SUSPICIOUS OF HIM WHEN THEY HEAR HIS FIRST NAME

Most of Mohammed's friends started calling him Mario when they found out that was his nickname in Iraq, because he'd spend hours each day playing Super Mario Brothers in the arcades—which were actually small storefronts with three or four PlayStations and plastic chairs.

Life in Iraq was different. School was from 8:00 to 12:00 (because a second shift of students came in the afternoon), Fridays were the only days off (except for national holidays, like Saddam's birthday), and television was really boring because there were only four channels.

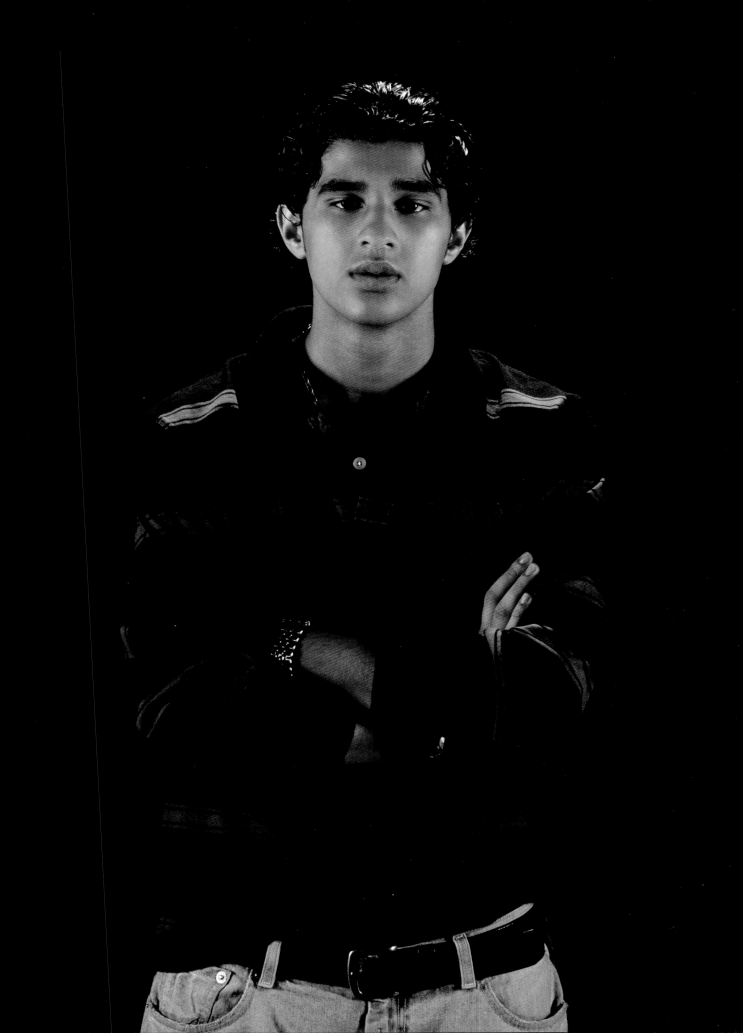

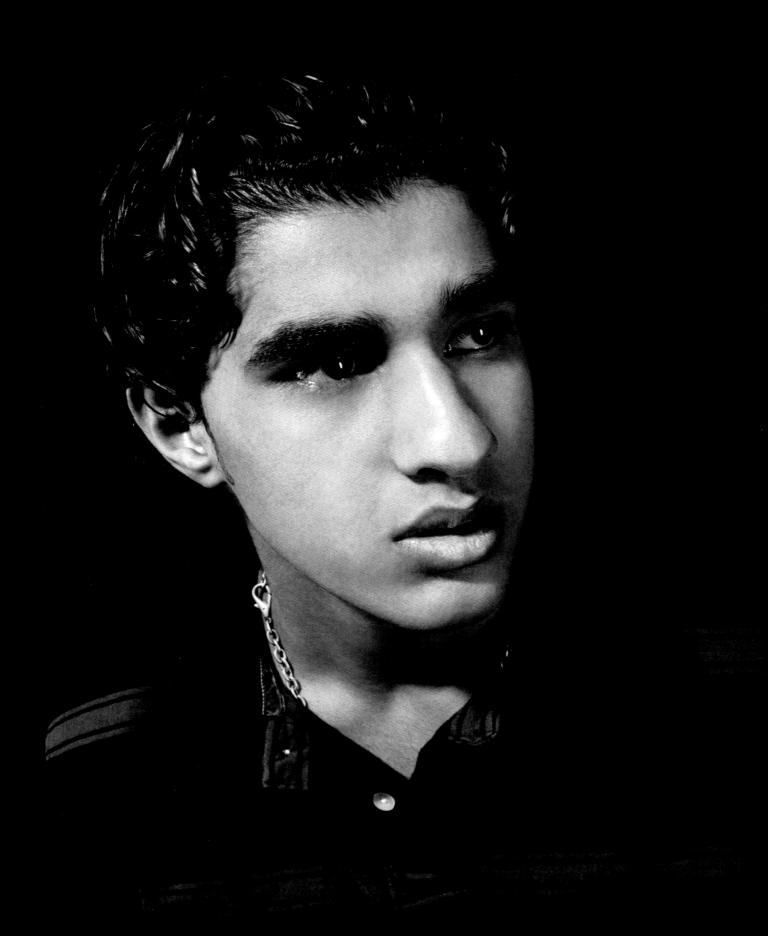

Mohammed was blown away when he got here and saw hundreds of channels on cable.

He was stunned when he saw his first sex scene. Over there, the government cut those out. They also cut out all kinds of other scenes. "No bikinis whatsoever," he says, shaking his head.

Recently, Mohammed saw *Gone in 60 Seconds* for the second time. The first time was in Iraq, and they had completely cut out a critical scene, because Angelina Jolie was wearing a tank top. The censorship made the movie impossible to understand, he says, but that was typical of life there.

Mohammed learned English after he got here. He says it was all MTV and the Disney Channel. His mom is still having trouble, and he recommends Disney movies to her, because they're easy.

Even now, his friends in Iraq are way behind on music and culture. A friend of his over there just told him about a single from New York rapper 50 Cent called "Candy Shop." "I'm, like, 'I've had that in my iPod for two years!'"

Probably the biggest difference for Mohammed is how teenagers view sex and relationships. Over there, it's all on the down low. Every girl has to stay a virgin. Parents sometimes kill their daughters for losing their virginity before marriage. (He says this means they "stick with anal.")

Mohammed believes it's wrong to have sex before marriage. But for Shiite Muslims like him, it's possible to arrange a temporary marriage, which can be as short as two hours. No one needs to know about it besides you and the girl you're with.

IT'S CALLED **MUTAA**, OR PLEASURE MARRIAGE.

According to Mohammed, *mutaa* started in the old days when men were going off to conquer foreign lands and would be away from their wives for a long time. "You see where I'm going with this?" he asks me.

Saddam Hussein's Sunni-led government had prohibited pleasure marriages, but now that the Shiites are in power, all kinds of people are doing it.

Mohammed is happy to share the details of how it works. "You need to read a passage from the Koran, and she has to agree. Then you need to give her something. That's all."

Even with American girls, Mohammed does this ceremony to stay true to his religion. Over spring break, he met a girl on the beach he really liked and they did the *mutaa* ceremony in his hotel room. (He actually had three pleasure marriages over spring break.)

She has to understand what she's agreeing to, so Mohammed explains the Koran passage to her in English after reading it in Arabic. He tells her what the duration of the marriage will be. And she says, "Yes, I agree." The final step is to give her a gift—anything of value. Sometimes he gives a flower.

Last time Mohammed arranged a pleasure marriage, he had no flowers, so he used money. I ask him how much. He laughs and tells me, "A dime."

I ask Mohammed what his future holds, and he tells me he plans to join the air force, like his dad. The U.S. Air Force. He recently wrote to his senator to ask how he could do that. He got a letter back, suggesting he start by joining the air force reserve for a couple of years.

I ask why he's got to join the reserve rather than going straight into the air force, and he can't believe I don't understand. "My name is Mohammed. It's not that easy."

APRIL LUV
18★ NEVADA

We're lost in the desert, 30 miles outside Reno. When I call for directions, I notice that the last four digits of the phone number spell out f·u·c·k.

The street number we're looking for is 69. We know we've arrived when we see this sign:

WARNING: HOT & NASTY WILD SEX 300 YARDS AHEAD.

Down the driveway, we find a one-story white building that could be a motel, except for the words posted above the entrance: "Best Whorehouse in the West."

We enter the World Famous Bunny Ranch, one of about 30 legal brothels in the state of Nevada.

A middle-aged woman asks if we're here to see the girls. We explain that we're not customers; we're here to photograph April Luv.

She leads us down a creaky narrow hallway to a small dorm room. This is where April conducts her business.

She's at the mirror putting on her makeup, and she waves us in with a smile. It's hard not to look at the dildo next to the cup of beer on the night table.

The only place to sit is the bed, and we all choose to stand.

For 6 months, April has been the youngest sex worker here at the brothel made famous by the HBO series *Cathouse*.

She used to watch the show back in high school. "At first, I thought it was crazy," she says. "I'd never heard about anything like that. I mean, you'd see prostitutes on the street, but that's all."

I ask if she calls herself a prostitute or an escort, and she snaps back, "I am an independent contractor."

"Escorts are girls that do out-calls, and prostitutes work the street," she says. "I mean, I know that's what I am. But I'm happy with myself and my life."

April lives here 5 days a week, and she works a 12-hour shift every day she's here.

On her dresser, we come across a card we're not supposed to see. It lists April's customers for the previous day. Three men each paid $5,000 to spend an hour with her.

A bell rings, indicating that a customer has arrived to see the girls. April warns us to stay clear of the hallway.

Two dozen girls in heels run to the "parlor," a small bar area where patrons make their selection. "If you get there late," she says, "you'll be way in the back, and the guy won't see you."

Often the customer already knows whom he wants, because he's seen the HBO show or visited the web site, and he's here to bring his fantasy to life.

"I'm staying here until I have enough in the bank to buy two or three houses and start a business," she says, "like a hair salon or something in real estate."

Back in high school, she worked at the No Fear store at the mall, and she can't imagine going back to that kind of job.

"You work 40 hours and get like a $350 check," she says. "That won't even pay my rent."

April has an apartment in Reno, where she spends 2 days a week with her bull terrier and two pitbull puppies. The rest of the time, her stripper roommate takes care of the dogs.

She's happy to talk about life on the Bunny Ranch for hours, but she's less interested in sharing details of her life as a child.

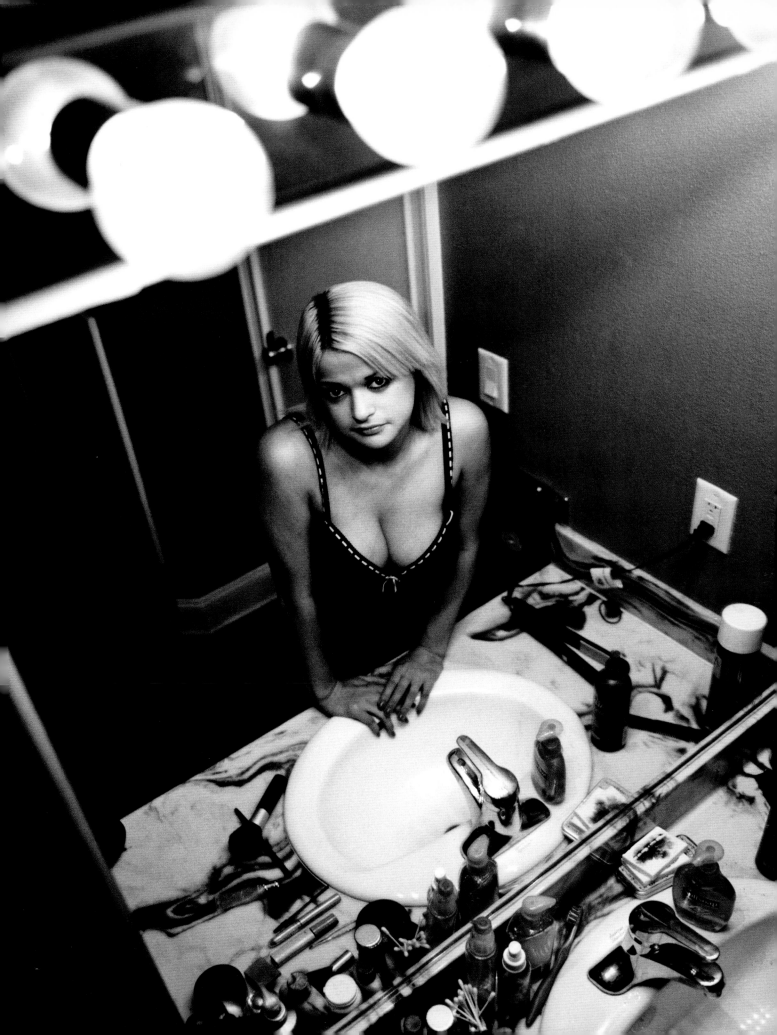

"You know, not everyone who works here was raped or neglected as a child," she says.

I ask if her parents are still married, and she tells me they got divorced when she was 5. "But it's not like I never saw my dad or anything."

She wants to make it clear that she had a happy, normal childhood. "I was never abused. I have good parents. I didn't even have sex till I was 16 or 17."

She was an all-star cheerleader, and she wore Abercrombie and Hollister, like all the other popular girls at school.

It bugs April when people get the wrong idea about her line of work. "No one is forcing me to be here," she says. "It's not like that."

April says her mom knows about her job here, and she's okay with it, although she'd rather see April go to college, settle down, and have kids.

She says the work isn't that bad. "It's not like every guy asks me to pee in his mouth." (In fact, that's only happened once.)

"A lot of guys just want companionship," she says. One recent customer just wanted to hang out and watch SportsCenter.

And if the guy is disrespectful or arrogant—or if he's dirty and grotesque—April will politely reject his offer and walk away.

April says that life on the Ranch is fun, and the other girls are like her family. Plus, she meets all kinds of interesting men, from all around the world.

"We're learning about life," she says. "It's like college, except we get paid for it."

MISTY
18 ★ MASSACHUSETTS

Misty calls it her "promise ring." It's been on her wedding finger since she was 12.

Throughout our interview, which takes place in her church, Misty's mom sits beside her. Misty often looks to her mom for approval, which she gets when she tells me her parents' policy on relationships: "I'm not allowed to date."

"Until when?" I ask. Misty hesitates so her mom answers for her: "Until marriage." That's why Misty and her boyfriend always hang out with her parents or brother. They're never without a chaperone.

"Guys with their hormones are pretty crazy," she says. "Guys think you go on a date and you're supposed to make out. That makes it hard to get to know someone." Misty's mom nods approvingly.

Her mom helped her found Purity Productions, a company dedicated to "clean" entertainment. So far, they've filmed two TV pilots, both financed by her parents—and both starring Misty.

They just wrapped *Starfish*, written and directed by Misty and her mom—and costarring Donna Douglas, who was famous for playing Elly May Clampett on *The Beverly Hillbillies* 20 years before Misty was born. She's not sure how much her parents paid Douglas to be in the film.

For Misty and her mom, it's all about spreading the word of Christ. When she travels around to high schools lecturing about abstinence, she wears these tiny feet pinned to her shirt. They're the size of a 10-week-old fetus.

She thinks they're really cool, because they get pregnant girls thinking about the fact that it's a real human being inside of them, and it's wrong to kill a human being.

I ask if there's ever a justification for abortion—for example, in the case of rape. Misty answers without hesitation: "It's not the baby's fault. It shouldn't be punished or killed for what happened."

The kids in the high schools make fun of her. And the guys hit on her. She politely declines when they ask her to come to a party or go out drinking.

" I DON'T DRINK. I DON'T SMOKE. I'M A VIRGIN AND I WILL BE TILL MARRIAGE. "

These are the words that define her existence.

Sometimes Misty goes to the movies with friends, but it's hard to find a movie that isn't dirty. That means no R-rated films—definitely no movies with swearing or sexual content.

If she makes a mistake and ends up seeing a movie that has a dirty scene, she covers her eyes until the scene's over. If the scene goes on too long, she'll walk out and wait for her friends in the lobby.

Misty has mixed feelings about the Internet. It depends on what people use it for. "I've had some really creepy people send me gross messages on MySpace," she says. "I delete them right away and go watch a Disney movie."

Sometimes, Misty's friends post inappropriate jokes or pictures on their MySpace pages, and Misty sets them straight. "My friends call me Mom because I lecture them."

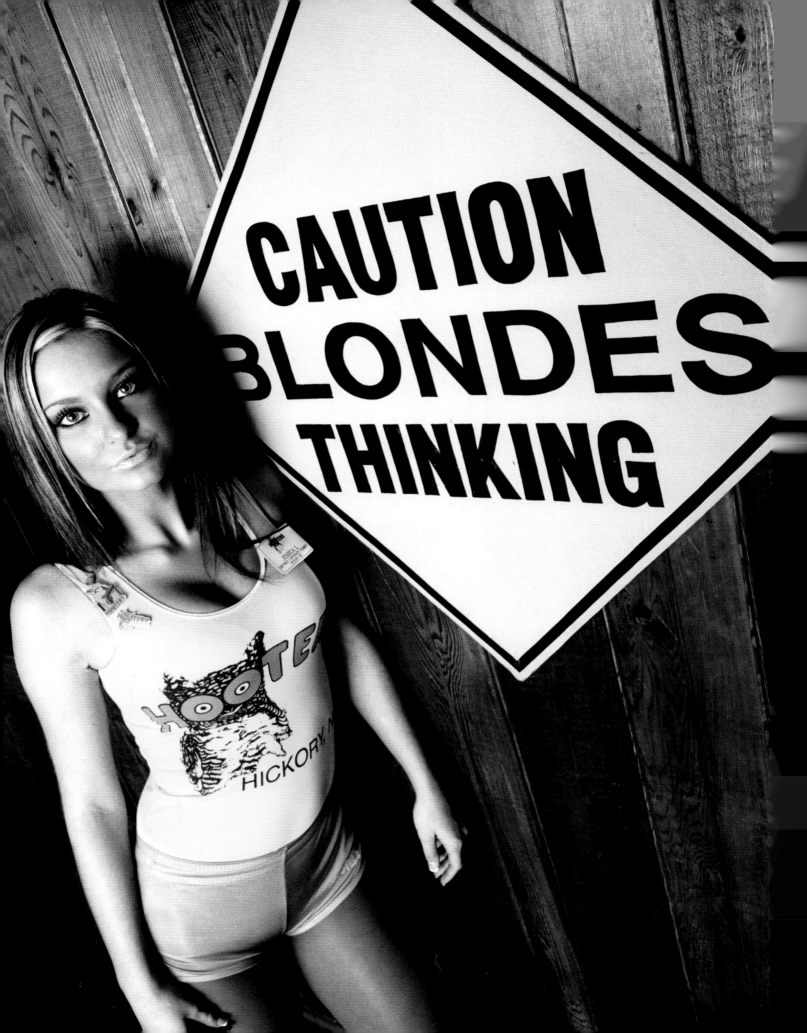

JESS

18★ SOUTH CAROLINA

We're at the Hooters in Asheville, South Carolina, and a middle-aged guy in cowboy boots is making blonde jokes loud enough to hear from across the restaurant.

Jess doesn't mind, but she does have mixed feelings about posing next to the "Caution: Blondes Thinking" sign.

In eleventh grade, she worked in a sub shop earning $5.45 an hour. The next year, Hooters hired her, and everything changed. Now she works here full-time and takes home $200 on a good night.

Most of the customers are cool, she says, but once in a while a table of girls will come in with an attitude. "They'll stick their noses up and say, 'Oh, look at her. She's a slut.'"

She's used to it. In high school, this happened a lot to Jess and the other popular girls.

66 SOME PEOPLE LOOK AT ME AND THINK I'M STUCK-UP, OR THEY THINK THAT I'M DUMB, BECAUSE I'M BLONDE. 99

Usually, she says, it's just jealousy.

Jess grew up in a log cabin behind a fish pond. On one side was her family's horse farm. On the other, a cow farm. The nearest neighbor was a 10-minute walk down the dirt road.

Jess enjoys the country lifestyle, but she's a people person, and there aren't enough people here. She loves

the idea of living in New York City but thinks Orlando might be more practical.

She's proud to say that her report cards in high school were filled with As and Bs, and that the senior class elected her best dressed because she was always "on point" in her heels, tight jeans, and dressy shirts.

Some people think the Hooters uniform is degrading, but Jess disagrees. She wouldn't dress like this at home, but she has no problem using her sex appeal to earn a good living. She's here to perform, and this is her costume.

At first, Jess's boyfriend didn't want her to work here. They'd been together since she was 15, and he hated the idea that guys would be staring at her boobs all day.

Jess says a lot of people think Hooters is more than it is. They think it's guys coming in to hook up with girls. She told her boyfriend it's not like that, and he just had to trust her.

Jess is the Hooters Girl of the Quarter for her region, and she is steeped in the Hooters philosophy. "We're here to give our customers a relief from reality," she says. "When they walk through the door, they need to stop stressing about their job and start having fun. My job is to help them do that."

I ask Jess what she thinks about the slang meaning of the word *hooters*, and she says it's no secret that bust size is important for the 15,000 Hooters Girls around the world.

"Obviously, Hooters is based on image," she says. "And I think that's okay."

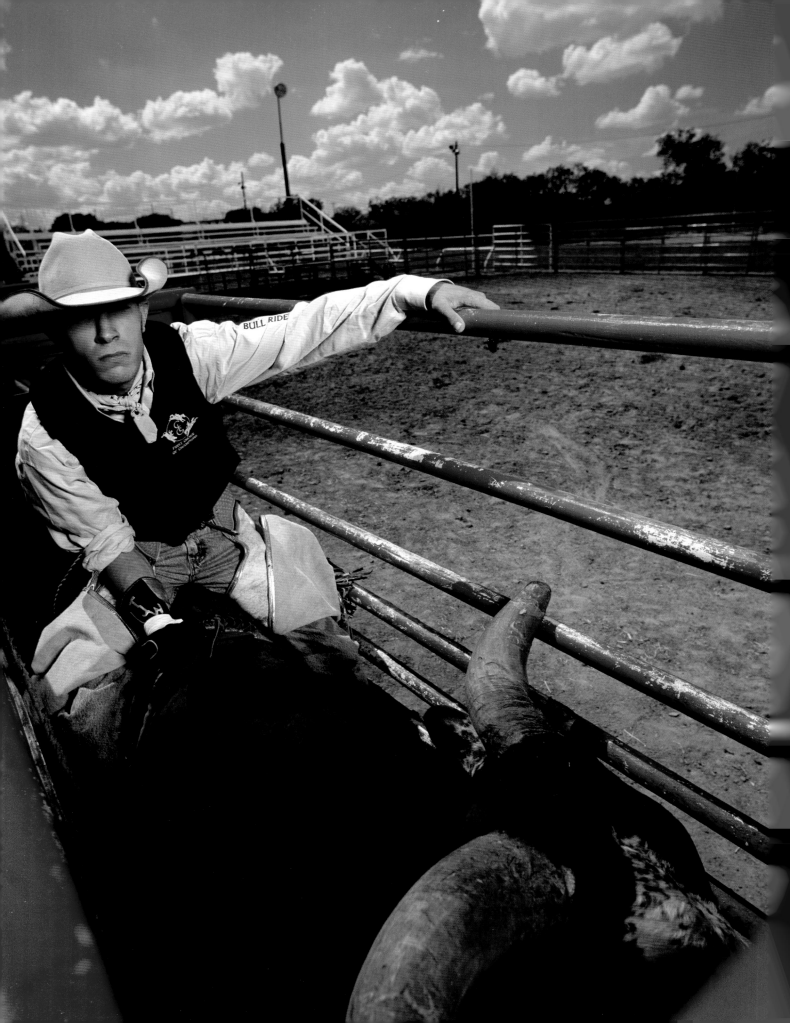

TJ

18 ★ TEXAS

" I EAT, DREAM, AND SHIT BULL RIDING. "

TJ says he lives life eight seconds at a time. "Every time I get on a bull, I don't know if I'm gonna walk out of the ring."

We're at a bullring in South Texas, and TJ is packing Copenhagen between his lip and gum before he climbs into the chute.

"I'm gonna be the next world champ," he says. "I love riding bulls. I love chasing women. I love drinking Coors Light. I love dipping Copenhagen. I love hanging with my boys. I love my folks. And I hate fat girls."

TJ talks fast and loud with a heavy Texas twang.

"I don't trust you," he says. "I just met you. But I'll tell you the same story I tell my best friend, because I don't have any trust in anyone."

When TJ was 5, his mom went into surgery to get a pacemaker. His parents were divorced and his sisters were taking care of him.

While his mom was in the hospital, his dad walked into the house and told the girls he was taking TJ to the park. He lured TJ into his El Camino with a packet of strawberry candy and drove him to a house hundreds of miles away where he had a secret family.

His dad brought him inside and said, "TJ, this is your step-mom and your stepbrother."

TJ says he still has scars on his arms where his step-brother would melt glue sticks into his skin. And his step-mom would pour her own urine on him and say he wet his bed. "They were the most horrible people in the world," he says.

After 4 years, his dad drove him to a gas station and left him there. He hadn't seen his mom since he was 5. She pulled up and told him to get in the car.

Since then, life has been good. "My stepdad, Steve, is the most amazing guy in the world," TJ says. "He's never broken a promise to me, ever."

TJ tells me how Steve promised to go to every peewee soccer game when he was little. Steve hurt his arm one day and needed surgery on a tendon. He refused general anesthetic because TJ had a soccer game that night.

But the real reason TJ loves his stepdad is that he taught TJ how to ride bulls.

"It's just the most amazing feeling in the world," he says, "because it's like you're tied to a tornado, and you don't know what the hell it's gonna do to you."

"You know you're gonna hit somewhere, and you hope to hell you hit somewhere soft."

Last year, a 2,100-pound tiger-striped bull named Headhunter threw TJ down and stomped his head with all its might. TJ tells the story of being there on the ground.

"My dad yells, 'Hey!' and I say, 'What?' He says, 'He tore your ear off'. And I say, 'Oh shit.'"

TJ hates needles so he had them use liquid stitches to reattach his ear. It's no big deal, he says. His toe is more of a problem.

"I always get my toes stomped. And this one toe is all swelled up and nasty as shit," he says. "To tell you the truth, I think that's why me and my lady aren't romancing, because she doesn't wanna get near that damn toe. It smells like something died and it's uglier than shit."

TJ is proud of his bull injuries. "I got the body of a 78-year-old man," he tells me with a smile. "And I have arthritis in every joint in my body."

Mainly, TJ wants to talk about bull riding, but he's not shy about sharing his opinions on everything else.

He says he's not a racist, but he does use the N-word all the time. And he says Mexicans don't bother him, but he wants them to speak English.

"GODDAMN IT, IF YOU'RE GONNA LIVE IN MY COUNTRY, YOU'RE GONNA LEARN MY LANGUAGE."

When he finds out we're from California, he stops and stares.

"Y'all live in California by choice?" he asks. We laugh and tell him it's not that bad.

"But they got all them queers there," he says. He's not laughing.

TJ climbs on the bull and laughs while I hold the camera near the horns. "He could take that fancy camera out before you can blink," he says.

Sitting there on the bull, TJ is strong and confident, like this is where he belongs. I tell him that, and he looks happy.

"I am a bull rider. That's what I do, and that's why I got this smile on my face."

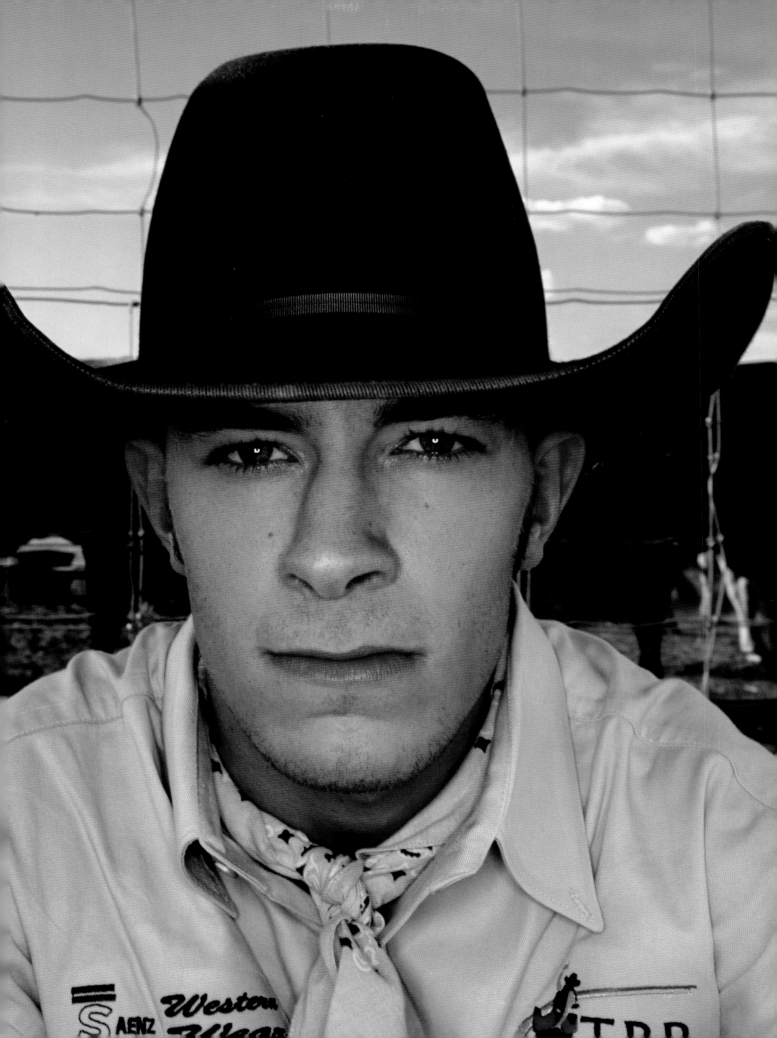

JOSH
15 ★ SOUTH DAKOTA

Josh wants to spend the rest of his life with Keith, but they might end their relationship because of this book.

We're driving through Sioux Falls with Josh, and he's sad and quiet. "Keith just broke up with me," he says. "He's pissed at me because he wanted to be the one in the book."

For the past year-and-a-half, Josh and Keith have been openly gay in a place where few others are.

They met in their "walkasize" class in eighth grade. "It's the easiest gym class you can take," Josh explains. "You just walk and talk." One day, Josh found out that Keith was gay and had a friend pass him a note while they were walking. All it said was "call me," with his phone number, and that was enough for Keith.

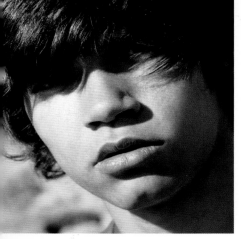

On their first date, in eighth grade, Keith told Josh he loved him. That shocked Josh, but he said it back to him. Now they say it all the time.

For the first year, they walked around school holding hands and people constantly yelled "fag" and "queer." Other kids would throw stuff at them in class, and even one of the teachers joined in, telling other students he thought they were disgusting.

"The football jocks were the worst," Josh says. "The weird thing is that some of them were nice to us when they were alone. They'd say, 'How are things with your boyfriend?' and we'd have a real conversation."

But the jocks got mean when their friends were around. They'd point and laugh:

66 UH-OH, HERE COME THE GAY GUYS. 99

Now things are better at school. "When they gave us shit, we just ignored it," Josh says. "After a while, it got old. They weren't getting anything out of it, so they stopped."

Josh came out to his mom in seventh grade, and she hugged him and said she loved him no matter what. Two months later, she hit a patch of black ice on the way to the mall.

An 18-wheeler smashed into the driver's side and killed her. His sister was in the car and survived but had to spend 2 months in a wheelchair.

Josh was back at school the next day, but he said he cried a lot that year. His dad had a hard time dealing with it, so Josh held off on mentioning that he was gay for a while. When he finally did, his dad told him the same thing his mom did: He still loves him.

We pull up at the falls—the incredibly beautiful cascades of the Big Sioux River—and it's time to patch things up.

I tell Keith that we want to include photographs of both of them in the book, and he instantly forgives Josh. The breakup is called off, and we can get on with the photo shoot.

"I want to be with Keith forever and ever and ever," Josh says. Keith says he wants that too, but he's worried that married life will get boring. I ask Josh what he wants more than anything in life, and he says, "Someone I can be close to and have trust in." He looks at Keith and smiles.

"I mean, what's the point of having fun if you don't have someone to have fun with?"

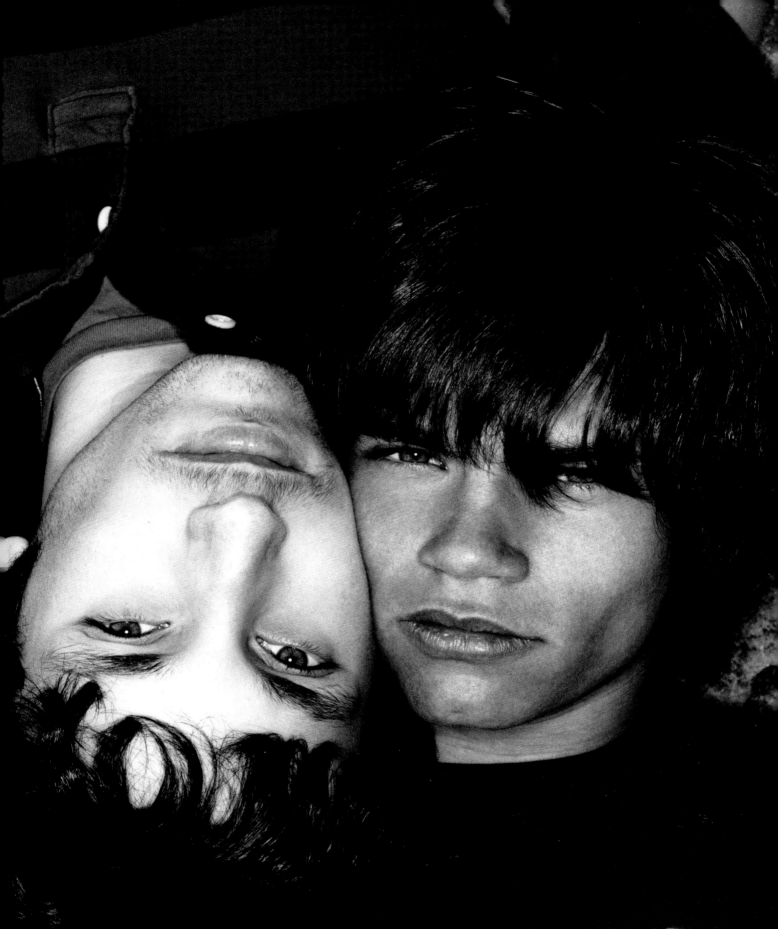

SHAKE WHAT YOUR
MOMMA GAVE YOU

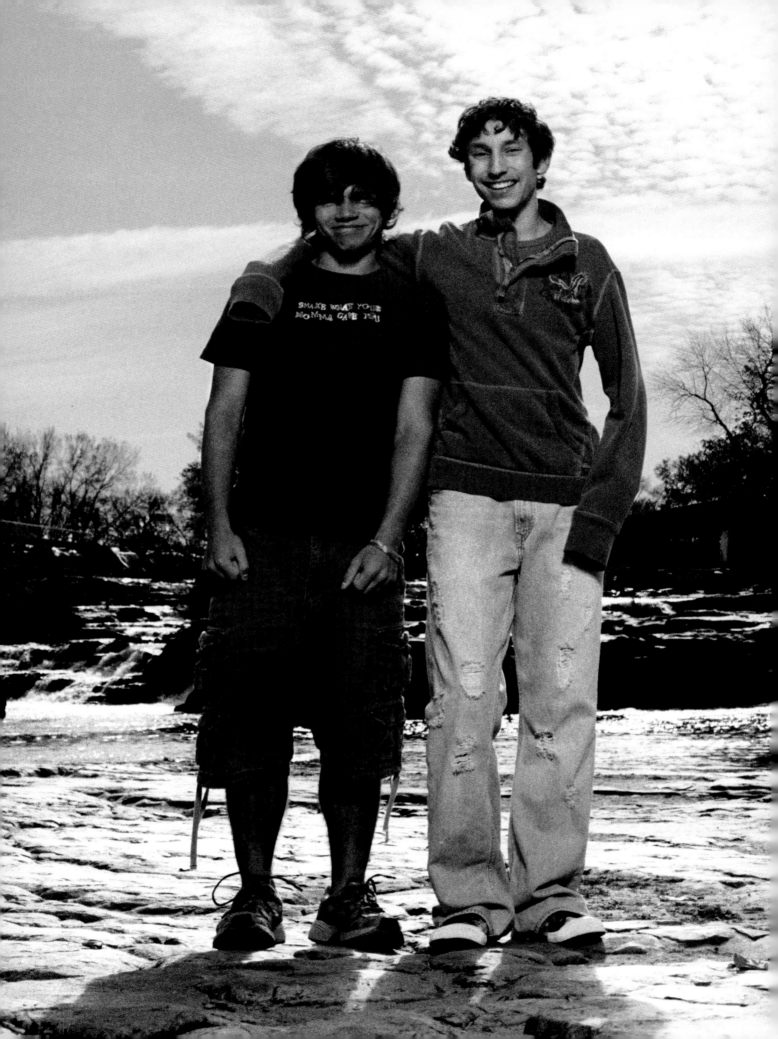

SARAH
16 ★ MAINE

Every night, Sarah sees herself die.

She's had the same dream for the past 5 nights. "I see my body being carried away by two people," she says, "and I look disgusting."

We're in Sarah's backyard, and it's a perfect fall day. She's sitting in an Adirondack chair looking like Jackie O, and her cat, Winnie, is playing in the grass.

Sarah says that depression is part of being a teenager. What she wants more than anything is to be happy, and she's trying to figure out how to do that.

At night, she lies surrounded by pillows and stuffed animals and thinks about her day. "I run through all the things I did wrong, forgot to do, or still need to do," she says, "and I can't stop thinking."

When she does finally sleep, she dies in her dream.

Sarah says she has no intention of taking her own life, but she does fantasize about death a lot.

66 YOU CAN'T REALLY BE FREE UNTIL YOU'RE DEAD. 99

Sarah doesn't show her writing to anyone, but she reluctantly shares a poem called "Freezing Hell." It's about slipping through a hairline crack into the cold abyss and finally being free.

"My writing and my art are just whatever I'm feeling at the moment," she says.

In eighth grade, she did a huge charcoal drawing of death-rock icon Marilyn Manson that got into an art show, but that piece was unusual for her.

"I hate painting people," she says. Sarah sees more emotion in an empty room or an inanimate object than a human face.

Middle school was the toughest time for Sarah. Her parents got divorced when she was 10, and her mom came out to her and introduced her girlfriend, Sandy, who now lives in the house with them.

The problem wasn't that her mom was with a woman. "I don't believe in the whole gay-straight thing," Sarah says. "I'm pretty open to both sexes in relationships."

The problem was that Sarah's older sister started partying a lot after her mom came out, and her mom was either out searching for her or spending time with Sandy. Sarah coped by drinking and taking pretty much any drug anyone handed her.

"I honestly couldn't tell you what drugs I did," she says, "because I never asked."

After rehab and counseling, life got better. Now she's on the honor roll and has a couple of close friends who can make her laugh.

She still gets really nervous when she brings a guy to the house, because she doesn't know how he's going to react to her lesbian mom. Usually people are cool, she says. But you never know who's going to have a problem.

She wants to dedicate her life to helping kids. "I think, sometimes, kids don't get enough attention," she says. "They deserve more attention than they get."

She definitely wants to get married, but she says she's undecided about having kids of her own. Probably not, she thinks. I ask her why.

"Kids ruin marriages," she says.

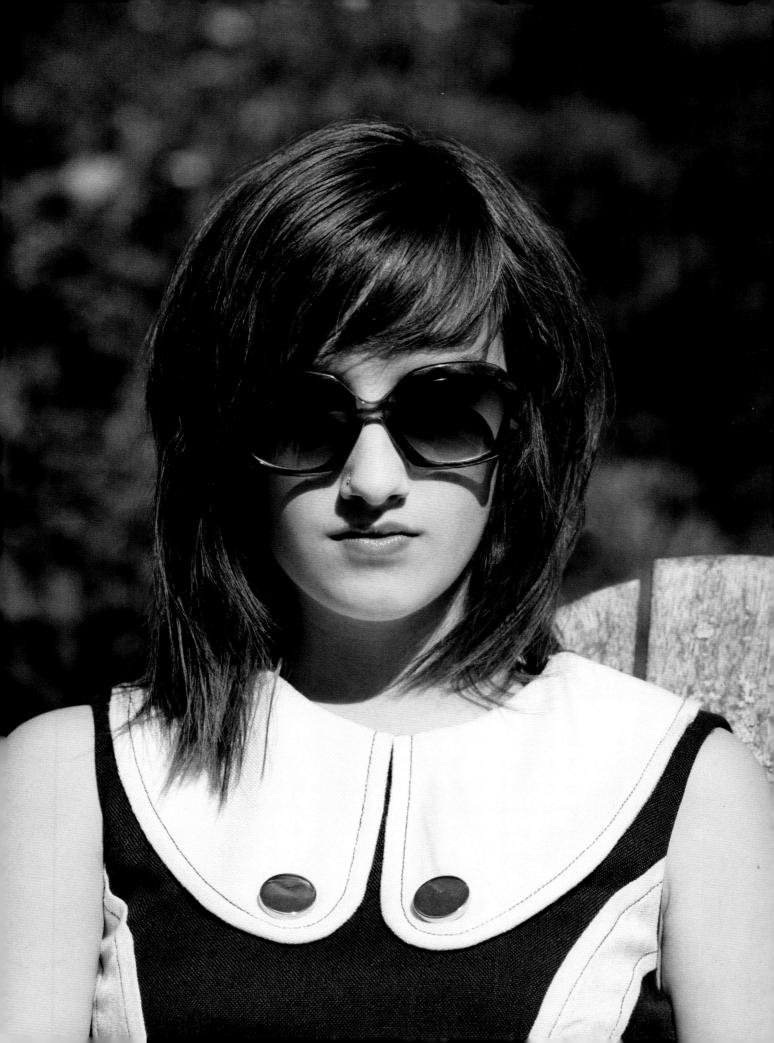

LEXI

15 ★ CALIFORNIA

WHEN LEXI WAS IN FIRST GRADE, HER MOM TOLD THE TEACHER THAT LEXI WAS HIV-POSITIVE.

The teacher cleared out half the classroom and made Lexi sit by herself so she wouldn't infect the other children. The teacher would follow her into the bathroom and once sent her home for spitting. Her only friends were the lunch ladies in the cafeteria.

Later that year, her mother died of AIDS.

When she was in seventh grade, some boys spray-painted "Lexi has AIDS" on her locker. All kinds of kids, including ones she didn't even know, walked up to her and asked if it was true. She told them it was a lie. (It was—Lexi was born with HIV and has not developed AIDS.)

I'm on the phone with Lexi, 3 months after these photos were taken, and she sounds like a new person. She's upbeat and energetic. She's got a new mom—a nice lady named Shannon. And she's back in school.

But Lexi was different on the day of our shoot. Our plan was to meet at 8:00 AM, but she called and said the room was spinning and she couldn't focus her eyes.

That's what the pills do to her—when she takes them. She's been on powerful HIV medications her whole life, but for a long time she was convinced that the pills made her sick, and she couldn't bear swallowing them.

"My dad would be in the living room, and I'd go put the pills down the garbage disposal. My stepmom would see me, and she'd shove the pills down my throat. I'd throw them up, and she'd shove them back down my throat."

Lexi remembers her dad and stepmom sitting on the couch, wailing, "Oh my God—you're going to die!"

Two years ago, Lexi was alone in her room, crying. She was angry at her father, who'd recently been diagnosed with lung cancer. So angry that she said, through her tears, "I hope he dies in surgery." Her stepsister was close enough to hear what she said.

A minute later, Lexi's dad came to the door and said he was getting rid of her. The next morning, he dropped her off at Child Protective Services. From there, she bounced around the system—from foster care to group home to family members back to foster care.

Now Lexi has a good mother, and she's happy. She just went to a place called Camp Laurel, where everyone is HIV-positive. She says it changed her life.

"There's so much love. Nobody makes fun of anybody. You don't have to worry about who you tell. Everyone hugs everyone."

Camp Laurel is free, and companies donate "angel flights" on their corporate jets to get the kids to camp at no cost.

Lexi says her new adoptive mother loves her more than anything. "She writes her goals up on the wall, and I write my goals. Her goals are to take care of me and make my goals happen."

Now Lexi sounds excited and happy. "If I want to learn Japanese, we'll go to Japan. I told her I want to learn Spanish, so she's taking me to Mexico this summer. We're going to Hawaii in the spring, Australia in the summer, and France in the fall."

I ask Lexi how she feels. "I love life," she says.

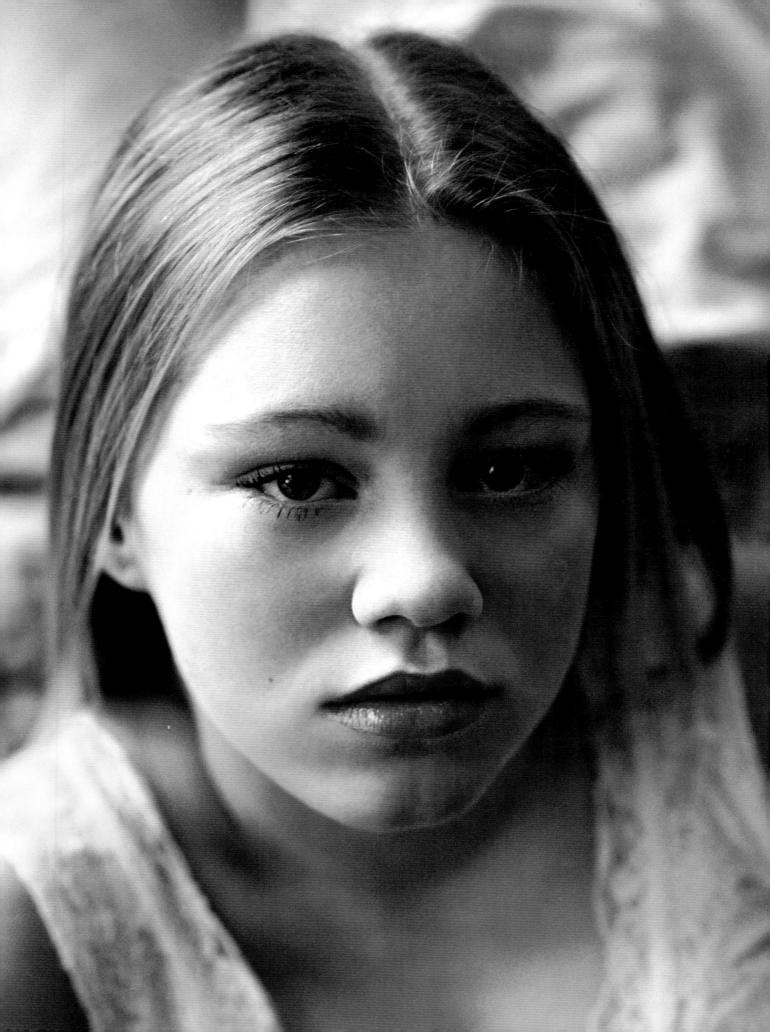

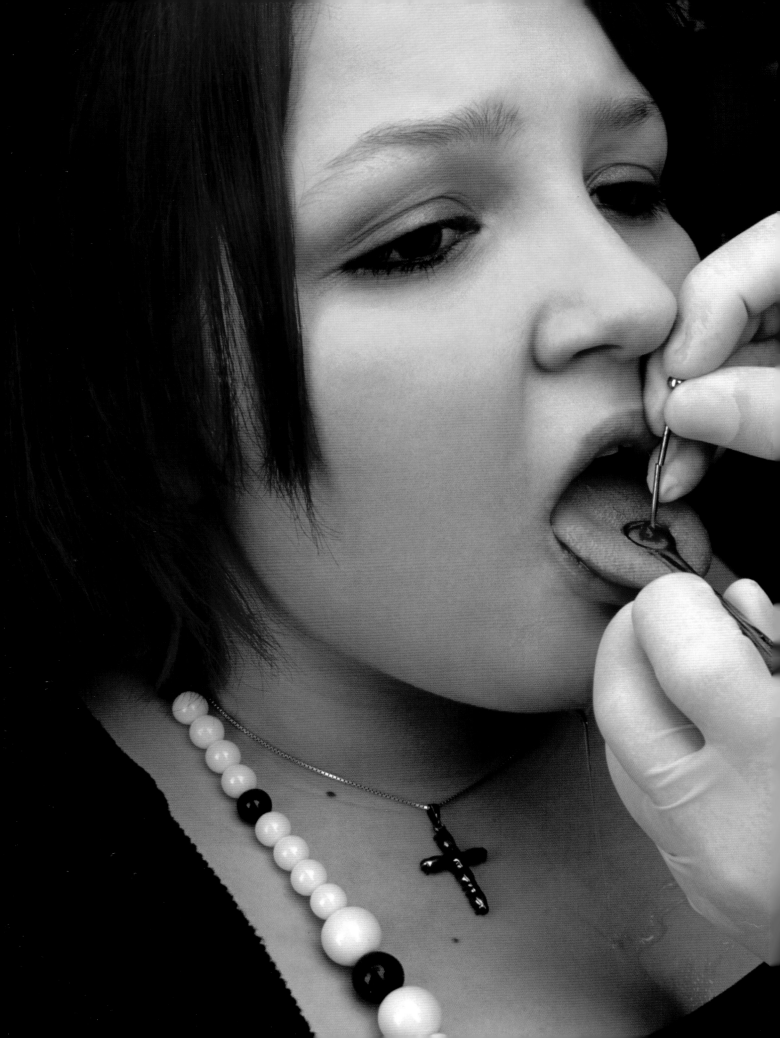

MARY

15★ OREGON

MARY IS SCARED.

She doesn't take her eyes off her boyfriend, Brandon, the whole time she's in the chair. The piercing room is surrounded by glass, and he's smiling at her from outside. Out in the waiting room, Mary's mom and little brother sit quietly reading magazines.

Mary's been planning to get her tongue pierced for a while. She used to have a "monroe" (a stud through the flesh between the upper lip and nose), but it got infected. Now she's ready for more.

For a while, she had bright pink hair too. Mary liked the reactions the neon hair got when she went out in public.

Basically, she just likes the attention. Her parents weren't always there to give her attention.

Mary's dad just got out of prison a few months ago. He was in for identity theft—getting credit cards in other people's names to buy drugs.

Both her parents used to do meth, and it pretty much tore apart their lives. Mary ended up in foster care with other family members for a while, till her mom got clean. In eighth grade, Mary moved back in with her mom, and there's been no sign of meth since then.

She says she's gotten really close with her mom in the past few months, and things are getting better. But she still struggles with depression.

Pretty much every night, Mary cuts into her arm with a razor blade. She cuts deep enough to bleed but not enough to cause serious damage.

She says she's had a lot of "stress and emotional stuff" in her life, and this is the only way she knows to get rid of it. "I feel better afterward."

Last year, her mom sent her to an "inpatient treatment facility" for 2 weeks to break her addiction to cutting. She says it was a horrible 14 days, and it didn't work. She ended up back at the same facility 3 months later, after she tried to take her own life.

Things had spiraled for Mary after she told her boyfriend she thought she was pregnant, and he responded by dumping her. She says all her friends liked him better, so they dumped her too.

So while she was waiting for the school bus one morning, she swallowed 35 Ritalin tablets. Her plan was to say goodbye to her remaining friends when she got to school. But she sat near this girl, Taylor, on the bus, and Taylor somehow knew what she'd done.

When the bus pulled up at school, Taylor found Mary's ex. Together, they dragged Mary to the school nurse.

The pills kicked in while the paramedics were wheeling Mary to the ambulance. The next thing she remembers is being in the ER with a ton of people around her yelling and moving fast.

Here in the piercing salon, it's finally time for the long hollow needle to go through Mary's tongue. Even with all Mary's been through, she seems terrified.

SHE DOESN'T LIKE NEEDLES.

The needle goes in. Some blood pools on her tongue. Within seconds, the piercer pushes a three-quarter inch bar through Mary's tongue, and it's all over.

"I feel good now," she says.

BEN
18★ NORTH DAKOTA

Ben just shot the wrong elk, and he's not happy about it.

We're at a 20-acre private hunting reserve in North Dakota. Ben can't hunt elk on public land anywhere in the state because he doesn't have an "elk tag"—a state-issued license to kill a single elk.

Here on the reserve, you don't need a tag, and you're guaranteed to leave with an animal. This takes away some of the thrill of the hunt, Ben says, but it's still fun.

It's 90 degrees and we're wearing long-sleeve thermal camouflage shirts so the animals won't see us. We just spent six hours on our stomachs, hiding in bushes and crawling through elk shit. Occasionally Ben would whisper, "They're coming," and cock his compound bow (like a crossbow but it shoots farther). Then they'd run off and we'd sink back into the bushes.

Suddenly Ben sees his animal and takes aim. He waited for her to get to the perfect spot, and he launched the bow. In the instant he shot, a much bigger elk ran between Ben and his target animal.

The bow plunged into the left hind quarter of a 750-pound male elk, far from any vital organs. Ben was paralyzed. For minutes, he couldn't speak. He sat and stared at the ground, and his prey ran off.

The problem is that you pick out your animal in advance, and they're all different prices. We'd selected a female elk for $1,000. When we arrived, the owner had pointed out his one prize specimen, a giant male elk worth $250,000. When Ben shot the wrong animal, he thought it might have been the quarter-million-dollar elk.

I persuade Ben to go talk to the owner of the reserve about what happened. The guy comes out with a pair of binoculars. He says it's not the prize elk. And it's still not down, so Ben needs to put another arrow in to end its suffering. The money will get worked out later.

It takes us another hour to get an arrow in the elk's lung. And two grueling hours watching it expire. The owner reassures us, "It don't feel nothin'."

"GENERALLY YOU WANT THE ANIMAL TO LAY DOWN AND EXPIRE. YOU WANT IT TO DIE PEACEFULLY."

Ben remembers the first time he killed an animal, when he was 7. He was running around the yard with a BB gun, shooting at blackbirds. After firing at a hundred of them, he got one right in the head, and it fell to the ground. Ben took it and ran back to his dad, who was proud and excited.

"It was a big step," Ben says.

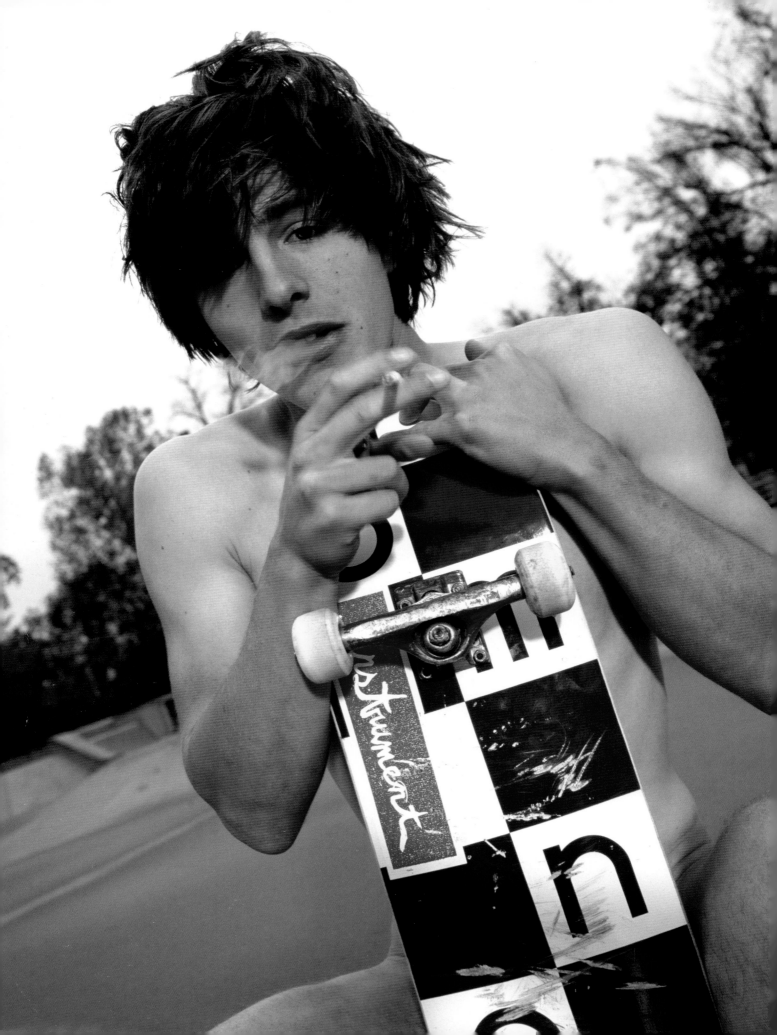

BROOKS
18 ★ KENTUCKY

Brooks is the guy at the party who keeps everyone laughing. He'll do anything on a dare, as long as it entertains people.

He will do anything to entertain us—smoking a cigarette through his nose, spitting in his hair, doing a handstand on his skateboard.

Within minutes, the hijinks escalate, and Brooks is standing on the freezing cement wearing only a skateboard. "I've lived here 18 years, and this is a first," he says. What's cool about this for Brooks is that it's illegal and spontaneous.

After three rolls of film and four cigarettes, we see the first sign of life in the park. A maintenance worker drives by in a pickup truck, with a clear view of Brooks's backside.

Five minutes later, as we're packing up the minivan, five of Kentucky's finest pull into the parking lot with their lights flashing. For the first time, Brooks is silent, as the officers approach us.

66 WE'VE HAD A REPORT OF INDECENT EXPOSURE HERE, 99 THE COP SAYS.

One cop takes our drivers' licenses to check for warrants while the others make friendly southern chitchat with us about the weather and which brand of Kentucky bourbon is smoothest. We tell them about our cross-country journey, and they gather around to hear our stories.

Brooks sits motionless on his skateboard and doesn't say a word.

A half hour later, we promise to send a signed copy of the book to the station house, and they all pull away.

Brooks seems shaken. "I guess I didn't have any warrants," he says.

I ask him if he gets in trouble a lot, and he says he used to be a "problem" kid—talking back to his parents and teachers and being angry at the world—but he's past that now.

"I guess I'm growing up," he says. "I just don't want to be a total fuckup. I need to get a good job, and I need to start finding girls that stimulate my mind and not just my penis."

For the last 9 years, he's spent most weekdays at his mom's house and weekends with his dad, and he's ready to get a place of his own. He says both his parents are great, caring people, but he needs his independence.

He wants to be able to skate when he wants to skate and play his bass as loud as he wants in the middle of the night.

"I'd love to be a pro skater or a rock star," he says, "but I gotta think realistically. Who knows, maybe I'll fall in love, get married, and decide I want to work in a bank for the rest of my life."

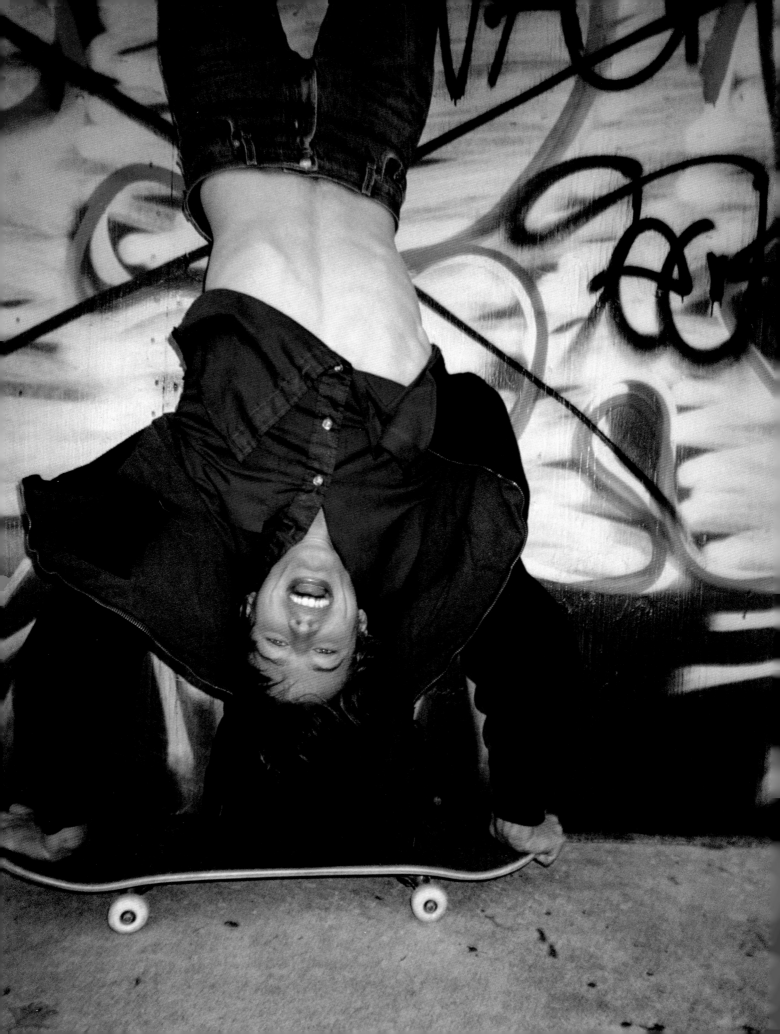

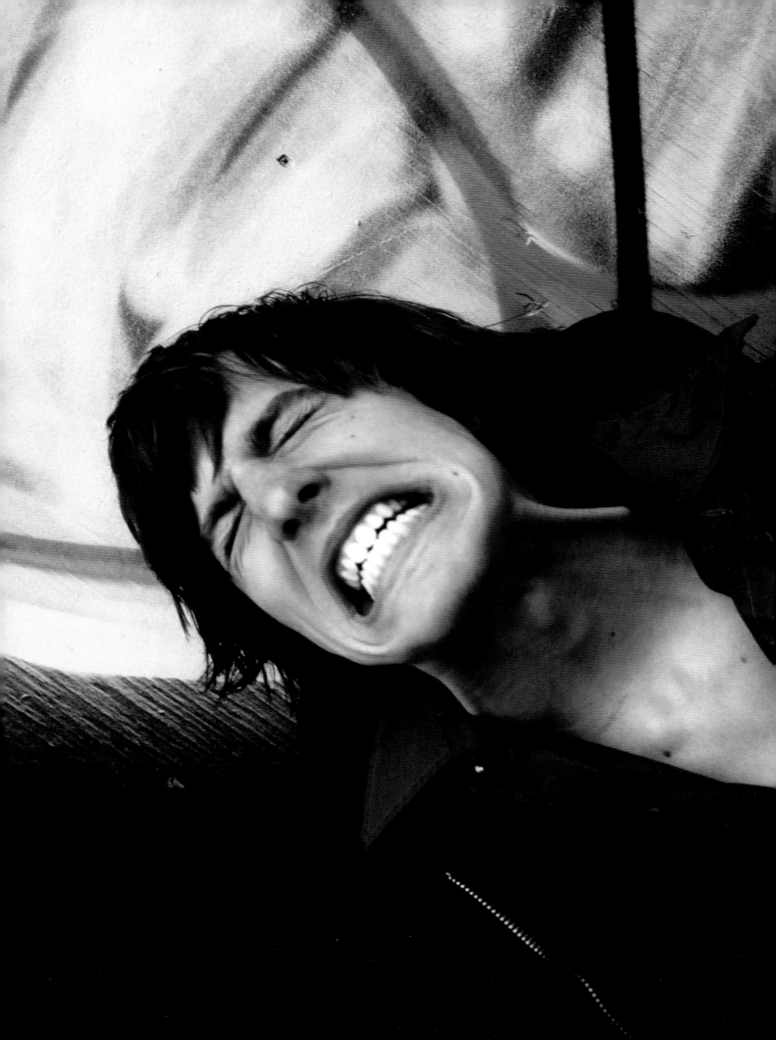

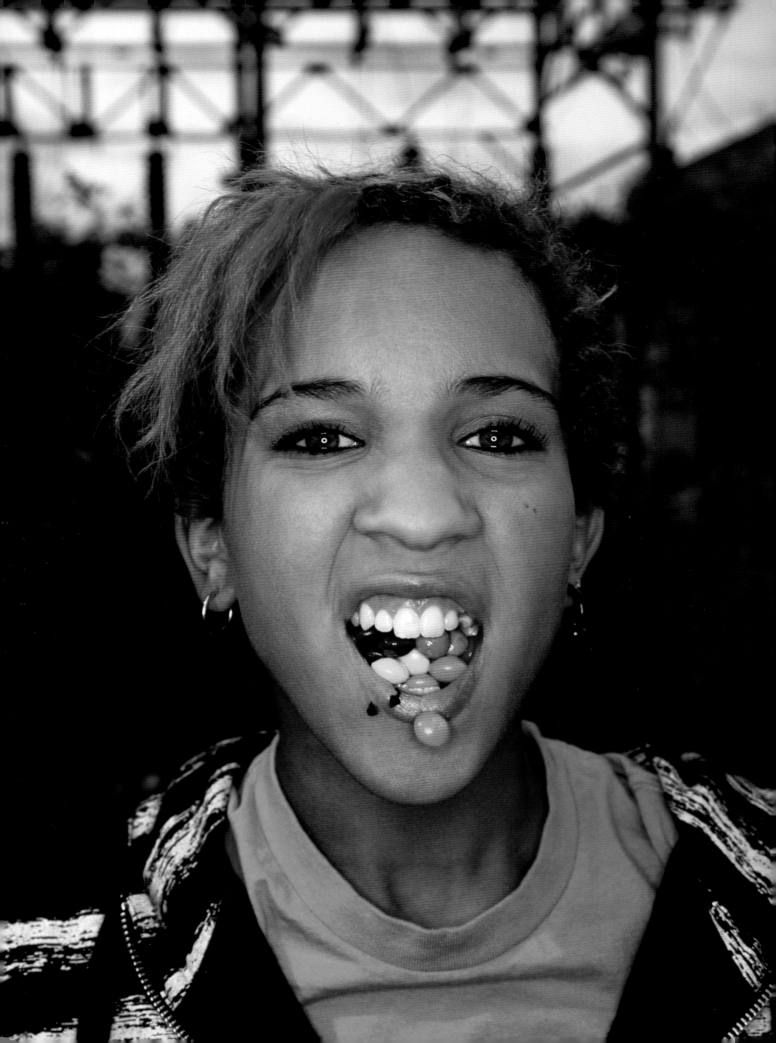

ANASTASIA
15 ★ VERMONT

"I'll talk to you about anything—sex, drugs, or any disgusting thing you can name."

"Do you know what a chili cheese-dog is?" she asks. "Not the food," she says. "It's a sex position." She starts to describe it, and I change the subject. (It has something to do with spitting between a girl's breasts.)

We're in the weeds between the skate park and the scary abandoned power plant on the shore of Lake Champlain, and Anastasia says she wants candy. Someone runs to the store, and we keep talking.

"People used to call me the horniest person they knew," she says. "I think I developed hormones before kids even knew what penises were."

When she was 11, Anastasia started getting her period, and she didn't know what it was. "I'd put toilet paper in my pants for 3 days a month," she says. "I didn't tell my mom for a year." She says her mom didn't believe it, so she took off her underwear and showed her.

"My mom was really scared about me using tampons. She probably thought I'd like the feeling of sticking something in my vagina."

Now she has sex with her boyfriend every morning before school, right after her mom leaves for work. "He's strong, he has blue eyes, and a really nice personality, and I can't breathe without him," she says.

Her dad grew up in Harlem and doesn't want his daughter to get in trouble with drugs or sex. Although he's African-American, Anastasia tells people that she's "one-eighth black."

"THIS IS VERMONT AND NO ONE HERE IS BLACK."

Her mom, boyfriend, and all 326 of her friends on MySpace are white, and she says race isn't really an issue in her life.

I ask what she looks for in a guy, and she says it starts with physical attraction, but it ends up being more about how understanding and caring they are—and how adventurous. "I mean, I don't wanna go to someone's house and just, like, hang out," she says.

Finally, the candy arrives, and I challenge her to eat a whole bag of M&Ms at once.

"No problem," she says. But her mouth isn't as big as she thinks it is. Candy and drool go everywhere, and Anastasia starts laughing and choking up half-eaten M&Ms.

Anastasia says people think of her as a tough girl, but she's not like that at all. "I'm just blunt," she says. "I'll say 'fuck you,' and then the next thing I'll say 'I love you.'"

She likes it when people call her crazy. "Not mental-institution crazy," she says. "Crazy like GG Allin." She means the late punk rocker who was famous for defecating on stage, throwing blood, and puking on the audience.

GG Allin died of a heroin overdose, and that's how Anastasia wants to go. But she doesn't want to die young. "I wanna get old," she says, "but I wanna be alive when I die."

Anastasia wants to live life at full throttle until it's over. "I want to overdose when I die, because you only die once."

KRYSTAL
18 ★ NEW JERSEY

"I WOULDN'T SAY I'M UGLY."

I'm trying to get her to tell me what she thinks about her appearance, and she's bashful. Eventually, she concedes that she thinks she's pretty. But she goes through phases of insecurity.

Krystal says she wasn't popular in high school and seems to mean it. At her public school in south Jersey, she knew the names of less than 100 of the 600 members of her senior class.

But they all knew her name. Krystal was both homecoming queen and prom queen.

After graduation, she won Miss Teen South Jersey, and the next day, she got signed by a modeling agency. I ask her if they've booked any work for her, and she says she's still in training.

Every other Sunday, she goes in for a day of classes at John Casablancas Modeling School. They teach her how to walk, talk, pose, and put on makeup. This sucks up one entire paycheck each month from her part-time job as a Sears cashier.

But Krystal has big dreams. She wants to be a household name, a supermodel. She loves the idea of being recognized by strangers, and she thinks it would be cool to be given everything for free.

In the meantime, she's hard at work on what she calls plan B, which is a degree in criminal justice and a career as a crime scene investigator.

She and her mom watch *CSI: Miami* together, and Krystal says it's just like her "criminalistics" class.

Krystal's family is her anchor. "We stick together, no matter what," she says. Everything we talk about ends up coming back to family.

All four grandparents were born in Puerto Rico, and she's proud of her heritage. Every Sunday, the entire family— sometimes 25 or 30 people— gets together for an 8:00 AM potluck breakfast. Krystal shows up in pajamas with pancakes and eggs, and she does her best to speak Spanish to her uncles and grandparents.

Krystal's ethnic identity is an issue for others around her. Recently at the Sears checkout, an old Puerto Rican woman told her it was shameful that she couldn't speak better Spanish.

In school, Krystal was known as "the Puerto Rican girl who looks like a white girl." All the other Hispanic kids wore Rocawear and Baby Phat, but Krystal wore Abercrombie and Aeropostale.

"Their attitude was hard-core, rough-edge, nobody-can-mess-with-them. They would say cuss words," she remembers. Krystal just didn't feel right saying those words. And she had no interest in partying, drinking, or smoking. Her grandfather built the first Pentecostal church in her town, and she still attends.

After she became prom queen, Krystal said she had a lot of "haters," girls who stopped liking her out of envy. But she's unaffected by them. She feels no anger.

More than an hour into our conversation, I realize that Krystal hasn't said anything negative at all. I ask if there's anything in the world that would upset her.

She thinks for a long time before answering. "Yes, one thing. To be separated from my family." And then another silence.

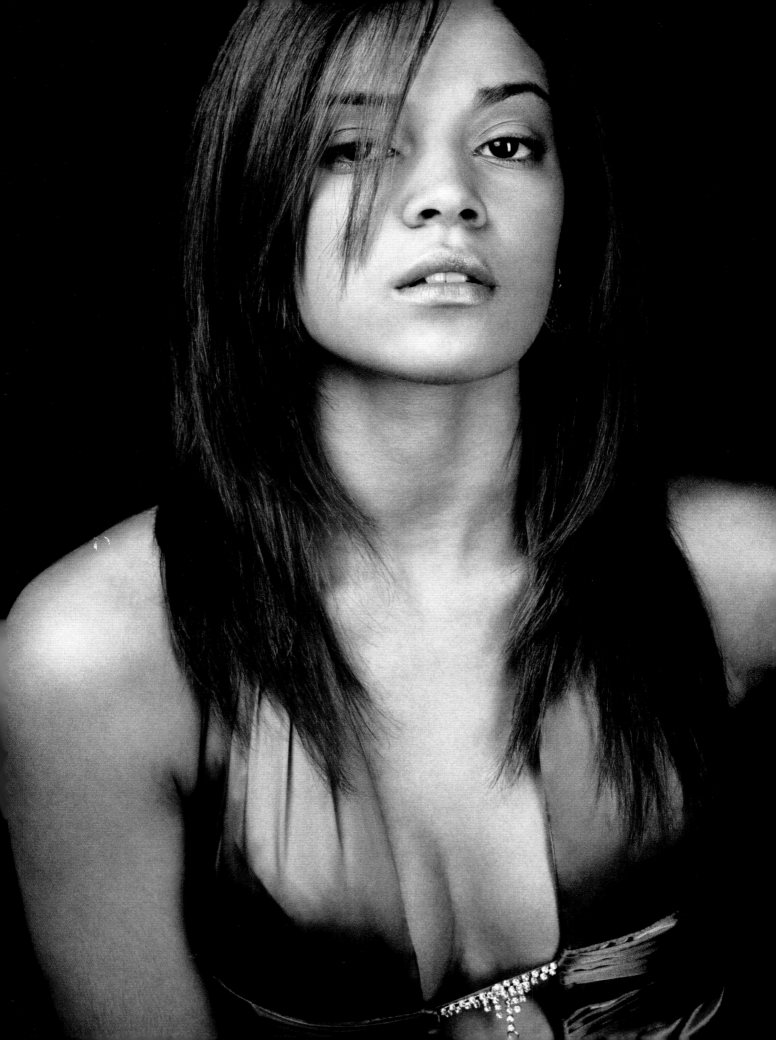

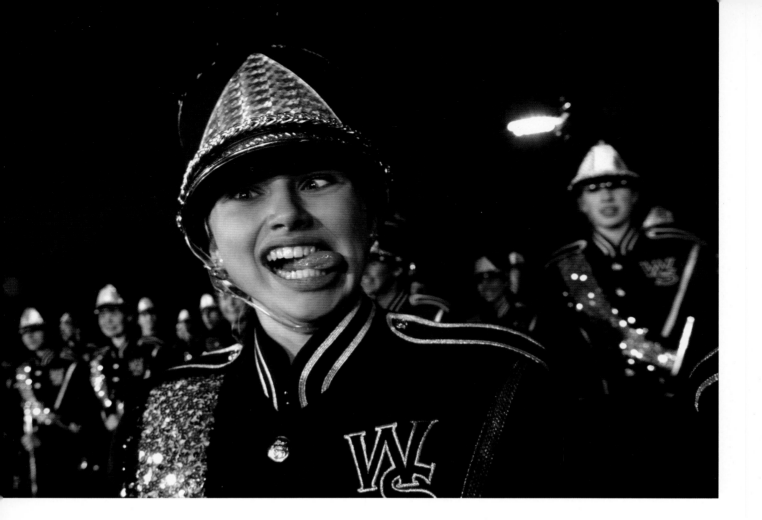

BRIELLE

14★ OREGON

❝I LIKE BEING CALLED A BAND GEEK.❞

Brielle says there are geeks in any group at school, and it's not a bad thing. "You see band geeks in cartoons with thick glasses and braces," she says. "We're not all like that."

Brielle admits there may be a kernel of truth in the caricatures of band geeks we see in movies like *American Pie*, and she feels sorry for the popular girls who agonize over their makeup and outfits every morning before school. Brielle's goal is to make people smile.

"I want people to see that I have a silly side, that I'm just a fun person," she says.

Photography is one of Brielle's many hobbies, and she doesn't like pictures of people who are trying to look perfect. She says they just seem uptight, and that's no fun.

Brielle says the best feeling in the world is being out there on the field at the end of a half-time performance, standing in final position.

"People are standing up and clapping, and you get a big smile on your face."

Brielle says she's not popular, but she gets along with absolutely everyone, including the popular people.

"I think we're all just people," she says. "Once you realize that, you can relax."

KELSEY

17 ★ TENNESSEE

KELSEY LIKES DRESSING UP LIKE PEOPLE DID 500 YEARS AGO.

As part of her school's madrigals group, she wears period costumes and performs sixteenth-century Christmas carols all over town—at old folks homes, company dinners, and country clubs.

Although Kelsey loves choir and theater, she's mainly focused on her schoolwork. She wants to go into international relations, or maybe become a senator.

Kelsey's GPA is 3.96. She hasn't forgiven herself for the one B in honors chemistry that stands between her and perfection.

She is driven to achieve in every aspect of her life. Kelsey is president of the student government, and she helps lead worship at the Church of Christ that she attends.

Her favorite place in the world is church camp, despite the old mattresses, nasty outhouses, and bugs everywhere. This is the one place she goes without her parents.

I ask how she feels about moving away from home to go to college next year.

"Nervous but excited," she says. With no madrigals, no student government, and no parents, she says, "It's going to be completely different than my life is now."

ROSS
17 ★ ALABAMA

Ross Wilson is the most famous high-school quarterback in America. And he just decided that he's done playing football forever.

For the past 2 years, Ross has been a reality-TV heartthrob for millions of teenage girls (and some guys) across America. The MTV reality show *Two-A-Days* chronicles the lives of football jocks at Hoover High, from the locker room to the bedroom. (Since the show airs on MTV, the focus is on the bedroom.) Ross is one of four stars of the show—the players that get the bulk of the screen time.

He's headed to the University of Alabama, where his older brother, John Parker Wilson, is the Crimson Tide quarterback. I ask Ross if his choice to give up football in favor of baseball has anything to do with his brother.

His answer is simple: "I like baseball more." Most of what Ross has to say is equally simple and direct.

Ross is hard to interview, because he has done many, many interviews. He denies that he's ever had media training, but he seems to know the safest answer to every possible question and reveals very little about himself.

Ross tries to be a good Christian in all aspects of his life. He doesn't drink, smoke, or cuss. He doesn't believe in sex before marriage (although oral sex is not sex). He values humility. And he believes it's important to get along with everyone.

When I ask Ross if he'd call himself a Republican or a Democrat, he says definitely a Republican but then quickly adds that he would vote for the best person for the job, no matter who they are.

Ross says he agrees with the war, explaining, "The average American has no idea what's going on over there." He goes on to tell me about the quarterback from another Alabama high school, Stephen Bicknell, who died when he drove a Humvee into an improvised explosive device in Baghdad a few months ago. Ross played against Stephen in the 2004 state championship. (Ross's team won.) He says the news hit him hard, even though he didn't know him off the field.

Football is not Ross' entire life. He excels at everything he does. He has a 3.6 GPA and will likely be offered millions to play pro baseball before this book comes out.

His dad played for the Red Sox for 3 years in the early 1980s; Ross hopes to make a career out of baseball and then move into business.

"I am a very competitive person," Ross tells me.

66 I DON'T LIKE TO LOSE. I DON'T LIKE TO FAIL. MY FAMILY INSTILLED THAT IN ME. 99

When he was younger, Ross would cry if his team lost in Little League. He says his dad didn't really say anything when that happened except to tell him to stop crying.

Ross says this made him work harder and do better at everything in life.

"It's a lot more fun when you win," he says.

LINDSEY
19 ★ TEXAS

The first time Lindsey crashed was 15 years ago.

She didn't want to ride her little baby blue bike with training wheels. Her older sister's big pink bike looked way more fun.

"Everyone told me it was too big for me," she says, "but I didn't care. I was going to ride it."

Her driveway was steep and Lindsey couldn't reach the brakes. She crashed hard into her playhouse. There was blood and crying, and her mom ran out of the house screaming. But Lindsey was proud of herself.

"I've always been confident," she says. "Even if I mess up, I'm still the best."

We're at a Formula Mazda race in Houston, and Lindsey's car is easy to spot. Out of a hundred cars, hers is the only pink one.

A lot of her competitors are what she calls "gentleman racers" who are just out for fun on a Saturday afternoon. For Lindsey this is just a step toward the Indy Racing League.

It's 100 degrees in the shade, and Lindsey is wearing an insulated racing suit and a heavy helmet. The race starts in a few minutes, and Lindsey is in the zone. She's quiet and focused. In just a few minutes, she'll be flying around the track at 140 miles per hour in a high-performance race car.

In her first race ever, a man passed her and spun out at the bottom of a blind corner. Lindsey managed to get around him, but she saw the crash in her rear-view. Another driver slammed into him and crushed his vital organs. She remembers his wife and kids screaming in agony.

Lindsey is a sixth-generation Dallasite and a third-generation racer.

When Lindsey was little, her dad raced motocross, and she'd spend hours with him behind the house working on his bikes. And she'd sit and watch car racing with him all the time.

In eighth grade, she finally persuaded her parents to get her a go-kart, and she was hooked by the end of her first race.

A lot of people tell her that racing is a guy's sport, but she shuts them out. She's been winning races for 5 years, and she's never raced a girl.

She has mixed feelings about the pink car.

❝ I DON'T WANT TO BE A GIRL DRIVER. I JUST WANT TO BE A DRIVER. ❞

But her godfather and sponsor, Dan Tomlin, convinced her that pink was the right choice.

The color has special meaning for Lindsey. Her mom has been battling breast cancer for years, and Lindsey travels around the country as a spokesperson for the National Breast Cancer Foundation.

"Racing and my mom's breast cancer are the two biggest things that affect my life," she says. Both of them are about overcoming challenges and succeeding, and that's the story of Lindsey's life.

"In a few years, you're gonna see me drinking the jar of milk at the Indy 500," she says.

The winner of the biggest car race in the world always drinks milk in the victory lane, and Lindsey has no doubt she'll make it there. She also has no doubt her mom will be there to see it happen.

"My mom is a survivor, and so am I."

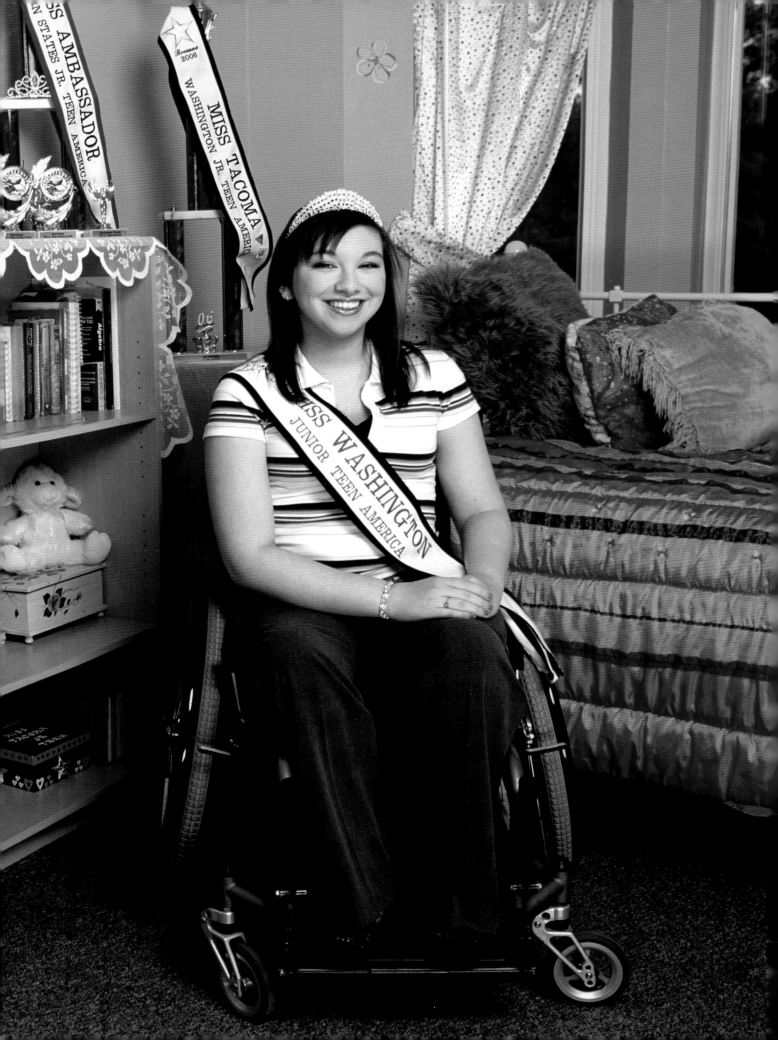

BREANNA

14 ★ WASHINGTON

It happened the same year that Christopher Reeve got thrown off his horse. Breanna was 3 years old. She was in the backseat. Her mom was driving, and her sister Amanda was riding shotgun.

A drunk driver swerved across the grassy median and hit their car head-on. Another driver ran through the pouring rain to pull Breanna out of the backseat.

She was bloody and limp. Two strangers lifted her onto a blanket. She had no pulse and wasn't breathing.

For 12 minutes, they gave her CPR. Just as the paramedics pulled up, she started to make slight whimpering sounds. A helicopter landed on the freeway and airlifted her to a trauma center 60 miles away.

Meanwhile, rescue workers used the Jaws of Life to remove her mom from the mangled car. Amanda had some bumps and bruises, but Breanna's mom lost her right eye, broke five bones, and suffered a brain injury.

FOR 8 DAYS, BOTH BREANNA AND HER MOM THOUGHT THE OTHER HAD DIED IN THE CRASH.

On her mom's MySpace page, she writes, "That night would prove to be the most horrific yet blessed event in our lives to come."

Breanna is now a giggly 14-year-old girl like any other. You can talk to her for hours, and if you don't mention the wheelchair, neither will she.

Mainly she wants to talk about beauty pageants, the color pink, and boys.

This year, Breanna won her first big pageant and was crowned Miss Washington in the Miss Junior Teen America competition.

Breanna has always wanted to be a beauty queen and a print model. And she doesn't see why her paralysis should get in the way.

Breanna's favorite thing to do is to go to the mall with her best friend, Chelsea. "Shopping is a sport," she says—and then laughs. Breanna laughs a lot.

Chelsea and Breanna are inseparable. "If there's something on the ground in front of my wheel, Chelsea kicks it out of the way," she says. "So I call her my 'legs.'"

When Chelsea was born, she had open-heart surgery, and her vocal cords were damaged. Now she can't talk very loud. "I yell things for her," Breanna says. "So she calls me her 'voice.'"

Breanna loves laughing and making other people laugh. She talks about the heavy stuff when she has to, but she'd rather think about how cool it would be to have a pocket pig—which she tells me is a new kind of pig the size of a Chihuahua.

Breanna says she thinks her parents are getting separated, but even that doesn't get to her.

"I love my dad, but I just wish he would stop drinking," she says. Breanna says she won't ever have a drop of alcohol in her life.

"Jesus is my homeboy," she says. Breanna calls herself a good Christian. And she knows that everything happens for a reason.

Breanna prays a lot. She prays for pocket pigs. She prays for her parents to get along. And she prays that someday she can have a little girl of her own. (The doctors say she will be able to have kids.)

"I want a girl really, really, really bad," she says, "so she can enter pageants and be a model."

MIKE
15 ★ IOWA

Last year, Mike's doctor told him his middle finger might stop growing if he didn't take a break from racing. He'd broken its growth plate during a race.

Mike ignored the doctor. All he wants to do is race motocross, and he's not going to let anyone stop him. "I mean, who's gonna be looking at your finger anyway?" He says it wouldn't be a big deal for one finger to be an inch shorter than the others.

" ASK ANY KID AT THE TRACK, AND THEY'LL TELL YOU ALL THE BONES THEY BROKE. I AIN'T SCARED. "

A lot of Mike's friends have quit the sport, because they've seen so many kids die on the track. Like this guy in Texas last year. Mike watched him flip his bike on a tabletop jump, launching him head first into the dirt. He died in the chopper on the way to the hospital.

"I know it could happen to me, but I'm not gonna let someone else's crash stop me. I'll take the chance."

Adrenaline is the reason Mike loves motocross. He feels it most right before the starting gate drops. "You're lined up with 42 different kids, and you're all going into one 20-foot-wide corner, and you're all just smashing in there. It's crazy."

But after the gate drops, Mike says it's all about fun and winning.

Mike tells me he's "almost" number one in Iowa, but that's because he's more focused on the national scene than his own state. He's done being "the little kid from some hick town in Iowa." He wants people to watch him winning races on TV, making millions.

Mike can't imagine having a regular job, like his dad does. He sees his dad go off in his brown uniform to deliver boxes all day, going where people tell him to go.

"That's not for me," Mike says. "I want to wake up every day and do what I love doing."

When Mike was a little kid, his dad raced with him. But then Mike started to get good, and his dad decided to give up his own bikes to focus on Mike's racing. "My dad has dedicated his life to helping me," he says.

His mom has never tried racing, but she studies the sport and coaches Mike. She'll be on the sideline, watching what the faster kids are doing. She says things like "Stay on the gas a little longer in the corner." And she's usually right.

"Motocross has made our family closer," Mike says. They drive thousands of miles a year in their RV, which is cool because the back half is a garage where Mike and his dad can work on his bikes.

When he's not racing, Mike is practicing. Pretty much every day his dad brings him here, to this sprawling backyard track on a friend's farm.

Usually his girlfriend, Madi, comes with him. "I like being seen with the hottest girl in school," he says. He hopes he can stay with her for a long time, but he says he's kind of a player, so he's not sure.

"Girls think motocross is really hot," he says.

Not that he's tempted by the "track whores"—the girls who hang out at the track to meet racers. "I don't know where they've been, and I don't want to know." He says they're dirty and he wants no part of them.

"Someday, I wanna have a beautiful wife and kids who race motocross," Mike says. "A bunch of little Mikeys riding around on their dirt bikes. That'll be sweet."

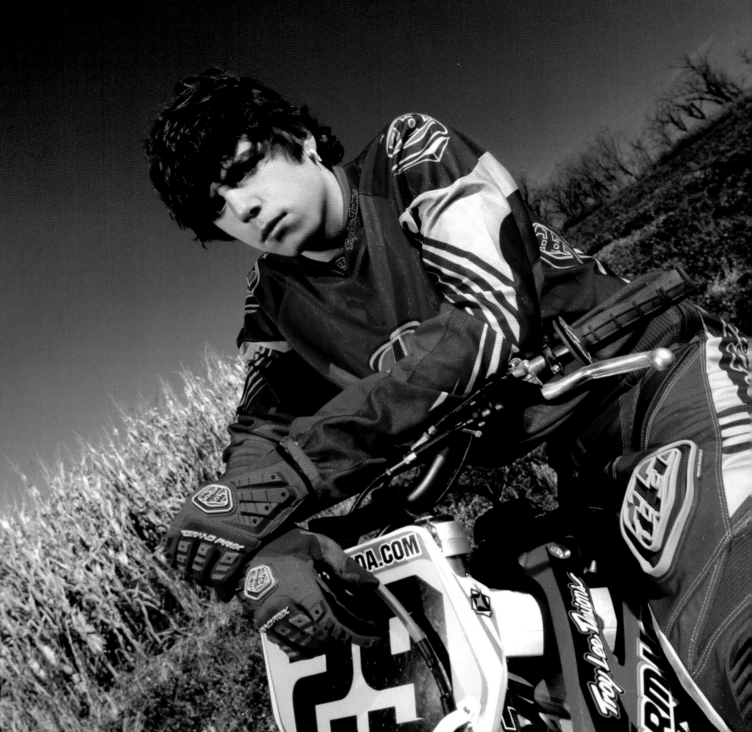

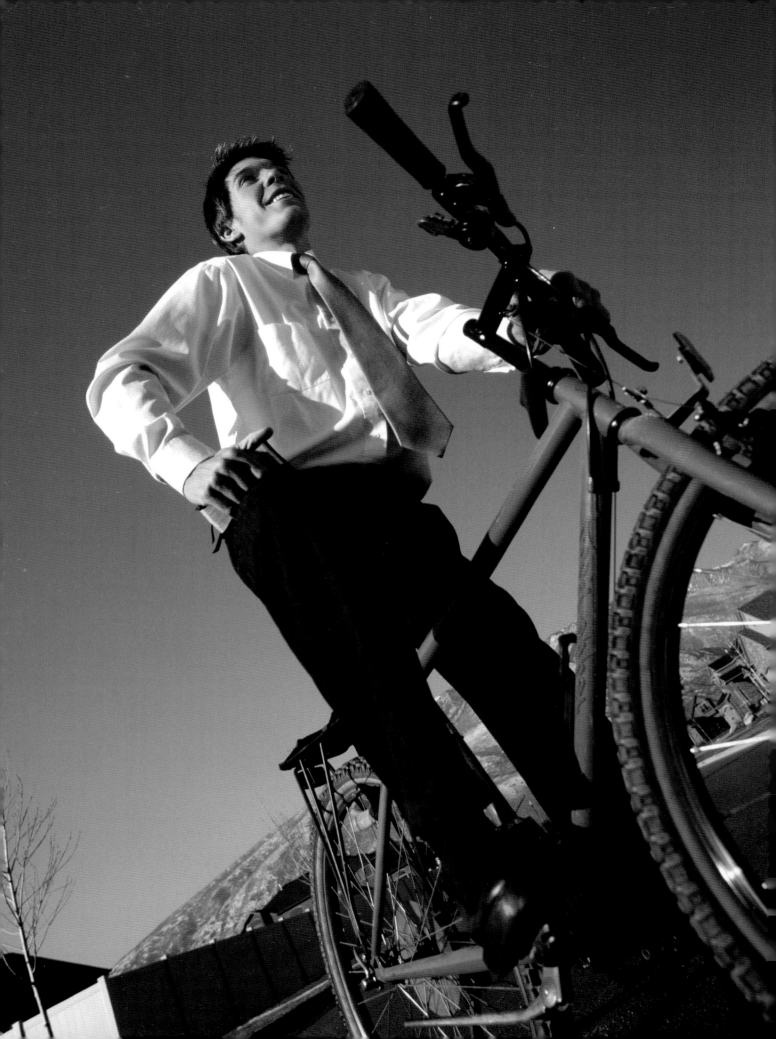

TRAPPER
17 ★ UTAH

> ## "WE DON'T PRACTICE POLYGAMY ANY MORE."

"That was like 150 years ago," he says.

Trapper is a member of the Church of Jesus Christ of Latter-day Saints. That's another way of saying he's a Mormon. But Trapper usually just says LDS.

"A lot of people have never met someone who is LDS," he says. "I've been asked if I have horns. And some people think I have lots of moms."

When I ask Trapper what it means to be Mormon, the first thing he tells me is that he can live with his family forever. He explains that he means after death, not after high school.

Trapper lives with his mom and stepdad, who are both devout Mormons.

He says his dad smokes cigarettes, drinks beer, and maybe once a year smokes marijuana. All of these are sins according to the Mormon Word of Wisdom (which, he explains, is "like the Ten Commandments, but way more detailed"). Every day, Trapper prays that his dad will return to the church so that they can be together forever.

Trapper admits that he does occasionally violate the Word of Wisdom. Sometimes, he'll break down and get a grande latte at Starbucks. And he will occasionally rebel against his mom and stepdad, even though the Bible says, "Obey your parents."

I ask for an example of his teenage rebellion, and Trapper tells me about sneaking out in the middle of the night to "power-box" rich people's houses. (Power-boxing means running through yards and pulling master breakers to cut off people's electricity.)

When he does things like this, he needs to repent, which sounds like it's mainly being sorry and praying a lot. But Trapper doesn't have to repent very much. He lives a clean life.

That means no sex before marriage and no masturbation. He's good with the ban on premarital sex (which includes oral sex), but like most Mormon teens, he struggles with the rule against self-pleasure.

Trapper goes on a lot of dates, with all kinds of girls—but he always follows the LDS rules, even if the girl isn't Mormon.

When he's 19, Trapper will be ordained as an elder in the church. This means that he gets his "garment"—sacred underwear he'll wear for the rest of his life (except bathing, swimming, working out, and having sex).

And if the bishop thinks he's worthy, he'll get to go on a mission, which means he'll "spend 2 years riding around on a bicycle trying to find people who will read the Book of Mormon and get baptized."

Eventually, Trapper hopes to make it to the celestial kingdom, which he says is the best part of heaven. In the meantime, he'll spend his days skiing, skateboarding, hanging out with friends, and praying.

"I know where I want to go," he says, "but first I want to live my life on earth."

ELLENORE
16★ NEW YORK

NO ONE DANCES ON THE TABLES IN THE CAFETERIA AT ELLENORE'S HIGH SCHOOL IN MIDTOWN MANHATTAN.

A decade before Ellenore was born, the movie *Fame* made her school famous.

Back in 1980, it was called the High School for the Performing Arts. Now it's called LaGuardia High. Every year, 300 14-year-olds audition for the dance program there, and 60 get in.

Ellenore lives to dance. Every day, she dances for hours at school then trains all afternoon at Alvin Ailey, the city's most famous dance academy.

The dance clique in Ellenore's class has a language all its own. "When we walk up to each other in the hallway, we all go 'Oh eight!' and make a zero with our arms, then curve them to make an eight." (She is in the class of 2008). "If someone does something really well during dance class, we have phrases we say like 'work!' or 'eat!'"

"When I was 3, my parents put me into ballet," she tells me. "At the first performance, I was the little girl in the corner of the stage pulling the wedgie out of her tutu."

Her mom gave her a hug and said maybe dance wasn't for her. Five years later, Ellenore gave it a second try, and she fell in love.

Here in Central Park for our photo shoot, we see a bicycle taxi, and Ellenore tells me she's never ridden one. Ten minutes later (and $10 to the driver), we've got our lights set up, and Ellenore climbs on.

She's on top of the world.

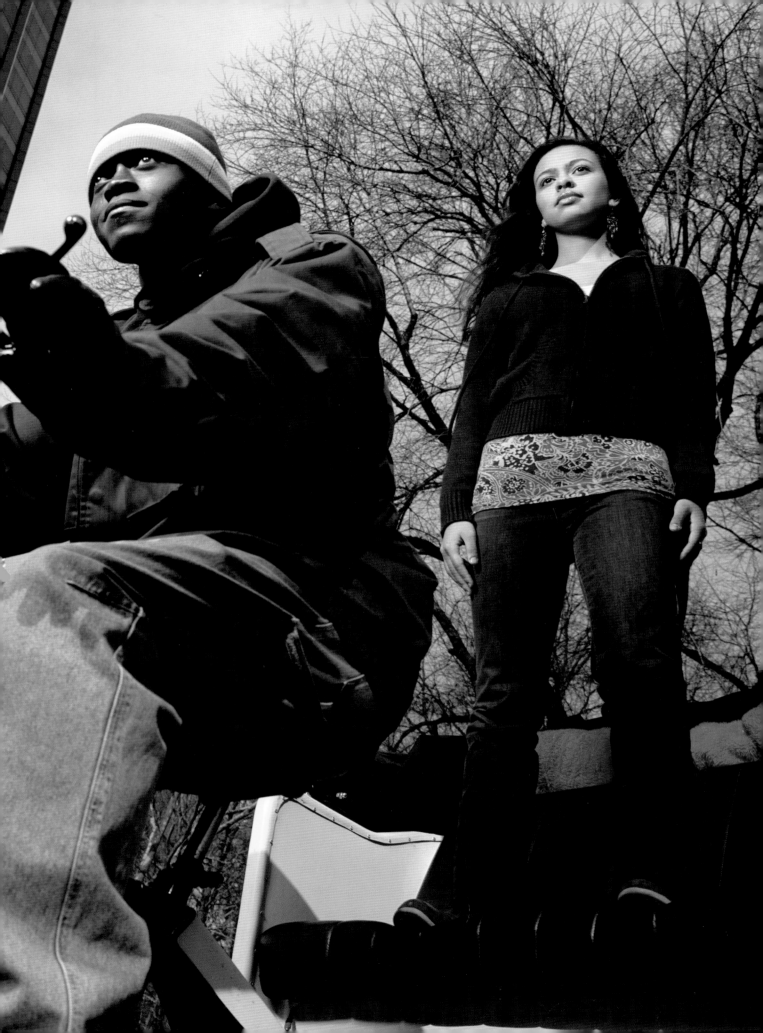

CALVIN
17 ★ IOWA

The worst-smelling place in America—at least of the places I've been—is on this farm. It's called a swine house and 100 fat pigs live here in cages that are too small for them to turn around in.

We're on a family farm in the middle of Iowa. Calvin, his parents, and his brothers all work here.

Calvin wakes up early every morning and feeds the pigs. He comes home after school and cleans up after them. And when they reach 250 pounds, he takes them to the slaughterhouse.

Calvin's older brother is in charge of the 1,500 head of beef cattle, including several hundred packed into a small feedlot, where they stand in one spot and eat all day.

THIS IS WHERE THE MEAT GETS " JUICY. "

Calvin has done pretty much every job on the farm, including driving a combine to harvest the corn they feed the cattle. None of us have ever seen a combine up close, and he's happy to show it off.

We naively set up our equipment on the edge of the cornfield and prepare to photograph Calvin as he drives by. We have no idea what we're in for.

The giant machine churns up a massive cloud of dust and launches hundreds of hard chunks of cornstalk at us and our equipment. We run for cover and wait for the barrage to stop.

Finally the combine is in the perfect spot. We're upwind of the swine house, and the sun is touching the horizon. And we get our picture.

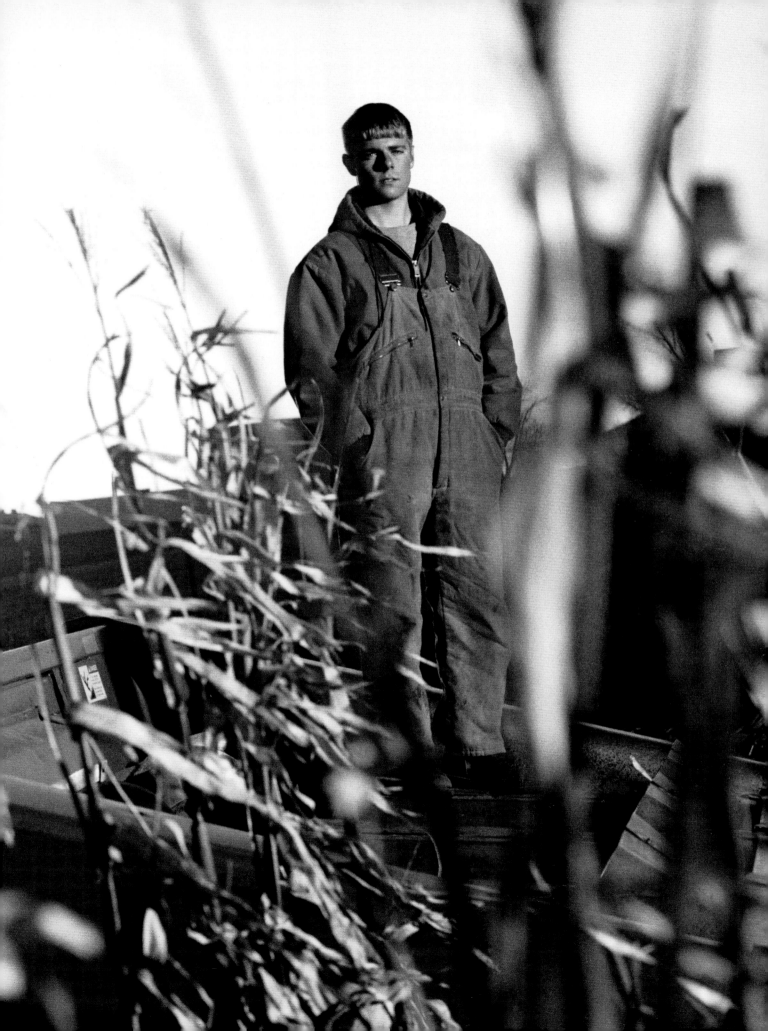

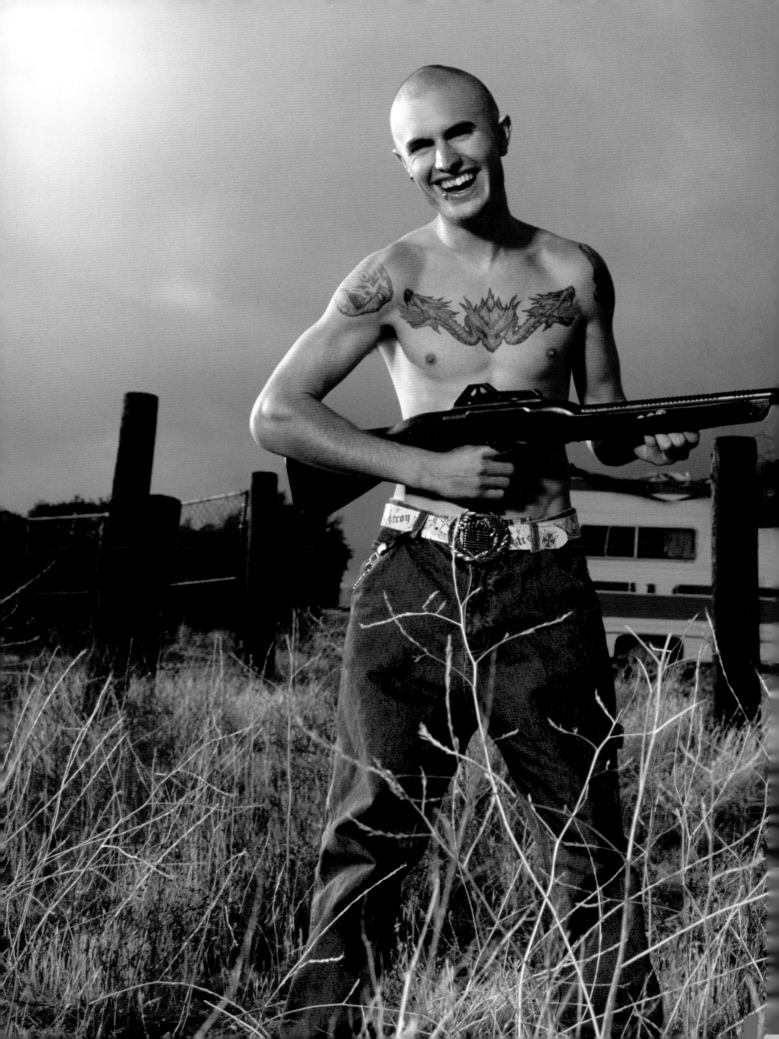

JON

19 ★ CALIFORNIA

JON IS WAITING FOR THE RACIAL HOLY WAR TO BEGIN.

"It pisses me off, because the white people are disappearing. We're going to be extinct because of all the racial mixing and shit."

We're interviewing him in his room, which is really a trailer about 50 feet from the one his grandparents occupy on a patch of desert in southern California.

On his floor, I notice a hockey mask with a swastika on it. "That's just something I made," he tells me.

He's happy to put it on and pose. He continues chain-smoking, as he has been all day.

His grandma chooses this moment to amble over and say, in the nicest possible tone, "You ain't gonna make him out to be some kind of racist, are you?"

Racist is exactly the word Jon uses to describe himself, and he does so without shame. It started when he was 13, in Riverside. He got jumped, punched, kicked, and shot at, all the time, he tells me—and never by a white person.

"I consider myself racist because I don't like most people that aren't white. I mean, I can respect anyone who has respect for me. But my main thing is the survival of the white race."

In his tone and delivery, Jon comes across as quiet and thoughtful. It's almost impossible to believe he means the words he's saying.

"We need to close the borders, stop letting people into this country. Soon there are gonna be more Mexicans in California than white people. I heard they're gonna change the state language to Spanish. That's not right."

Two hours into our photo shoot, Jon's grandpa stumbles out the door and starts yelling at us. "Get the fuck off my property right now or I'm gonna go get my rifle!" Jon says he's a bipolar asshole and we'd better go. He grabs his own gun and some bullets before we jump in our car and pull away.

We go to Jon's favorite spot to shoot, and he's excited that we all want to take turns firing his gun into the dirt hill. The distance from his grandfather makes him noticeably calmer.

Jon's had trouble at home as long as he can remember.

When he was little, his stepdad would kick him and hit him a lot. And Jon would always see him throwing shit at his mom. When this happened, Jon went into his room, closed his door, and sat quietly.

His whole family tells him he's a freak and an outcast. It's his appearance they have a problem with, not his ideas. They're not fans of the tattoos and piercings.

"Pretty much my whole life, they've made me feel like a piece of shit."

Once when he was 8, he put a belt around his neck, tied it to the top of his bunk bed, and jumped off. Both the belt and the bed frame broke. Jon survived.

Now Jon shakes his head and says, quietly, "I just gotta move away from here before I do something stupid and fuck up my life."

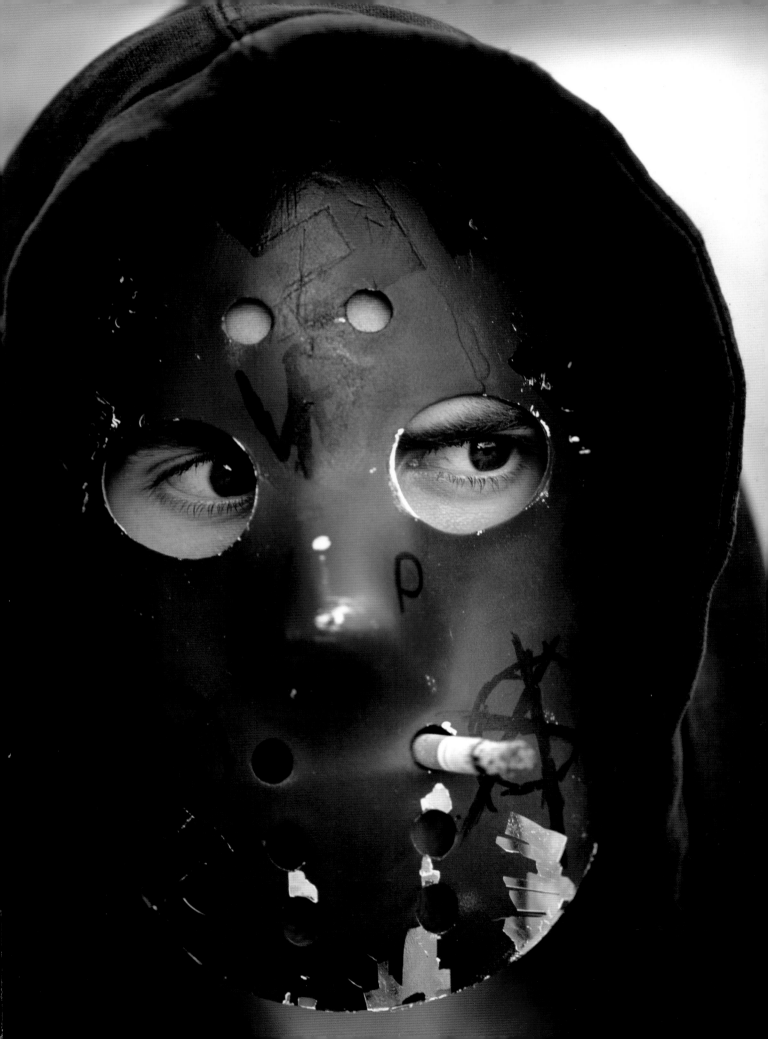

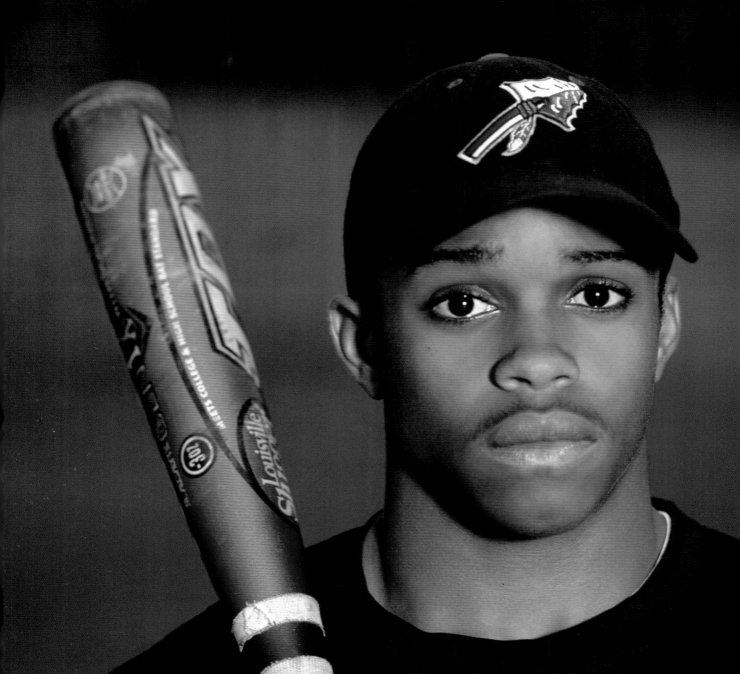

DELINO
14★ GEORGIA

His last name is DeShields. Google "Delino DeShields" and you'll find a lot of articles about a star baseball player, most of which refer to his dad, the famous second baseman. But some refer to Delino Junior.

Two years ago, *Baseball America* magazine called him the best athlete in his age group. The article quoted a scout as saying, "He is one of the strongest 12-year-olds I've ever seen, and he is the fastest."

When I ask him if he wants to follow in his dad's footsteps, he says, "I want to do better than him."

Delino sees his dad every weekend for baseball practice, and he stays with him every other weekend. The rest of the time, he lives in a small house in "the bad part of town" along with his mom, grandma, aunt, sister, and two brothers.

DELINO USED TO LIVE IN A MANSION ON THE LAKE.

It had a batting cage, a playground, a pool, a trophy room, a private dock, and a barber shop where his dad used to cut his hair. Now he lives in a house so cramped he can't even have friends over.

He says it's okay, because he's not home much. He attends an exclusive private academy, and he's the only freshman on the varsity baseball team.

Practice ends at 6:00, and then he makes himself a bowl of ramen, takes a bath, does a little homework, and crashes.

Delino is angry at his dad. Two years ago, he heard his parents having a loud argument. His dad moved out that night.

"He could have done better if he had just focused on baseball more," he says, "instead of women and stuff." He tells me this is why things didn't work out with his mom.

(He still won't talk to his dad's girlfriend. He says she broke up his parents' marriage, and he's not ready to forgive her for that.)

Delino and his mom continued to live in the mansion with the barber shop for another year after the breakup. But then his dad didn't want to pay for it any more, so they had to move. (Delino's dad also lives in a much more modest house now.)

I ask if he has any happy memories of life with his dad, and he tells me all about traveling around the country and watching with his mom from the clubhouse while his dad ran the bases.

Now his dad is working on making Delino a better player. "He's a good coach," Delino says, "but he's really hard on me." If Delino does something like swing at a bad pitch, he can't bear to look at his father, who just shakes his head and looks at the ground.

Delino hopes to get drafted right out of high school, and he'd like to get a World Series ring someday—and enough money to buy a house like the one he grew up in.

PARSON

18 ★ DELAWARE

A lot has happened to Parson in the 2 months after this picture was taken. Most of it is a blur to him.

Days after our shoot, he quit his job at the Hot Topic store in the mall, and for 2 weeks, locked himself in his basement bedroom, avoiding his parents as much as he could.

"I just had to take a little break in my life," he explains.

THEN HE SLASHED HIS WRISTS AND TOOK ENOUGH COUGH MEDICINE TO STOP HIS HEART.

He says his parents seemed disappointed in him when they came to visit him in the heart ward after his suicide attempt. "They were looking at me like, 'Why did you do this to us?'"

Parson describes his parents as middle-class and snobby. His dad is a management consultant and is never home. He flies all over the country giving group therapy to coworkers so they can get along better.

His mom does something with libraries in Philly, an hour away. Their own days of hard drugs are over, he thinks. But they still smoke plenty of weed. He and his dad have been talking about getting a dime bag together and smoking out, just father and son. That'd be cool, he says, but weed is not his favorite drug.

Parson likes taking cough medicine. A lot of cough medicine. He and his friends call it Robotripping, because you drink a whole bottle of Robitussin and you hallucinate. He's done it maybe a thousand times, and it takes him a lot to get high now.

The first time Parson Robotripped, he was in the mall. At first, he thought he was fine but then found himself on the down escalator with his hand over his mouth, vomit spraying through his fingers on the people coming up the other side. His friend Joe drove him away before security could catch up.

When Parson was killing himself, he drank a bottle of Everclear mixed with fruit punch and 60 triple-Cs, the potent cough suppressant capsules Parson favors over liquid Robitussin. (According to Parson, 50 is enough to stop your heart.)

I ask him which way he cut his wrists and he sounds indignant: "*Lengthwise.*" As if I thought he didn't know how to do it.

Then he drove to the mall to say goodbye to his friends. They were too high to notice the blood gushing from his wrists onto the floor.

They decided to pile into a car to drive to the parking lot behind Starbucks, so they could smoke some more weed and hide their drugs before calling an ambulance.

Joe, the same driver as last time, was Parson's boyfriend. But Parson's not gay; he's just "open." He also has a girlfriend, and he says that everyone his age makes out with everyone, and it doesn't really matter guy or girl. He definitely likes sex with girls better and thinks he might get married someday but doesn't sound like he believes himself when he says that.

After the doctors stitched up his wrists and pumped his stomach at the hospital, they put him in a bed and let him have ice cream. "That was cool."

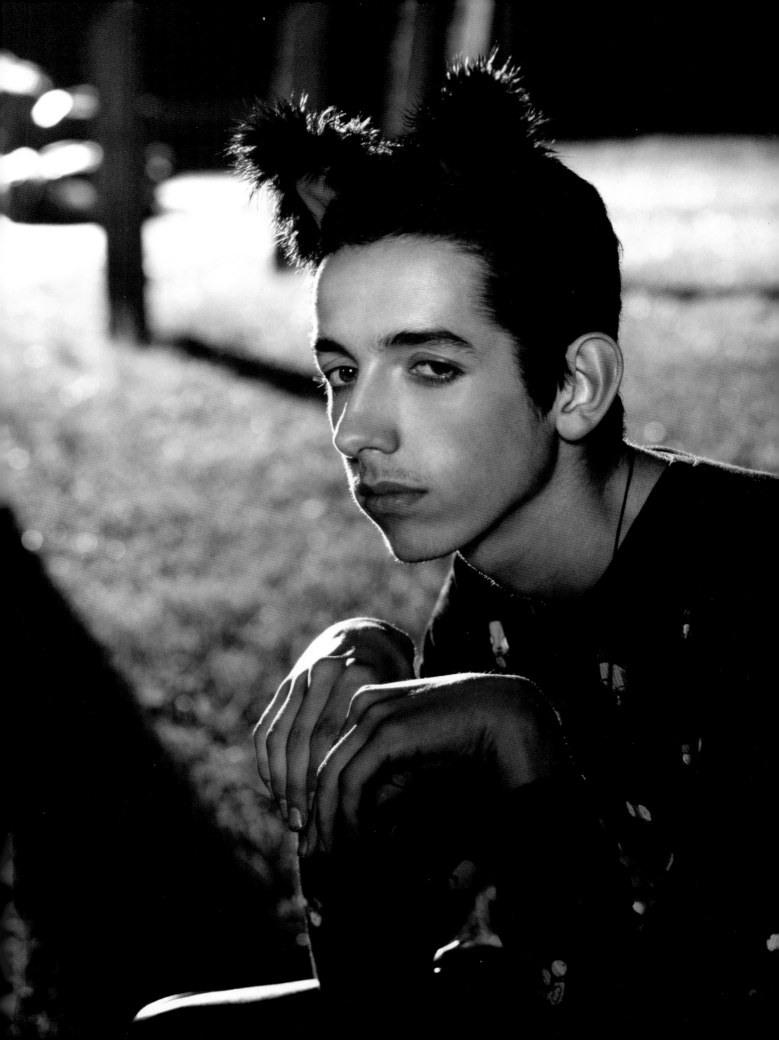

BROCK

17 ★ LOUISIANA

"It's not hard to kill an alligator," Brock says.

66 YOU PUT YOUR BOOT ON THEIR NOSE, HOLD THEM BY THE TAIL, AND STICK A KNIFE IN BEHIND THE HEAD. THEY'RE DEAD INSTANTLY. 99

We're on an alligator farm on Forked (pronounced *fork*-id) Island, and he's explaining the process for catching, killing, and skinning alligators.

Brock thinks it's funny that we have so many alligator questions for him. This is just a minimum-wage summer job—and not a great one.

All the country people at school have summer jobs like this. Brock isn't sure what the city people do for the summer. These are the two main groups at school, and, although everyone gets along, there's not a lot of mixing.

Here, the word *city* refers to a nearby town with a population of 5,000 and a median household income of $22,000. He says city boys spend more on clothes and are likely to wear baggy pants, while the country boys just wear "regular jeans and boots." City people like more hip-hop, and country people, naturally, like country.

On the alligator farm, they listen to a country music station while they're working. And they spend a lot of hours working.

Dozens of small, round white buildings are arranged in rows next to the swamp. Brock takes us inside one. It's like a steam room filled with putrid fish.

He wades into the water, and 300 alligators swim for their lives. They know Brock is their grim reaper. He grabs one by the tail and the head and holds the mouth closed while a worker wraps electrical tape around it.

The killing starts at 1:00 AM, he says. He and a few other guys go in the day before and tape all the mouths shut, so all they have to do in the morning is pull the gators out and pile them in a bin.

Once they kill their morning quota of 1,000, it's break time. This is usually around 6:00 AM, and the sun is just coming up. Time for breakfast: some homemade boudin and a carton of milk. Pronounced *boo*-danh, it's sausage filled with rice and pork—including the heart, liver, and blood.

Brock and 10 other people work the rest of the day—about 16 more hours—in the skinning shed, where they use an air gun to blow the alligator up like a balloon so they can cut the skin off. People take different jobs every day: skinning, gutting, cleaning, and packing.

With every question I ask, Brock seems more bemused. We do, after all, live in the same world. Brock has a MySpace page, although he rarely touches it. And he uses a cell phone all the time and sends instant messages to his friends.

But life is pretty simple for him. I ask if he ever worries about money, and he says his pickup truck is paid for, so he doesn't have to worry.

He says he doesn't think too much about the future. Maybe he'll work as a welder on the pipeline, like his brothers.

But that's the future, and Brock lives in the present.

50% ALLIGATOR FOOD

INGREDIENTS

Poultry by-product meal, ground yellow corn, flash dried blood meal, fish meal, animal fat (preserved with BHA, BHT, and citric acid), soybean meal, corn gluten meal, potassium chloride, dicalcium phosphate, salt, vitamin A supplement, vitamin D3 supplement, vitamin E supplement, vitamin B12 supplement, L-asocrbyl-2-polyphosphate (source of vitamin C), riboflavin supplement, dl-methionine, niacin, calcium pantothenate, choline chloride, menadione sodium bisulfite complex (source of vitamin K activity), folic acid, biotin, thiamine mononitrate, pyridoxine hydrochloride, sodium selenite, calcium iodate, ferrous sulfate, manganese sulfate, zinc sulfate, copper sulfate.

...ed with other animal protein sources such as ...s. Monitor the amount fed carefully. Excess feed ...e water. ...en fully documented. The National Academy of ...ient Requirements of Alligators". Texas Farm ...tritional adequacy or results which may be

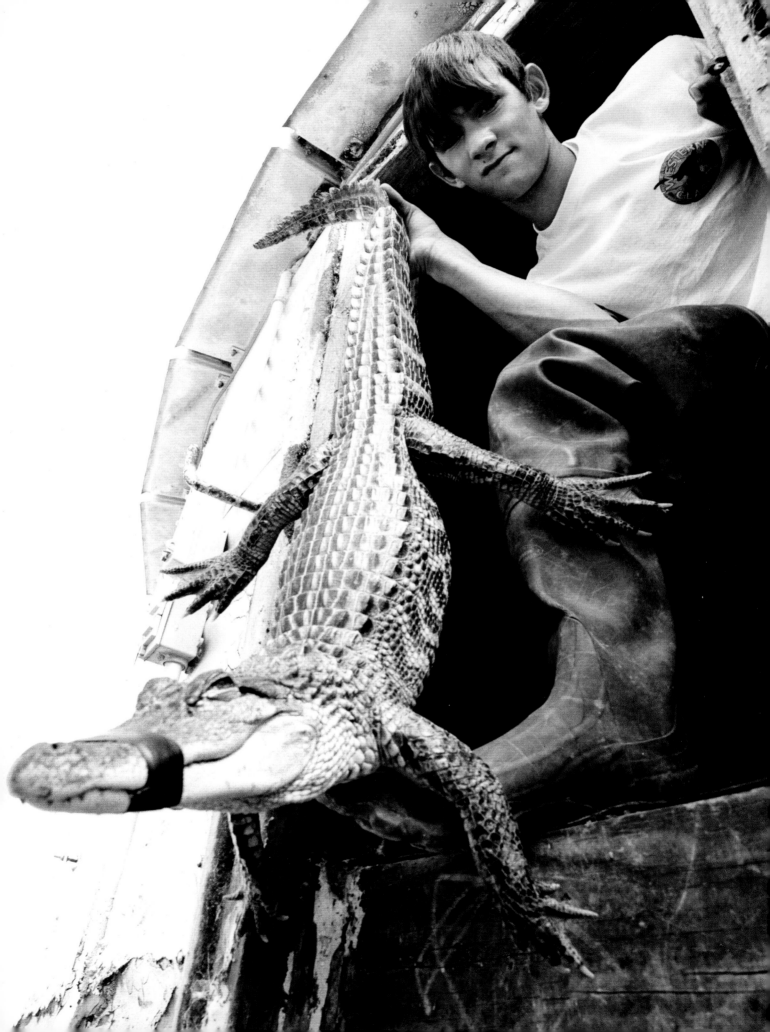

ALISON
14★ MINNESOTA

When Alison was 6, she went over to a friend's house and was shocked to see a basketball court in the backyard. "I thought that was so weird," she says.

"I ASKED WHY THERE WAS NO LAKE IN HER BACKYARD."

We're loading up the ski boat behind Alison's house, and her little brother is zipping off in a tiny motorboat to go visit a friend across the lake.

Alison always thought life was like this for everyone, but now she knows how good she has it. Her favorite place in the world is here in the water behind her house.

Alison's dad is a dentist, and at age 57, he still water skis competitively. Today he rushes home from work to help Alison train for slalom racing and jumping.

He drives the boat and coaches Alison on her style. The lake is 4 miles around, and she needs a break after 6 laps. Now, she's ready to jump.

The ramp at the far end of the lake is Alison's. She puts on a full-face helmet and gets ready to take the jump. Her dad circles the boat and drags her up the ramp. She loves the way it feels when she hits it just right.

Alison says she wouldn't change anything about her life. She knows she's going to look back on these years as the best ones of her life.

"I love being a kid."

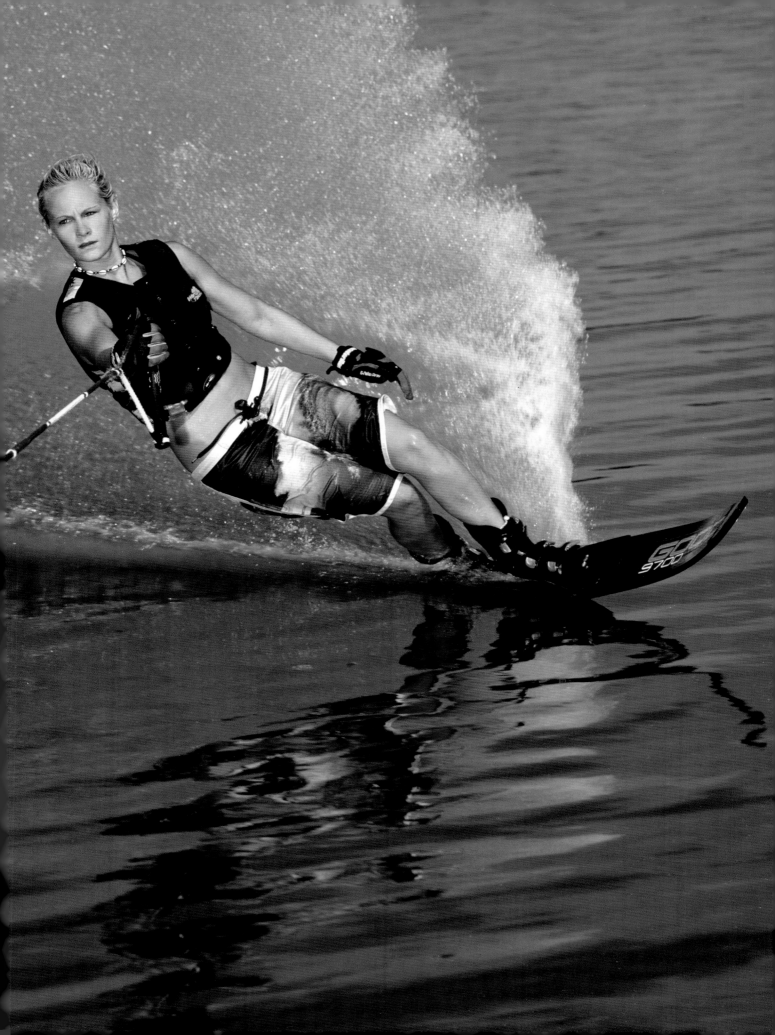

JOSH
16 ★ PENNSYLVANIA

"Wake up, school, work, ride, food, sleep."

This is Josh's life. He says there's nothing else to do in this small town but ride bikes, and he doesn't know why the cops hate all the bikers.

We're in a deserted alley in an industrial part of town, and nine teenagers are laying scraps of soggy plywood into a makeshift half-pipe up against a giant oak tree.

Josh says this is a good spot because the cops never drive down this alley.

A minute later, a police car pulls up. The cop wears mirrored aviator sunglasses and has a giant moustache. He just sits and stares.

66 WHY THE HELL CAN'T THEY LEAVE US ALONE? 99

We approach the cop, and he tells us we're all trespassing, and he'll give us 10 minutes to take the ramp apart and get out of here.

Usually, they just get out of their car and start writing tickets. Josh has collected 9 tickets in 2 years, and they run 130 bucks a pop. He says his parents pay, because they think it's bullshit that there's nowhere for kids to ride their bikes in town.

In most places, cops hate skaters, but not here. Skaters and BMXers ride the same parking lot, and the kids on bikes will get tickets and the skaters won't.

Josh says no one can stop him from riding. He and his friends just find another spot—usually a set of stairs where they'll take turns sliding down the handrail on their pegs.

Josh is an only child, which he says is cool because it means he gets more stuff. His first BMX bike appeared under the Christmas tree when he was 8, and motocross bikes came two years later.

For 4 years, Josh raced motocross, until he collapsed one day in woodshop. He woke up twitching on the floor with the whole class gathered around him.

He says migraines run in his family, and he got a bad one that gave him a grand mal seizure. The doctors said it could happen on a motorcycle, so he had to stop racing.

Around the same time, a friend died in a head-on dirt-bike collision, and BMX started looking like a better idea. He says it's not hard to get the same rush on a little bicycle, like when you fly 20 feet in the air off a dirt jump in the woods.

Josh likes school and gets all As and Bs, but he says he's just starting to think about the future. His dream is to be a BMX pro, but he figures he'll go to culinary school if that doesn't work out.

Ten years from now, he sees himself living in the same town, with a good wife and a job as a chef. I ask if he thinks he'll still be riding then.

"Hell yeah," he says. "BMX is in my blood."

SPENCER

14★ HAWAII

We're in the most beautiful place in America, trying to convince five "grommets" to get in the back of a pickup truck.

A grommet is a kid who lives, eats, and breathes surfing, and these kids are all grommets. All of them are homeschooled so they can go out surfing whenever the waves are good. On a typical day, they'll surf six or eight hours and maybe spend a couple of hours online doing schoolwork.

Today was a good day for waves. Now the sun is setting and a dozen of them are on their skateboards, crisscrossing a wooden half-pipe in a lush tropical backyard in Kauai.

Grommet conversation is 80% surfing and 20% girls, although most of them are way too busy surfing to have girlfriends. Mainly they talk about where the best waves were today, and who "dropped in" on whom. (Dropping in means stealing someone else's wave, and it's a serious crime.)

The other day, Spencer rolled under a wave and smashed his legs on the coral reef. He shredded his board shorts and scraped his legs up pretty bad.

"It was pretty sharky out there, so I decided to come in cuz of the blood."

Still, he's a little scared, especially because his friend Kai wasn't as lucky when he hit the reef a month ago. (Spencer's MySpace page says "RIP Kai Martin" under Heroes.)

Fear is the only thing that prevents him from becoming a great surfer. He always makes the finals in competitions, but then he has a "shocker" (surfer talk for something bad and unexpected) and comes in fourth or fifth.

"I psych myself out," Spencer says. His mind starts going, and he can't stop it. Even when he's just out having fun, it can happen. He may see some black shadows in the water and then get distracted for the rest of his session thinking about sharks.

One time he and his friends really did see a giant shark—at least its fin and tail. Everyone paddled in, but Spencer and the other grommets went back out, stoked that they could have the perfect spot all to themselves.

That was exactly where 14-year-old Bethany Hamilton lost her arm to a shark while surfing. Spencer says he sees her all the time, and she's cool.

Everyone on Kauai is cool, Spencer says, except for the tourists. When the grommets are taking a break from surfing, they like to hide in ditches next to the road and hurl rotten guavas at passing tourist cars.

HE DOESN'T THINK OF HAWAII AS PART OF AMERICA.

Here, you can get Spam sushi at the 7-11, and there's always a bowl of poi in the fridge. On a hot day, you take a dip in the "wet cave," a giant lava dome over a pool of frigid spring water. And when you're done, you can hitchhike back to your house, which is safe to do because you know everyone who lives here.

This is life in paradise, and it's where Spencer plans to stay forever.

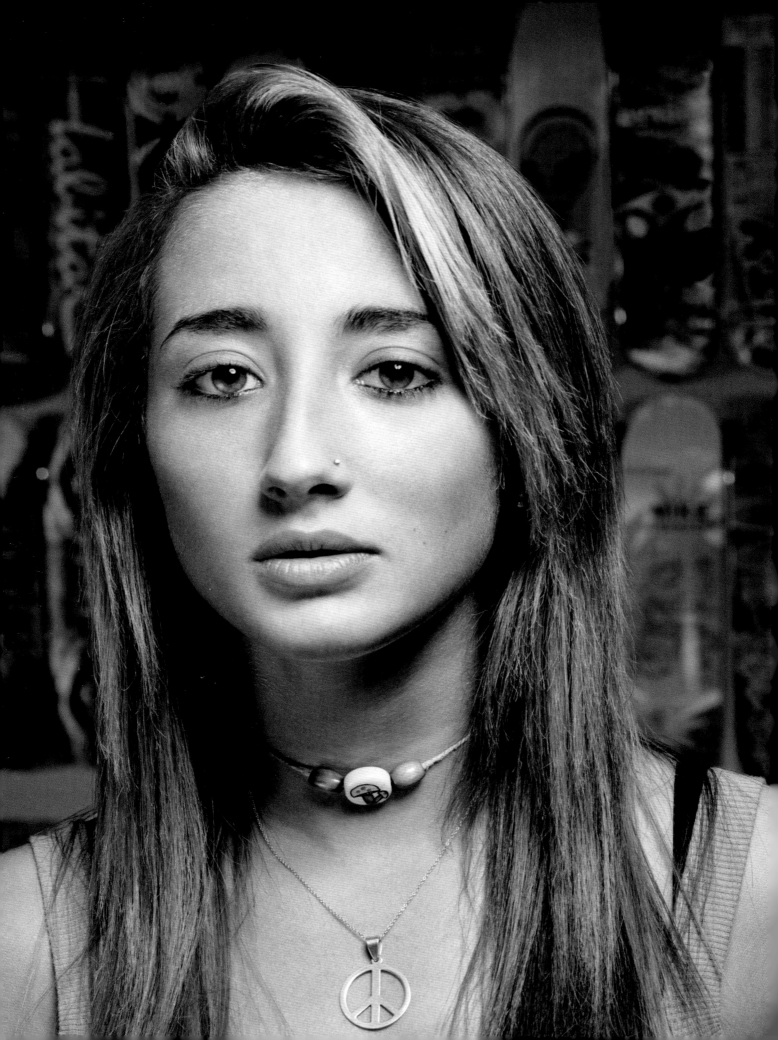

KATRINE
16 ★ FLORIDA

Katrine thinks she might never have discovered it if it weren't for skateboarding.

She'd been skating in the street one day and crashed so hard she could barely walk. "I'm not one for pity," she says, "so I went inside and when my mom asked me what happened, I brushed past her and said I was fine."

The next morning, she woke up in severe pain. Her knee was the size of a big grapefruit. Her mom rushed her to the hospital, and they saw a little white dot on the X-ray that wasn't supposed to be there.

It was a tumor. It wasn't malignant, but the doctors said it was still serious. They scared the shit out of her when they used the word *amputate*. But Katrine thinks they were overstating the problem.

Even though her knee keeps her from skating, she says she's still a skater.

66 MOST PEOPLE HAVE THE WRONG IDEA ABOUT SKATERS. THEY THINK WE'RE TRASHY AND DIRTY AND WE DO DRUGS. 99

Katrine hates how people base so much on image. Her dad, a Cuban ex-skater whom she describes as "superstrict," is one of those people. She says her dad is just beginning to understand that she needs space.

"People who are older don't remember that they were teenagers once. They just want us to learn from them and not make our own mistakes."

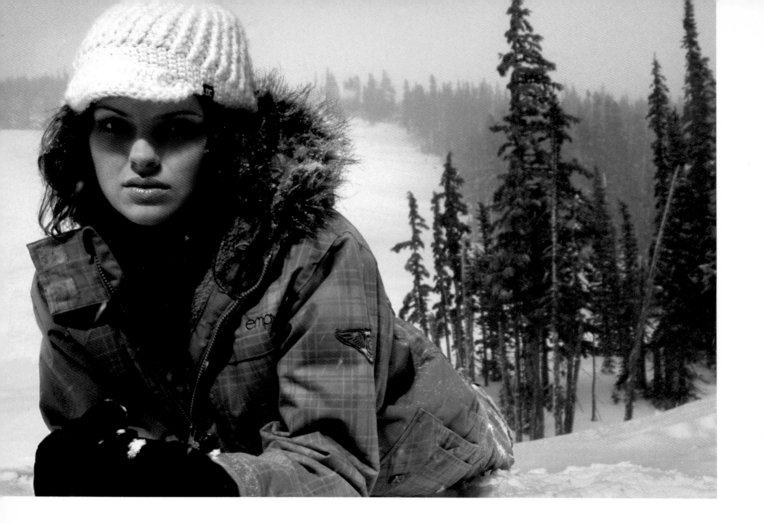

SAMANTHA
18 ★ OREGON

The four-wheel drive in our Ford Expedition isn't cutting it on the icy roads here on Mount Hood. Less than a mile away, three climbers are dying in a snow cave, and a storm is rolling in. News media satellite trucks are all over the mountain.

Samantha wants all the media to leave her small town alone and let the rescuers do their jobs. And she wants to be up on the slopes, not down here with us at the bottom.

SAMANTHA IS NOT A TYPICAL SNOWBOARDER.

Recently, Samantha taught her boyfriend to snowboard, because she couldn't stand the thought of him missing out.

"It's such a privilege to live in a place like this," she says; "you have to go up there and experience the beauty of it."

Samantha says she used to be "that little girl with braces that no one would look at"—including her current boyfriend, whom she had a crush on in eighth grade. The high point of high school for Samantha was when he asked her to the prom.

Samantha says it will be hard to leave the small mountain town where she grew up, but she's ready. She's studying to be a real estate agent but secretly hopes she'll be discovered when she gets to California and become a star.

The one thing she knows for sure is that she'll always live close enough to the mountains to go snowboarding when she gets the urge.

KAYLEIGH
17 ★ NORTH CAROLINA

Kayleigh feels a surge of exhilaration every time she steps into the ocean.

"Standing up on something so awesome that God made," she says, "is just so cool to me."

"The ocean is such a powerful thing. It could easily take away your life in a minute."

Everyone at school knows Kayleigh as "that curly-haired surfer girl."

I ask about her shiny BMW and the million-dollar view from her bedroom. (Her dad is a successful cardiologist.)

"I'm not going to lie—I'm very blessed to have these things," she says, "but these aren't things we can take with us after this. We can't take them to heaven."

I ask if she considers her family rich, and she smiles:

"WE'RE RICH IN OTHER WAYS. WE'RE RICH IN THE HOLY SPIRIT."

Kayleigh has an absurdly high GPA, and she was the teacher's pet all through middle school. She says she's never had a rebellious period, and she's never tasted alcohol in her life.

All she wants for the future is to find a husband who makes her a better person and to raise kids who love Jesus.

And to surf forever.

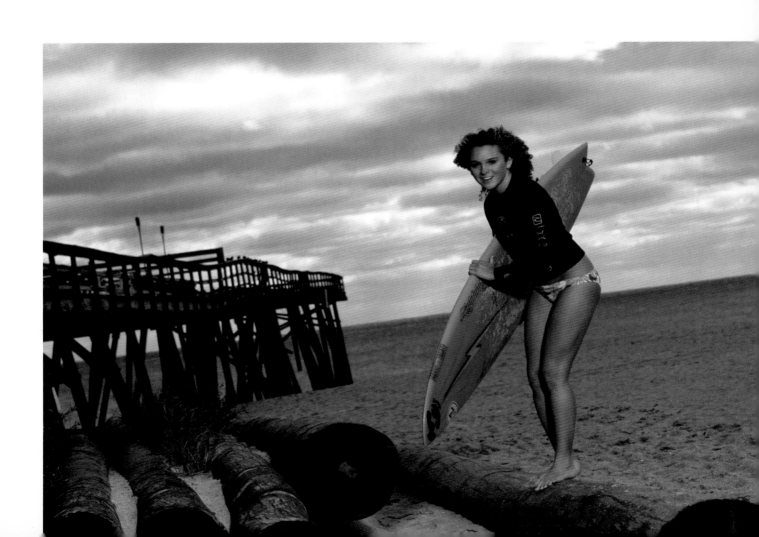

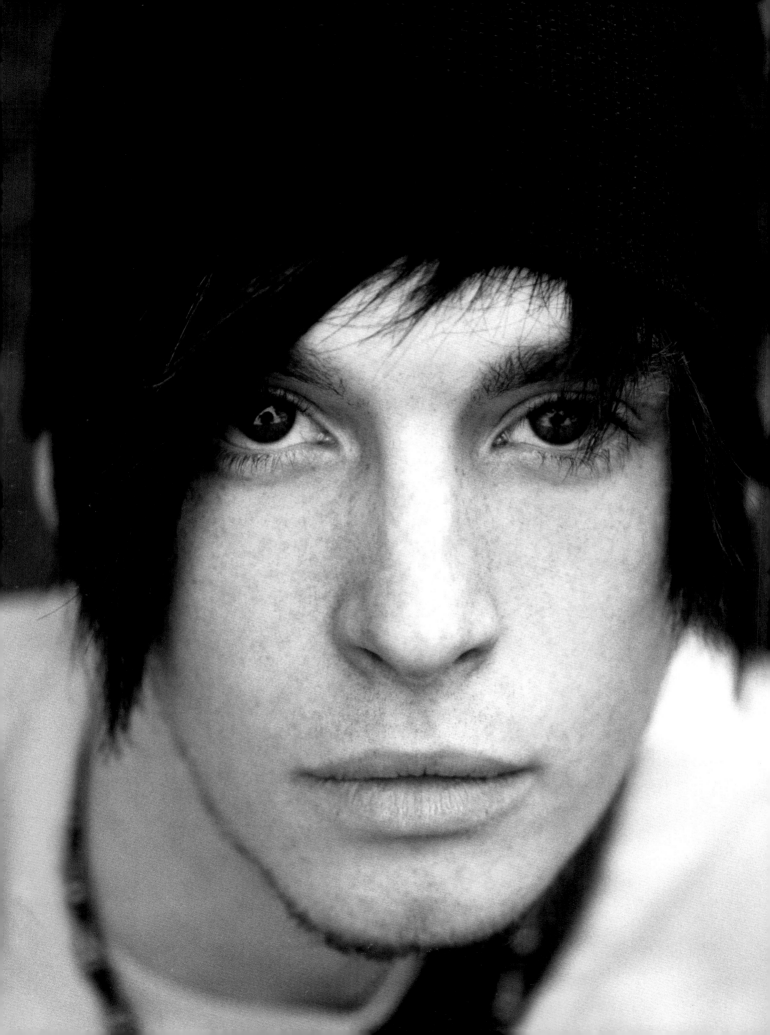

CHRIS
18 ★ MISSOURI

Chris says he'd be dead if it weren't for the Book of Revelation. Especially the part about wrongdoers being judged in front of the Father.

Two years ago, Chris and his friends beat up his sister's boyfriend. She was 14, and her boyfriend was 19. Chris didn't like the guy, and he decided to do something about it.

The boyfriend retaliated by calling the police and telling them that Chris had a 9-millimeter handgun and a lead pipe in his room. That turned out to be a lie.

But when 4 highway patrol officers and 5 city cops busted down his bedroom door, they found 5 cases of beer, a quarter-pound of pot, and 20 Seroquel pills instead.

Since he was 13, his life had been a blur of pot, cocaine, and toward the end, a cocktail of prescription pills that included Xanax and Ritalin—because they were easy to get—and the pain reliever OxyContin, also known as "hillbilly heroin." The oxy was his favorite.

Chris spent Christmas and New Year's in jail, and then the judge sentenced him to 3 months at a live-in rehab facility for teens. The days started at 6:00 AM, and every moment of his day was planned and supervised, including a three-hour therapy session.

Exercise was the only activity that was optional. The only catch was that he had to go to a church group if he didn't exercise. The first day, Chris sat in the back and kept quiet. The next day, he moved to the front and asked a lot of questions. That afternoon, the pastor gave him a Bible.

Before leaving rehab, Chris read the Bible from cover to cover. "That's what got me through it," he says.

When he got out, he had a hard time figuring out where he belonged. He became a "scene" kid, which looks a lot like an emo kid. Chris says his fashion was pretty extreme, especially for small-town Missouri: tight girl-pants cut off at the knees, extrasmall T-shirts, headbands, and bangs down to his chin—with two big blond stripes.

Chris took things a step further when he joined the cheerleading squad. He was the only guy out of 21 cheerleaders. "I always like to push the envelope," he says. "I wanted to see if my friends would still be my friends."

He did lose some friends, mainly the cowboys—the guys with the big hats, boots, chewing tobacco, and pickup trucks.

Chris's scene phase ended when he joined the Rose Theory, a hard-core Christian band. The band's bass player had gotten married and moved away, and they needed a replacement.

One of Chris's band mates was the star quarterback when Chris was a cheerleader. So at the start of every performance, the band gets in a huddle and prays. They go around the circle and each take their turn.

The huddle always ends the same way. All together, they loudly rap:

"WHEN THE FIRST NOTE HITS, THERE'S A PARTY ON THE STAGE."

The music they play is serious hard-core. The lyrics are all about God, and there's never a cuss word. But the band screams. They don't sing. No one can possibly understand the words.

"We're just doing our best to spread God's word," Chris says.

JOSH
17 ★ MICHIGAN

We're in a huge Detroit photo studio usually used to shoot cars. Josh disappears to transform himself with his mother's help. He comes back as a more confident, less inhibited person.

Josh was born in 1989, 7 years after Ace Frehley left Kiss, but he's happiest when he disguises himself as the (now middle-aged) heavy-metal guitarist.

> **"WHEN I'M IN THIS OUTFIT, NO ONE CALLS ME JOSH. THEY CALL ME ACE. I GET TO ACT DIFFERENT, BECAUSE I'M SOMEONE ELSE."**

Josh's mom is totally into Kiss too. His dad was a fan back in the day—he actually went to a few Kiss shows in the 1970s. But Mom discovered them at the same time as Josh, and now she cranks them in the car, even when Josh isn't there.

When he's not in disguise, Josh hangs out by the garbage can at the front of his school with the other music kids. School starts at 7:50 but they all get there at 7:30 to talk about what band they just found online or what show they're going to on the weekend.

The other kids, especially the jocks, look down on the music kids. This one football jock named Rubio always messes with Josh. Like when Josh is sprinting down the hallway late to class, Rubio will stick his foot out, slamming Josh face first into the floor, sending his books flying everywhere.

In spite of the abuse, Josh and his band mates decided to go to school in full Kiss regalia one day. "All the preps and jocks made fun of us, but we didn't care, because we weren't who we were before."

Josh says they made a bunch of friends that day. The next day, they came in and these girls were like, "Oh, that was you guys? That was so cool."

Josh first dressed like Frehley 2 years ago, in tenth grade, when he and his friend Justin played Kiss's "Rock and Roll All Nite" in their school's talent show. He walked out on stage to face 800 people and was petrified. The video of that performance shows Josh frozen in place as he screams the words, "I wanna rock and roll all night and party every day" over and over. But he says he's gotten over his stage fright and now jumps all over the place when he performs, like the real Ace.

He tells everyone he wants to be a history teacher—because he's supposed to. (And maybe because Gene Simmons was a seventh grade teacher before Kiss made it big.) But Josh dreams about how cool it would be "to walk up on the Grammys and get an award and have that loser Rubio on his couch seeing me on TV."

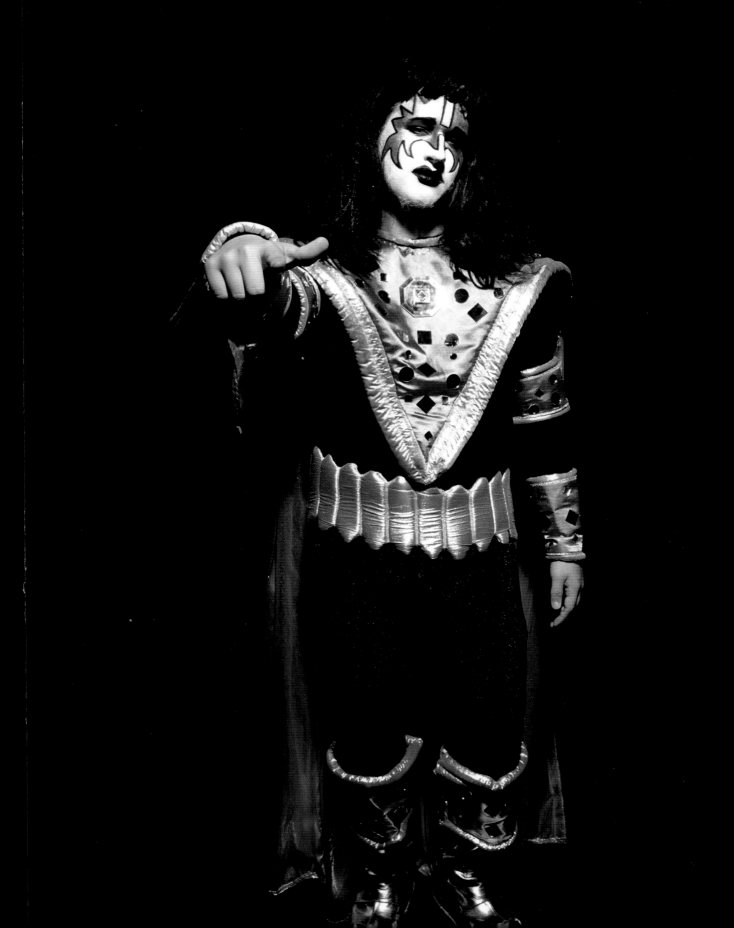

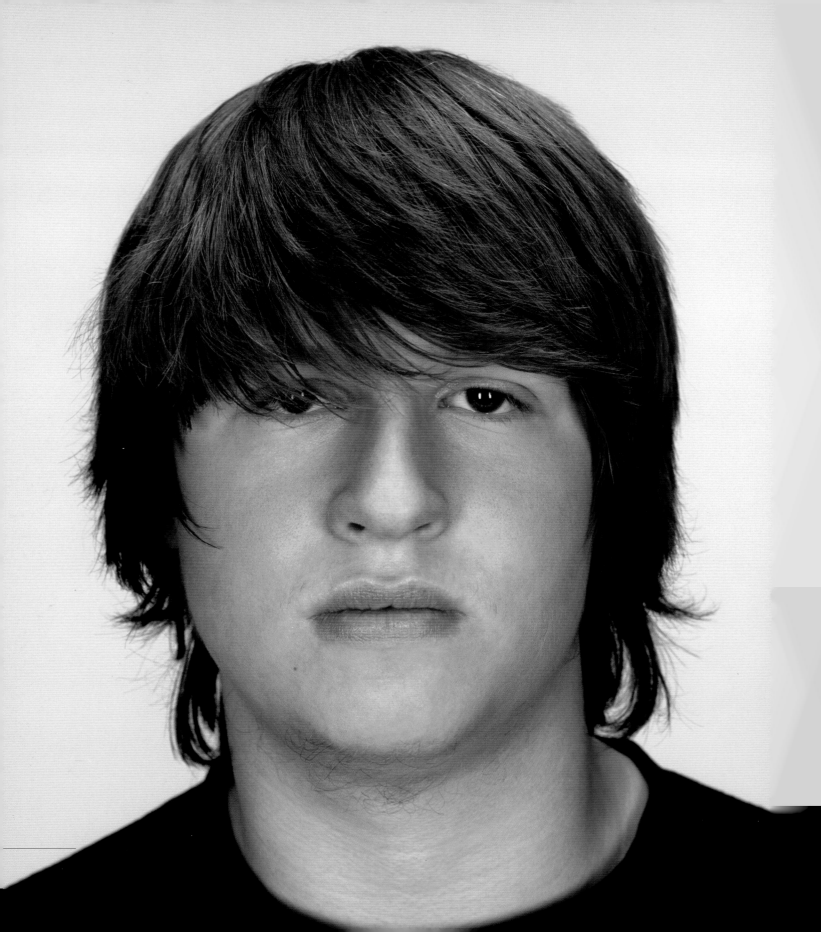

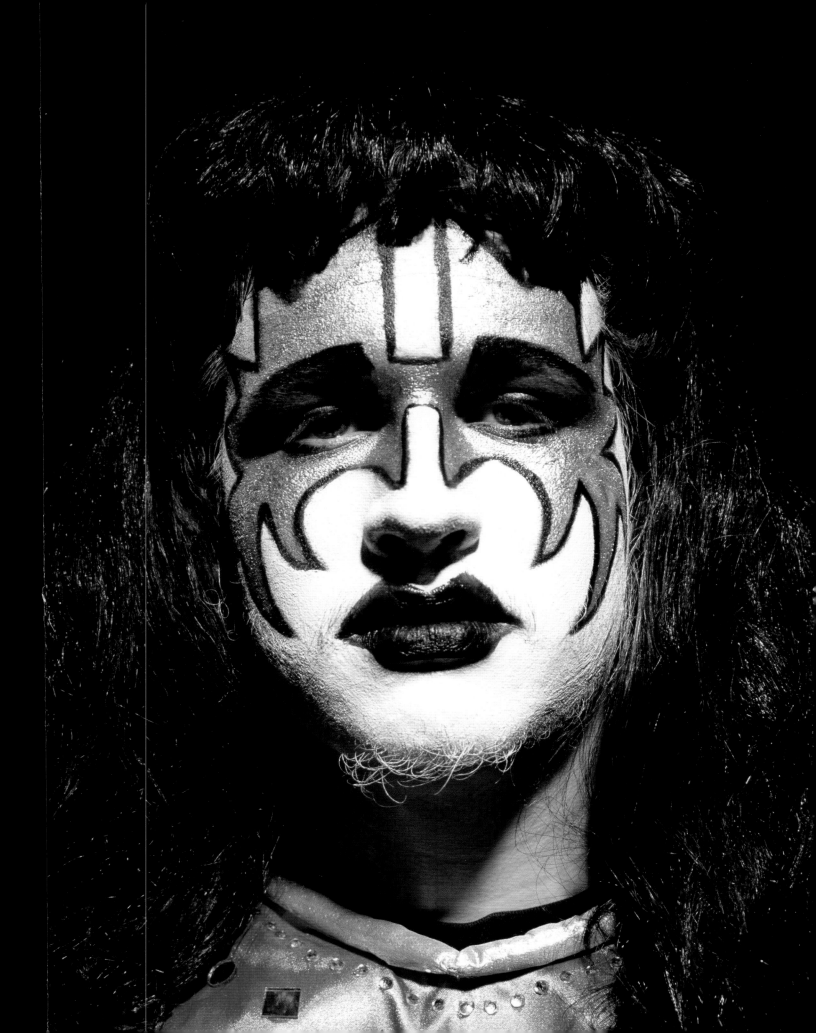

KYLE
17 ★ FLORIDA

When Kyle wants to impress the girls at school, he pulls up on his lawn mower.

"So many people gather round, it looks like a fight scene," says Kyle. Everyone wants to know what it is. They say, "I've never seen anything like that."

We're at a lawn-mower racetrack in northern Florida with Kyle and his parents, and he's unloading three different racing mowers from his dad's truck.

Kyle's dad tells us all about the history of the sport of mower racing. On April Fool's Day, 1992, some guys in Chicago started the U.S. Lawn Mower Racing Association, and now they've got 700 members in 19 states who race at tracks like this one.

People give their mowers names like Sodzilla, Ace of Blades, and Mowin' for Broke, and they travel hundreds of miles to attend "mow downs" all over the South and Midwest.

"I like racing anything," Kyle says. Someday he wants to race Nascar or Monster Trucks. For now, he's sticking with mowers, because they're fun and they're cheap.

Kyle and his dad have a little cottage industry building mowers to make race money. It costs $20 to enter a race—not to mention the gas and hotel for out-of-state races—and the parts can be pricey, like the $150 rod and piston Kyle just broke when he took a turn too fast.

These are real riding lawn mowers, the kind you get at Home Depot. But the first rule of lawn-mower racing is remove the blade. Depending on what class you're racing, you can soup up your mower in different ways. Some of them can go 85 miles an hour.

Once, Kyle got pulled over for doing 45 through a school zone on his mower. Luckily, the cop was a redneck.

" I AIN'T GONNA GIVE YOU A TICKET, CUZ THAT'S THE COOLEST THING I EVER SEEN. "

Kyle uses the word *redneck* with pride. Kyle was part of the redneck group in high school—the kids who wore Wranglers and boots and caused problems in class.

School was tough for Kyle. He was always getting disciplinary referrals from the teachers for no good reason. Like the time he was taking a test, minding his own business, with his feet up on the chair in front of him. The teacher came over and kicked his feet off the chair. Kyle threw a book at the teacher, and the teacher got him suspended.

Even worse, they were trying to switch Kyle onto the "exceptional student education" track, and he didn't think he belonged in the slow classes, just because he's not "test smart." His mom couldn't take it any more. She pulled him out of school, and, within a month, he passed the GED and got a diploma, at age 16.

Now Kyle works filling soda machines. If he doesn't make it on one of the racing circuits, he figures he'll drive a semi. He likes anything with wheels.

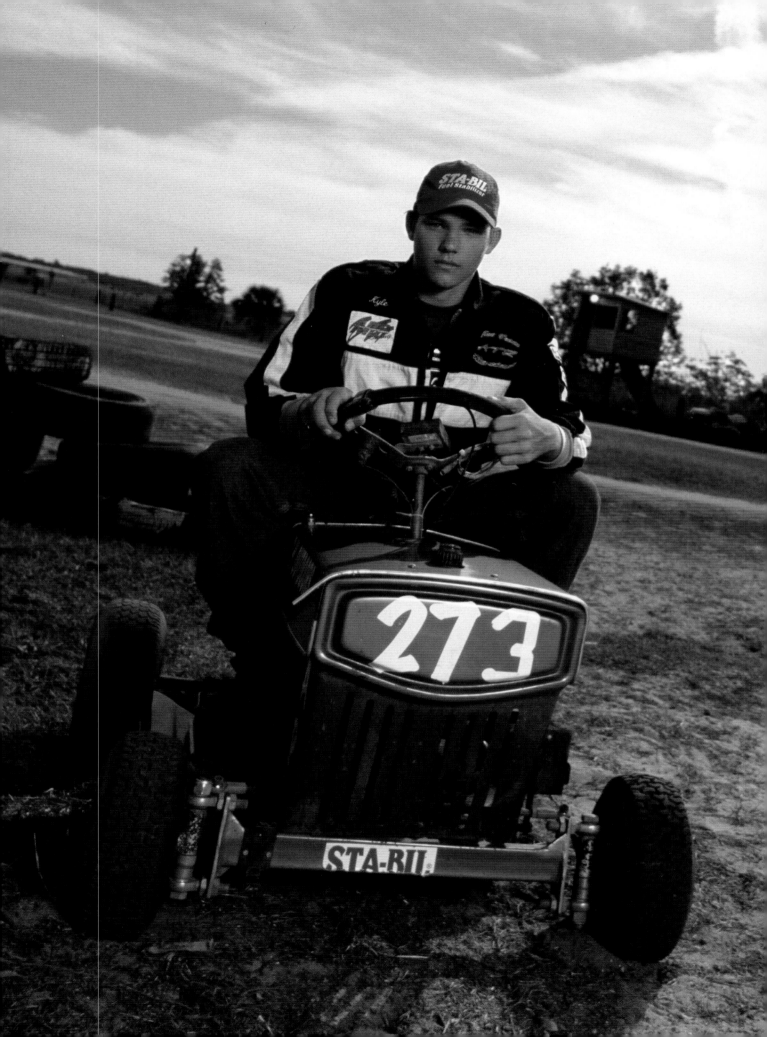

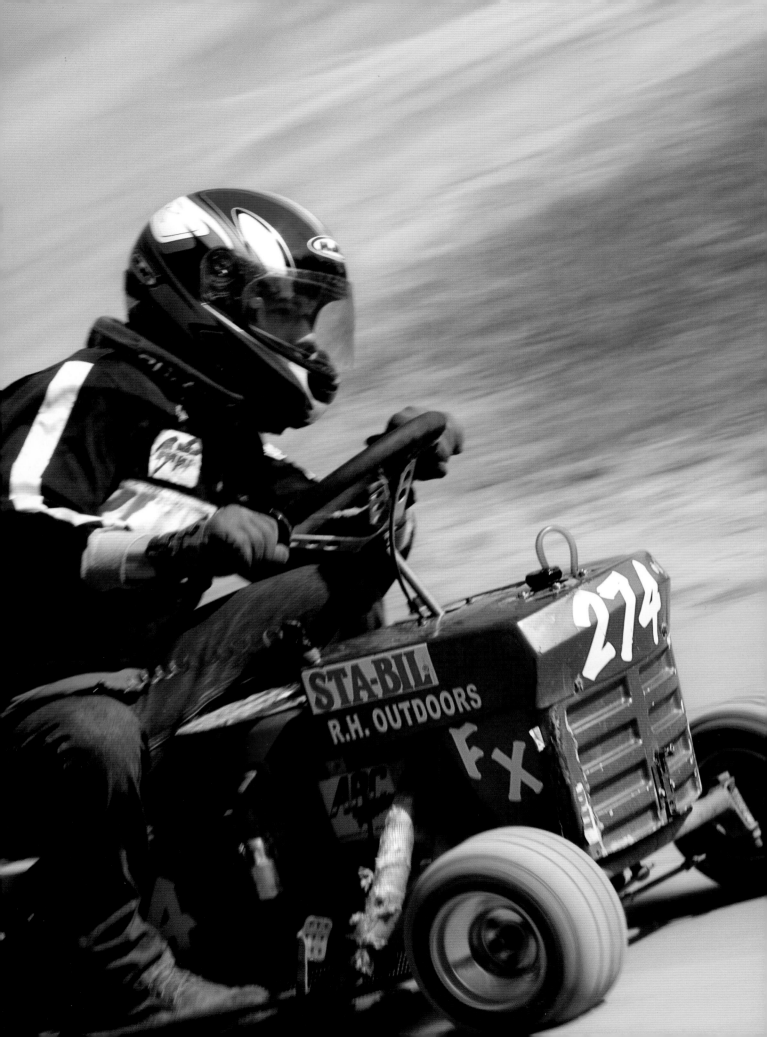

JANINE
19 ★ MARYLAND

Janine says most men are dogs.

"They don't treat me with respect," she says. "They look at me and just see my boobs and my curves."

We're in a suburban backyard in Maryland, and a neighbor storms in and starts yelling in a Nigerian accent. "You must not do this," he says. "This is blasphemy. How can you do such a thing in the house of a pastor?"

Janine's roommate is a pastor at the local Baptist church, and the neighbor thinks Janine is showing too much skin.

"This ain't none of your business," she yells back at him. "You get out of here." It was Janine's choice to wear the bikini, and she doesn't care what he thinks.

Yet another neighbor walks in and joins the screaming match. It feels like a fistfight could erupt at any moment. This kind of chaos is familiar to Janine. For her whole life, violent conflict has surrounded her.

"Basically it was me and my mom, with horrible stepdads coming and going," she says. "My biological dad disowned me when I was 4 and moved to New York."

"When he got mad, he didn't know how to control his temper," she tells me. "It's funny, I guess I got the same problem as him."

Everything changed last year when Janine found Jesus.

She had been cooking meals for the 80-year-old woman who lived across the hall. One Sunday morning, the neighbor invited her to church.

66 THAT'S WHEN I GOT SAVED. 99

She says everything got better after that. Her pastor (not her roommate) helped her to see the pattern of abuse.

"My mother was abused, I was abused, and it's going to stop with me."

Janine says she's waiting for the right man to come along so she can have kids and give them the childhood she wished she'd had. "My kids are gonna grow up in a perfect marriage with one father for their whole lives," she says.

Her pastor tells her to be patient, and Jesus will bring her the right man. In the meantime, he says, "This is a time for dreaming."

Janine's dream is to be a singer/songwriter, but she doesn't know how to make it come true. For now, she's studying nursing in community college, but she hates the idea of being a nurse. She just can't figure out what else to do.

"It's harder being black," she says.

Janine tells me the story of applying for a waitress job at a restaurant in the nice part of town. She filled out the application online, and they called her in right away for an interview.

"I was the only black person walking down the sidewalk," she says. "I walk in the door, and it's all white people dressed in black. The only black person is this blue black African-looking guy washing dishes in the back."

"A man walks over and gives me a drink in a to-go cup and tells me he'll call me after he checks my references. He didn't even want to talk to me."

Janine says she feels better when she does accomplish something, because it means she's beating the odds.

I ask her what she's going to do.

"I'm gonna go after my dream," she says. "And I'm gonna wait for the right man. With God, all things are possible."

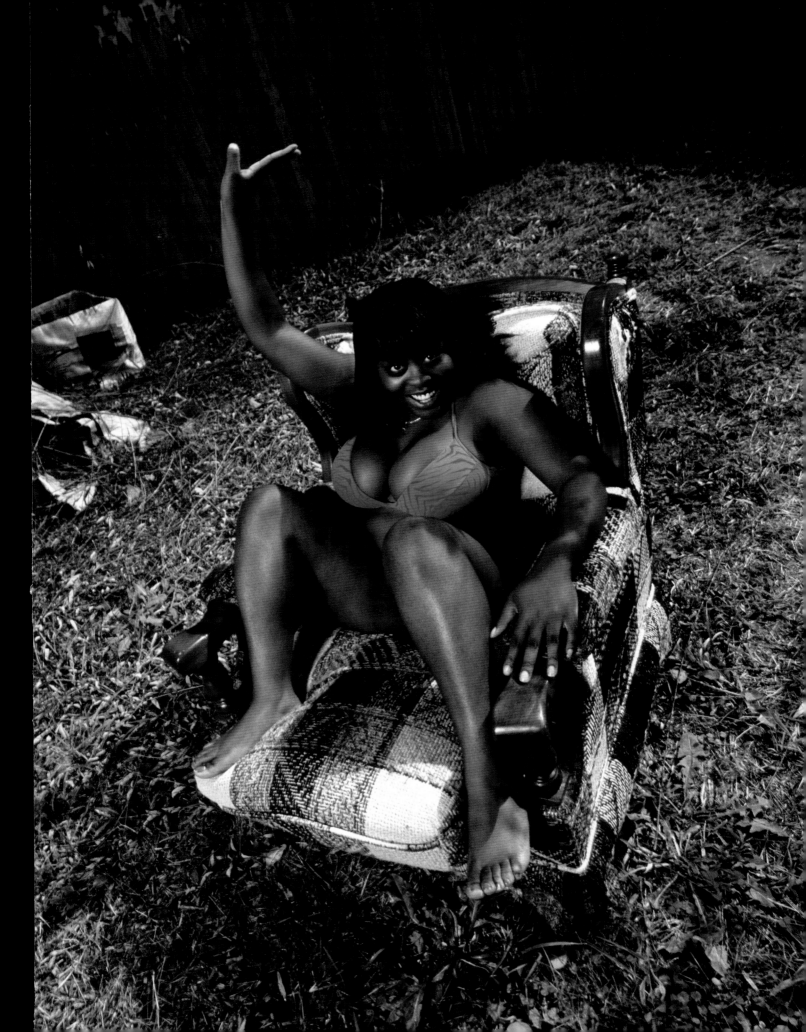

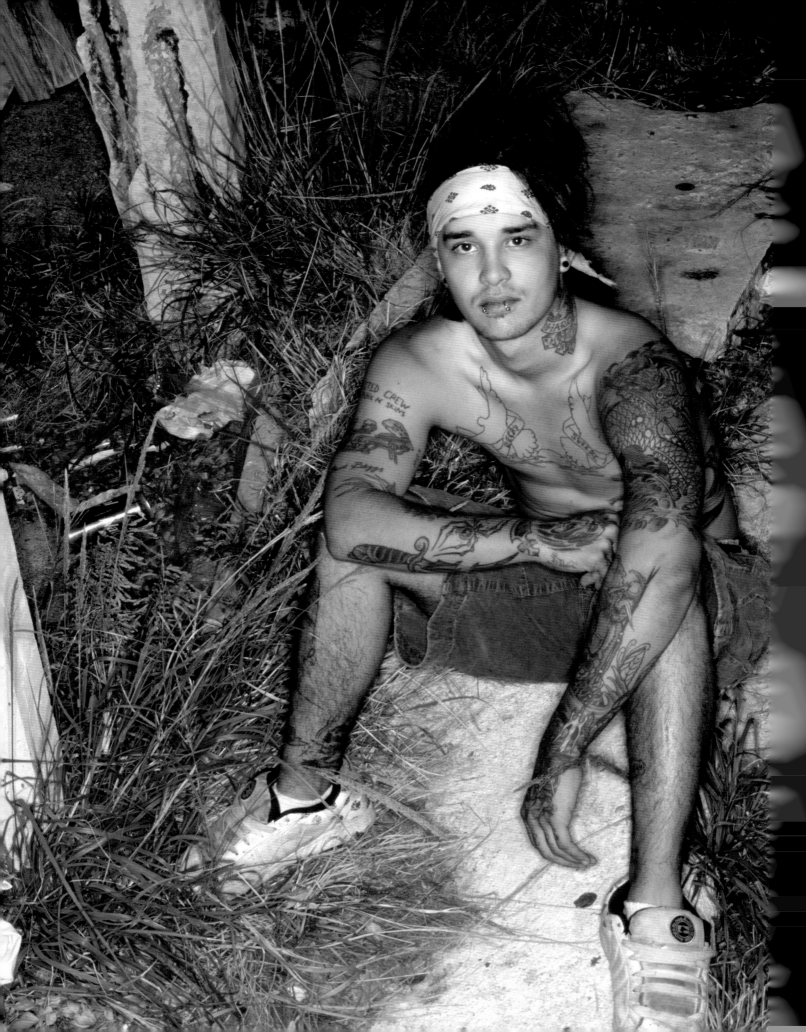

BORIS
19 ★ FLORIDA

"Your skin is sacred. It's what God gave you. Don't ruin it."
Boris hears this from his dad all the time and he always
gives the same answer:

" IF GOD GAVE ME THIS SKIN, I CAN DO WHATEVER I WANT TO IT. IT'S MINE. "

Boris got his first tattoo at 16, and now he's addicted.
At 19, he already has about 35 of them. (He doesn't have
an exact count.) He says he'll run out of skin to tattoo
when he's 26.

"All the space I have left is pretty much spoken for,"
he tells me. We're at the tattoo shop where he works
as an apprentice tattooist and a body piercer. The
real money, at the moment, is in the piercings. He gets
a 50% commission on those, and a lot of them run
a hundred bucks.

We ask Boris if we can shoot him getting tattooed, and he
says, "Hell yeah."

While Boris waits in the chair, the owners of the shop look
for a piece of art. Boris has no voice in the selection of
the image that will remain on his body forever. The owners
discuss it for 20 minutes, and he's never asked
his opinion.

The question of who makes decisions for Boris is central
in his life.

His dad has old-fashioned beliefs, like "You have to go
to school" and "You have to get a job." Boris doesn't think

that's right; he wants to be the one who decides what
he does with his life—and his skin.

He feels the same way about the born-again Christians
who try to force their beliefs on him when he walks down
Ocean Drive with his shirt off. He'll take a marker and write
the number of the beast—666—all over his body and walk
alongside friends covered in demon and skull tattoos.

They yell, "You're going to hell!"

Boris says his skin is none of their business. He does
believe in a higher power but not in Jesus Christ. He gets
up in their faces and tells them what he thinks: "You don't
tell me to cover up my tattoos, and I won't come up and
snatch the cross off your neck."

A long time ago, Boris was different. He got straight As and
looked pretty normal. Then something happened. "Being
a good kid wasn't working for me any more," he says.

When Boris was 11, his parents split up. Within a year,
he started smoking weed and rebelling. "I was like a gutter
punk who stayed out all night," he says.

These days, Boris mainly likes hanging out with his
girlfriend and drinking Colt 45. I ask what they do for fun,
and he says that whenever he gets bored, he tattoos her.

Boris doesn't know what makes tattoos addictive, but
he does know that everyone who gets one comes back for
more and more. I ask what all the ink does for him, and
he explains:

"I feel better about myself having all this on me. It makes
me feel more like myself. More of who I should be."

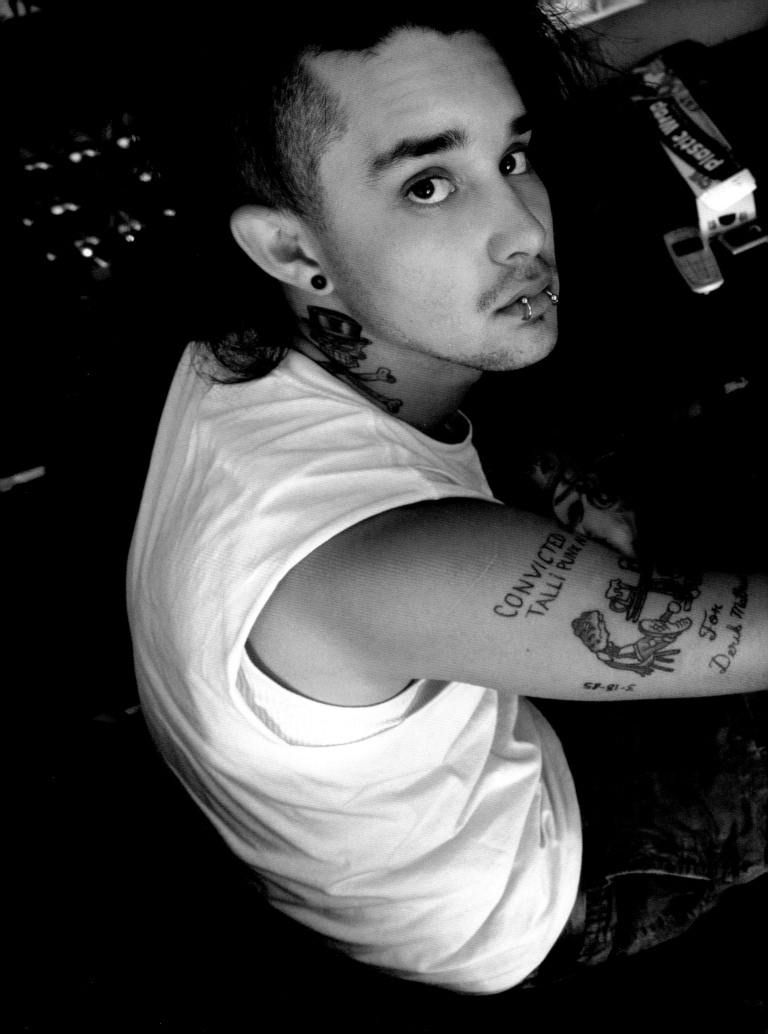

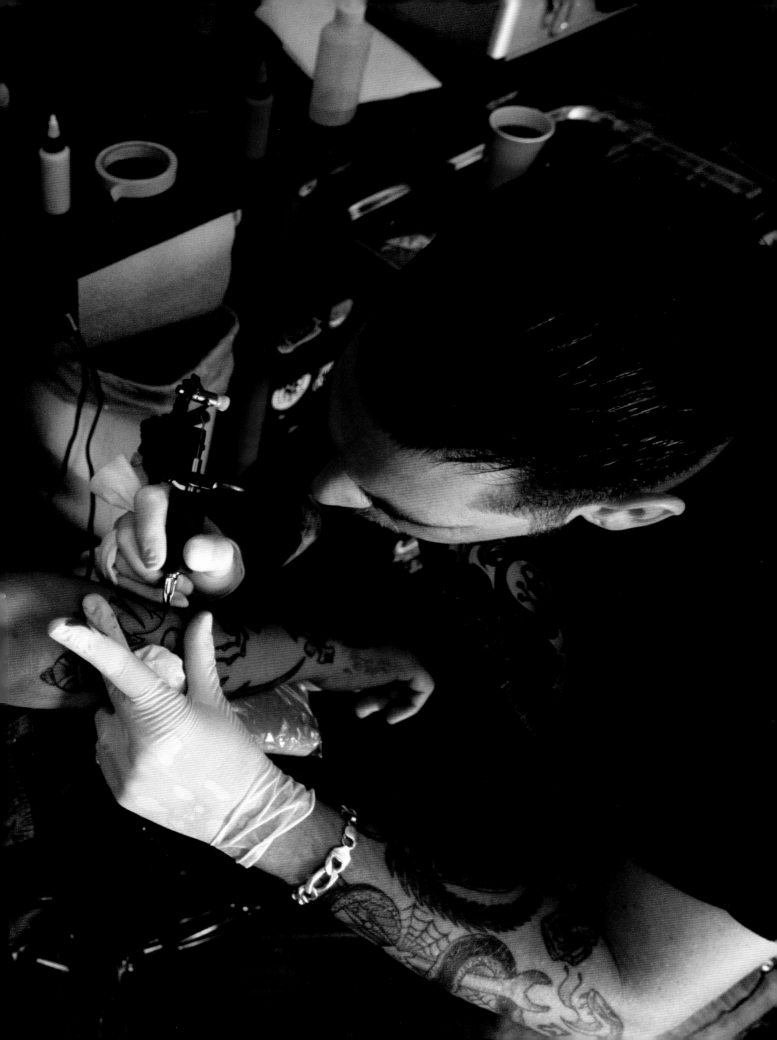

BILLY
15 ★ ILLINOIS

Billy is an eBay entrepreneur, and he takes pride in his perfect feedback rating. For years, he's been buying and selling clothes, shoes, and sunglasses for a profit.

Mainly he buys things that he likes, but he gets more than he needs and sells off the excess. In his room, he has a collection of giant-framed Gucci and Chanel sunglasses. They're made for women, but Billy doesn't care; he thinks they're cool.

Last year, his school had a flip-flops and sunglasses theme day, and he wore his Guccis. He says a lot of the girls really liked them, and a lot of guys made fun of him.

" I TAKE PRIDE IN HAVING MY OWN UNIQUE STYLE. "

"I don't want to wear what everyone else is wearing just to fit in. People are more comfortable just following the norm, doing what everyone else is doing. Me, I'll wear what I want."

Billy says the other kids at school probably think of him as "weird and kind of shy." He's okay with that because he really just has one close friend—a guy named Simon.

Billy hangs out with Simon a few times a week, and the rest of the time he spends on eBay.

Billy has a cell phone but rarely turns it on, and he doesn't really have a need to instant message with people. He just talks to Simon.

As for other people, he says he's not here to judge, and it doesn't really bother him if people judge him. Billy will just keep doing his own thing.

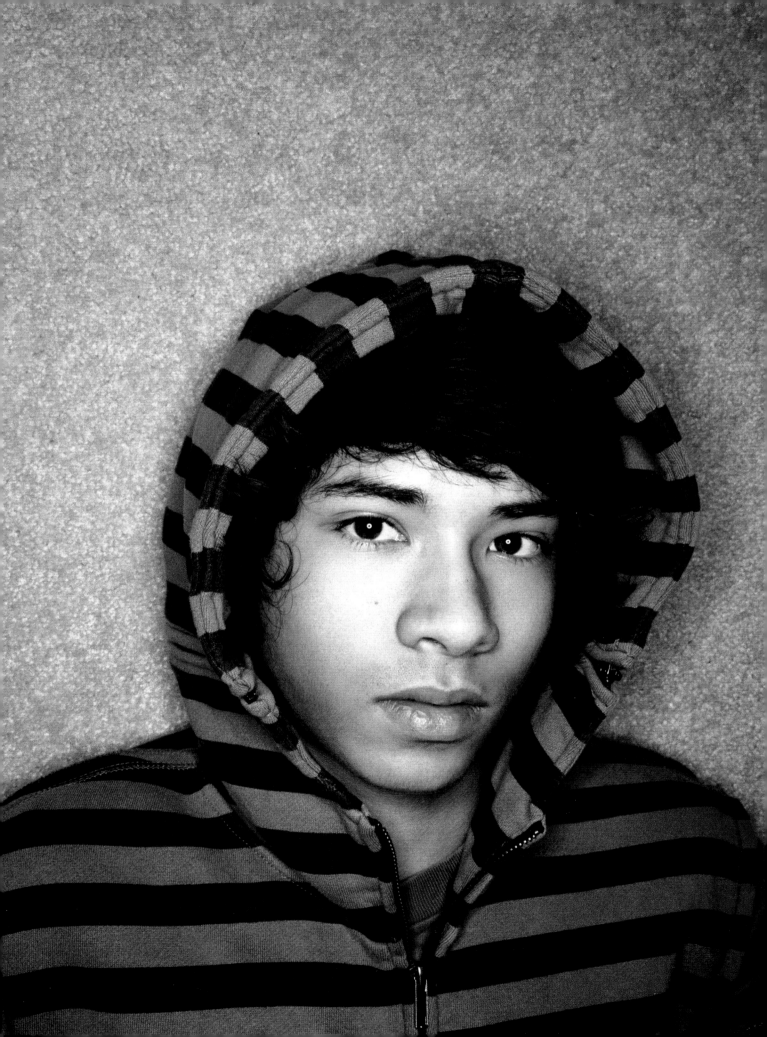

BETH AMPHETAMINE
18★ KANSAS

Her real name is Elizabeth, but everyone calls her Beth Amphetamine.

Beth says she doesn't like amphetamines—or any drugs—and doesn't care to be around them. I ask why she chose the name, and she says, "It just fits me."

" IT'S BECAUSE I'M SO ADDICTIVE. PEOPLE CLING ON TO ME AND DON'T LET GO. "

Beth tells me about her one real boyfriend, an "asshole who lied about everything." He was somewhere between goth and punk, and his tongue was pierced four times in the shape of a cross.

Now she refuses to have a serious boyfriend. Instead, she has what she calls "man candy." These are guys that are nice to look at and fun to hang out with. She refuses to sleep with any of them. "I want there to be some feeling; if they're just man candy, there are no feelings."

Beth is pissed off at her father. "He cares more about alcohol than seeing his daughter," she says. Every Christmas Eve, for as long as she can remember, she and her real sisters have gone over to their dad's house. He's 54 and lives with his mother, Beth's 80-year-old grandmother.

Their dad stays in his room drinking beer, coming out just long enough to collect any presents that his daughters have brought for him. Grandma tells him to grow up and face his family, but he slams the door and keeps drinking.

Until recently, Beth had a stepdad who drank even more than her real dad. The last time she saw him was the night he got drunk and said he was going to shoot her 13-year-old brother, Kyle. Beth pulled a knife on him, her mom called the cops, and they took him away.

Beth sits in front of a mirror with a large safety pin that she has sterilized in rubbing alcohol. She stabs herself and then forces a ring through the hole. She says that's the part that hurts—the ring basically rips through the flesh.

I cringe and ask how she could bring herself to do that, and she explains that she thought about things that pissed her off while she was doing it.

"Mainly, I just thought about my stepdad."

ALEXANDRA

13★ TEXAS

66 SOMETIMES MY DAD NEEDS TO STEP IN AND DEFEND ME. 99

The other day at dinner, the waiter was hitting on Alexandra. He was more than twice her age and had no idea he was flirting with a 13-year-old.

Her dad doesn't get angry. He says, "Try to guess her age," and no one ever comes close. When they find out, they recoil and slither away.

At school, the teachers assume she's a senior. At restaurants, she always gets offered wine. And when she's walking down the street, all kinds of grown men check her out. "It feels kind of weird," she says.

I ask Alexandra if she would snap her fingers to make herself look 13, if that were possible. "No way," she says. "I like who I am."

She tries to dress her age, but most of the clothes from the teen stores don't fit her. And she's more into creating her own style, anyway. She calls it vintage punk.

"If I were a normal teenager," Alexandra says, "I wouldn't have any crazy piercings, but I'd dye my hair a different color. I'd look punk."

Alexandra can't do that because she's a model.

While I photograph her on a riverboat in San Antonio, her parents crouch behind the camera and coach her on how to pose and what facial expression to make.

Alexandra got signed by a modeling agency when she was 12. Her first gig was a runway show for a jeans company in Beverly Hills, and later that year she modeled new "indie" fashion on the runway for a crowd of 3,000 in Austin.

What Alexandra really wants to do is act, but her looks get in the way. "They want 18-year-olds who can play 15-year-olds," she explains. She'll have to wait 5 years, and then she'll be up against 30-year-old women who are playing younger.

For now, Alexandra's dream is to be a supermodel, and she'll do whatever it takes to get there. She misses days of school and birthday parties because she travels so much for work, but only her closest friends know about the modeling.

When she does make it to a friend's birthday party, she doesn't touch the cake. "You have to be really skinny to be a model," she says.

Pretty much the worst part of modeling is not being able to eat pizza. Sometimes, she fantasizes about Margherita pizza and mac'n'cheese, two of her favorite childhood meals.

I ask Alexandra if the sacrifice is worth it, and she tells me about the most exciting moment in her life. She walked into the supermarket and saw herself in a magazine.

"I felt like I'd accomplished something," she says. "Like all of this is not just wasting my life."

ERIC

18 ★ LOUISIANA

We pull up to Eric's house and get a warm southern welcome: a giant basket of shrimp hot off the grill. Even before we know everyone's name, we all have a plate of shrimp in our hands.

The shrimp are wrapped in bacon and cooked in foil on the barbecue. This is Eric's favorite way to eat shrimp.

Eric and his dad have been shrimping together for 6 years, and now that Eric has his captain's license, he can go out on his own.

"I'm a country boy, and country boys like to get muddy and go fishing," he tells me. But Eric rarely has time for fishing, because he's too busy catching shrimp.

I ask him if he likes shrimping, and he answers with a huge grin: "Yes, sir! It's my favorite thing to do." He says it's about the peace and quiet and the wind blowing under the stars.

Eric agrees to take us out on the shrimp boat, even though it's daytime, and the shrimp come out at night. During the day, they bury themselves in the mud. On the right night, they all come up to the surface.

66 YOU GOTTA THINK LIKE A SHRIMP. 99

"When the water is real dirty, they all go near the top, because they can't see you. When it's clear, you gotta put your net down near the bottom."

We climb on the family shrimp boat, and soon there's nothing in sight but bayou. Eric lowers the net into the water, and we troll for 20 minutes.

He says he'd like to be a full-time shrimper when he graduates, but he knows people who have lost everything when they hit a bad season.

He figures he'll be an electrician. He says that's the kind of work people in Louisiana do, by contrast with big-city people. "Over there, they gonna be lawyers and stuff. Down here, we gonna be an electrician, plumber, welder."

"Most of the city folks go for the indoor jobs." Eric says he could never sit at a desk all day. He'd climb the walls.

Eric says country folk are outdoor types. They like to do things like catch frogs. Eric says he can catch about 40 frogs in an hour—with his bare hands. He kills them with a knife through the head and cuts off the legs. Dip the hind quarters in fish fry and drop them in hot oil, and you've got Eric's second favorite snack (after shrimp, of course).

When he pulls the net out of the water, there are just a few shrimp inside and a variety of other critters. Eric's smile doesn't fade. Although he can pull $800 worth of shrimp on a good night, he clearly doesn't care about money.

We head for the dock, and Eric says he'll be back out here as soon as the sun goes down. "If we're catchin', we'll stay out all night." If that happens, he'll drop the shrimp at home on his way to school, and his momma will sell them in the driveway.

On Eric's MySpace page, he describes himself as a "coon-ass," which is a crude way of saying he's Cajun. He's proud to be a Cajun country boy, and he wouldn't trade his life for anything.

I ask Eric if he can remember the last time he got angry. He thinks for a long time, and he can't think of a single time in his life he's been angry. He says that's not his nature.

I ask him where he sees himself in 20 years, and he says, "I gonna be right here shrimping and living in the same house."

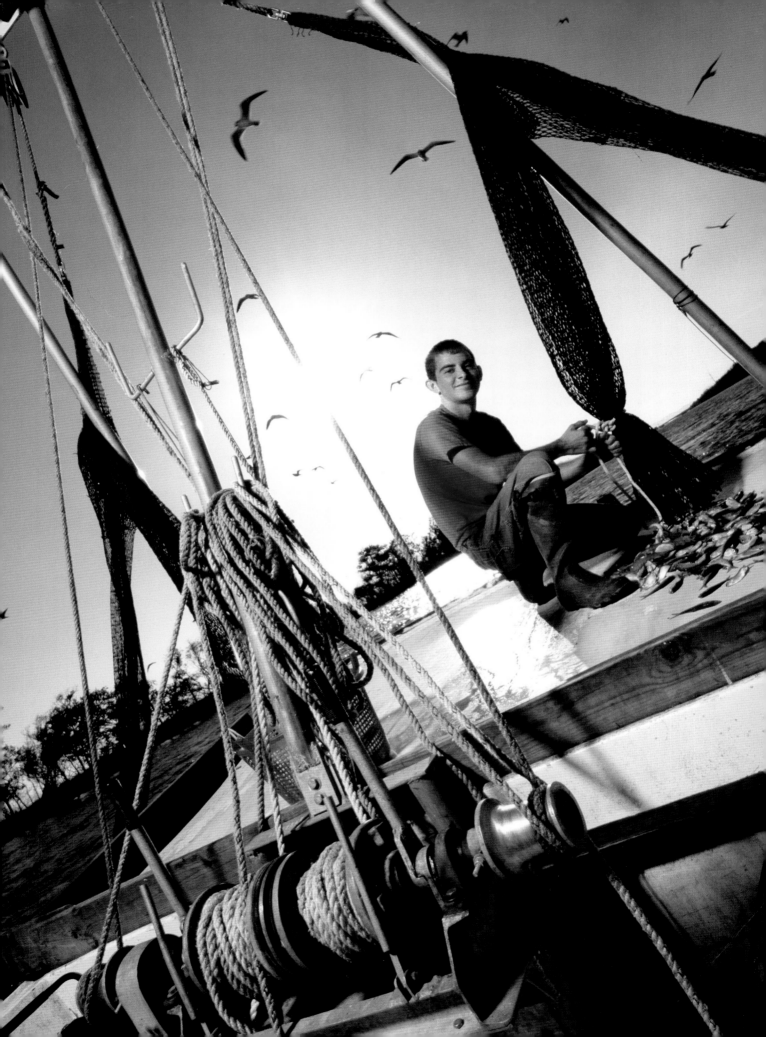

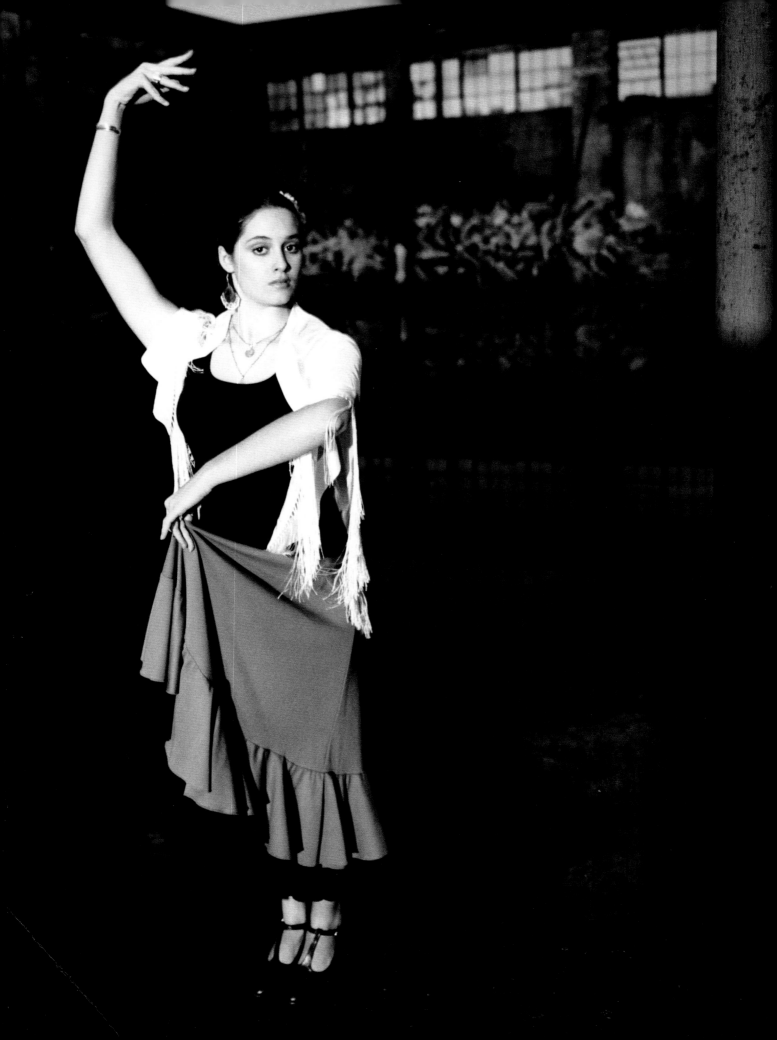

AISHA
17 ★ OREGON

We're inside the shell of an abandoned warehouse in Portland, and four guys across the street are waving their arms and yelling. They say we're trespassing, and they're going to call the cops on us.

It's a wet afternoon, and we drove around with Aisha for an hour before stopping here. We were going to take pictures in the dance studio where she practices 4 days a week, but she wanted to go somewhere cool and new.

AISHA SAYS SHE LOVES BEING THE CENTER OF ATTENTION. THAT'S WHY SHE LIKES FLAMENCO DANCING.

Her goal is to be a professional flamenco dancer and she's incensed about a recent crackdown in Portland on "freak" dancing—teenagers simulating sex on the dance floor. She doesn't freak dance, but she thinks the public outcry is ridiculous.

"A hundred years ago, the Pope banned the tango because he thought it was lewd. In the 1970s, there was disco. This is how teenagers dance now."

Over spring break, she'll be visiting family in Barcelona and Madrid. And when she has time, she'll visit her dad in Miami. (Her parents got divorced when she was 4, and she has mixed feelings about her dad because of his "anger control issues.")

After graduation, Aisha wants to go to Antarctica to work at a research station for a few months. She wants to see what it's like to be trapped with a group of people and not be able to leave.

Then she plans to meet up with her boyfriend, who lives in Chile, and ride motorcycles around South America. Aisha met him during a year-long trip to Chile with her mom. Now she instant messages with him every day in Spanish. And she counts the days until she can see him again.

"I don't like staying in one place very long," she says.

Aisha was born in Cuernavaca, 50 miles outside Mexico City. Her mom brought her to Portland in second grade, and now this is home—at least as much as Aisha has a home.

She likes experiencing different cultures and seeing how other people live their lives. Her year in South America changed her perspective on a lot of things: "I just realized there's more to life than all the stupid drama that happens in high school."

"In the U.S., everyone is materialistic," she says. "In other places, you can't afford to have more than one pair of shoes." For her entire year in Chile, Aisha lived out of a backpack that contained one pair of shoes, two pairs of pants, and three shirts.

"I was fine," she tells me. As soon as she got back to Portland, she saw all the stuff in her closet she doesn't need.

Now she only has one pair of shoes.

WILL

19 ★ WASHINGTON, DC

"I WANT TO BE PRESIDENT OF THE UNITED STATES."

Will says this with conviction and determination.

After talking to him for two hours, I believe he can do it. He's a sophomore at American University in Washington, DC, and he's running for vice president of the College Republicans.

He's presidential in every way. He answers questions in sound bites and has an amazing ability to fire back politically perfect one-liners on any subject:

Sex: "Without love, it's not worth it."

Drugs: "Never really tried them. Never wanted to."

Music: "A good form of expression, but out of control." (The example he gives is a song called "Slob on My Knob.")

MySpace: "Don't use it. I'd rather interact with people in person." (Although he did tell me he met his girlfriend, Caroline, on Facebook.)

Suicide: "It's a permanent solution to a temporary problem."

Body piercings: "I have enough holes in my body already."

He calls poverty and homelessness "the dark side of democracy" and pledges to do something about it.

When he goes home for break, his mom makes chicken parmesan and apple pie, and his dad—a cable repairman—argues politics with him. Will sums up his relationship with his dad in one sentence:

"My father has always been my number one fan, even if he shows it by being my number one critic."

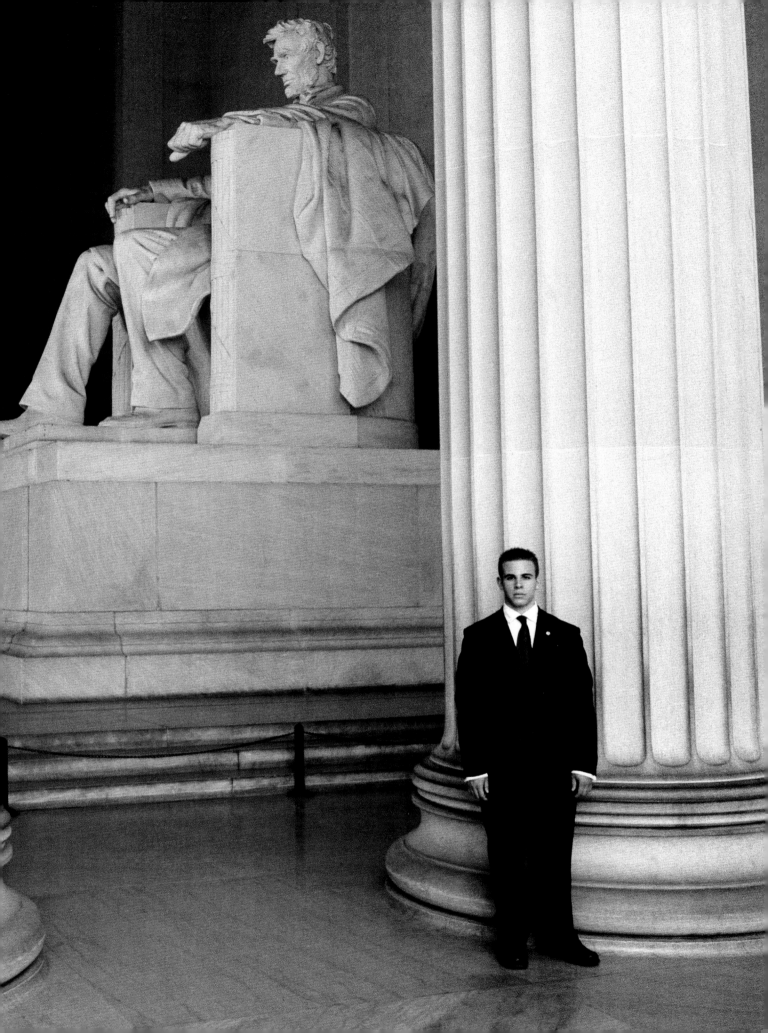

AUDRIANNA

14 ★ NEVADA

At age 13, Audrianna made what she calls a "mistake."

I ask if she's saying that her 1-month-old son, Elijah, was a mistake, and she snaps back, "My son is not a mistake—he is a blessing from God."

"Actually, I'm really proud of myself," she says. "Most of these girls that are 14, they would not be taking care of their baby. They would have put it in a garbage can or they would have had an abortion, you know?"

EVERYONE WANTED HER TO HAVE AN ABORTION.

But she says that babies have a soul starting at 2 weeks in the womb, and she was not willing to kill a human being. She also says she wouldn't put Elijah up for adoption because, even with all the background checks, the new parents could secretly be molesting her baby.

Elijah's dad got sent to Spring Mountain Youth Camp, a prison for teenagers, a month before Elijah was born. The 16-year-old had done a robbery to help finance his rap career.

The only time he's ever seen his son was a week before our photo shoot, at a wrestling meet in Vegas. (The teen prisoners compete in team sports against Nevada high schools.)

Audrianna misses Elijah's dad but says the time is going faster than she expected. He's only in for 6 months, so the family will be together soon enough, she says. She plans to move to southern California as soon as she can, because Vegas is no place to raise a kid.

"A lot of people want to come here because of the lights and the casinos and everything," she says, "but Vegas isn't really all it's cracked up to be."

I ask her what it was like to go to school pregnant, and she says it was horrible. "For one thing, I didn't fit in the desks. For another, people judge you when you're pregnant. They say, 'Oh she's this' or 'Oh she's that.'"

"I understand how you feel" is the biggest lie ever told, according to Audrianna. The only people who really understand her are her friends, mainly guys. "Girls like to talk a lot of mess," she says. "'Oh my God, she was looking at your boyfriend,' they'll say. And I'll be like, 'I don't want to sleep with your boyfriend anyway cuz he's ugly.'"

She says it's time to tune out all the drama now.

She tells me she's got no time for herself any more, and she needs to grow up 10 times faster. "If I didn't have a son," she says, "life would be easier."

Audrianna's grannie helps her take care of Elijah. She doesn't live with her mom, because they don't get along—although her mom is the one who took her to get her tongue pierced a month ago, against Grannie's will.

Her main hopes for Elijah are that he finishes school, stays out of gangs, and goes to college. For now, Grannie takes care of him during the day, until Audrianna can transfer to a high school with day care.

"All teenagers in the whole wide world should use condoms and birth control," she says. "If you don't, you're not gonna sleep, you're not gonna party, and you're not gonna get a good education."

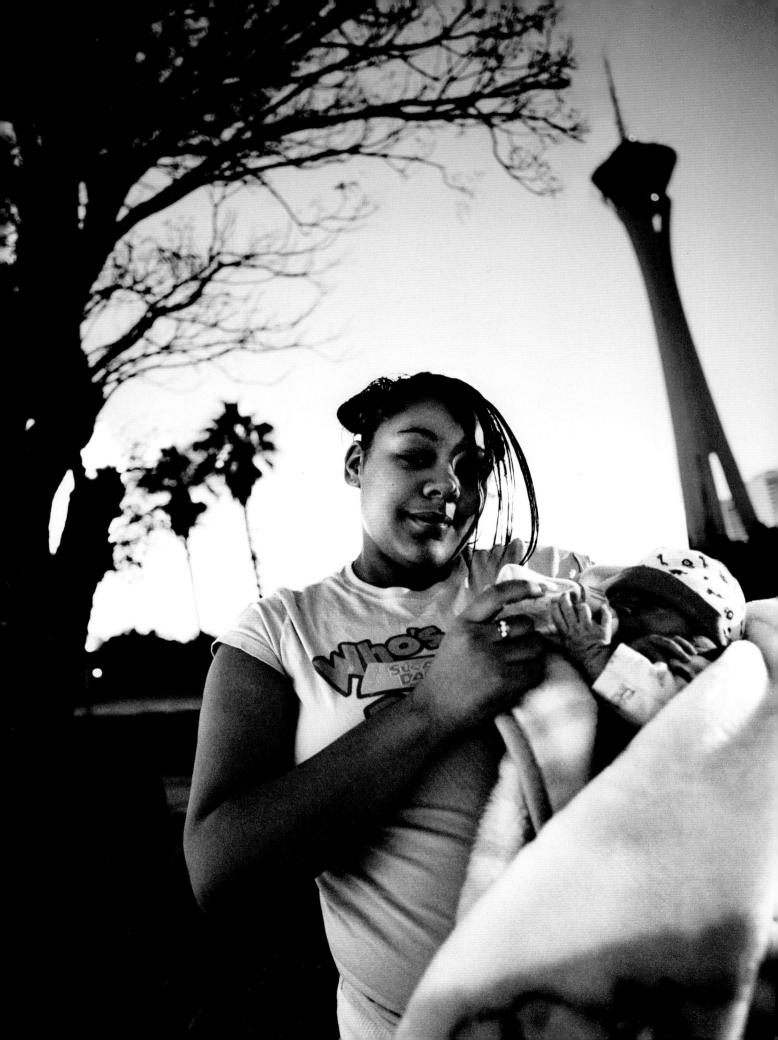

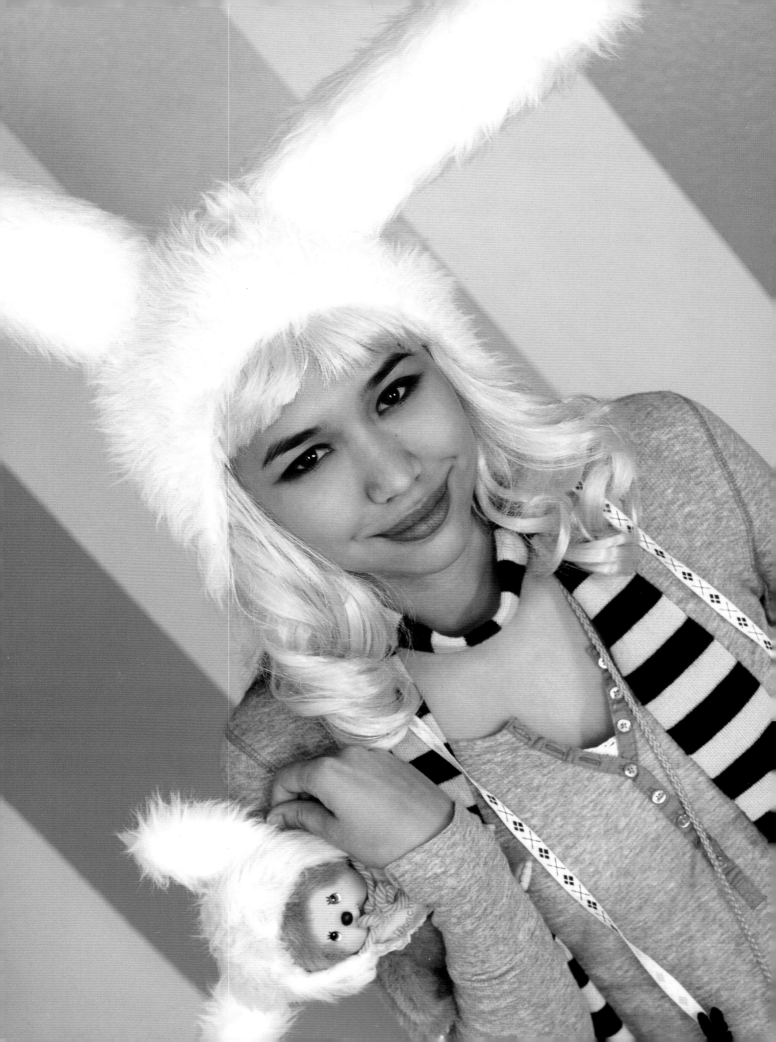

KAMMIE
18★ LOUISIANA

Fuzzy ears, anime conventions, video games, and *cha-lua*. For 18-year-old Kammie, a college freshman in New Orleans, these are the four pillars of existence.

"YOU GUYS HAVE NEVER HAD CHA-LUA?!?"

It's the Vietnamese interpretation of Spam, and she's shocked when we tell her we've never tasted it.

Google *cha-lua* and you'll quickly find your way to Kammie's MySpace page. She and her friends—all younger than Kammie—have made up a song about this packaged substance that's mostly minced pork, potato starch, and fish sauce.

But that's not their only obsession.

They go out in public wearing big fuzzy ears that Kammie makes on her mom's sewing machine. She calls it "cosplay," short for costume play, and tells me it's big in Japan, where it's known as *kosupure*.

"Basically, the idea is that every day is Halloween and you dress up as your favorite anime, manga, or J-pop characters."

The fuzzy ears Kammie makes are replicas of the ones worn by J-pop megastar Kana. Kammie saw the ears on a Kana CD cover and decided she would bring them to America.

"Sometimes people get really mad at us for wearing them. We went to a mall once and security made us take them off. They said they were costumes, and they don't allow costumes."

At anime conventions like Oni-Con and MechaCon, no one gets mad at them for wearing fuzzy ears or dressing up as characters from Final Fantasy 12—which Kammie describes as a "role-playing game."

Suddenly, in the middle of our photo shoot, Kammie and her six friends (who have been watching us work) all start a loud, weird chanting. It's somewhere between a burp and a bleep, over and over, in unison. The bewildered response they get seems to satisfy them.

Kammie doesn't like talking about serious things. And she doesn't really want to talk about life "before the hurricane."

Kammie was in Lafayette at MechaCon when Katrina hit. But she wasn't worried because this happened every year and the flood never came.

Her whole family was staying at her aunt's house in Dallas when the levee broke. All she could think about were her two kittens, Shiny Black and Milo. Every day for weeks she checked Petfinder.com. Eventually, she accepted that they were gone.

A month passed before Kammie and her family returned to the remains of their house, and they were shocked to hear Shiny Black's meow from the rafters. Somehow, the kitten had managed to survive.

Over a year later, the black cat watches from a safe corner of Kammie's bedroom as Kammie and her friends, all wearing fuzzy ears, bleep and sing about *cha-lua*.

TITUS

18 ★ IDAHO

One slice of dry toast for breakfast. A small bag of peanuts for lunch. A piece of chicken and some peas for dinner. And water. Nothing else.

Titus ate this way for months. In eleventh grade, the coach wanted him to get down to the 145-weight class. He also had to do sprints and push-ups wearing five layers of clothes and sit in the sauna for half an hour a day.

"It sucked," Titus says. "I felt small, weak, and frail."

Everyone in school knows Titus as a goofy, funny guy who's always bouncing off the walls, high-fiving people he doesn't know in the hallway, and making people laugh in the cafeteria.

But he started to feel tired all the time. And the big problem was that he didn't like the way he looked in the mirror. He thought getting lean was going to give him ripped abs and definition, but it didn't. He could put his hand all the way around his bicep and that freaked him out.

We're here in the wrestling room with Titus and a few teammates, and he's back up to 160 pounds, the weight he's meant to be. Titus flexes for the camera, just like he does in front of the mirror at home.

It's not like he does a whole posing routine in his room. "I get out of the shower and give a good flex in the mirror, that's all," he says. Sometimes he likes to show off next to his 14-year-old brother, Chase, comparing biceps, but Chase doesn't care; he's a skinny skate kid.

Titus also plays football, but he says he's too small to be any good. He says he'll be at a party talking to people and he'll notice that everyone else is taller than him. "If I had two more inches, I'd have a full-ride scholarship for wrestling or football."

"Put my size body in a 6-foot person, and I'd be an animal."

Some girls at school think Titus already is an animal. "Every hot girl at my school is preppy, and they're just too stuck-up for me," he says.

When Titus decides he wants to meet a particular girl, he ditches his usual skater/jock look and borrows a shirt from his preppy friend Brian down the street.

"He's way preppy. He throws me a shirt that's all tight, and my muscles are showing. I spray some of his cologne, so I smell the way the girls like it."

Last year, Titus wore a preppy shirt to pottery class to meet a girl, and it worked. He was with her for 4 months but then broke it off because "it was like we were married."

Although Titus is a jock he also skates and snowboards. "I'm an adrenaline junkie," Titus says.

“ANYTHING THAT INVOLVES ME GETTING HURT IS AN ADRENALINE RUSH FOR ME. ”

His dream career is to be a smoke jumper—a firefighter who skydives into forest fires. I tell him that sounds ridiculously dangerous, and he tells me that's where the adrenaline comes from.

Titus calls wrestling "civilized fighting." The handshake that starts a match is the first surge of adrenaline, because that's the first hint of what you're up against.

"The real rush comes when you pin a guy. The moment the referee raises your hand, nothing beats that."

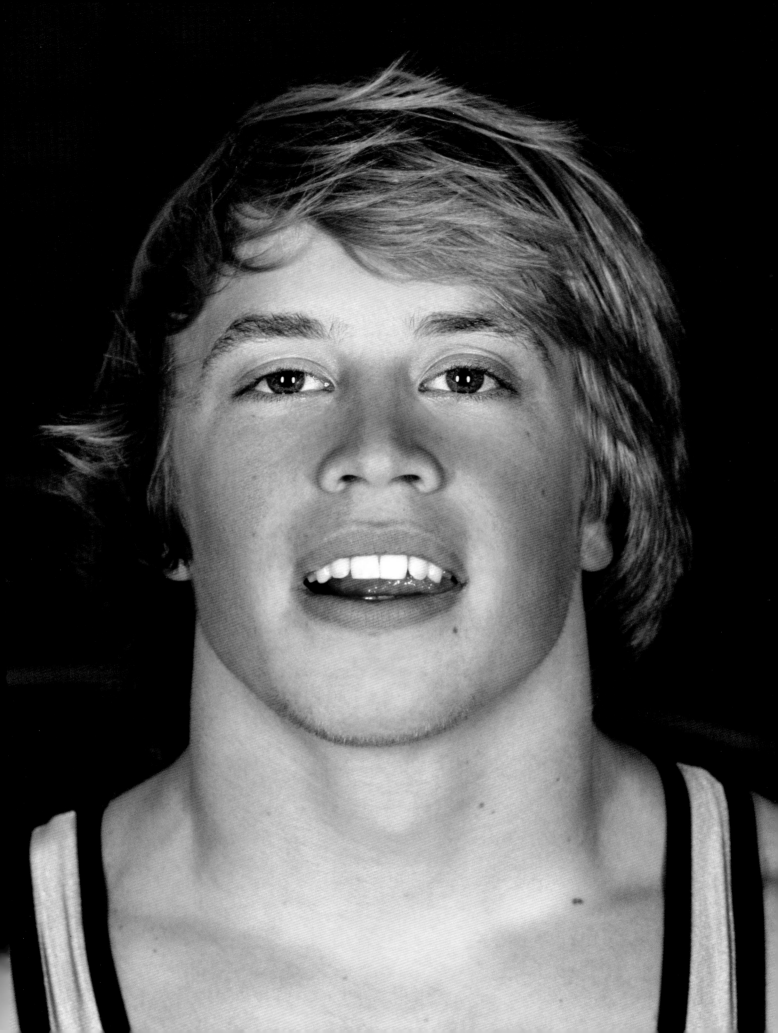

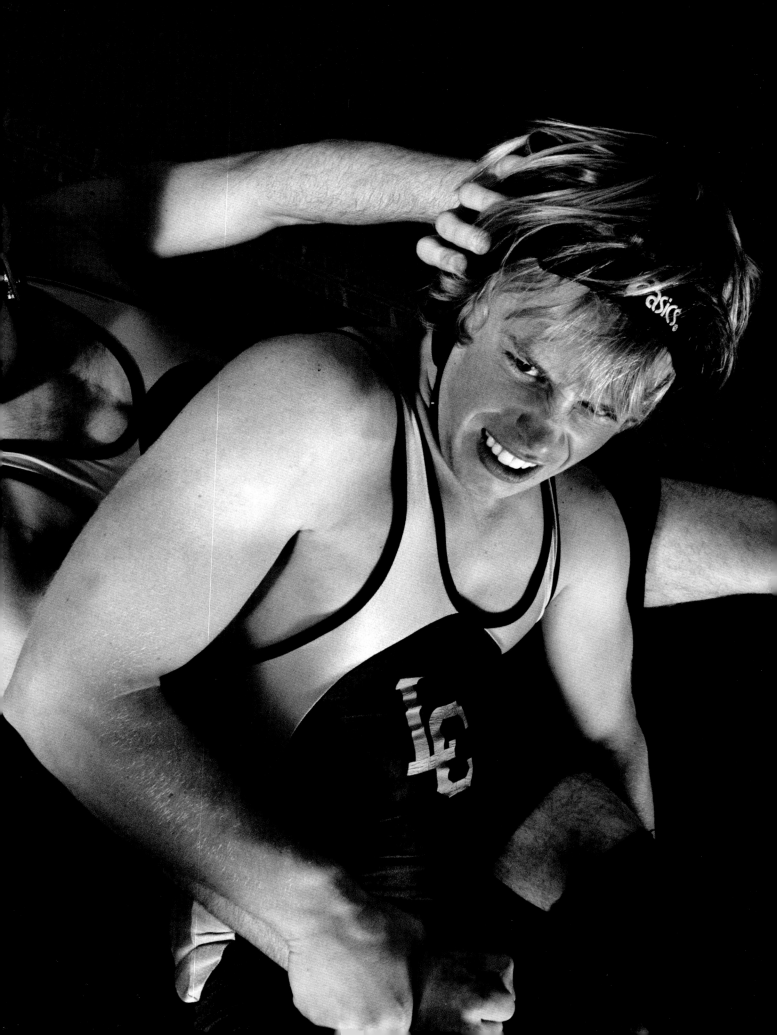

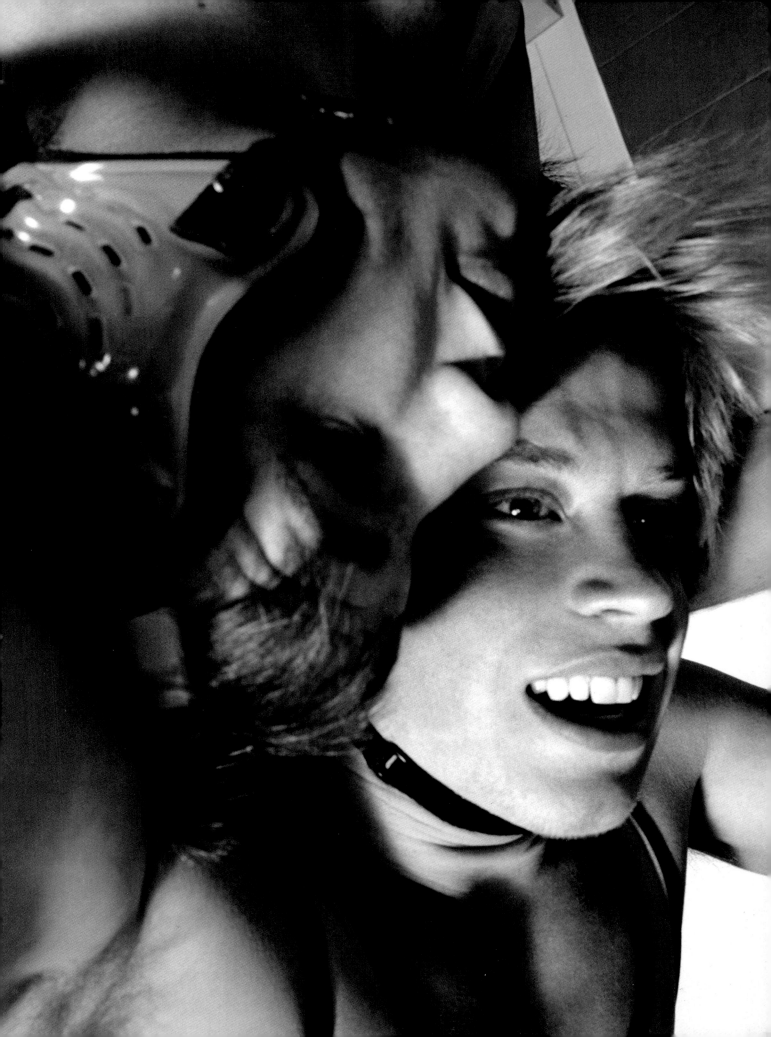

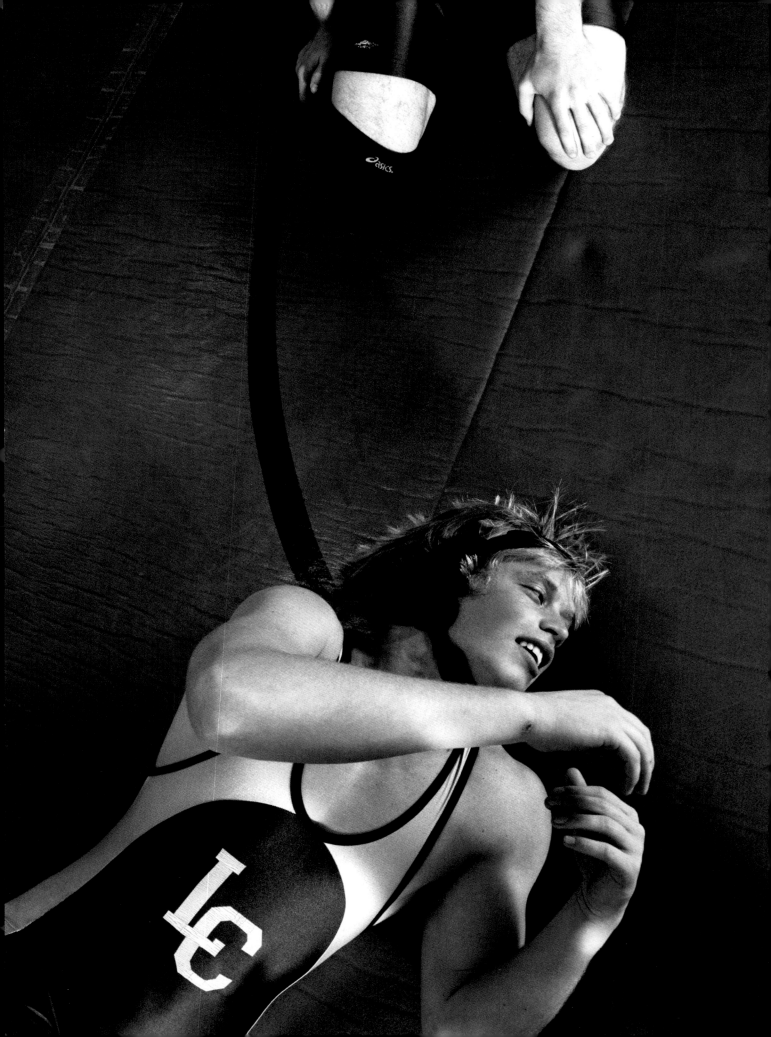

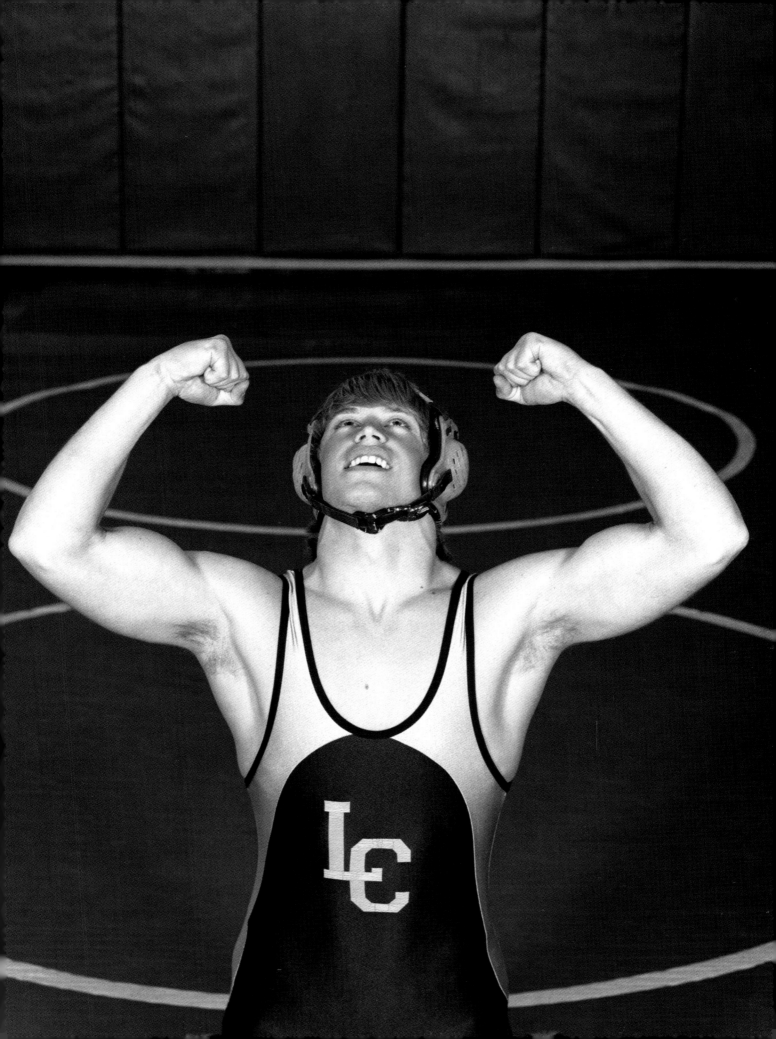

LIANE
18 ★ RHODE ISLAND

All of Liane's hair fell out in seventh grade.

When she was little, Liane was a total tomboy. She started getting into girlie stuff like makeup and lip gloss in middle school, but that's also when she started to get really stressed out about school and boys.

The doctors told her she had an autoimmune disease caused by stress, and it had no cure. She had to bring a doctor's note to the principal's office to get a special exception to the school's no-hat rule.

"It was hard," she says. "Seventh grade is when you're going through puberty and starting to make friends. For a girl that age not to have hair, it was huge."

"My big insecurity had always been my teeth," she says. "And I didn't wear shorts for a whole year, because my cat had fleas and I'd have like 70 bites on both my legs. They all got scarred, cuz I scratched them at night, and it wore me down."

Liane says her hair grew back by eighth grade after she'd bottomed-out.

She says she'd sit alone in her room and let her emotions out through art and poetry.

"I just decided to be me. I didn't want to be a part of any group. I wanted to see how people would react to me not lying, not putting on a mask to fit in."

The result was that she felt better but didn't have a lot of friends.

Liane remembers sitting in the cafeteria with a table full of girls who were making fun of her, and it really upset her. Now she realizes they were just jealous of her for not having to work so hard to be cool.

When Liane was 14, she started dating a 24-year-old who lived next door. For 3 years, she kept the affair a secret from her parents and friends because she knew it was taboo—and illegal.

At the time, the age difference didn't seem like a problem. "I was all into the Backstreet Boys and N'Sync, and they were in their twenties," she explains.

"It just seemed right."

After 2 years of therapy, Liane now realizes that it wasn't a healthy relationship. "I wasn't happy, and I didn't know why," she says. "He took away my voice and didn't let me think for myself."

Back then, Liane wrote poetry and never let anyone see it. "I wrote about letting my soul roam free," she says.

❝ I DIDN'T WANT TO BE IN MY BODY ANYMORE. ❞

"I wasn't really thinking about suicide," she says. "I just wanted to be loved and taken care of."

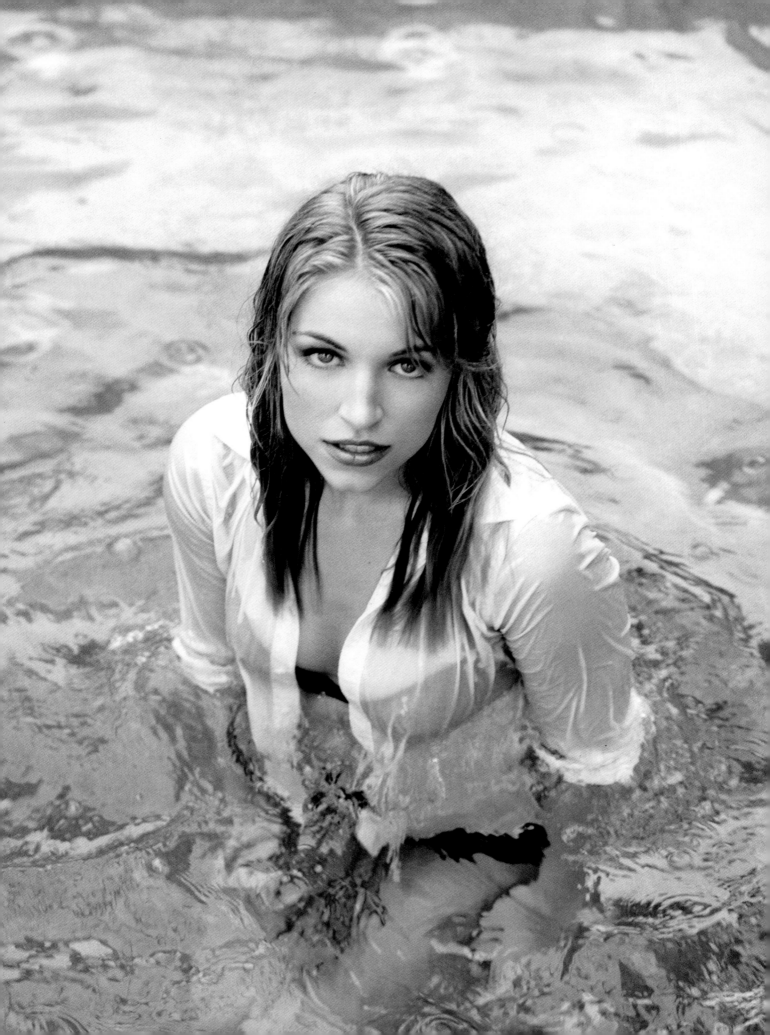

JACQUELINE
19 ★ OHIO

"GOD MADE ME EXACTLY THE WAY HE WANTED ME, AND I'M GOING TO FLAUNT IT."

Jacqueline is proud and confident. She has a bubbly, outgoing personality that attracts people everywhere she goes. She says self-confidence is the key. "If you walk around saying 'I wish I was skinnier,' people are going to see right through that."

"If you walk around with your head held high, trying to accentuate all your good qualities, that's what people will see. You need to have confidence, or no one will have confidence in you."

Jacqueline has no problem making friends. She says her high school wasn't a place where skinny cheerleaders were the top of the social pyramid. In fact, a lot of the cheerleaders were on the heavyset side, she says.

Her school was in the country but not far from the city. She thinks that may be one reason the kids were easygoing and accepting—rather than closed-minded and cliquish.

"There will always be people who are judgmental," she says. "People will look at you and say you're not as pretty as the supermodels in the magazines. But not everyone was meant to be skinny—genetics plays a big part."

She thinks it might be better if everyone were blind, and they could get past appearance to see you for who you really are.

Jacqueline looks to God to help her understand what she's meant to be.

She's now a sophomore at a Lutheran university in Columbus. Before college she was a deacon in her church and that's when she began to focus her life on helping others. She volunteered in a shelter for pregnant teenagers, where she was horrified to see an expectant 9-year-old girl and a 10-year-old who already had a baby.

"I'm against abortion in most cases, but when a little girl has been raped by a family member or a foster parent, you have to do what's right for the girl."

The high point of her teen years was a mission trip to Nicaragua, where she worked in orphanages, playing with the kids and doing odd jobs.

"The first thing that hit me was how extreme the poverty was. Driving through burning trash and dead cows in the street. People walking around naked. Kids eating out of garbage. We were there to do what we could to make a better life for people."

Jacqueline defines success in life as "being able to help as many people as you possibly can." When she finishes college, she wants to open an international adoption agency in Chicago, so she can help find loving homes for babies from overseas.

"What it all comes down to," Jacqueline says, "is that everyone deserves compassion and acceptance."

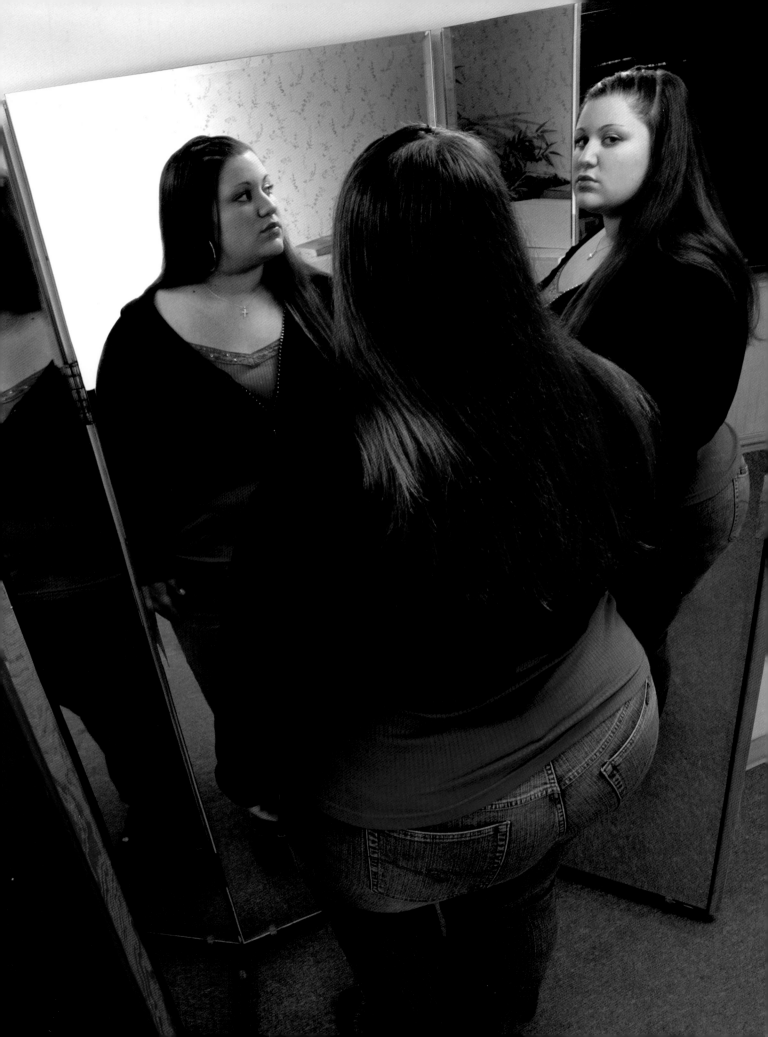

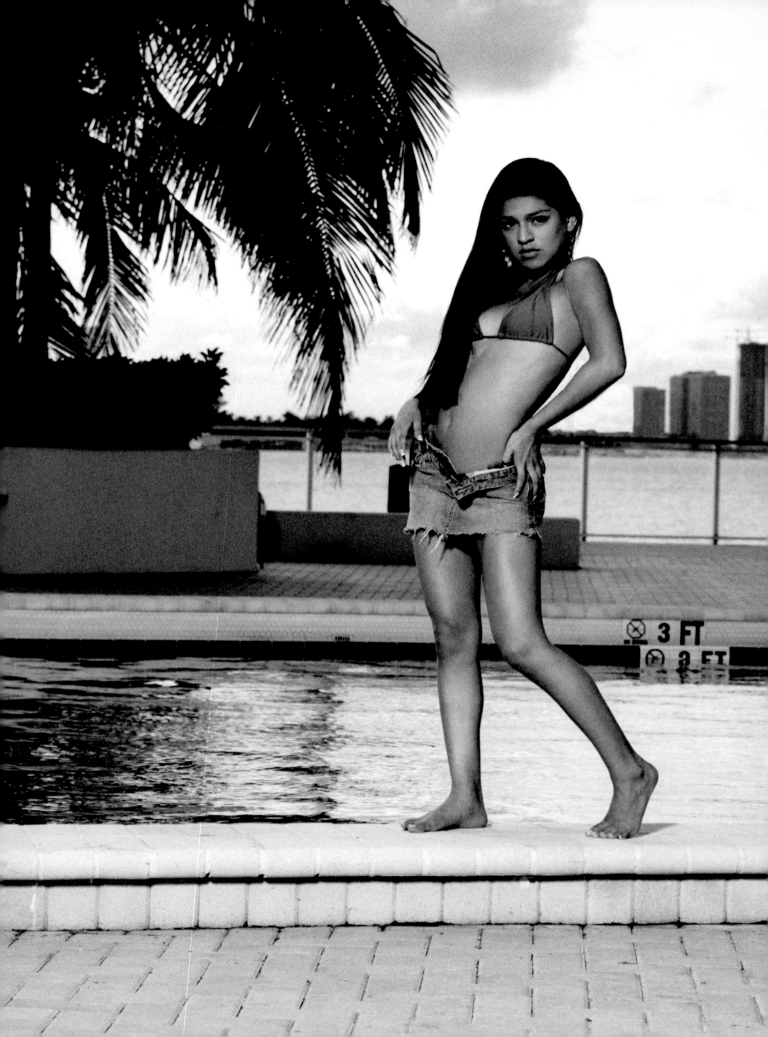

ALESSANDRA
18 ★ FLORIDA

Alessandra is a sophomore psych major at Miami Dade College. She's also an Ice Dancer for the Florida Panthers hockey team.

HER FAVORITE THING TO DO IS "SEXY DANCING" IN FRONT OF 20,000 PEOPLE.

During half-time at every home game, she and 14 other young women dance on a platform above the ice wearing little more than bikinis and tall white vinyl boots.

We're in South Beach, 40 miles south of the hockey stadium, and Alessandra says she wants to take some sexy—but tasteful—pictures. She's lived here since her parents brought her from Peru when she was a baby.

Alessandra's mom is a school teacher, and her dad works for the school board. They raised her to understand the value of education. Her plan is to be a school psychologist counseling kids in kindergarten through sixth grade.

The dancing is just a way to make money, she tells me.

One hundred thousand people in Miami live below the poverty line, but you don't see them on Ocean Drive in South Beach. Alessandra says she doesn't like all the rich people who are unhappy because the other rich people have nicer cars or bigger yachts.

"Don't get me wrong," she says. "It's good to have money. If I had money, I'd have a Bentley and shop at Gucci and Fendi all the time."

I ask if she'd have a chauffeur, and she says she'd drive it herself. Then she indulges in another moment of fantasy and says, "No, I guess I'd need a driver."

"It's really hard to park here."

ANDY
17 ★ NEW YORK

If a nuclear bomb was heading for New York City, Andy says he would stay.

Then he reconsiders and says he'd leave so that he could come back to rebuild it. Andy loves this city so much that his rap name is AND·Y, which sounds a lot like N·Y, especially if you talk as fast as he does.

AND·Y is also an acronym. It stands for Andy Naturally Dominates You.

He lives in East Harlem and carries two switchblades. "There's always some crazy asshole who's trying to rob you," he says. One time, he had to pull a knife on a guy who was trying to steal his jewelry. (Andy wears $2,000 worth of "ice": gold, onyx, platinum, and diamonds.)

"The guy kept his distance," Andy says.

66 NO BLOOD WAS SHED. 99

He's only stabbed a couple of people. The first one was his godbrother, but it was with a penknife. "He didn't die or nothin'." The second one was this Asian kid in class who kept on saying, "Go ahead, stab me in my hand." Andy obliged, and he says it was no big deal. The kid kept quiet and just poured some peroxide on his wound.

Andy is a gangsta rapper, but he also sings love songs. "Sometimes you feel hate and sometimes you feel love," he says. The gangsta rap comes out when he feels like the world is against him.

Andy knows a lot of genuine gangstas. He's close with his 23-year-old cousin, who just got sent to prison. He says his cousin made $80,000 last year doing armed robberies and even got in the newspaper. He went around the city holding up cell phone stores with a Glock 9.

I ask Andy if he would ever do that, and he says he doesn't get ideas like that. But he likes doing "crazy shit," so he probably would have gone along if his cousin had invited him.

Like all gangsta rappers, Andy talks about himself as the kind of guy who commits violent crimes, even though he doesn't. He spends four hours a day online promoting himself, and he's proud of the 13,000 plays his tracks have gotten on MySpace.

He thinks that he'll be discovered online, but he knows he needs to pound the pavement with his mix tapes (which are actually CDs). "Someone will have a cousin who's like A&R for Def Jam," Andy explains. "It's just six degrees of separation, you know?"

The mix tapes sell for $5 a pop, but once you pay for the album art and everything, there's no real profit. On MySpace, you can download his songs for a buck each.

If Andy gets as big as his idol Jay-Z, he'll get a brownstone in Harlem, to keep his roots. He'll also have places to crash in Miami, Paris, and Hawaii. He says he'll fly to New York to get his hair cut.

In the meantime, he earns a living by selling knives. Before his cousin got busted, the two of them found this great deal on TV—200 knives and swords for $200.

Andy says he was a "bad kid" in school who disrespected the teacher and made the other kids laugh. He dropped out last year to focus on his music career.

"People go to school out of fear, not love," Andy says. "People think if they don't get a diploma, they won't make it in life."

"That's bullshit." Andy says he'll just keep hustling till he makes it.

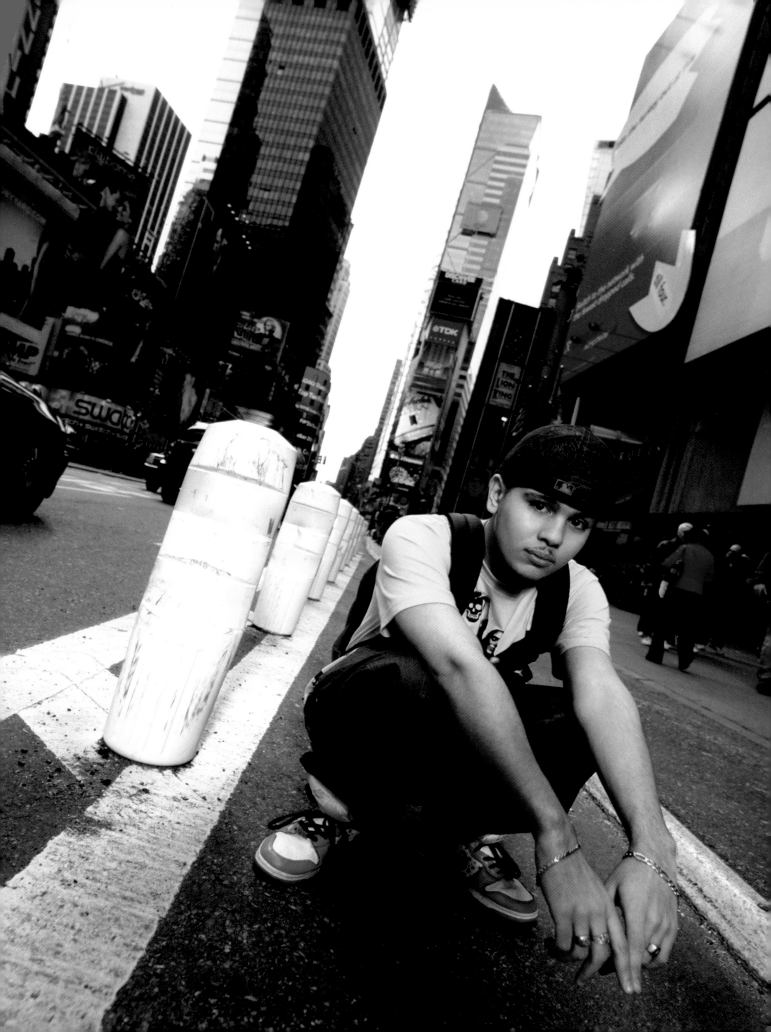

GRIFFIN

16 ★ COLORADO

Griffin can't hear a word I say to him, and he doesn't want to.

I ask him if he would snap his fingers to have perfect hearing, if he could. "What you're saying is sacrilege," he tells me, with the assistance of a sign language interpreter. "Being deaf is not a flaw; it is a blessing."

Both of Griffin's parents are deaf, so they understand. But deaf children of hearing parents have a hard time, he says. Their parents always want to "fix" them with cochlear implants or other controversial procedures.

66 IT'S LIKE THE PIGS IN ANIMAL FARM, PRETENDING TO BE SOMETHING THEY'RE NOT. 99

He says we can call him deaf, even though, technically, he's "hard of hearing." When people talk, he does hear sound, but it's all "human gibberish—just distorted voices."

He spends half his day here, at the Colorado School for the Deaf and Blind, where he feels comfortable, surrounded by "deaf culture." But he also attends a mainstream high school, which he says is miserable.

For the most part, he is invisible there. What really gets to him are the "denied glances." When people do notice him, it is more often with a look of pity than with one of respect.

Griffin tells me a story of waiting outside his school for the bus. "A kid comes up and shouts in my ear, and I mean he yells—not in a friendly way—'Can you hear me?'"

"It was almost obscene, the way he tried to blatantly provoke me. Thankfully, I kept my temper reined in. I turned to face him, made eye contact, said, 'Thanks for the free hearing exam,' and stepped onto the bus."

Griffin is a gifted student, with a genius-level IQ. But life outside the deaf community is not easy. "People consider me wasted effort," he says. "So I try harder academically, because that's the only way I know to prove them wrong."

His only hearing friends in mainstream school are outcasts. "I am an outcast, myself," he says, "but I choose to be. I don't want to put my heart out there and have it brushed aside."

The last time that Griffin tried to fit in with the hearing kids was sixth grade. "I had to keep a false smile plastered on my face, chuckle at jokes I could not hear, and try to follow up with my own jokes, even if I couldn't stay on topic."

At the end of that year, he decided to stop pretending.

"There is no cure for deafness," he says. "The cure is not to fake being able to hear—but to embrace deafness, because it is not a problem at all."

Being deaf is at the core of Griffin's identity, and he says he would be less confident and less capable if he could hear. "I love being unique," he says. "I have no idea how I'd survive just being another face in the crowd."

Griffin plans to grow up to be a snake scientist. "I like snakes because they seem to be untouchable," he says, "and they are extraordinary examples of evolution."

I ask if there's anything he's afraid of, and he has to stop and think. "Yes, one thing," he says.

"I am afraid of the dark, because it represents all things unknown in my life."

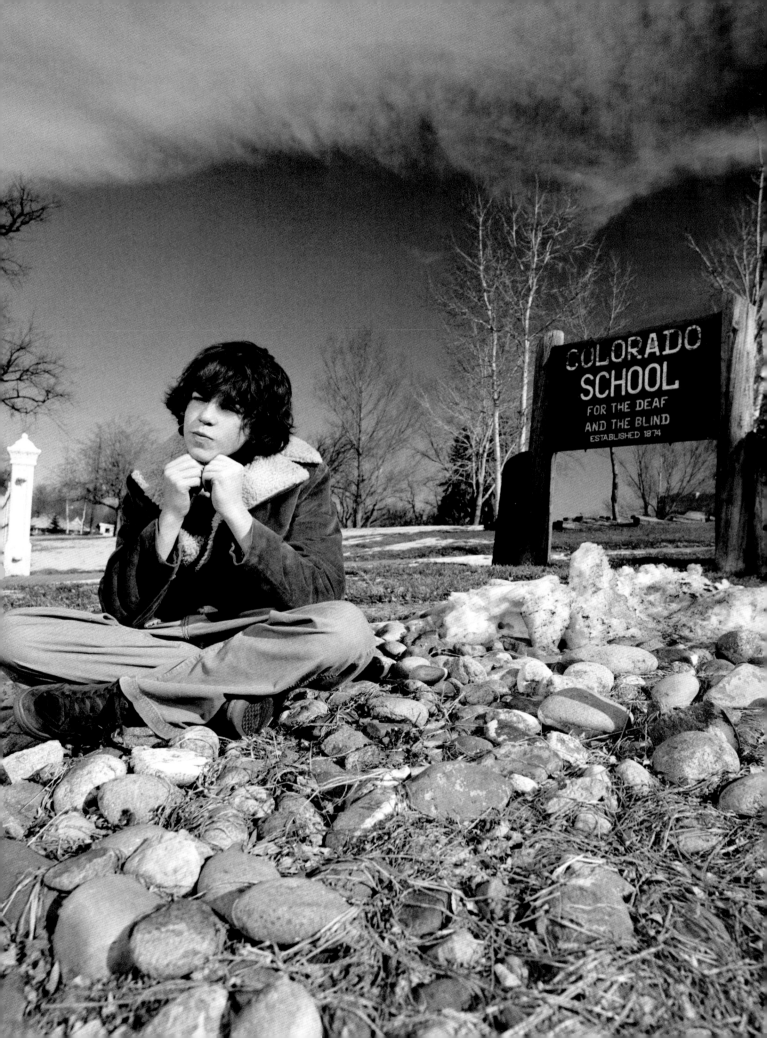

RAYNE
18 ★ ALASKA

Rayne says we can call him an Eskimo, even though that word offends a lot of Native Alaskans.

"*Eskimo* means a person who eats raw meat," Rayne tells me. "The white man came here a long time ago and saw us eating raw lamb and called us all Eskimos."

We're at the Alaska Native Heritage Center in Anchorage, where Rayne works part-time as a "cultural host," answering questions and giving tours.

He tells people all the cool facts about Alaska: Like if Alaska was a country, it would be bigger than 90% of all the other countries in the world; or if you put the westernmost point in Alaska on top of San Francisco, the state would stretch to Jacksonville, Florida.

He hates when people ask stupid questions. "People ask me if I live in an igloo," he says. "And they ask if I know what a TV is."

Rayne says he is a Native Alaskan, but he's also an American.

His mom is half Yupik, which is one of the two Eskimo cultures. "Not all Native Alaskans are Eskimos, so you have to be careful with that word," he says. "But I am an Eskimo."

When other Natives meet him, however, they aren't always friendly. "When I started working at the Heritage Center, they thought I was like a gangsta thug."

Rayne likes to dress "casual but a little flashy," wearing hip-hop brands like South Pole and Sean John. He also has a big collection of NBA basketball jerseys. And his iPod is filled with rappers like Ludacris and 50 Cent.

66 THERE'S A LOT OF DISCRIMINATION AGAINST THE NATIVES. 99

The other day, a friend of his said he didn't want to hang out with someone who looked Native. "I said, 'Hey, I'm Native!' and he said, 'It's okay, you don't look Native.'"

There are classrooms at school that are just for Natives at lunchtime, but Rayne doesn't feel welcome there. "They don't like people who are popular."

Rayne doesn't like how much the other kids in school drink and smoke weed. "My parents raised me to believe that stuff will slow you down and mess you up."

One out of four Native Alaskan teens drinks alcohol regularly, and problems like fetal alcohol syndrome, alcohol-related suicide, and domestic abuse are rampant in the state.

"In seventh grade, I made a pact with my best friend, Ryan," he says. "If either one of us ever touched alcohol or drugs, we'd beat each other up so bad that we'd never do it again."

Everyone else in school goes to "the pit"—a big dugout next to the faculty parking lot—to smoke weed at lunchtime. Rayne says he's never set foot in there and doesn't plan to.

Rayne is not actually a Native name, he tells me. When his mom was pregnant with him, his dad was in the army and was supposed to go fight in the Gulf War. He decided not to go, and his best friend went ahead without him. The friend—an African-American man named Rayne—died in combat, and the name is a tribute to him.

Rayne is proud that his name preserves the memory of his father's friend. He says it's important to respect and learn from those who came before us. That's why he works in the Heritage Center.

Rayne plans to leave Alaska for college. "But this is where I'll live for the rest of my life. This is where I'm from."

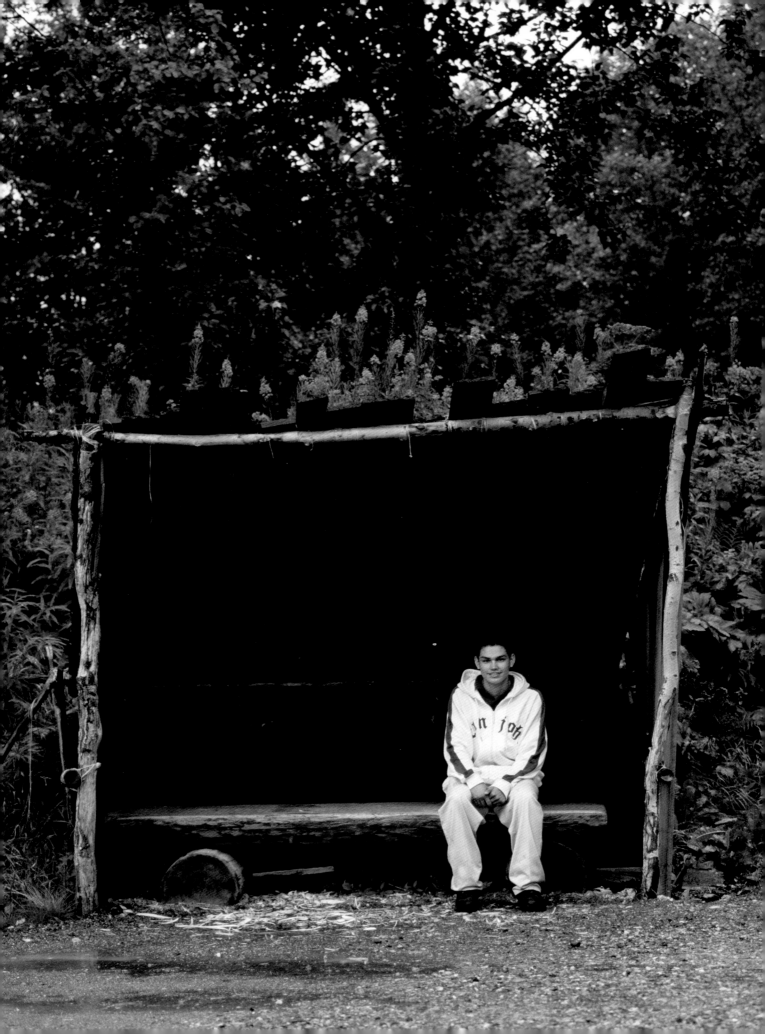

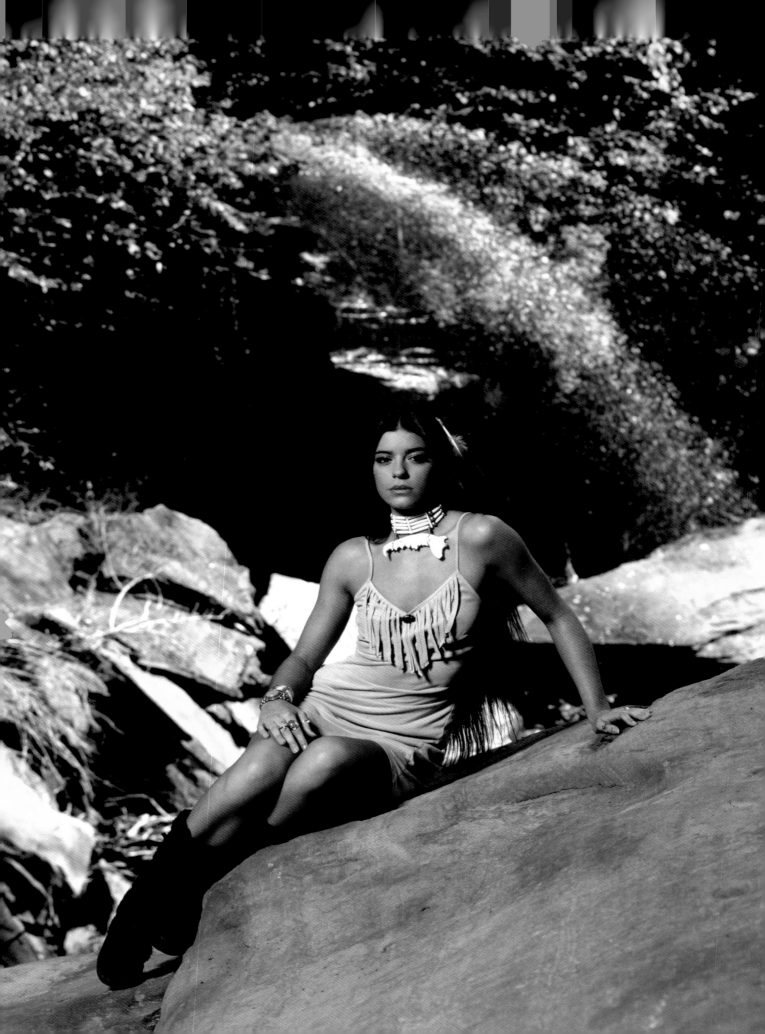

KIMAMA
19 ★ OHIO

We're in the living room of her suburban house near Cleveland, playing with three shih tzus, and her mom says it will just be another 10 or 15 minutes before Kimmie comes down.

Kimama (pronounced kim-*may*-may) is the Shawnee word for butterfly, and that's what she tells everyone to call her. Her dad, who is half Native American, gave her the name when she was little.

Over and over, we roll a tennis ball on the hardwood floor, and the tiny dogs fight over who will carry it back to us. After 45 minutes, Kimama emerges in full makeup.

This is the way she dresses every day of the year, and she's the only one in her family to dress this way.

❝I PRETTY MUCH ALWAYS HAVE A FEATHER IN MY HAIR.❞

At school, people called her Pocahontas, but she didn't mind; she liked being compared to the Disney character.

We drive a few miles to a stunning waterfall. "God made everything perfect," she says. "He doesn't make mistakes."

Kimama says she has a closer relationship with Jesus Christ than anyone else in her family. It began when she was 5, even before she was baptized.

Her mom was sitting on the couch watching Billy Graham. "I pointed at the TV and said, 'Mommy I want that. I want Jesus in my heart.'"

Since then, God has guided every decision Kimama makes. Like when her fiancé started trying to change her—telling her to be less shy. God told her that he was not the right man for her.

We spend hours taking pictures under the waterfall, and I ask if she would let me shoot a few rolls without the heavy makeup. She seems stunned by the suggestion. Not even her boyfriends get to see Kimama without makeup.

In sixth grade, she was infatuated with a boy named Timmy. Her friend called Timmy and said, "Kimmie likes you. Will you go out with her?"

He said, "No, because she doesn't wear makeup. I might go out with her if she wore makeup."

"That traumatized me for the rest of my life," Kimama says. I remind her that she said God made everything perfect. She laughs. "I knew you were going to say that."

"I guess I just need to get over it."

KIRSTEN

18 ★ UTAH

Kirsten would love to have a hot punk chick for a girlfriend.

> ## "I LIKE GIRLS CUZ THEY'RE GIRLS. I DON'T LIKE GIRLS WHO TRY TO BE BOYS."

Kirsten has strong opinions and isn't shy about voicing them. She likes all animals except sea cows. She doesn't like Big N' Tasties. And she hates her dad.

Sometimes when she sees her dad, she has flashbacks to dark times in her childhood. She has relived the worst moments of her childhood hundreds of times.

She tells me about waking up to her father beating her and her sisters with a belt. "One of my sisters was giggling," she says, "and my dad didn't like it. He came in yelling 'Shut up!' Shut up!' and swinging his belt."

It was dark, and he couldn't see where he was hitting. The next day, the girls had bruises all over their bodies and faces.

Another time, when Kirsten was 4, she heard her dad screaming at her 10-year-old brother in the living room. She walked in and saw him holding her brother against the wall by the neck. She remembers seeing her brother's feet dangling above the floor while her father choked him.

"My parents were getting divorced the whole time I was growing up," she says. "They got divorced and remarried seven times."

Her dad, an aircraft inspector for the air force, would go too far, and Kirsten's mom would end up in the hospital. They'd get divorced, and her dad would be gone for a few months.

Then he'd appear on Christmas with lavish gifts—like a fancy laptop computer for Kirsten and an envelope of cash for her mom. By January, they'd be married again.

Kirsten tries to tell her mom that he'll never change, but she doesn't listen. Her mom always needs the money. Kirsten has five brothers and three sisters, and her mom's been on disability her whole life.

Starting when Kirsten was 7, the whole family attended weekly group therapy sessions. "We'd all talk about the abuse, and he wouldn't admit anything," she says. "He'd say, 'I'm sorry if I hurt you.'"

She thinks the group therapy was useless but credits the individual therapy she started 2 years ago with saving her life. "I used to be a bad cutter," she says, "and my therapist helped me develop self-control."

Some situations are still hard to handle, like when any man gets angry anywhere near her. "I'll start to shake and I may even black out," she says. "I try to stay away from angry men."

Kirsten says that high school was her refuge. She loved every minute she could spend away from home, and she learned to make new friends quickly because her family kept on moving, sometimes with her dad when he got transferred, and sometimes to escape from him.

Kirsten wants to marry a nice girl and have a family—but definitely not in Utah. She plans to live far away from her dad and the Mormon church.

For her whole childhood, her mom forced her to go to church, and she hated hearing them talk about how it's sinful to be gay. She still believes in God, just not the Mormon religion.

"I believe in heaven and hell," she says. "My dad will go to hell, for sure. And my mom will go to heaven. That's the only way she'll get away from him."

ASHLEY
16 ★ CALIFORNIA

Life in Beverly Hills is exactly what it looks like on TV, according to Ashley.

Clothes shopping is a major pastime for Ashley and her friends. It's really more of an obligation that comes with popularity.

"PEOPLE SAY WE'RE SNOBBY RICH PEOPLE, AND IT'S KIND OF TRUE."

Ashley says some girls will show up at school wearing "just, like, a T-shirt and blue jeans," and those people don't have a lot of friends. She says those are "farm people" or something.

"Everything matters—what you're wearing, how your hair is, what brand your jeans are." She says you need to wear what's in style right now—not what was in 2 years ago.

"We pretty much base our fashion on what famous people are wearing," she says. She and her friends comb through piles of magazines for paparazzi shots of celebrities. "It's like 'Oh, that's what they were last wearing when they were walking on Robertson,' and we'll go get the hot new pink Burberry scarf or whatever it is."

Cars are a key fashion accessory for students at Beverly Hills High. The student parking structure is filled with hundreds of BMWs, Range Rovers, and Land Rovers. Ashley wants a Lexus RX, but her mom thinks a BMW is more practical.

"We live in Beverly Hills," Ashley explains. "We need to have the best cars."

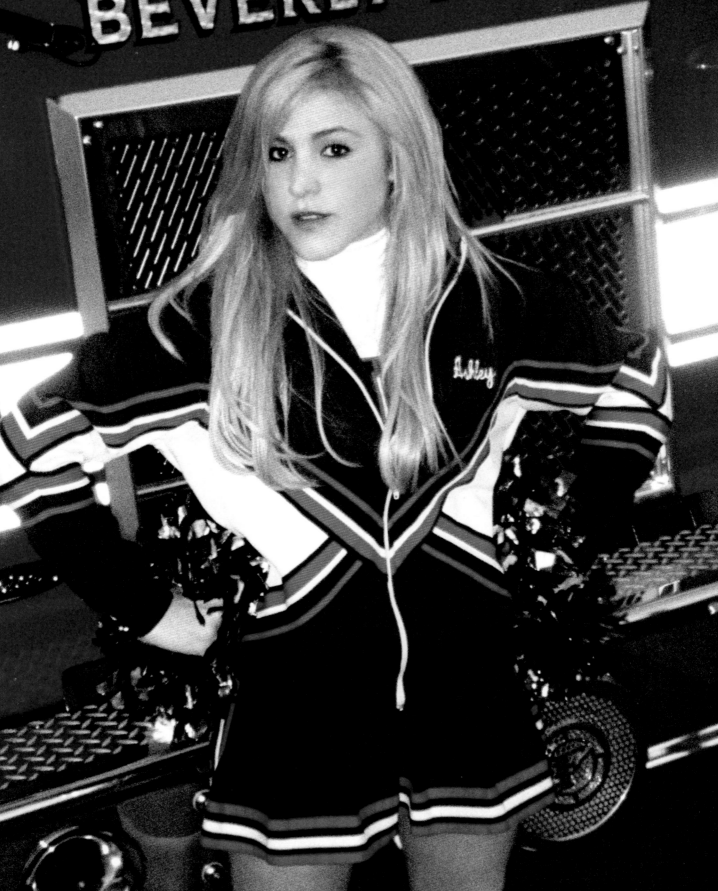

CHUCKEE
11 ★ GEORGIA

The only time Chuckee shows up to school these days, according to his dad—a fast-talking southerner who goes by Big Man—is to make "guest" appearances and sign autographs.

Big Man says Chuckee's homeschooled now, because public school's "too dangerous." Chuckee says it's because school kept getting in the way of his career.

" THE CHILDRENS, THEY BE ASKING FOR AUTOGRAPHS. I BE SAYING IT'S NOT THE TIME, NOT WHILE THE TEACHER IS TEACHING. "

Chuckee's clear on his priorities: first God, second education, third family. He's confident it will all work out for him if he stays focused on the Lord and his studies.

"I gonna be a rap star," he says. "If the rap career don't work out, I gonna be an actor. If the actor business don't work out, I gonna be a professional basketball player."

I ask what he's in it for, and he tells me it's "the children."

"I want to change it around and be positive for children, not violence and cussing and all that. I want the children to look up to someone."

Chuckee, whose real name is Rashad, tells me his parents say he's mature. "I'm above my age," he says, looking over at Big Man, who gives a nod of approval.

TRAVIS
17 ★ ARKANSAS

Travis (AKA MC Phate) goes to all the battles—and usually wins. All over Little Rock, he's known as the "white rapper battle guy." Still, Travis doesn't know why anyone needs to say *white*. It's not about the color lines anymore.

He works weekdays in a bowling alley but lives for the weekend battles. "They're all *8 Mile* lookin' shit," he tells me, referring to the movie starring the most famous white rapper of all time.

Like Eminem, MC Phate is mainstream—not underground. He tells me to check out his tracks on MySpace and I'll understand.

MYSPACE HAS CHANGED THE MUSIC WORLD BIG TIME.

No one records demo CDs anymore because all the A&R guys are online. "You just gotta get the street buzz first," he says.

The hip-hop scene where Travis lives is 80% black, and a lot of teenagers are using the word "wigger." But not Travis. He says it's offensive. And he definitely would never use the word *nigga* in a rhyme.

"It's not the fuckin' 1970s," he says, "all that racial profiling and shit."

KATY

17 ★ VIRGINIA

In Katy's favorite video game, Gears of War, you can slice your enemies in half with a chainsaw attached to an assault rifle.

The game puts you in the role of a soldier who needs to save a colony of humans from zombie-like alien invaders. One of its innovations in gore is that the aliens die slowly, lying on the ground bleeding. To prevent them from being saved, you can perform a "curb stomp."

A CURB STOMP IS WHEN YOU CRACK THEIR HEAD OPEN ON THE GROUND LIKE A COCONUT.

Nothing makes Katy angrier than when people blame video games for violence in the real world. "I don't have a violent bone in my body," she says. "I brake for butterflies. I'd rather wreck my car than hit a squirrel. I don't even like walking on grass because I might hurt it."

Katy spends hours each day playing Gears of War. She'd love to be the number-one pro gamer in the world, but she says she's not nearly good enough. "If I could just make the top 100, I'll be the happiest person alive."

Katy also works as an unpaid PR person for an elite gaming crew called Empire Arcadia. She travels to gaming conventions and talks to anyone who will listen. She tells them about her crew, which is led by a 29-year-old Emperor from the Bronx.

The Emperor's followers all wear black T-shirts bearing the words *Deadly Alliance*.

Katy hands out business cards with her MySpace handle—Bunny-X-ablaze—and she's amassed more than 28,000 friends on the site.

I ask about the name, and she tells me that it's a long story that begins with some friends of hers slashing

a woman's throat and burning down her house with a toddler inside.

Katy was a freshman and was good friends with a 19-year-old named Rocky. One day, she saw a news report that Rocky and his sister were arrested for murder.

They bound the woman to her bed, cut her throat, and stole her valuables. On the way out, they set fire to the house. Her 3-year-old son suffocated in the blaze.

Everyone in school knew that Katy was friends with the killers, and she quickly became an outcast.

She started hanging out with the gamer guys, because they didn't judge her. "We'd hang out in the CAD lab and play Halo," she says. "I like rabbits, so my name was Bunny. The gamer guys called themselves Bunny Killer 1, Bunny Killer 2, and Bunny Killer 3."

The next year, a sketchy new guy at school had a crush on Katy. When he finally got up the nerve to ask her out, she rejected him.

A few weeks later, he walked up to Katy and handed her a present. "I was so excited. I never get presents."

It was a stuffed rabbit with its ears cut off and its throat slit, with fake blood all over it. She cried when she saw it.

A friend of Katy's invited her over after school to comfort her. He told her to bring the bunny.

When she got there, he set it on fire. They watched it burn on the lawn for a while and then put the remains in a plastic bag.

The next day, they threw the charred bunny at the guy in the cafeteria and told him never to do anything like that again.

Now more than 28,000 gamers around the world know Katy as Bunny-X-ablaze.

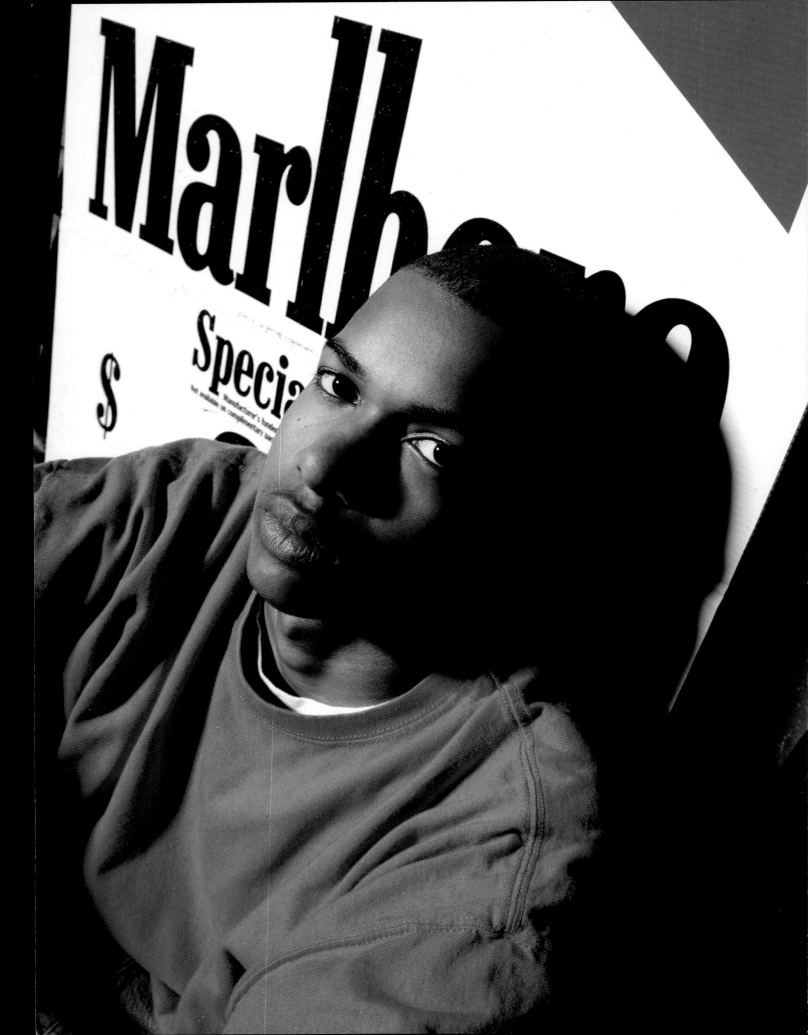

CHAD
17★ NORTH CAROLINA

Last weekend, Chad taught a bunch of teenagers at a mall how to make second-hand-smoke soup.

He gave them an apron and a hat. A big old soup bowl. And he put the ingredients out on the table:

AMMONIA, BUTANE, EMBALMING FLUID, MOTH BALLS, AND DOG URINE.

Chad says these really are the ingredients in tobacco. Then he asks if anyone wants to taste the soup.

This is Tobacco 101, a class Chad has taught to over thousands of teenagers. He works for a youth empowerment center recruiting new young soldiers in the fight against the tobacco industry.

"I'm pretty excited," he says. "Next month, we're going to protest at an Altria shareholders meeting. They make Marlboro."

Smoking killed Chad's great-grandfather. He's afraid cigarettes will kill his grandma. He prays for God to give her the power to quit smoking.

Chad has never smoked a cigarette in his life, but he reluctantly tells me the story of picking up a cigarette butt off the ground when he was 11 and putting it in his mouth, pretending to smoke.

"Yeah, it's gross, but it proves that I thought it was cool," he says. That makes him angry.

It's hard for Chad to see people smoking at school. He wants to tell them why they shouldn't, but they get mad when he does that. "It's kind of sad," he says.

Although he's not yet old enough to buy a pack of cigarettes at the local store, he's already being quoted in news stories on tobacco use.

He takes media calls on his cell phone at home, and his little brother makes fun of him while he talks. His brother says he's two-faced for talking all "proper."

His friends do too. They'll show up at his house when he's blasting Justin Timberlake or Nickelback, and make fun of him. "Chad's all in with the white people now," they'll say.

It bothers Chad when they say this. Most of his friends in high school are black, and he sings on the "praise team" of the largest African-American church in the state. But he says he feels sorry for his friends who think he's selling out.

"They're stuck in the mindset that you're supposed to listen to a certain type of music or dress a certain way or act a certain way because of your ethnicity."

Chad says it's not about race, it's about being professional. Some days, he's gotta wear the preppy American Eagle instead of the Rocawear (Jay-Z's brand), just so people will take him seriously.

And when he's talking to the media, it doesn't matter if they're black or white, he won't use hip-hop slang.

"Young people today have two types of communication—there's the way we talk to each other online, and there's the way we talk to the rest of the world."

"All I want," Chad says, "is for people to hear what I have to say."

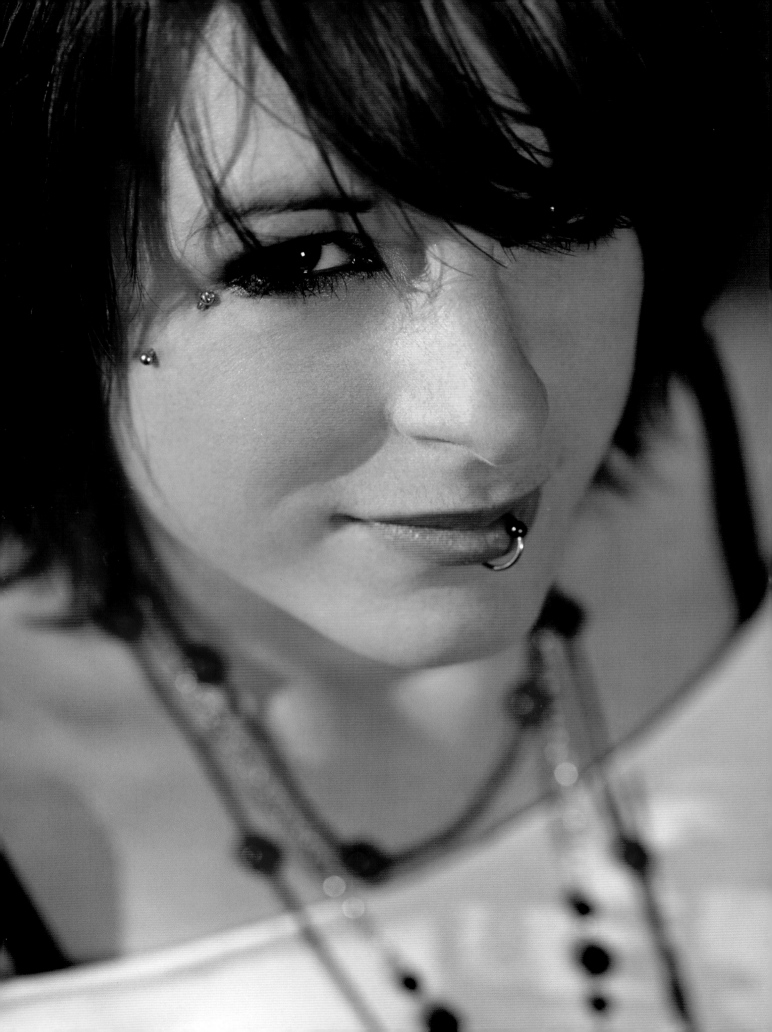

NICOLE
18 ★ NEW MEXICO

"EVERYONE IN PRIVATE SCHOOL IS UPTIGHT."

Nicole needs the freedom to express herself, and she found it in the huge public school she transferred to after a miserable year at a stuffy prep school.

She says her new school has the worst reputation in the state because of all the gangs and fighting in the hallways, but she likes it anyway. People are more laid back and open-minded.

People at her new school know Nicole as an art girl, and a lot of them like her unique style, which she describes as "accidental."

"I wake up with really good bed-head, and I just improve on it," she says. "I don't understand why people try so hard to all look the same. I think it's fun to just do what you want to do."

Nicole says she just doesn't get the cheerleaders and the other popular girls. "The heels, the skirts, all of that. They have to spend four hours getting ready in the morning, and in the end they wear the most boring outfits."

The popular girls don't get Nicole either. They call her a weirdo. Nicole says her sister is a "high-maintenance type" like the cheerleaders. She thinks Nicole dresses like a homeless person.

Making clothes and jewelry is Nicole's passion. She's already got her own clothing business and plans to study design at Art Center.

Last year, she went on a "bitchin" class trip to Japan and found tons of cool stuff like Godzilla jewelry and little toys that come in plastic bubbles from vending machines on the side of the road.

Nicole loves traveling to discover fashion. On a family trip to Cancun, she woke up with an "unfortunate" tattoo—a star on her right arm. "It turns out the tequila in Mexico is pretty good," she explains.

Like Nicole said, her style is accidental. "I got my lip ring because I was pissed at my boyfriend," she tells me. He said she wouldn't have the guts to get a piercing, and she had to prove him wrong.

Nicole says she's a weenie and can't even bear to go to the doctor and get a shot in her arm. Recently, she found a water bug and gently placed it in a cup so she could paint its portrait in watercolors. When she was done, she set it free behind the house.

Nicole is totally against animal testing, and she makes sure all her makeup is cruelty-free. She says she absolutely loves makeup, and I remind her what she said about all those girls that take four hours in the morning. I thought Nicole was an all-natural kind of girl.

"No!" she says. "Makeup is like art on your face. I love that."

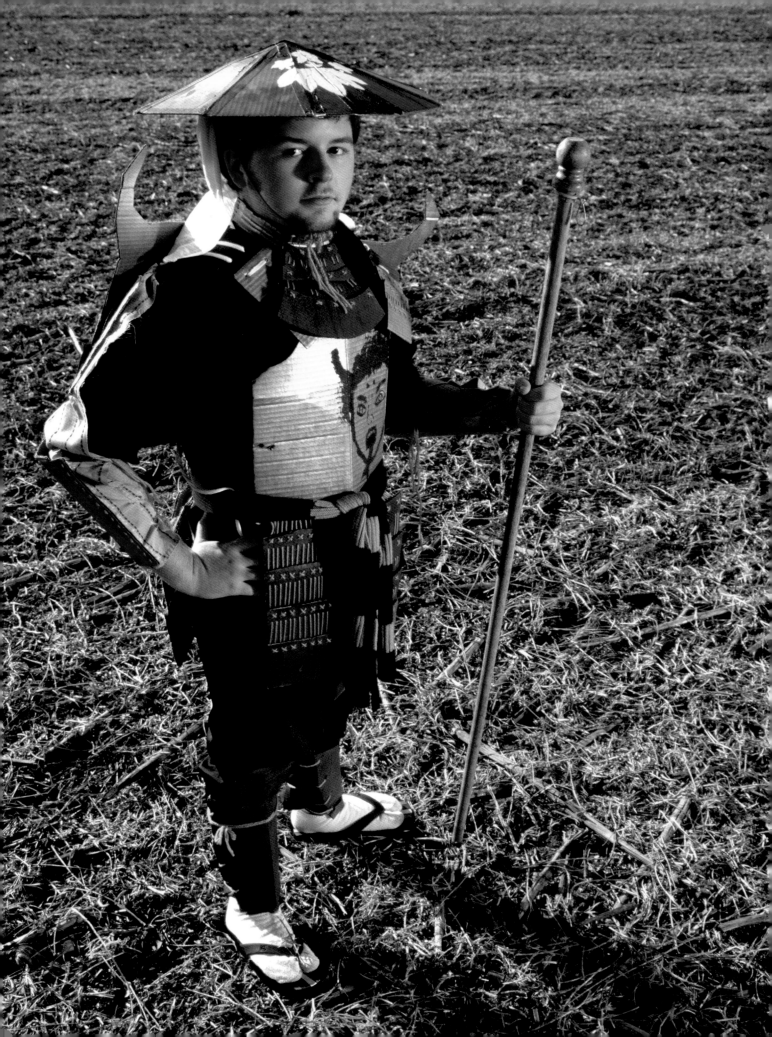

BRADY
18 ★ INDIANA

Three years ago, in church camp, Brady made a cardboard suit of armor to wear when he played paintball. The camp officials said it wasn't safe to wear on the paintball field; he might trip.

So Brady started wearing the cardboard armor everywhere else—including to his high school's football games. Everyone called him Cardboard Samurai. His outfits are based on Samurai characters in a religious novel he's writing.

Brady is 600 pages into his tome about a knight who gets excommunicated by the church and joins a Samurai clan in Japan. It's what he calls "alternative history": a fictional story of what might have happened if history had been slightly different.

The armor he's wearing in the photograph is based on Saito Musashibo Benkei, a twelfth century warrior monk who was conceived when his father raped his mother. The face on the front is a mythical Japanese creature called an *oni*, which is basically a big ugly ogre with claws and horns.

Brady describes himself as a nerd. He and his friends sit at the same table every day in the cafeteria; the rest of the school refers to them as "the weird people."

"It's social suicide to hang out with us," Brady says. For cheerleaders and other kids who care about their social standing, they just can't be seen near the weird people.

Brady is fine with that. In fact, he seems to enjoy the attention he gets for being weird. "In ninth grade, I decided that fitting in isn't really worth it. I think I've had more fun not fitting in than most people have fitting in."

Most of the school drinks and parties, but Brady has no interest in that. He's never had a drink of alcohol in his life and is horrified at the thought of trying marijuana or other drugs.

A lot of the popular kids do those things, but Brady says life will change for them after high school. He says nerds will mostly grow up to be successful, and the popular kids—especially the ones who drink and party—will be secretaries and janitors.

"IF BILL GATES WERE A TEENAGER AT MY SCHOOL, HE'D BE SITTING AT MY TABLE IN THE CAFETERIA."

Brady's one real girlfriend in high school was a punk rock girl he dated freshman year. One day, he heard she was doing drugs ("smoking, drinking, or marijuana—something like that"), and he told her how dangerous that was. That conversation was the end of the relationship.

The main benefit of being part of his clique, he says, is that he doesn't need to worry about losing popularity—which he says is the full-time concern of all the popular kids.

"Once you're already down here in the low social standing, it's not really that bad," Brady explains. "It's easier to have fun."

MEGAN
17 ★ DELAWARE

It's midnight, and we're in Megan's bedroom. We met her two hours ago in the mall, and now her parents are making us coffee.

We had plans to photograph a 16-year-old who wears masks all the time because he's shy and doesn't like to be looked at. When we got to his house, his dad sat us down in the basement and told us that he doesn't allow his son to talk to strangers, much less get his picture taken by them.

We were afraid we'd leave Delaware empty-handed and decided to stop at the mall to see if we could find a last-minute replacement.

Megan works at a store that sells clothes to emo and punk rock kids, and she instantly got excited about the book. Within minutes of finding her, we were following her home.

Many of the teenagers we've met live in stark white rooms which reveal nothing about their personalities. Not Megan.

She calls her room "organized chaos," and everything is here for a reason. She says it paints a picture of what she's about:

"CRADLE OF FILTH MEETS CARE BEARS."

All of her favorite bands, movies, and TV shows are all over the walls. Dracula, Lost Boys, Social Distortion, Rancid. "I change my walls based on my mood," she says.

Megan is obsessed with bats, stars, and nighttime. Her favorite color is blue, and her favorite day of the year is Halloween, which also happens to be Megan's birthday.

"I kind of wear that as a badge," she says. "I've always been into creepy stuff."

The bats, she explains, are a big part of Halloween—plus they're cute. Megan says she loves animals more than people, because they're helpless and they need to be taken care of.

When she first saw Cooper, her guinea pig, he was in the pet store at the mall. He had a cut on his nose from being picked on by the other guinea pigs, and it was love at first sight.

Now she pets and cuddles with him every night, and he squeaks to tell her he's happy.

Megan is trying to be a vegetarian, because she thinks it's wrong to hurt animals, but she hates veggies, so it's hard. Mainly she lives on pizza, chicken nuggets, and fries.

Megan says she started to become the person she is now in fourth grade. She dressed "like a dork" and spent a lot of time alone reading vampire fiction.

People call her gothic or "scene" a lot, but she says she doesn't have any specific style. She just wears what she likes. And she almost always sticks out in a crowd.

"Everyone looks at me and assumes I hate my parents and don't care about school, but I'm the opposite."

She says that no one else has parents who would let a hard-core band practice in the house, but her parents are cool. Right now, her band is on hiatus, because their guitar player—Megan's 14-year-old brother—got a bad report card.

A couple of years ago, Megan slipped into a pretty bad depression. She says it runs in her mom's family.

At first, she didn't like the idea of taking medication to feel better, but she decided to give it a chance. She says it saved her life.

"If you're depressed," she says, "don't be embarrassed. It's not your fault. There is hope."

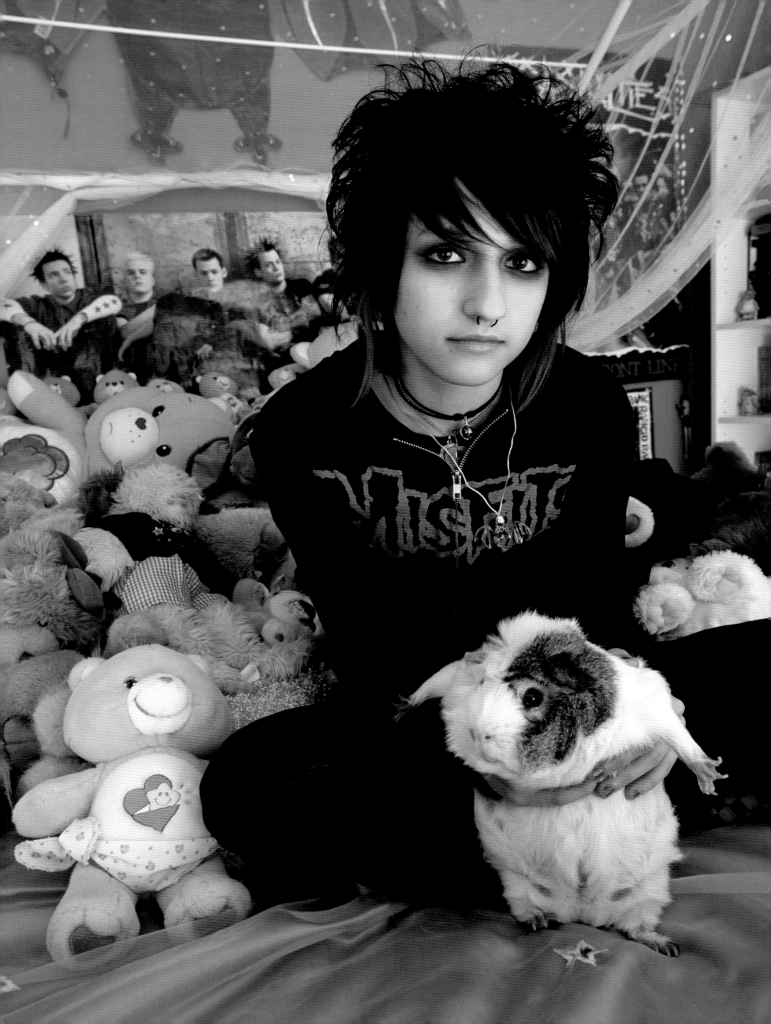

BLACKMAN
17 ★ NEW YORK

His real name is Desmond, but the only person to call him that is his mother, and he doesn't talk to her. So he tells me to call him Blackman, like everyone else does. (He says it as if it were two words—*black man*—but he writes it as one.)

When he was 10 years old, he was the only black kid in a group of white and Latino BMXers in Brooklyn, and they wanted to give him a nickname. He told them to call him D but they said, "No, we're going to call you Blackman."

Blackman says people all over the city know his name, because he's the best street rider in New York.

Life so far has been hard for Blackman. When he was 9, his parents split up, and he spent the next 5 years in 7 foster homes. "I was a little kid with so much hate," he says, "moving into strangers' houses all the time. A little kid shouldn't have to do that."

Blackman's tough exterior cracks a little when he talks about foster care. Only one of the foster homes was good. "These two old people in Flatbush. I had my own room with AC and a radio. It was cool."

He only got to stay there for 4 months. "They just keep moving you around," he says.

"All the rest were bad. I'd always be in a room with like five other kids, and they all had problems."

Blackman says most foster parents don't care about the kids. They just need a way to pay the rent, and more kids means more money.

Some of the memories are so bad that Blackman gets angry when I ask him to talk about them. "I don't like talking about that shit," he says. "All I wanna do is ride my bike."

For the past few years, Blackman hasn't really had a home. Sometimes, he'll crash with his aunt in Flushing, but she's got giant roaches and he can't cope. Twice, his mom and stepdad let him move in, but kicked him out both times.

Now he's sleeping on a couch in someone's living room, while his dad—whom he met for the first time this year—sleeps on another couch in the same room. The shower doesn't work, so he tries to wash up in the sink every morning.

At school, the other kids made fun of Blackman for smelling bad and wearing dirty clothes, and he got in a lot of fights. Now he doesn't bother going to school at all. He just rides all day, sometimes 20 miles into the Bronx.

"When I want to get away from trouble," he says, "I ride my bike."

Most of the time, Blackman is stressed out, angry, and hungry. Figuring out a way to eat is a big part of his life. I ask if he ever begs for money, and he says he'd rather go without food.

Blackman is so good at BMX that a local company used to give him bikes to ride, but they stopped when a friend ratted him out for selling bike parts to buy food.

He finds a way to get by, sometimes resorting to selling weed or metro cards, but that's not his thing. His dream is to be a pro rider.

66 RIDING MY BIKE IS MY LIFE. 99

"It's my heart. It takes me away from my problems. It's the only thing that makes me happy."

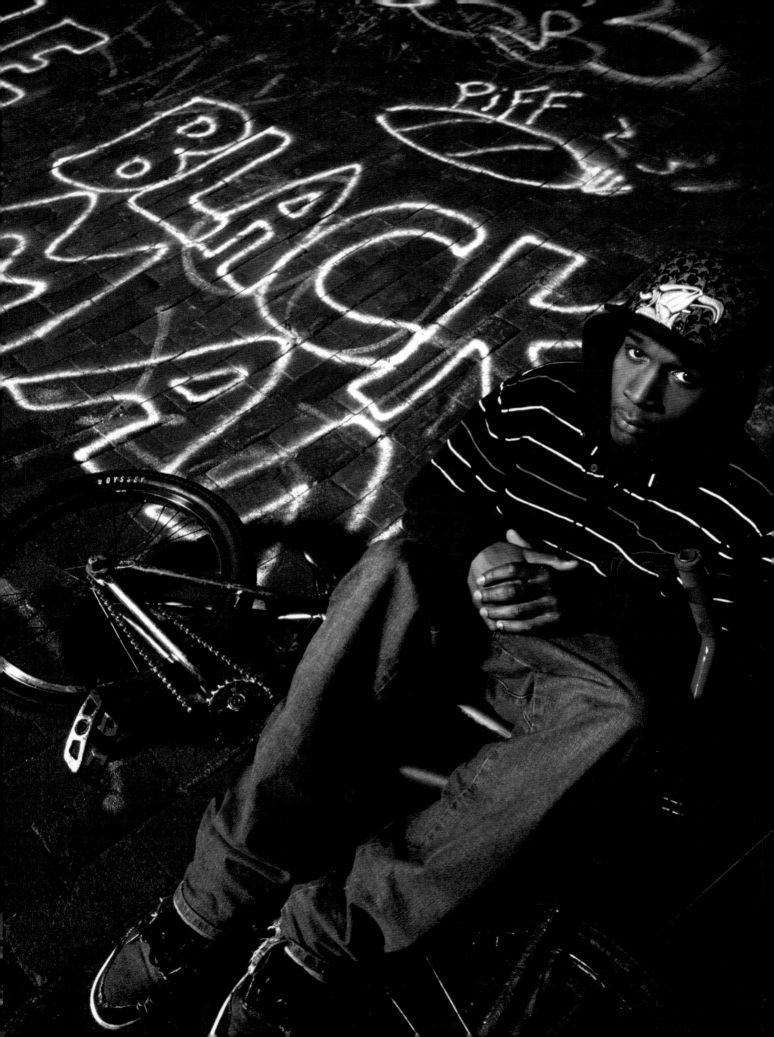

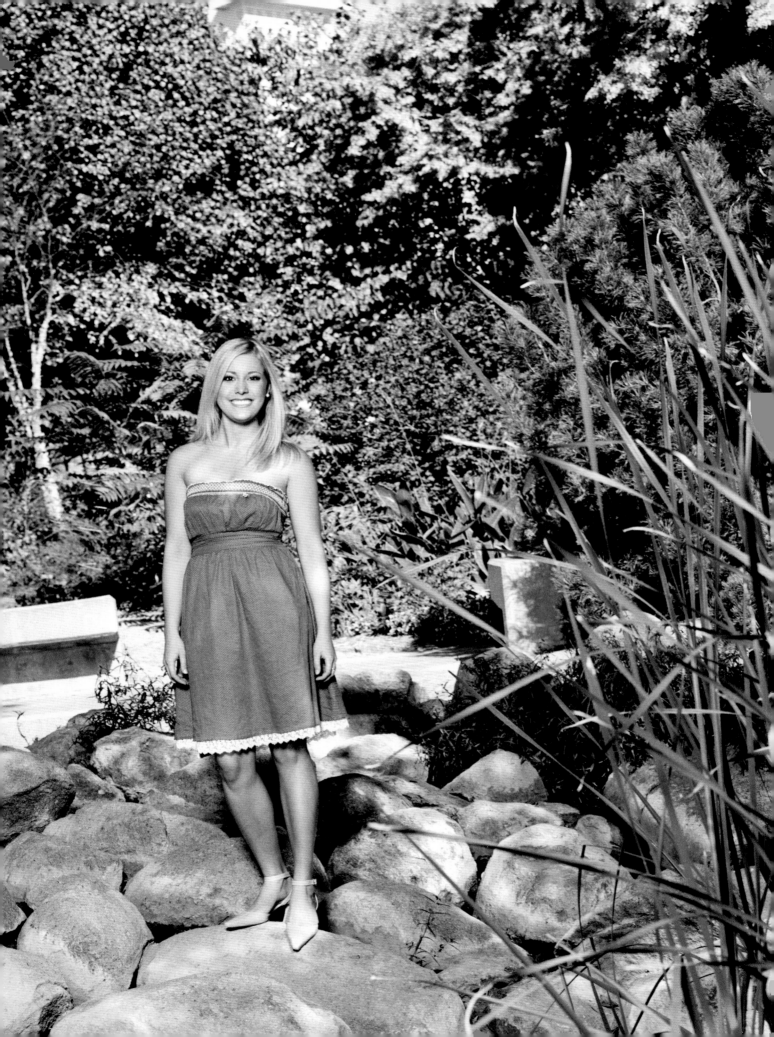

ASHLEY

18 ★ OKLAHOMA

The three people Ashley most wants to meet are Jesus Christ, Marilyn Monroe, and Oprah.

Her dream is to be a movie star living in a huge house by the beach in Malibu, but sometimes she thinks it could be better to fall in love with a nice guy and raise a family.

"When I was in first grade, I saw an interview with a famous actress," she says. "She looked so pretty and classy, and everyone was taking pictures of her. I pointed at the TV and said, 'Mommy, I want to be like that.'"

Her mom thought that was funny, because Ashley was such a tomboy. She and the boys on her street played cowboys and Indians, climbed trees, and caught turtles.

In sixth grade, the boys started getting interested in her, and that ended their playdates, but she became friends with three girls who had the same adventurous spirit.

"We'd go off and play in this junkyard near my house," she says. "We made up Indian names for ourselves like Sunrise and Sunset. And we built a house out of old car parts and found old coffee cups and an old mattress."

Ashley says she always loved playing make believe, and that's why she wants to be an actress.

"Some people want to grow up to be a firefighter or a policeman or a teacher. When you're an actor, you can be any of those things. You can live all of those different lives. I think that's really exciting."

Ashley is afraid she'll leave friends behind when she makes it, but she has no fear of getting swept up in the Hollywood lifestyle of late-night partying and drugs. She says she's a "strong Christian."

"I was raised not to do bad things," she says, "and I've seen what happens to friends who go down the wrong path."

Two years ago, Ashley lost a friend to meth. Actually, he's not dead, but everyone pretends he is, because it's too painful to see him now.

The same year, her friend Michael overdosed on pills. "He was a really nice guy," she says. "He just liked to party hard."

She credits her success in life to parents who pay attention and care, although she thinks they care too much sometimes. She says they're convinced she'll get abducted when she moves to L.A.

At home, Ashley had parental controls on her computer that blocked sites like MySpace and limited her Internet usage to 30 minutes a day.

Now that she's on her own, she's enjoying her freedom. Her MySpace page plays the Christina Aguilera song "Still Dirrty," which includes these lyrics:

DON'T TELL ME WHAT TO DO CAUSE I'LL NEVER BE UPTIGHT LIKE YOU.

Ashley is friends with tons of dancers and actors at school, and she says they all want to be famous. "I'm pretty sure it's what I want," she says.

"I just don't want to look back and think, 'I could have married someone in Oklahoma and had a life with people around me who really cared.'"

MAIRIN

18 ★ NEBRASKA

Mairin belches and farts really loud, and she doesn't care what people think.

She shaved her eyebrows off so she could draw them on. Sometimes she draws normal ones so she doesn't scare little kids in the mall.

Mairin says that most people feel the need for perfection, and she's the complete opposite. She loves things that are conspicuously imperfect: scars, weird hair, big noses.

Her personal style is "a mixture of death rock, cyber punk, and goth."

Mairin moved in with her boyfriend when she turned 18 to get away from her little sister, the "social butterfly."

"After I turned 18, I got grumpy toward everything."

Mairin gets sick of people being mean to everyone, and she hates that people think they need to go to the doctor to inflate their lips or get fake breasts.

"Everyone wants to be a beauty queen," she says. "You turn on the TV and see 16-year-old girls on plastic surgery shows getting breast implants. Why do they need to do that?"

I answer her rhetorical question and suggest it's about getting a reaction from people, in the same way she does with hair, makeup, and clothes.

"I do this for myself, not to get a reaction," she tells me. "I don't even notice the way people look at me anymore."

Then Mairin concedes that she likes the attention because it's amusing. When someone calls her a devil worshipper, she laughs. "I am far from a devil worshipper."

"JUST CUZ I LOOK CRAZY DOESN'T MEAN I'M GONNA MURDER YOUR CAT OR SOMETHING."

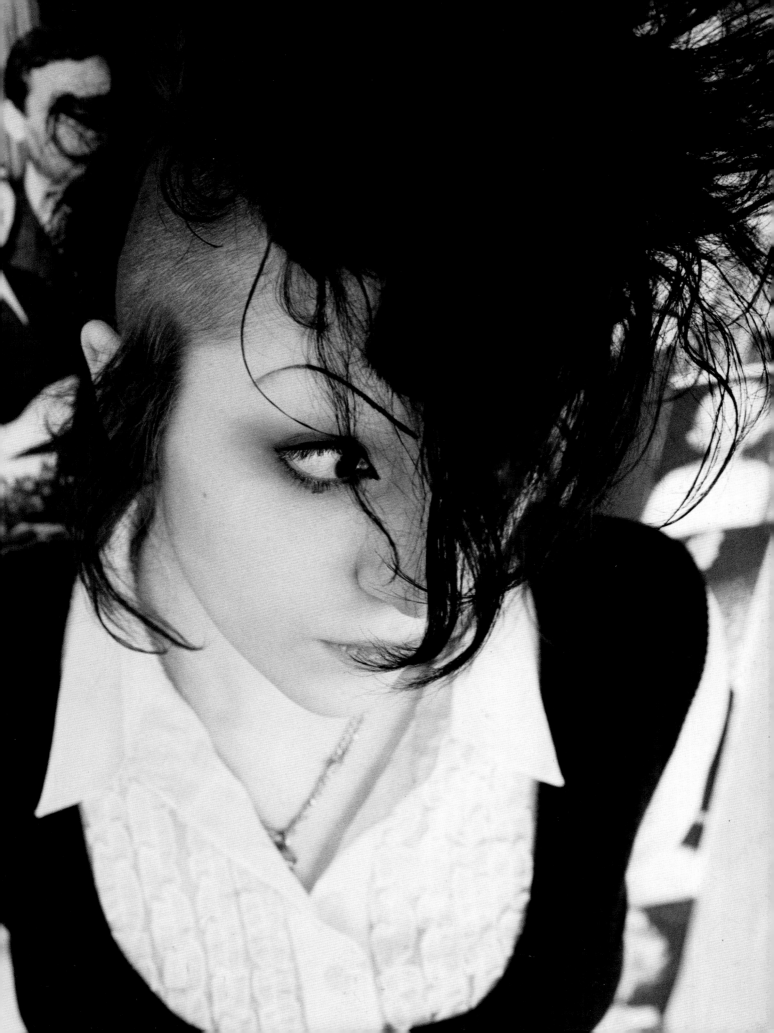

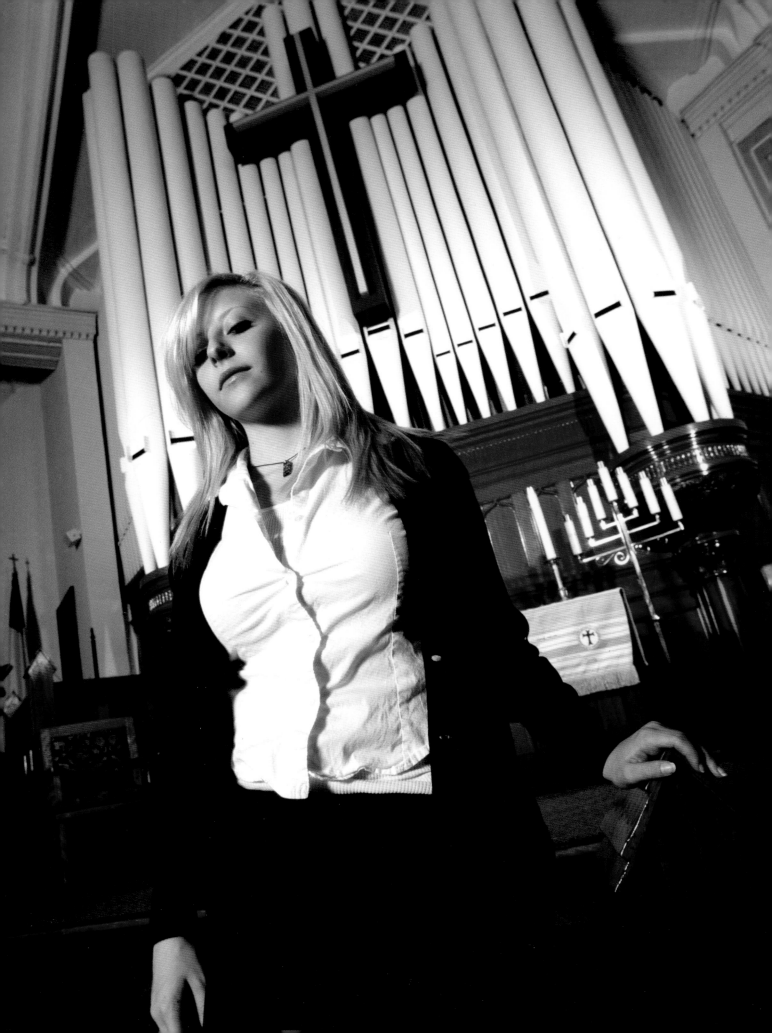

CHRISTINE
17 ★ CONNECTICUT

CHRISTINE DOESN'T BELIEVE IN GOD. AT LEAST NOT THE GOD THEY TALK ABOUT IN SCHOOL.

Her parents are deeply religious and hate the fact that she won't go to church with them. "My mom says she's seen angels before," she says. "I can't completely deny there's something there. I'm just not sure."

She wants to try going to a Wiccan church down the street. And she likes the ideas behind Buddhism. Things like peace and reincarnation. She also wants to see what it's like to go to a synagogue, but she says she could never follow Jewish laws, like keeping kosher.

Earlier this year, Christine was the only student with neon blue hair out of 600 in her Catholic high school. While her parents were away on a cruise, she went to a local punk salon and got a dye job.

She thought it looked good with her uniform, but the principal disagreed. Every day, he asked her to go back to her natural color. She gave in but then circulated a petition to demand freedom of hair color. It was rejected, she says, because she's not on student council.

Last year, Christine almost got expelled for wearing sweat pants to school. But the school play was coming up, and there wasn't time to replace her. So she just got detention instead.

She's spent a lot of time in detention. She thinks she's not cut out for Catholic school—and she says she'd never send her own kids to one.

Her friends in public school have classes on current events and the media, where they get to voice their own opinions. "In Catholic school," she says, "you're not allowed to express yourself. You learn what they want you to learn."

She says she's completely against the church's opinion on a ton of things, like abortion and gay marriage. It's hard for her to sit through Christian morality class without arguing with the teacher.

MySpace is a great example. Her school held a full-day assembly on the dangers of MySpace, which she summarizes in one line: "You can meet people on MySpace that will give you drugs and rape you."

"We're not that dumb," Christine says. "They're not giving us enough credit."

I ask Christine what she thinks about drugs and alcohol, and she fumes, "The war on drugs is ridiculous. Prohibition didn't work for alcohol, and it's not going to work for weed."

As for alcohol: "Teenagers are going to drink, especially if it's out of their reach." She says a lot of her friends do it, even though they don't like doing it.

I ask her why they do it, and she thinks the answer is obvious: "Teenagers do what they're told not to do."

BENTZY
19★ NEW YORK

Bentzy has never heard of MySpace. He's lived in New York since he was 11, but he lives in a different world from most American teenagers.

66 WE ARE HERE FOR A PURPOSE. 99

"We are not here for enjoyment. God created us to do something. And the something isn't to play basketball all day or to eat pizza. If teenagers in America knew this, it would be good."

We're inside a storefront synagogue in Brooklyn, and Bentzy—who is studying to be a Hasidic rabbi—gets excited when he learns I was born a Jew.

My mother was a Jew, and Bentzy says that makes me a Jew. Period. It doesn't matter that I don't consider myself Jewish.

Brett, my producer, does consider himself a Jew. He had a bar mitzvah and can recite Hebrew scripture from memory. But his mom converted to Judaism—she wasn't born a Jew.

Bentzy tells us that "a Jew is a Jew is a Jew; there's no such thing as half a Jew." But it's clear to everyone in the room that he doesn't really consider Brett a Jew. This is most apparent when he pulls out a pair of small wooden boxes he calls tefillin.

He asks if I will join him in a prayer, and he proceeds to attach the boxes to my head and arm using long leather straps, which he says are made from the skins of kosher animals. He tells me they are filled with tiny scrolls of biblical verses.

Bentzy recites lines from the Torah in Hebrew, and I do my best to repeat them. This is what Bentzy does. He tries to connect with the "Jewish" soul in every Jew—especially nonpracticing Jews like me.

Bentzy spends nine hours each day studying the Jewish scripture and three hours praying. Sometimes at night he'll play basketball, but only after a full day of study and prayer.

"We are here for a reason, and the reason is not pleasure. Pleasure is not truth. When you think about it, pleasure is here today and gone tomorrow and it doesn't get you anywhere in life."

Soon he's talking about the 613 commandments, and I'm embarrassed to ask if the Ten Commandments are included. (They are; Jews have another 603 they need to follow.)

Bentzy is standing in front of the ark, the cabinet where the Torah scrolls he holds are stored. This is the spot where they read from the Torah during services.

At his feet is something that looks like a sidewalk grate. Desperate to get back to talking about things we can fully understand, we ask him what that is.

"That's so the women downstairs can hear the reading of the Torah." During the services, they send all the women to the basement.

At first, Bentzy gives the simple explanation that "there just isn't room up here for them." But then he adds that having women present would, obviously, be distracting for the men who are trying to pray. And they can hear just fine through the grate.

We ask if the women mind, and he says they complain all the time about it, but they're used to it.

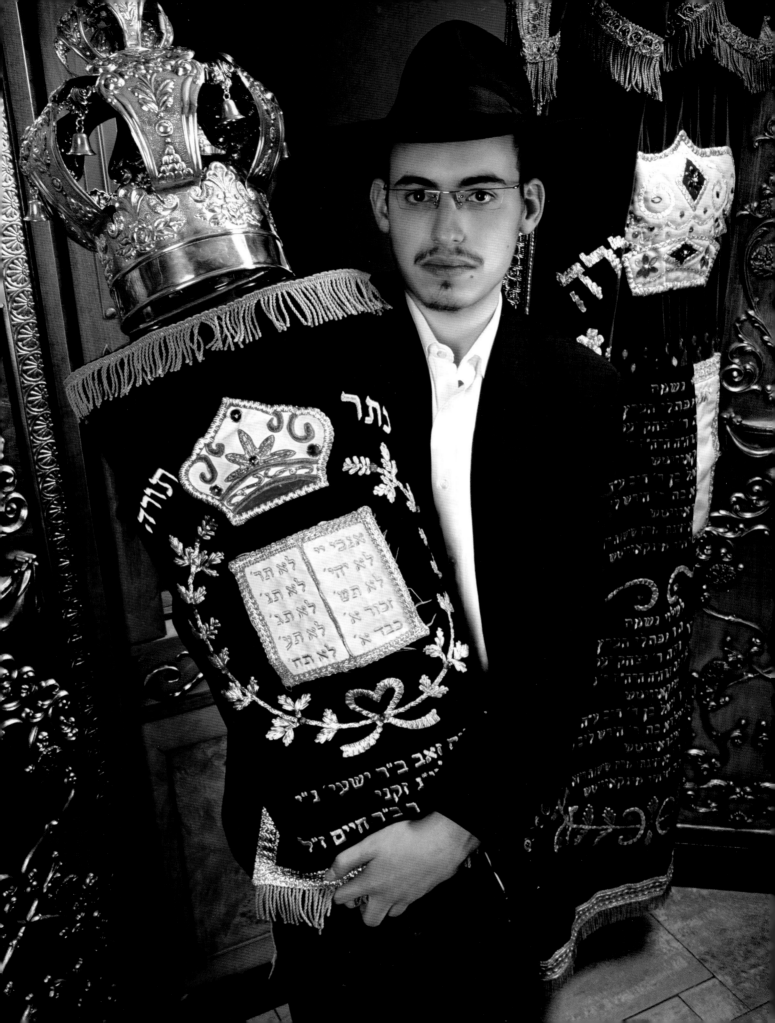

RESKEW
19 ★ NEW YORK

We can't tell you his name and we can't let you see his face.

He says to call him by his graffiti name, which is pronounced like the word *rescue*, but he spells it his own way, because that's what taggers do. He thinks it suits him, because he likes to help people.

His tag—which he's painted in more than 200 illegal locations around New York City—is Reskew ACC. The last three letters mean he throws down with the All City Crew, a kind of exclusive club of 50 to 100 graffiti artists around the city.

Reskew was famous in the New York graffiti world before anyone knew who he was. Then the leader of ACC discovered him one night in Brooklyn.

He was roaming around as usual, bombing, when this guy who seemed like a cop pulled up next to him and asked him what he writes. Once Reskew figured out who the guy was, he told him, and he was instantly in the crew.

Reskew's in it for the adrenaline rush.

"RUNNING FROM THE COPS, CLIMBING ROOFTOPS, GOING TO GHETTO NEIGHBORHOODS BY YOURSELF."

"The freaks come out at night," he says. That's when he does all his bombing. "Afterward, you've got this high. You got through the night without getting arrested."

He's also in it for the notoriety. The idea of being a famous outlaw is pretty cool. He likes when people come up to him and say they saw his stuff down on Coney Island or over on Bedford Avenue.

Before graffiti, Reskew hadn't found his place in the world. Growing up, he bounced back and forth between his mom and dad, and that meant he switched schools a lot.

"I was always the new kid, I didn't have friends, and I didn't really have people on my level to talk to." Reskew says he was his own person.

It's 100 degrees on this SoHo rooftop, and the plywood wall we built for Reskew is ready to go. He's got 30 cans of spray paint, and we watch him fill the wall with his art.

In less than two hours, his vision materializes. Even though he's not breaking the law here, he still clearly gets a thrill.

I suggest that he consider making money from his talent, like Shepard Fairey or Banksy, two famous street artists who have gone commercial. He shrugs and says he's trying to do a T-shirt business, but he's not sure how to get it off the ground.

Besides, T-shirts don't give him a rush the way graffiti does. He says it's mainly about getting away with it. It's also about proving your independence at the same time as giving the world a giant fuck you:

"They don't care about you, so why should you care about them? Do what you want to do, and don't let them oppress you. Don't let them make you a robot."

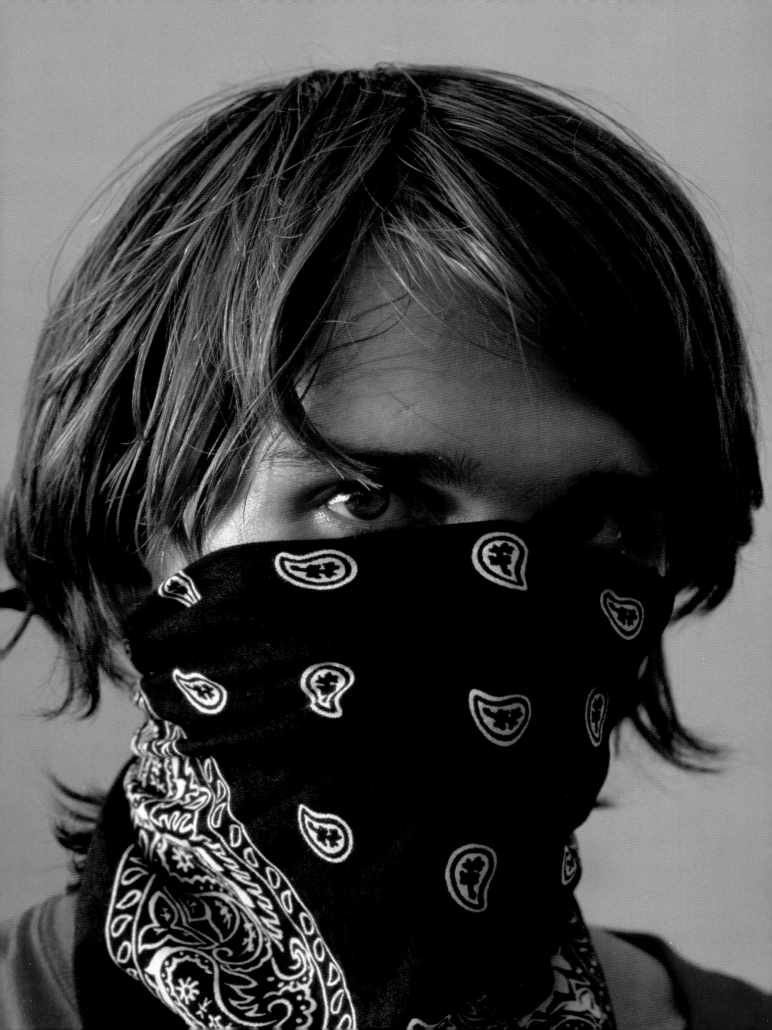

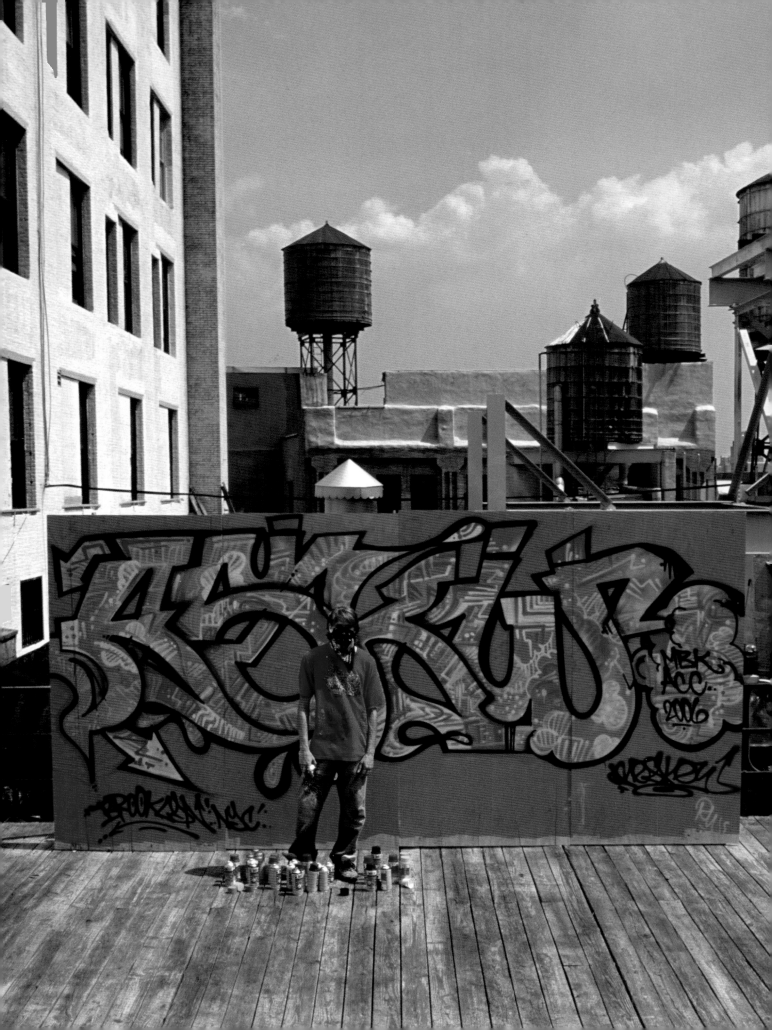

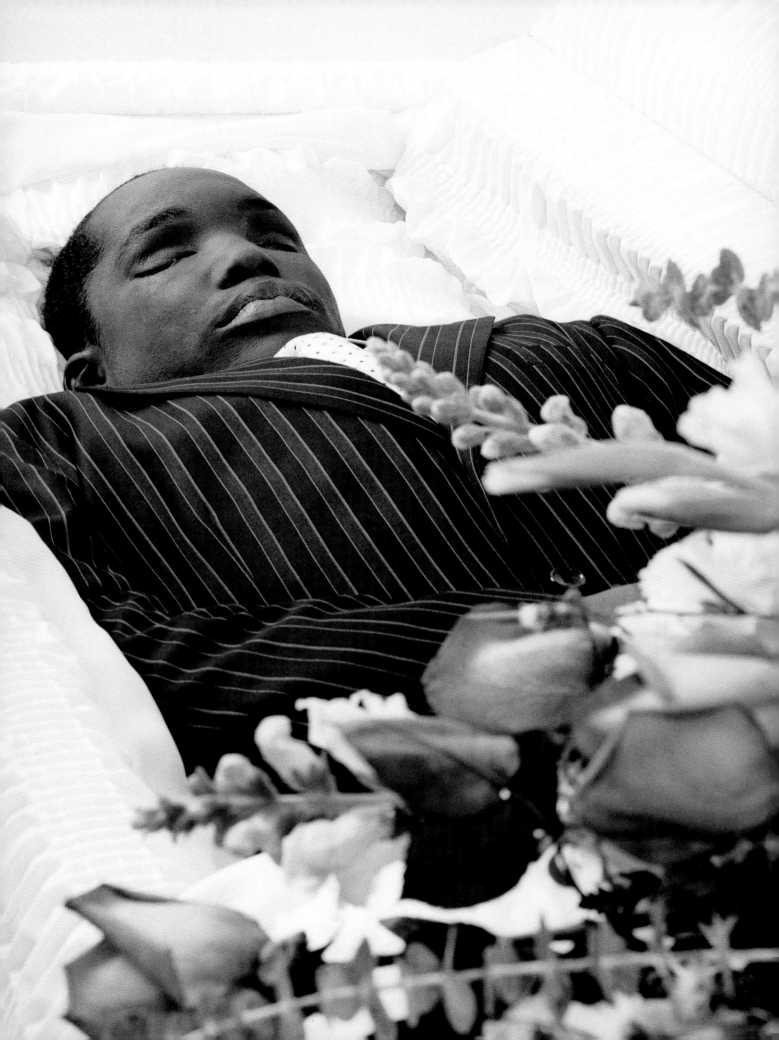

BRYCE
13★ CALIFORNIA

The bullet wasn't meant for him.

Bryce was part of a big family, and they had a lot of parties. On this particular Saturday night, it was someone's birthday—a cousin or a niece. To Bryce, it didn't matter who; he just wanted to go hang out with his older cousins.

I ask one of his cousins about Bryce and he smiles. "Bryce was the comedian of the family. All he wanted to do was make people laugh."

"He was a real entertainer," his mom says. "He was always doing something silly. Like running around the house wearing a giant pair of underwear outside his pants."

Bryce's mom gets so emotional she can barely talk, as she tells me about a conversation she had with him 2 days before his death.

"I was trying to tell him he had to start being careful where he went," she says. "I was telling him he didn't look 13—he looked 16 or 17."

"I didn't want anybody to make a mistake and think he was older than he is; I didn't want anyone to kill my baby."

He told her not to worry.

66 IF I'M JUST GOING DOWN THE STREET, NOTHING'S GONNA HAPPEN TO ME. 99

At about 7:30 on the night of the party, some of Bryce's cousins headed out the front door to get some rope to hang up the piñata.

Bryce was in a group of eight guys, mostly older cousins. The last words his sister said to him were, "You better not go nowhere." But Bryce snuck out with his cousins anyway.

They were all walking down the sidewalk, goofing around and laughing, when the car pulled up.

A single bullet hit Bryce in the chest, and his heart exploded.

No one knew who did this or why. Only much later did the police discover that the shooter was a 32-year-old gang member who was after one of Bryce's cousins. (By all accounts, Bryce had nothing to do with any gang, despite the pressure to join one felt by every kid who lives in the neighborhood.)

His mom says she will forever regret the decision to meet a friend for dinner and come to the party late.

By the time she got there, the entire block was sealed off with yellow police tape, and Bryce's cold body had been on the ground for hours.

The police let her see her son one last time.

"I was in shock," she says. "There were ants crawling all over his face, from being there on the ground so long. I brushed them away and gave him a kiss. Then they took him away."

His mom says he looked handsome in his brown pants and white shirt with brown pinstripes.

She tells me about shopping for these clothes with him a week before he died.

"He wouldn't let me pick anything out for him. He said everything was too tight. You know, kids these days want everything baggy."

The girl in the store was laughing, because Bryce was being funny, as usual.

"I told him, 'This is the last time I'm taking you shopping,'" his mom says. "I wish I had never said that."

THE **INSTANT ACCESS GENERATION**

The half-year I spent on the road, meeting America's teenagers, was the greatest educational experience of my life. My debt to these young people is enormous.

It is because of them that I saw parts of the country I never thought I'd see, and some parts I never knew existed. I learned how to milk a cow, how to pierce a tongue, how to skin an alligator, and how to race a lawn mower.

I was welcomed into their schools and chased from their skate parks. I fired rifles, drove farming combines, and received a belated education in Jewish law.

It was hard at times to absorb everything these kids had to offer. And it was tempting to impose easy categories on them, to label them as goth, or nerd, or emo, or druggie, and feel I'd figured them out. But they defy labels.

Each kid has a unique history, and a complicated set of motivations, and it wouldn't be fair or accurate to suggest that they all share a common world view.

What they do share, however, is a common set of circumstances. They are the *instant access generation* because they're the first group of Americans to have grown up entirely within the technological revolution of the past twenty years, and they have confronted the risks and benefits of this revolution every day of their lives.

I met kids who have googled their way to dangerous discoveries: Deadly recreational drugs in their parents' medicine cabinets; violent and hate-filled subcultures; predators and bullies lurking in chat rooms.

I met others who prided themselves on their ability to "multitask"—to send instant messages, update their MySpace pages, play video games, scroll their iPods, and text-message, all simultaneously—but who can never give more than a fraction of their attention to any one thing at any one time.

I also met kids who are capable of making better, more informed decisions than any previous generation has ever been able to make—as the slow but significant decline in sexual intercourse and drug abuse among America's teens, and among the teens in this book, bears out.

Instant access means that some very important information is trickling down to young Americans, no matter where they are on the economic or geographic spectrum. Rich or poor, urban, suburban, or rural, these kids know how to make sense of the multimedia white noise—often better than their parents and teachers do.

They also know how to participate in an instant access culture, which is probably the most fortunate development for me as a photographer/writer/director.

They've been bombarded with pop-culture images since the day they were born. They know how to pose for the camera, how to smile, how to pout, how to project an image, and even how to sit for interviews.

Some, like 13-year-old Alexandra from Texas, have had several years of model training; her poise and maturity, though remarkable, have been earned the old-fashioned way. Others, like rappers Chuckee (Georgia) and Travis (Arkansas), only had to turn on the evening news to learn how to flash their "ice" for the camera.

But many like Angel, the vampire from New York, or Kammie, the Manga devotee from Louisiana, have joined communities of like-minded people on-line, and have adapted themselves to a virtual universe. For better or worse, they've discovered their peculiar niches in ways that are unique and specific to their generation.

They've mastered even the most minute details of their chosen identities. All I had to do was point my camera. They showed me the rest.

Without a doubt, these young people have made mistakes. Most know it. It was the running theme of my interviews: Every one of them demanded the right to screw up, free from parental interference and free from the meaningless platitudes of the adult world.

They're asking a lot. *Instant access* often means that the mistakes of today's teenagers have far greater consequences than ever before. Like everything else in our culture, teen angst—and teen violence—have gone global.

But so has teen idealism, earnestness, compassion, and optimism—all of which I found in abundance during my travels, and can be found on the pages of this book.

These kids are connected, to each other and to the world. For this reason, if for no other, we have to pay close attention to them.

Five months, fifty states, and one hundred kids later, I'm more convinced than ever that they can teach us more than we can teach them.

THANK YOU

BRETT HENENBERG gave up 18 months of his life to make this project a success. He is the most talented and dedicated producer on the planet. Brett orchestrated the planning, production, and postproduction of this massive project without a hitch. But he is far more than a producer. He is a creative visionary. Every page of this book has benefited from his ideas. And Brett is one of the few individuals I have encountered who shares my unwillingness to settle for anything short of perfection. Most importantly, Brett is a close friend. After spending half a year driving around America with Brett, I'm eager to do it again for the next book. Brett is a truly exceptional human being. This book would not exist without him.

JOHN TESSITORE is a lecturer in History and Literature at Harvard and was my collaborative editor on this book. John put in many nights helping me make the text of this book strong and focused. His insight and experience as an Americanist added an important dimension to this project. Working with John was an education, and I hope this is the first of many books we create as a team.

SHAUN FOROUZANDEH designed this book. Shaun's exceptional talent and drive for perfection made this book what it is. He lost many nights of sleep creating (and re-creating) these layouts. Shaun's life, for a solid 6 months, was designing this book. Starting with a blank screen and over 100,000 images, Shaun did a phenomenal job of crafting these 256 pages. Whatever Shaun decides to take on in the future, whether it is designing a book or making a feature film, I am certain he will succeed. **www.shaunforouzandeh.com**

MANJA ZORE retouched the images in this book. Manja has an amazingly refined eye for color and detail. She managed to preserve all of the nuances of the original images while removing imperfections and getting the color and contrast just right. **www.manjare.com**

ASTOR MORGAN is a phenomenally talented photographer with a thriving career. It was my privilege to have Astor accompany me to all 50 states as my photo assistant for every single day of shooting. Astor turned down many lucrative photo assignments to do this project, and I am deeply grateful to him for that. He was more of a collaborator than an assistant. The quality of images on these pages benefited immensely from his presence. Astor is the best there is. **www.astormorgan.com**

ROBERT RUEHLMAN is a talented art director who has worked on many of my favorite photography books. I was thrilled when he agreed to join us for the final month of design. His creative insight and his quiet charm make Robert a shining star in the design world.

VICTORIA SANDERS is my book agent and is a wonderful person. Within a month of meeting her, I was sitting in the offices of HarperCollins, and this project was underway. Victoria has a way of making things happen. Thank you, Victoria, for making this book happen. **www.victoriasanders.com**

IAN MCCALISTER worked as our production manager on this project for a solid year and was amazingly dedicated.

LINUS LAU is our associate producer and is the key person who keeps everything running smoothly. He is also a talented director, and someday soon he will take my advice and get to work on his first feature.

MICHAEL ASH is director of the print division of Radical Media, where I am represented as a photographer. Meeting Michael marked a turning point in my career. He is famous for spotting and building new talent. I am grateful to Michael for all he has done, including the challenging task of editing the images for this book, which he did with incredible ease. **www.radicalmedia.com**

AUSTIN JAMES is a talented and accomplished Hollywood real-people casting director. His reputation in the world of reality TV is unmatched. Austin and his team helped find the young people in this book. **www.fsaentertainment.com**

RU SOMMER, DAN MCCOLLISTER, JONNY ROWLES, AND MARIE KENEL worked many long days on the search for our young Americans.

ROCKET STUDIO, the Rolls Royce of L.A. retouching houses, donated time to work on this project.

HEINZ WEBER created the color separations and did so flawlessly. **www.heinzweber.com**

MARTA SCHOOLER, PAUL OLSEWSKI, GEORGE BICK, TERESA BRADY, ANGIE LEE, MARGARITA VAISMAN, RONI AXELROD, DINAH FRIED, LIZ SULLIVAN, ILANA ANGER AND OTHERS AT HARPERCOLLINS all dedicated themselves to making this book something special.

Special thanks to the following people, who helped make this project a success: **MATT SEMINARA, JESSICA KEET, FRANK RODRIGUEZ, SEAN NEWHOUSE, JASON CALACANIS, MIKE AND BARB MURPHY, VINCE CIANNI, MARK HARVEY, STEPHANIE MENUEZ, SARA KRUEGER, RIC ERNST, AND JORDAN QUEEN.**

The following individuals have supported me in more ways than I can list here. I am grateful to have them in my life. **DOUG ALLENSTEIN, IAN ROWE, KEVIN MACKALL, JON KAMEN, FRANK SCHERMA, TERRY SMITH, GARETH MONKS, LISA KARADJIAN, CHRIS RENSHAW, CISCO DELGADO, BRIAN NEWMAN, BRUCE MAZER, MIKE TARTAGLIA, DANNY LOGAN, ALEX KORDIS, LILIA GARCIA-LEYVA, SHALER LADD, MIKE SAKAMOTO, STEPHEN WEED, BRUCE MAZER, SEYMOUR AND CAROL HENENBERG, JIM JOHNSON, DAVID DECHMAN, TIM GILL, BRUCE BROTHERS, ANDY TOBIAS, CHARLES NOLAN, TIM SWEENEY, MICHAELJOHN HORNE, MARIE GROARK, ELI BROAD, GEOFF MCGANN, PETER IAN-CUMMINGS, AND DAVID FINCHER.**

DONN HOFFMAN is the most important person in my life. Thank you, Donn, for your endless encouragement and enthusiasm for every new project I take on.

Most importantly, I want to thank the **100 HUNDRED YOUNG AMERICANS** profiled on these pages. Their willingness to share their lives with the world made this book possible.

PRO ONE is the only photo lab in Los Angeles that I would trust with my film. **www.proonela.com**

TAKE ACTION

MTV THINK COMMUNITY
A massive, multimedia activist community where young people get informed, connect to one another, voice their concerns, and take real-world action on the issues important to them and their friends. **think.mtv.com**

AMERICORPS
A network of local, state, and national service programs that connects volunteers with communities to help in education, public safety, health, and the environment. **www.americorps.org**

BIG BROTHERS AND SISTERS
Matches children ages 6 through 18 with mentors in professionally supported one-to-one relationships. Also has volunteer programs in communities across the country. **www.bbbs.org**

VOLUNTEER MATCH
Matches the user with a community organization of that person's choice. **www.volunteermatch.org**

MENTOR
The premier advocate and resource for the expansion of mentoring initiatives nationwide. **www.mentoring.org**

TEACH FOR AMERICA
A national organization that sends college graduates to teach in urban and rural public schools for 2 years and become leaders in the effort to expand educational opportunity. **teachforamerica.org**

GET HELP

SUICIDE
NATIONAL SUICIDE PREVENTION LIFELINE
A 24-hour, toll-free suicide prevention service available to anyone in need.
www.suicidepreventionlifeline.org
1-800-273-TALK

NATIONAL HOPELINE NETWORK
A national suicide hotline that connects the caller with the nearest crisis center.
www.hopeline.com
1-800-SUICIDE

DRUGS AND ALCOHOL
ALCOHOLICS ANONYMOUS
A fellowship of men and women who share their experience, strength, and hope with one another to solve their drinking problem and help others to recover from alcoholism.
www.alcoholics-anonymous.org

PARTNERSHIP FOR A DRUG-FREE AMERICA
A place to get help—whether it's finding a treatment center or learning how to help others with a drug or drinking problem.
www.drugfree.org/Intervention

ALATEEN
Alateen is part of Al-Anon, which helps families and friends of alcoholics recover from the effects of living with a problem drinker.
www.al-anon.alateen.org

CRYSTAL METH ANONYMOUS
CMA is a 12-step program for people who are addicted to crystal meth. Links provide support for family and friends as well.
www.crystalmeth.org

DEXTROMETHORPHAN (COUGH MEDICINE)
The information on this site comes directly from medical research, news artcles, and from people who have abused DXM.
www.dxmstories.com

GAY AND LESBIAN RIGHTS
GLSEN
A national education organization dedicated to ensuring that every student is treated with respect, regardless of sexual orientation or gender expression. **www.glsen.org**

PFLAG
A national nonprofit organization that provides support, education, and opportunities to get involved on a grassroots level to parents of gays and lesbians. **www.pflag.org**

THE TREVOR PROJECT
A 24/7 suicide and crisis prevention helpline for gay teens and those who are questioning their orientation.
www.thetrevorproject.org
1-866-4-U-TREVOR

RUNAWAYS
NATIONAL RUNAWAY SWITCHBOARD
For teenagers who are thinking of running away from home, or have a friend who has run away and is looking for help, or who are runaways ready to go home. There is also a link to the Home Free Program, a partnership with Greyhound Lines, Inc., that reunites runaways with their families free of charge.
www.1800runaway.org
1-800-RUNAWAY

TEEN PREGNANCY
PLANNED PARENTHOOD
Planned Parenthood health centers offer sexual and reproductive health care, including family planning, gynecological care, STI/STD testing and treatment, pregnancy testing, and abortion services.
www.plannedparenthood.org
1-800-230-PLAN

VIOLENCE, GANGS, INTERNET SAFETY
NATIONAL YOUTH VIOLENCE PREVENTION RESOURCE CENTER
Offers information on violence prevention—whether it's stopping someone from committing a violent act or finding out how to start a school nonviolence program—sponsored by the Centers for Disease Control and Prevention and other federal agencies.
www.safeyouth.org/teens
1-866-SAFEYOUTH

NATIONAL CRIME PREVENTION COUNCIL
Provides resources for teens and parents on gangs, guns, cyberbullying, and anger management. **ncpc.org**

EATING DISORDERS
NATIONAL EATING DISORDERS HELPLINE
A toll-free information and referral service for anyone who is suffering from an eating disorder, or for someone who is a friend or family member of a person with food issues.
www.nationaleatingdisorders.org
1-800-931-2237